BLOOD AND BEAUTY

ORGANIZED VIOLENCE IN THE ART AND ARCHAEOLOGY

OF MESOAMERICA AND CENTRAL AMERICA

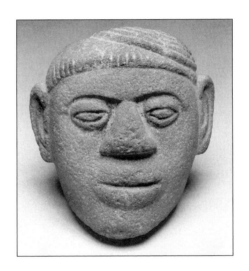

EDITED BY

HEATHER ORR AND REX KOONTZ

COTSEN INSTITUTE OF ARCHAEOLOGY PRESS

2009

This book is set in Adobe Jenson Pro
Edited and produced by Leyba Associates, Santa Fe, New Mexico
Cover design by Carol Leyba
Index by Robert and Cynthia Swanson

Library of Congress Cataloging-in-Publication Data
Blood and beauty : organized violence in the art and archaeology of Mesoamerica and Central America / edited by Heather Orr and Rex Koontz.
 p. cm. — (Ideas, debates and perspectives ; v. 4)
 Includes bibliographical references and index.
 ISBN 978-1-931745-80-2 (cloth : alk. paper) — ISBN 978-1-931745-58-1 (pbk. : alk. paper)
 1. Indians of Mexico—Rites and ceremonies. 2. Indians of Central America—Rites and ceremonies. 3. Violence—Mexico. 4. Violence—Central America. 5. Violence in art. 6. Indians of Mexico—Antiquities. 7. Indians of Central America—Antiquities. 8. Social archaeology—Mexico. 9. Social archaeology—Central America. I. Orr, Heather S. II. Koontz, Rex. III. Title. IV. Series.

F1219.3.R56B55 2009
930.1—dc22

200902157

BLOOD AND BEAUTY

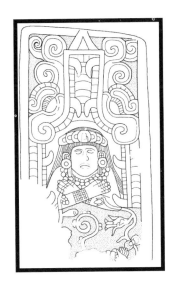

SERIES: IDEAS, DEBATES AND PERSPECTIVES

UCLA COTSEN INSTITUTE OF ARCHAEOLOGY PRESS
IDEAS, DEBATES AND PERSPECTIVES

CONTENTS

ILLUSTRATIONS

SECTION I

SECTION II

Section III

SECTION IV

ACKNOWLEDGMENTS

The editors wish to express their gratitude to two anonymous reviewers, whose insightful remarks challenged us to fine-tune the volume into a more cohesive whole. We thank Shauna Mecartea, and her predecessor Julia Sanchez, who worked diligently with us through the entire editorial process. We also wish to express special thanks to Carol Leyba for her expedient and meticulous copy-editing of the manuscript. We are especially grateful for the hard work and efforts of our outstanding contributors in seeing this volume to completion. Many participated in the 2005 Society for American Archaeology meetings, Salt Lake City, Utah, session that initiated this volume. Other contributors were invited to include their current scholarship in this venture following that session. The first part of the title for this volume was borrowed from a chapter heading in Cynthia Freeland's exceptional *But Is It Art?*

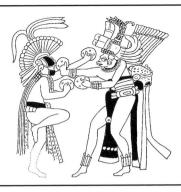

INTRODUCTION

Heather Orr and Rex Koontz

S cholars generally concur that displays of organized violence were important to ancient American ritual life, and few dispute that many of those displays were directly related to political power. This book asks how organized violence and power are related in ancient America, and how we can talk about those relations. Recent research in many parts of the Americas has greatly increased our knowledge of ancient warfare, that most obvious form of organized violence. Studies of Mesoamerican warfare have produced a particularly complex picture, one showing the ties between warfare and ballgame variants and how these were ultimately linked to assertions of supernatural potency and social status. The papers in this volume question the traditional categories, such as warfare, "the ballgame," and ritualized sacrifice, through which organized violence has been examined in pre-Columbian studies, and reconsider conventional notions of "power" attributed to these activities. Thus, volume topics encompass such concerns as gladiatorial-like combats, investiture rites, trophy-head taking and display, dark shamanism, and the subjective pain inherent in acts of violence, in addition to the traditional ballgame and warfare activities. The authors scrutinize the representation of, and relationships between, different types of organized violence, as well as the implications of these activities, which can include the unexpected, such as violence as a means of determining and curing illness, and the use of violence in negotiation strategies.

This volume brings together scholars from diverse perspectives and schools of thought, in an effort to better represent discourse on the subject of organized violence in pre-Columbian studies. As editors, we made a conscious effort to avoid imposing a false sense of unified thought, and instead have endeavored to

maintain a plurality of approaches. In this sense we encouraged detailed readings of local data over generalizations and prescriptive theorizing. Recent studies of the origins of warfare have stressed the large variations in small-scale, regional conflict situations (Thorpe 2002); we believe that similar variations in more complex societies should hold our attention as well. However, inasmuch as the volume is multivocal, we believe that coherence is attained through the common desire of each author to examine organized violence as a set of practices grounded in cultural understandings, even when the violence threatens the limits of those understandings.

ORGANIZED VIOLENCE

The categories of warfare, sport, and ritual sacrifice have largely controlled the discourse on organized violence in the pre-Columbian Americas (refer, for example, to Chacon and Mendoza 2007). Several authors in this volume suggest that these traditional categories are no longer adequate when dealing with the more detailed and contextualized scenarios presented here. While the traditional categories continue to be useful heuristic devices, they do not always reveal the internal relations and indigenous logics in which the practices were originally embedded. For this reason the authors of this volume ask how these analytical categories were connected in indigenous theory and practice.

Before we further treat specific cases of organized violence in ancient Mesoamerica and Central America, however, it is helpful to consider just what we mean by "organized violence." Popular conceptions of violence often categorize it in terms of disorder and irrationality—indicated by such adjoining terms as "irruption" or "outbreak." Our view on violence instead appeals to recent anthropological critiques of this view, in which violence may be rule-based, systematic, and laden with meaning, especially when it is performed by governing authorities. As such, violence is viewed here as ordered or organized—a way to reinforce culture—rather than as a purely destructive force (Carrasco 1999; Whitehead 2004). This does not mean, however, that we emphasize cultural order over conflict, factionalism, and political posturing in aggressive acts of violence. Rather, as Neil Whitehead (2004:9) explains: "(The) way in which violence . . . marks the limit of cultural order . . . is the source of the cultural possibilities for violence to remake and redefine the cultural order itself." In other words, violence marks the limins or threshold of cultural order. As such, representations of violent acts can provide insights into the disintegration and reintegration of that cultural order.

The search for constructs of cultural order in violence is particularly appropriate, given the fact that our materials on ancient violence are in the great major-

ity already cultural encodings of violent acts. The papers in this volume all focus on the encoded record of violence, not the acts themselves. With this limitation of the data in mind, recent examinations in anthropology and art history have turned to the relationship between violence and the imagination (Strathern et al. 2006; Whitehead 2004) and cognitive responses to visual representations of violence and pain (Elkins 1996). Emphasis on the cultural encoding of violence moves the discussion away from simple illustrations of violence to more complex levels of interpretation, involving the consideration of the often problematic concept of power and the notion of pain itself.

POWER AND PAIN, BLOOD AND BEAUTY

It is useful here to specifically treat the concept of power as it is common to the papers in this volume and thereby avoid the vague notions of power that are now regularly critiqued (for example, Benson and Cook 2001; Blomster 2007; Masson and Freidel 2002; Quilter and Hoopes 2003; Strathern et al. 2006). On one hand, several volume papers attempt to more narrowly define the concept of power in the political arena, through highly particularized case studies. However, common to all chapters is a reliance on the visual record for supporting data, along with discussions of how the visual may be related to power. This relation may consist largely in the illustration of indigenous concepts of political power, but it may also contain thoughts on an image's effects beyond the readings of literal political statements. As briefly mentioned above, recent anthropological and art historical theory has turned to the embodied power of artworks. For example, power may be viewed through the "aura of ideas . . . identified as the imaginary" in the forms of terror, or fear of violence (Strathern et al. 2006). This view of power particularly implicates the visual record as an important source for our understanding of power as well as violence; the visual record itself relies on the imaginary, or the ability of culturally based iconography to stimulate the brain to "fill in" the narrative.

In his study *The Object Stares Back*, James Elkins (1996) highlights the power of visual art objects to activate the imaginary. Pain is experienced in the imaginary as a cognitive response to embodied visual representations (a more complex response than empathy; see particularly pp. 108 ff.). Thus, Elkins's proposal suggests that images exert power through their unique hold on the imaginary, which in turn sways the individual both cognitively and viscerally.

The cognitive-biological interpretive theory known as "iconotropism" develops an avenue parallel to that of Elkins for the understanding of the power of images (Spolsky 2004). Iconotropism is defined as "the almost irresistible magnetism that

turns people toward pictures, as the sunflower turns toward the sun" (Spolsky 2004:23). This perspective suggests that audiences are irresistibly drawn to visual artworks—that it is part of our psychological and biological makeup as human beings to respond to images. Moreover, iconotropism addresses the processes by which even the most grisly representations of violence and pain (for example, works by Baroque masters such as Gentileschi) are irresistibly visually compelling if well rendered within an aesthetic system—that is, how blood becomes transformed into beauty. The approaches of Elkins and iconotropism highlight a specific agency of the artwork, a perspective also upheld by mediation theory (see below; also Hay 2007; Gell 1998; Rampley 2005).

On this fundamental level, the imaging of violence may not mitigate or distance those involved in its viewing from the violence presented, although admittedly one must also attend to local knowledge in these cases. Whatever these local conceptualizations, and with the understanding that much of what we explore here are images related to violence, the act of image making and the effect of the image (complementing and interacting with the reading of the image) may be significant factors in any consideration of ancient evidence for violence.

Inasmuch as representation itself must then be considered, it becomes clear that agonistic displays or acts can be discursively centered on cultural conceptions of violence to impact the cultural force of those events (Whitehead 2004: 6). Acts of violence and terror may in themselves be representational tools to affirm culture and express identity (this viewpoint is particularly relevant to contemporary acts of violence and terror and the global "ethnoscape"; Whitehead 2004:6).

However, the authors in this book are additionally cognizant that the volume itself is a "representation of violence (and) its production as an object of contemplation" (Whitehead 2004:7). Indeed, mediation theory warns that not only does the artwork mediate viewer experience, but that interpretation is a form of mediation (Hay 2007). Such re-presentation or mediation carries the concomitant danger of further reinforcing constructs of the Other held by the interpretive community. This is a particular danger in American studies, where scholarship on violence and sacrifice has found itself reconfigured in popular culture ventures, such as Mel Gibson's recent *Apocalypto*, which ultimately bolster romanticized stereotypes of Native Americans having their roots in Rousseau's "Noble Savage," colonial constructions of the Americas as the "New Eden," and Manifest Destiny. These stereotypes are invoked despite the claims to sincerity (see Todorova 1997 for similar strategies in the Balkans; see also Chacon and Dye 2007; Chacon and Mendoza 2007). And yet, not engaging violence in ancient American studies has not been productive, as Neil Whitehead indicates:

The counter-danger is that by refusing to critically engage with the fleshy detail of violent acts, we remove them from that very context that makes them meaningful to others, if not ourselves. This temptation to abstract violent acts from their wider field of meaning and significance suggests that it is precisely the cultural contextualization of violent acts that is the theoretical prerequisite for their interpretation. (Whitehead 2004:11)

CONTEXTUALIZATION AND CATEGORIZATION

The first chapter by Workinger and Joyce exemplifies the cultural contextualization of violent acts central to the concerns of this volume. The authors examine the specifics and localization of conflict, rather than relying on the monolithic category of "warfare" to explain the evidence for violent encounters in ancient Oaxaca, Mexico. Joyce has expanded this thesis elsewhere (2007), looking outside the conventional binaries in warfare studies of oppressor and oppressed, powerful and powerless, to seek an understanding of conflict in pre-Columbian coastal Oaxaca as a form of negotiation strategy employed by both commoners and elites.

Another conventional tendency in the field has been to view warfare as a principally male-dominated activity—women asserting any authority in secondary ways (for example, Schele and Freidel 1990). However, recent evidence has pointed to an important role for women, not only as warriors, but as war leaders. Indeed, the second chapter of this volume by Reese-Taylor et al. identifies noble females at the Maya site of Coba who ruled in the office of "warrior-queen."

Apart from warfare, one of the central categories for examining organized violence in the ancient Americas in general, and ancient Mesoamerica in particular, is "the ballgame." The colonializing Spanish were fascinated by the physical danger inherent in the game as well as by the violent rites surrounding at least some of the games. When surveying the landscape of recent scholarship on the ballgame, several themes emerge. Many tie the game and its attendant rites with other social practices. The ballgame has long been seen as more than a simple competitive display, and it is now well established that the game in its many variants is closely tied to astral associations, creation mythology, warfare, rain-petitioning ceremonies, sacrificial rites, and assertions of power (for example, Cahodas 1975; Freidel et al. 1993; Krickeberg 1966; León Portilla 1978; Miller and Houston 1987; Pasztory 1972; Seler 1963). Once again, however, current studies have tended to diverge from categorically lumping all activities involving ballgame paraphernalia as the "Mesoamerican ballgame."

In this volume, Taube and Zender, along with Chinchilla, all challenge traditional assumptions about a unitary Mesoamerican ballgame with a single set

of meanings. Taube and Zender identify ritualized combats that appear programmatically throughout Mesoamerican iconography as "boxing" or gladiatorial matches, rather than as ballgame-related activities. Chinchilla, likewise, finds iconographic support for this identification in the artistic record of Cotzumalhuapa, Guatemala. It is clear, however, that these ritualized combats, like the ballgame, were tied to cosmology and fertility, and, as Day and Orr suggest, perhaps bolstered authority through the assertion of a kind of spiritual power (compare with Strathern et al. 2006; Whitehead 2004). Daneels and Agüero further these latter considerations. They argue that the archaeological record reveals a rise in ballgame architecture in Central Veracruz that can be clearly tied to elite strategy and the formation of complex hierarchies in the region. Scott reviews the evidence for the meaning of the well-known Classic Veracruz ballgame equipment (yokes, *hachas*, and *palmas*) and concludes that these objects marked divisions of the cosmos, thus turning the wearer into a cosmogram. Baudez argues that violent Mesoamerican ballgames were specifically structured to provide injured bodies for the sacrificial rites that followed. The wounding of the body in sport was seen as an integral part of the sacrificial process.

Sacrifice is the third of the best-studied categories for violent practices in the Americas. In the important recent volume *Ritual Sacrifice in Ancient Peru* (Benson and Cook 2001), the authors expanded our understanding of these practices in the region; yet, Elizabeth Benson perhaps most succinctly expressed the principal assumption about sacrifice in her introduction: "To sacrifice is to make sacred." In this volume Hoopes and Mora-Marín closely inspect the underpinnings for that sacredness in ancient Costa Rica by demonstrating that trophy-head taking was integral to certain shamanistic curing rituals. This explanation is a radical break from the conventional view that the practice was an aspect of warfare and sociopolitical strategy. Day ties trophy-head taking to the emergence of paramount chiefs but questions the gender of the headhunters in a careful examination that reveals female roles in these sacrificial practices. Orr considers the well-known stone spheres of the Diquís region within the wider context of the ideological foundations for trophy-head taking, ultimately looking to creation mythology for those foundations.

Koontz examines specific representations of violence in public art, rather than looking at the evidence for actual physical violence or the cosmic symbolism of that violence. He argues that in the case of Cacaxtla and the Gulf Coast during the Epiclassic Period, these works formed a referential system in which presentations of power in one area could be transformed into violent stage sets that were clearly viewed as humiliating in another.

THE LIMITS AND BENEFITS OF LOOKING AT INDIGENOUS VIOLENCE

In the end, any volume that treats so insistently of the ancient indigenous view must acknowledge a healthy skepticism toward the finer details of such a view. One need not go far to see that this is warranted, especially when dealing with such a loaded category as violence, even when we focus on current semantic domains for the term. The word "violence" itself, at least in Latin-derived languages, tends to focus on bodily harm, and the authors below all treat cases in which bodily harm is a central component. By comparison, the German term *Gewalt* is not as focused on bodily harm, as the definition intimates more a compulsion, backed by the threat of force or not, and thus is not as negatively charged (Haupt 2001). The differences in supposed cognate terms in European languages should alert us to the conceptual gulf that can open between those who would explain ancient indigenous violence in the Americas and those who would have participated in such acts.

Problems involved in the translatability of experience and thought, such as the problems with indigenous violence, both conceived and experienced, are commonplace in Mesoamerican studies. Scholars regularly attempt to square current Western academic discourses, European Renaissance records, and an enormous amount of work on indigenous peoples and their archaeology in the modern anthropological tradition. To treat something like organized violence in pre-Columbian cultures is to sift and reconcile the records in all three discourses. Problems in this procedure—and they should not be minimized—can lead to a skeptical stance toward the possibility of any substantial "emic" or subject-centered knowledge of these cultures.

This is especially true of historical hypotheses proposed by this volume, with their desire to examine indigenous intellectual categories and social acts in specific ancient contexts. Can we really know anything about conceptual schema and their relation to social acts in the pre-Columbian past when the more richly documented colonial and modern periods are unmasked as extremely complex historical phenomena? Issues arising with historical knowledge generated from these later periods only exacerbate the problems of pre-Columbian studies, whose scholars at one time or another rely on that same information.

While the problems with generating historical knowledge on rich emic categories are serious, the response to these problems by students of ancient America has been broad and robust, often taking into account skeptical stances toward the materials that would provide emic data. To take an important example, in the study of pre-Columbian Maya epigraphy, a critical textual discourse has emerged that neither takes the texts at face value nor dismisses them as propaganda with little or no reliability (Houston 2000).

We raise these perennial issues not to propose an overarching theoretical solution—indeed, the most interesting work on these issues is very often at a detailed, local level—but instead to map out the volume's pragmatic approach to problems of propaganda and skepticism. We are clearly aligned with those who believe that phenomena such as organized violence cannot be reduced to a mechanistic social logic that pays little or no heed to ideational phenomena, nor can the search for that ideational data be dismissed by an appeal to skepticism.

To transform the above argument into the terms of another important discourse in Mesoamerican studies, the authors of this volume on the whole are interested in the actor's agency and thus in the world view shaping that agency (Gillespie 2001; Joyce 2000). That said, we must point out a special consideration, discussed above, that this volume cannot evade: the analysis of pain. While a profound historical skepticism in Mesoamerican studies may no longer be viable, the depth of empathy that thinking through violence creates in the work of both analyst and reader can render even the most die-hard believer in the possibilities of historical knowledge uncomfortable. There is simply no easy escape from the immediate embodiment of thinking about the human body in intense pain. Stephen Houston's concluding chapter looks back on the accomplishments of this volume by raising once again the question of pain and its analysis.

CHAPTER SUMMARIES

The following summaries are intended to provide the reader with an overview of the volume and the chapter organization. The organizational sections reflect the previous discussion of the categories for examination of organized violence. However, as also considered above, the papers intentionally overlap these categories and one another in significant ways. The volume thus commences with warfare and a group of papers we believe opens the challenge we hope to bring to the discourse on organized violence in Mesoamerican and Central American studies.

Section I: Warfare

CHAPTER 1: *Reconsidering Warfare in Formative Period Oaxaca,*
 by Andrew Workinger and Arthur Joyce
Workinger and Joyce's essay examines the nature of warfare in ancient Oaxaca and finds it heterogeneous and complex. This is important, because earlier models of Oaxacan development posited a long-term state of conquest warfare in the

rise of Monte Albán, the largest urban settlement and the acknowledged central power in the region. The authors point out that endemic war for territorial conquest is part and parcel of the West's historical imagination and is often a contemporary truth, but is less successful in explaining the Mesoamerican evidence. Mesoamerican warfare was rarely so consistent or uniform, and a close reading of both the material and iconographic evidence for the persistent conquest-war model finds that evidence equivocal if not absent.

Instead of a long-term conquest-war model, the authors suggest that several forms of war were in play in the area. They map out a number of archaeological scenarios in which it is clear that the area once assumed to be under the capital's sway was either not conquered at all or only sporadically subjugated. Further, the authors give us real insight into the way iconographic readings can be framed by larger theories of organized violence that do not do justice to the possibilities of meaning still inherent in the imagery. The glyphs of Mound J at Monte Albán are a supremely important case in point. These glyphs may still be considered records of violent episodes in the history of Monte Albán, but the authors suggest a number of plausible alternate readings to that of long-term conquest war.

Workinger and Joyce's essay is in several ways exemplary of what the volume as a whole attempts, especially in the authors' attention to the details of organized violence and the refusal to make the category of "warfare" a natural one. At the same time, these authors have no doubt that conflict and armed violence played a crucial role in the development of Monte Albán. The authors strive for a more subtle and detailed knowledge of that role through a more nuanced notion of the various avenues for the performance of warfare.

CHAPTER 2: *Warrior Queens among the Classic Maya, by Kathryn Reese-Taylor, Peter Mathews, Julia Guernsey, and Marlene Fritzler*
Reese-Taylor et al. complicate the often heavily male-gendered discussion of warfare and power by identifying Maya warrior queens at the site of Coba. They suggest that the hieroglyphic and artistic records indicate that these queens ruled autonomously. This argument is based on examples of carved stone monuments representing these "warrior queens" independently—that is, without male counterparts. Maya society is generally considered to have been patrilineal; thus it is unusual and cause for interest when women are represented in more characteristically "male" roles in the arts. Although female warriors and warrior queens have been identified in the arts of Central Mexico (for example, at Cacaxtla; McCafferty and McCafferty 1994) and the Mixtec codices (for example, Lady Six Monkey), the discussion of such powerful females is relatively new to Maya research (compare with Schele and Freidel 1990).

The authors demonstrate that during the later part of the seventh and early part of the eighth centuries, these autonomous queens actually participated in battle and captured enemies. They further suggest that Coba was the source for this unusual behavior, which is documented in this paper at other lowland sites during the period. Identity and ethnicity thus further play a role in the ability of these women to transgress gender assignations.

CHAPTER 3: *Investiture and Violence at El Tajín and Cacaxtla, by Rex Koontz*
Koontz's essay raises a fundamental consideration for interpreting artistic records of organized violence—namely, the function of iconographic borrowings. He considers how representations of organized violence related to other representations, and how knowledge of this "discourse of images" can help us to think more critically or insightfully about the nature of the violence portrayed. The case study examined here involves the identification of political accession imagery at the site of El Tajín, on the Mexican Gulf Coast, and similar imagery used in humiliating and violent sacrificial imagery in the art of the contemporary peoples of Central Mexico. Koontz asks whether the borrowing and inverting of Gulf Coast imagery and meaning are to be considered a specific discursive move on the part of the Central Mexican artists. And, after pondering these images of violence as a highly referential iconographic system, where does this leave the widely held idea that these images represent actual violent rites?

Section II: Ballgames and Boxing

CHAPTER 4: *Human Sacrifice in the Iconography of Veracruz Ballgame*
 Sculptures, by John Scott
John Scott examines the sacrificial uses of Classic Veracruz ballgame equipment (yokes, palmas, and hachas) from a historical perspective. This author pioneered the historical approach to these objects, and here extends his thesis on the development of the forms to include the definition of cosmic levels in later iterations of ballgame garb. Like several authors in this volume, Scott shows us that there was no one Mesoamerican ballgame; and even in a coherent tradition such as that of Classic Veracruz, there are important developments over time in the use of body symbolism attached so intimately to the ballgame.

CHAPTER 5: *Competition as a Political Tool, by Adriana Agüero and*
 Annick Daneels
Agüero and Daneels argue that competitive displays associated with the ballgame were central to the rise of complex elite culture in Central Veracruz. The evidence

for this is wide-ranging and profoundly interdisciplinary. The authors first relate the rise of ball-court architecture in the region using data obtained over two decades of survey and excavation in the area. These ball courts are integrated into the very definition of elite architecture from very early in the sequence and continue to play a central role throughout the first millennium of this era, the time span of what has been called "Classic Veracruz" style and culture.

Along with a history of elite architecture involved with competitive display, the authors offer a history of the imagery of competitive display in the same region. This sort of in-depth diachronic analysis of imagery has been too rare in Classic Veracruz studies and is only made possible here by the enormous amount of data amassed in the studies of site plans and settlement that went into the identification of the architectural sequence referred to above.

While the ballgame was probably played in the area for centuries, the integration of a masonry court, elaborately carved objects, and a decapitation sacrificial ritual emerged only in the first centuries of the first millennium A.D.. The integration of this agonistic cult and the rise of the complex centers and site hierarchies cannot be coincidental. Instead, the authors argue that the ballgame as developed by the elite was integral to the formation of complex hierarchies in the area. Any understanding of the emic construction of power in the area, then, must wrestle with the problem of the ballgame: its context, process, and meanings as experienced by both the burgeoning elites of the area as well as the larger audience these rites were meant to impress and engage.

As Agüero and Daneels argue, the movement in the imagery is from ball-playing heroes to sacrificial victims and eventually overt scenes of warfare. This suggests to the authors that as the ballgame cult and associated political system matured, more coercive means were found to establish power, or at the very least more coercive aspects of power were important to proclaim publicly. This argument views the ballgame and warfare as linked in such a way that the emphasis on one may indicate a decrease in the other.

CHAPTER 6: *Games, Courts, and Players at Cotzumalhuapa, Guatemala, by Oswaldo Chinchilla*

Chinchilla contests the long-standing perspective in the literature that views the sculpture of Cotzumalhuapa as synonymous with the Mesoamerican ballgame. The latter perspective is based on a homogeneous view of the artistic corpus at the massive site, one that has made little progress in identifying or qualifying the specifics of Cotzumalhuapan iconography. Recent excavations and research, including the identification of the first Cotzumalhuapan ball court by Chinchilla and his colleagues, have highlighted the necessity to revise previous assumptions.

Chinchilla's analysis reveals a more complex picture of Cotzumalhuapan iconography and reassesses the importance of the ballgame at the site. Ritualized violence was certainly an institution of political and religious life at the center, but the sculptural corpus includes a variety of scenes that are not explicitly related with the ballgame. For example, the much-cited El Baúl Monument 27 more than likely represents a form of staged battle or boxing that may or may not be related to the ballgame per se. Chinchilla thus highlights the heterogeneous nature of Cotzumalhuapan sculpture and the complexity of organized violence at the site, calling for more careful and contextual readings of the iconography.

CHAPTER 7: *American Gladiators: Ritual Boxing in Ancient Mesoamerica, by Karl Taube and Marc Zender*

Taube and Zender's identification of boxing in the iconographic and archaeological record is a ground-breaking challenge to the emphasis on rubber-ball games in studies of Mesoamerican competitive sports. The authors demonstrate that these combative events involved opposing individuals or teams who engaged with knuckle-dusters, wooden or stone balls, and other likewise dangerous implements, causing severe injuries and even death. While these matches were clearly often ritual in nature, it is equally evident that many were conducted as pure entertainment—apparently involving the imbibing of alcoholic beverages. The evidence indicates that boxing had a long history in Mesoamerica, from the Formative Period through the present day. In addition, it appears that these combative events were framed by religious ideology stressing a relationship to rain production and fertility.

Section III: Trophy Head Taking

CHAPTER 8: *Heads of Flesh and Stone, by Jane Day*

Day demonstrates the relationship between a localized Costa Rican expression of the American trophy-head cult and the structure of power. She considers the iconography of trophy-head taking within the context of a shift she observes in the artistic and archaeological record of the Atlantic Watershed region around 1000 B.C. She demonstrates that records of a long-beaked bird associated with trophy heads give way to the appearance of larger-scale stone sculptures, associated with larger-scale architecture, representing human actors juxtaposed with various aspects of trophy-head taking. Day points out that this artistic transformation accompanies archaeological evidence of increasing social complexity in the region. She situates the relationship between power and trophy-head taking within a paradigm linking the bloody violence underlying this tradition with creation mythology and notions of agricultural fertility.

Day draws parallels between the cult of trophy-head taking in Costa Rica and the Mesoamerican ballgame, with its emphasis on decapitation sacrifice, noting Stern's (1950) evidence for a Taino ballgame in the Caribbean region, and a hip-pad, or "yoke"-like device around the hips of some Atlantic Watershed stone representations of warriors.

Furthermore, she interjects gender into the discussion of trophy-head taking. Although it seems evident that Costa Rican society was largely patriarchal, Day notes several examples of sculpted females with iconography not only suggestive of rank, but intriguingly linked to trophy-head-taking iconography. Perhaps most compelling for the excavation of past indigenous history is Day's observation that many representations of trophy heads and their takers are clearly individualized portraits—introducing agency to the long-standing discourse on this topic.

CHAPTER 9: *Rolling Heads: The Diquís Stone Balls and Trophy-Head Taking in Ancient Costa Rica, by Heather Orr*

Orr examines the well-known stone balls from the Diquís region of Costa Rica within the broader context of the trophy-head cult in this region. Noting several examples of Costa Rican and Mesoamerican stone sculptures carved (literally) in the round that represent severed or trophy heads conflated with balls, she suggests an abstraction of this subject in the Diquís balls. The balls and trophy-head cult are further linked through a consideration of creation mythology and the nature of paradigmatic ranking in ancient Costa Rica.

Section IV: Pain and Healing

Chapter 10: *Pretium Dolores, Or the Value of Pain in Mesoamerica, by Claude Baudez*

Claude Baudez reinvigorates the debate on the meaning of pain and torture in Mesoamerica by insisting on its variety. The author points to the different practices of priest, noble, king, and commoner in Aztec society, suggesting that a monolithic explanation of pain's functions is misguided. In the same vein, he draws important distinctions between Maya and Central Mexican traditions, attuning us to the specificities of regional traditions of the representation of pain.

CHAPTER 11: *Violent Acts of Curing: Pre-Columbian Metaphors of Birth and Sacrifice in the Diagnosis and Treatment of Illness "Writ Large," by John Hoopes and David Mora-Marín*

Hoopes and Mora-Marín examine the relation of curing rites, rites involving transformation, and violent sacrifices in pre-Columbian thought and practice.

The relation of curing and violence, little discussed until recently in relation to other forms of organized violence, is seen as a key link in this semiotic chain. The authors show that it is through this medical discourse that the bloody rites of warfare and the equally dangerous rites of childbirth are related. Relating warriors and women in childbirth is a well-known analogy, often cited in its Aztec form, but here the authors show how this logic created a much larger network of associations that consistently guided pre-Columbian logics surrounding violence. Perhaps most importantly, these relationships make much sense of violent practices, such as decapitation sacrifice, that are often used as a marker of indigenous otherness.

CHAPTER 12: *To Boast in Our Sufferings: The Problem of Pain in Ancient Mesoamerica, by Stephen Houston*

Houston's contribution closes the volume with a challenge: For many of the contributors the language of violence is to be read in social practices and the relations these practices engender, but there is also the language of the senses and the relationships that pain, its infliction, and its witnessing create. While Baudez alludes to this most clearly in his reconstruction of a Teotihuacan rite, in which the empathy generated from the violent rite produces tears that metonymically signal rain, Houston calls on researchers to understand more generally how the phenomenology of these rites consistently played a fundamental role in the construction of meaning. As the author notes, this does not mean that organized violence is to be analyzed at the individual level. Instead, there were understandings of these sensual phenomena that were apparent to the audience and that played a significant role in the social construction of meaning. By calling attention to the history of the senses and its relationship to organized violence, Houston renews and revitalizes the charge at the very heart of this volume: to delineate the meaningful relationships between organized violence and power in the ancient Americas.

REFERENCES CITED

Benson, E., and A. Cook
 2001 *Ritual Sacrifice in Ancient Peru.* University of Texas Press, Austin.
Blomster, J.
 2007 *After Monte Alban: Transformation and Negotiation in Oaxaca, Mexico.* University Press of Colorado, Boulder.
Cahodas, M.
 1975 The Symbolism and Ritual Function of the Middle Classic Ballgame. *American Indian Quarterly* 2(2):99–130.

Carrasco, D.

1999 *City of Sacrifice: The Aztec Empire and the Role of Violence in Civilization*. Beacon Press.

Chacon, R., and D. Dye

2007 *The Taking and Displaying of Human Body Parts as Trophies by Amerindians*. Springer, New York.

Chacon, R., and R. Mendoza

2007 *Latin American Indigenous Warfare and Ritual Violence*. The University of Arizona Press, Tucson.

Elkins, J.

1996 *The Object Stares Back: On the Nature of Seeing*. Simon and Schuster, New York.

Freidel, D.A., L. Schele, J. Parker, and J. I. Kislak

1993 *Maya Cosmos: Three Thousand Years on the Shaman's Path*. W. Morrow, New York.

Gell, A.

1998 *Art and Agency: An Anthropological Theory*. Oxford University Press, New York.

Gillespie, S. D.

2001 Personhood, Agency, and Mortuary Ritual: A Case Study from the Ancient Maya. *Journal of Anthropological Archaeology* 20(1):73–112.

Haupt, H. G.

2001 Violence, History of. In *International Encyclopedia of the Social and Behavioral Sciences*, Vol. 24, editors-in-chief N. J. Smelser and P. B. Baltes, pp. 16196–16202. Elsevier, Amsterdam.

Hay, J.

2007 Interventions: The Mediating Work of Art. *Art Bulletin* 89(3):435–459.

Houston, S. D.

2000 Into the Minds of Ancients: Advances in Maya Glyphs Studies. *Journal of World Prehistory* 14(2):121–202.

Joyce, A. A.

2000 The Founding of Monte Albán: Sacred Propositions and Social Practices. In *Agency in Archaeology*, edited by M. R. Dobres and J. Robb, pp. 71–91. Routledge, London.

2007 Domination, Negotiation, and Collapse: A History of Centralized Authority on the Oaxaca Coast before the Late Postclassic. In *After Monte Alban: Transformation and Negotiation in Oaxaca, Mexico*, edited by J. P. Blomster. University Press of Colorado, Boulder.

Krickeberg, W.

1966 *El juego de pelota mesoamericano y su simbolismo religioso*. In *Traducciones Mesoamericistas*, translated by J. Brom O., Vol. 1, pp. 191–313. Sociedad Mexicana de Antropología, Mexico. [Originally published in *Paideuma Mitteilungen zur Kulturkunde* 3(3–5), 1948.]

León Portilla, M.

1978 *México-Tenochtitlan, su espacio y tiempo sagrados*. Instituto Nacional de Antropología e Historia, Mexico, D.F.

Masson, M., and D. Freidel (editors)

2002 *Ancient Maya Political Economies.* AltaMira Press, Walnut Creek, CA.

McCafferty, S. D., and G. G. McCafferty

1994 Conquered Women of Cacaxtla: Gender Identity or Gender Ideology? *Ancient Mesoamerica* 5(2):159–172. Cambridge.

Miller, M. E., and Houston, S. D.

1987 The Classic Maya Ball Game and Its Architectural Setting: A Study of Relations between Text and Image. *Res* 14:46–65.

Pasztory, E.

1972 The Historical and Religious Significance of the Middle Classic Ball Game. In *Religion en Mesoamerica, XII Mesa Redonda de la Sociedad Mexicana de Antropología*, pp. 441–455. Sociedad Mexicana de Antropología, Mexico, D.F.

Rampley, M.

2005 Art History and Cultural Difference: Alfred Gell's Anthropology of Art. *Art History* 28(4):525–551.

Schele, L., and D. Freidel

1990 *A Forest of Kings: The Untold Story of the Ancient Maya.* William Morrow, New York.

Seler, E.

1963 *Comentarios al Codice Borgia.* Fondo de Cultura Económica, Mexico.

Spolsky, E. (editor)

2004 *Iconotropism: Turning toward Pictures.* Bucknell University Press, Lewisburg.

Stern, T.

1950 *The Rubber-Ball Game of the Americas.* Monographs of the American Ethnological Society 17. J. J. Augustin, New York.

Strathern, A., P. J. Stewart, and N. Whitehead (editors)

2006 *Terror and Violence: Imagination and the Unimaginable.* Pluto Press, London.

Thorpe, I. J. N.

2002 Anthropology, Archaeology, and the Origin of Warfare. *World Archaeology* 35(1):145–165.

Todorova, M. N.

1997 *Imagining the Balkans.* Oxford University Press, Oxford.

Whitehead, N. L.

2004 *Violence.* School of American Research Press, Santa Fe.

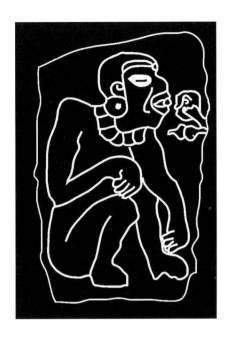

SECTION I

WARFARE

CHAPTER 1

RECONSIDERING WARFARE IN FORMATIVE PERIOD OAXACA

Andrew Workinger and Arthur A. Joyce

Archaeological research in Mesoamerica has increasingly demonstrated the different types of pre-Hispanic warfare as well as their variable causes, goals, and effects. Warfare ranged from small-scale raids and battles in the ritual domain, designed primarily to take captives for sacrifice, to large-scale military actions designed for territorial conquest that could result in political and economic domination (Brown and Stanton 2003; Freidel et al. 1993; Hassig 1988, 1992; Webster 1998). Recent archaeological and epigraphic evidence shows that the Classic Period Maya had glyphs that distinguished at least four types of warfare which varied in scale, intensity, religious significance, and political impact. At least two types of Maya warfare (*chuc'ah* and *ch'ak*) were small scale and did not involve significant demographic or economic consequences, although they were ritually and at times politically important. The nature of warfare also may have changed over time, with data suggesting an increase in scale and intensity toward the end of the Classic Period, particularly in the Maya Lowlands and during the Postclassic in the Mexican highlands. In this paper, we use this emerging perspective on pre-Hispanic warfare to consider evidence for conflict in Formative Period Oaxaca, drawing on comparative archaeological, epigraphic, and ethnohistoric investigations of the Lowland Maya and the Aztecs of Central Mexico (Figure 1.1). Warfare has long been the focus of research in Oaxaca, and the collected data are explored in the second section of this chapter. We end with an alternative approach to current highland interpretations of Late/Terminal Formative conflict, especially those concerning Monte Albán and the polity's territorial ambitions.

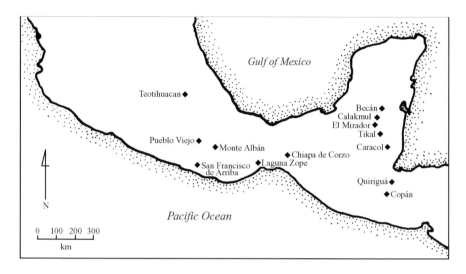

FIGURE 1.1. Map of Mesoamerica including sites mentioned in the text.

Researchers in the Oaxacan highlands, including Kent Flannery, Joyce Mar-
cus, Charles Spencer, and Elsa Redmond, have argued that frequent, large-scale
warfare was a key factor in the development of the Monte Albán state at the end
of the Formative Period (Flannery and Marcus 2003; Marcus and Flannery
1996; Redmond and Spencer 2006; Spencer 2003, 2007; Spencer and Redmond
2001). According to their model, by the Terminal Formative, Monte Albán had
expanded beyond the Valley of Oaxaca to form a territorial empire of some
20,000 km² (Figure 1.2). While we agree that warfare and conquest were impor-
tant for sociopolitical change at the end of the Formative (for example, Joyce
2000), we argue that their model of predatory state expansion is based on a view
of large-scale conflict and territorial conquest that more closely resembles mod-
ern Western traditions of warfare than the more varied patterns of conflict indi-
cated for pre-Hispanic Mesoamerica.

We begin with a consideration of recent research on warfare practices in
Mesoamerica, particularly in the Maya Lowlands and the Central Mexican high-
lands. This research shows that the nature, intensity, causes, and effects of war-
fare in pre-Hispanic Mesoamerica are more variable than has been assumed,
with ever finer-grained data on specific situations allowing for the detection of
significant variation in the record of warfare. Contemporary debates include the
degree of military involvement by Teotihuacanos in Early Classic regime change
at Tikal (Coe 1999:83–84; Martin and Grube 2000:29–37; Stuart 2000), which

can be considered part of a more general debate over militarism and imperialism associated with Teotihuacan (Braswell 2003; Cowgill 1997; Santley 1989; Smith and Montiel 2001; Stark 1990). Another long-standing debate has been the degree to which Maya warfare involved large armies and territorial conquest or was more limited to ritual competition among the nobility (Freidel 1986; Webster 1998).

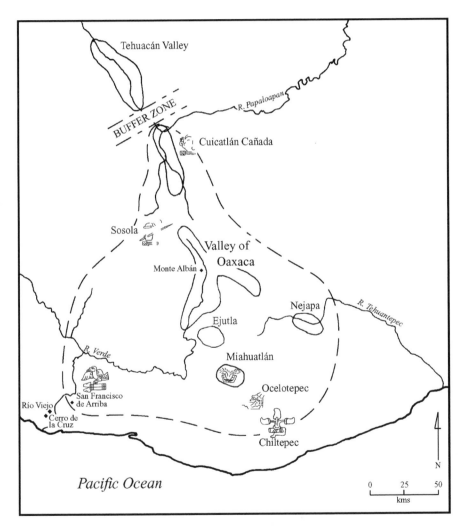

FIGURE 1.2. Proposed extent of the Monte Albán empire.
(*After Marcus and Flannery 1996.*)

RECENT RESEARCH ON MESOAMERICAN WARFARE

The difficulty of resolving different opinions on pre-Hispanic warfare stems from the problem that the archaeological record is often ambiguous in terms of its associated variables (Sheets 2003; Vencl 1984). Indirect indicators of conflict, such as settlement shifts to higher locations, burned structures, and changes in ceramic styles, can be the result of factors unrelated to war. Changes in settlement patterns could indicate the need to vacate lands that could otherwise be dedicated to agriculture. Changing ceramic styles might well suggest newly forged ties between distant elites or the emulation of styles from a prestigious political center (Stein 1999). Evidence for the burning of structures can be the result of accidental fires or reverential termination rituals as well as from conflict (for example, Walker 1998; Freidel and Schele 1989).

Other categories of data that are often more confidently linked to warfare are also frequently ambiguous. For example, defensive features such as walls and ditches may be designed to protect an entire populace or only site centers targeted by enemies for destruction and denigration. In some cases, earthworks originally interpreted as defensive walls are now being reconsidered. Reevaluation of the wall/earthworks surrounding the Maya center of Tikal suggests that it may not have been defensive, as was first assumed, but instead was some sort of marker of Tikal's territorial boundary (Webster et al. 2004). In the Mixteca Alta region of Oaxaca, ongoing work at the site of Pueblo Viejo de Teposcolula (*Yucundaa*) has uncovered a wall that may have served as a ceremonial pathway linking sacred caves, rather than as a defensive feature (Spores 2005).

Iconography depicting scenes of conflict, conquest, or sacrifice often fail to provide clear evidence for the intensity of warfare or whether victory involved territorial conquest, site destruction, tribute extraction without territorial incorporation, the capture of rival elites, or other forms conquest. While multiple independent data sets can help to tease out different forms of conflict, as Diane and Arlen Chase (2003:181) state, "data are more often than not open to multiple interpretations with careful analysis of context providing the only potential resolution of meaning." These methodological problems, which are essentially ones of equifinality, often mean that researchers' interpretations sort according to their theoretical orientations. David Webster (1993, 1998), for example, criticized views emphasizing the ritual dimensions of Maya warfare for projecting a romanticized image of the Maya based more generally on what he termed "the proliferation of mentalist models" in archaeology. In a different vein, Payson Sheets (2003) has cautioned against relying too heavily on Western views and categories of warfare for addressing the pre-Hispanic past. Sheets's point is one that we will return to later in this paper.

Investigations of warfare in ancient Mesoamerica, particularly of the Aztec and Lowland Maya states, have benefited from an approach that combines regional archaeological data with iconographic, epigraphic, and ethnohistorical evidence. This research indicates that rather than being focused solely on territorial conquest on the one hand, or ritualized combat on the other, pre-Hispanic warfare was highly variable in scale, intensity, duration, tactics, goals, and outcomes.

In the case of the Aztec empire, Hassig (1988) has argued that in addition to warfare aimed at conquest, the Aztecs initiated *xochiyaoyotl*, or flowery wars, against formidable enemies such as the Tlaxcalans and the Chalcas. Flowery wars involved low-intensity combat designed to take captives for sacrifice, obtain training for soldiers, probe the strength of the enemy, as well as to demonstrate to others the might of the Aztec army. While Hassig's interpretation of flowery wars has been questioned (Smith 1996:140), Aztec specialists agree that warfare varied in duration and intensity (Hassig 1988; Smith 2003), with outcomes including stalemates, capitulation under threat, victory on the battlefield, and the conquest and partial destruction of settlements. Both flowery wars and conquest warfare included ritualized elements, and military tactics were affected by the need to take captives for sacrifice (Smith 2003:155). This need may have been the principal cause for some battles, especially those that coincided with the inauguration of a new *tlatoani* or the dedication of a new temple. Aztec rulers were required to demonstrate their bravery and skill on the battlefield, and the time between the death of the previous *tlatoani* and the inauguration of his successor was a vital period in which to do so (Conrad and Demarest 1984; Hassig 1988).

Most defeated cities were incorporated as tributaries and not directly administered by the Aztec state, although some indigenous rulers were replaced by imperial administrators in cities near the imperial core (Hodge 1996). Farther afield, logistical and economic constraints forced the Aztecs to rely on the threat of reprisal to keep tributaries in line. Garrisons of Aztec soldiers were originally thought to have enforced tribute schedules and discouraged rebellion, although Smith (1996) finds that their locations were aimed more toward maintaining frontier boundaries than internal control. The Aztecs therefore exhibited what Schreiber (1992) terms a "mosaic of control" across the empire. Most regions within the Aztec empire were dominated indirectly through the cooptation and coercion of local rulers and therefore reflect a hegemonic, rather than a territorial, form of imperialism. Some areas, particularly in Central Mexico, were ruled directly through the imposition of administrators from the imperial core and sometimes the establishment of military garrisons, and so are consistent with a territorial form of imperialism. In certain strategic frontiers,

local rulers were kept in place, although military garrisons staffed by Mexica and/or local forces were established to monitor and defend the boundary.

In the Maya Lowlands, archaeologists have recognized for some time that there were different types of warfare and that conflict varied in intensity through the pre-Hispanic period. Possible evidence for warfare in the Lowlands goes back to the Middle Preclassic at Blackman Eddy and Cuello in Belize and includes the burning and destruction of public buildings (Brown and Garber 2003). Iconographic and osteological evidence of human sacrifice, almost certainly associated with warfare, is found throughout the Maya Highlands during the Middle and Late Preclassic; evidence for sacrifice is limited in the Lowlands, however (Joyce 2008). Sacrificial victims in the Maya Highlands are usually associated with rulers in both imagery and burials, but the nature of warfare associated with these sacrificial victims is unclear. The presence of earthworks and ditches at Late Preclassic sites like Tikal, Becán, and El Mirador have been used to suggest large-scale warfare (Webster 1975, 1977). There are few examples of the destruction of buildings or of warfare-related site abandonments, however, and at least in the case of Tikal, the defensive role of these features is now being questioned (Webster et al. 2004). Clark and his colleagues (2000) have suggested that the El Mirador polity may have conquered regions to the north and west, including Chiapa de Corzo in the Late Preclassic, although they admit that alternative explanations are equally plausible.

Evidence for warfare is more common during the Maya Classic Period. The archaeological and particularly the epigraphic records clearly demonstrate a variety of types of warfare by the Late Classic. Recent reviews by Chase and Chase (2003) and by Webster (2000) discuss the variable nature of Maya warfare. The Chases argue that Maya hieroglyphs reference four distinct types of warfare-related events. In their suggested order of scale and intensity, these are (1) capture events (chuc'ah in Maya), usually of one or a few opposing warriors; (2) ax (batcaba) or decapitation (ch'ak) events, which refer to victory in battle, with the capture and probably the sacrifice of an important noble; (3) destruction events (hubi), which refer to the attainment of specific goals in warfare that suggests a substantial military victory; and (4) shell-star events, which involve territorial conquest and political domination, or conversely, a successful war of independence that can also include the capture and sacrifice of defeated nobles. Archaeological evidence supports this degree of variability, with destruction and shell-star events having the greatest economic, political, and demographic consequences. An example of a shell-star event can be seen in the victory of Caracol and Calakmul over Tikal in A.D. 562, which resulted in a period of political and demographic decline at Tikal, while Caracol grew considerably in size and

prosperity (Chase and Chase 2003:177; Martin and Grube 2000:88–90). Large-scale, destructive warfare seems to have generally increased throughout the Maya Lowlands during the Terminal Classic and into the Postclassic, with evidence of siege warfare and the destruction and sacking of sites particularly evident in the western margins of the region (Webster 2000). Probably the most famous ax event in Mesoamerican history is the capture and sacrifice of Copán's ruler, 18-Rabbit, by Quiriguá. Evidence suggests that while this event had a significant impact on governmental institutions in both cities, the general populace was little affected. This ax event, despite the fact that Quiriguá claimed to have conquered Copán, was most likely the result of a successful war of independence rather than one aimed at acquiring more territory, and Quiriguá appears to have flourished afterward (Fash 2004:99–101).

Exactly who did the fighting when the Maya went to battle is widely debated (Demarest 1978; Freidel 1986; Webster 1998, 1999). Most evidence of warfare in the Classic Period comes from carved stone stelae and murals accompanied with hieroglyphic texts. As the nobility were the people who commissioned these monuments, it is not surprising that the histories inscribed on stelae were overwhelmingly focused on elites dressed in their fine regalia and often shown trampling on the naked bodies of captured enemies (Figure 1.3). Missing are the representations of foot soldiers—armies of commoners of sufficient numbers to suggest that Classic Maya warfare took place on a scale resembling Western forms of warfare, although battle scenes displayed on murals at Bonampak and Chichén Itzá show warriors numbering perhaps in the hundreds. Evidence for fortifications, in some cases hastily constructed, as well as for the destruction of site centers, particularly in the western Lowlands, indicates that by the Late/Terminal Classic, warfare at times involved relatively large armies of both elites and commoners. Lithic studies, however, show that at Aguateca and Copán, Late Classic Maya nobles both manufactured and used projectile points in warfare, and elites may have been more involved in warfare than commoners (Aoyama 2005). By the Postclassic and the colonial era, we have clear evidence from ethnohistory and iconography of commoners fighting alongside the nobility (Pohl and Pohl 1994). Advances in the epigraphic decipherment of Maya texts have also enhanced understandings of the ritual aspects of their warfare. Auspicious dates, often linked to the cycle of Venus (compare Lounsbury 1982; Schele and Freidel 1990), governed the timing of war, and the battles themselves may have had "highly choreographed and stylized phases, and perhaps even been prearranged in some cases" (Webster 1999:347). As with the Aztec, research on the Lowland Maya is therefore increasingly showing the great variability in pre-Hispanic warfare.

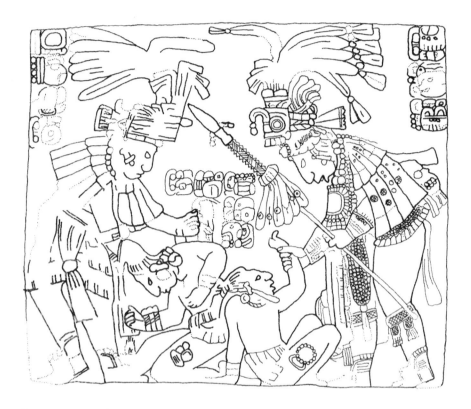

FIGURE 1.3. Yaxchilan Lintel 8 showing the site's ruler, Bird Jaguar (*right*) capturing lord Jeweled Skull. Bird Jaguar's subordinate ruler, or *sahal*, is shown taking another named captive. (*Redrawn from Sharer 1994.*)

WARFARE IN FORMATIVE PERIOD OAXACA

Oaxaca is another region in Mesoamerica that has been a focus of recent research on pre-Hispanic warfare. Research in Oaxaca has concentrated on the Formative Period and the role of warfare in the rise of complex societies and especially the early development of the Monte Albán state in the Valley of Oaxaca. Given the multiple lines of evidence for conflict, the argument for warfare throughout the Oaxacan interior during the Late/Terminal Formative is compelling (Joyce 2003; Marcus and Flannery 1996; Spencer 2003). Possible evidence for conflict includes a shift in settlement to defensible locations, especially involving the development of regional political centers located on hilltops. Some political centers had large walls, such as at Monte Albán as well as at Cerro de las Minas in

the Mixteca Baja region and Yucuita in the Mixteca Alta. There is evidence for burned structures at Yucuita as well as at El Mogote and El Palenque in the Oaxaca Valley and at Llano Perdido in the Cuicatlán Cañada region 50 km north of Monte Albán. Probable trophy skulls have also been found at several sites in the Mixteca Alta, and Spencer (1982:236–239) recovered the remains of a skull rack at La Coyotera. Further compelling evidence of conflict in the Cuicatlán Cañada comes in the following forms: a shift in settlement patterns from the alluvium to the previously unsettled piedmont; an unburied human skeleton lying on a house floor, suggestive of rapid site abandonment; and a sparsely occupied buffer zone between the Cuicatlán Cañada and the Tehuacán Valley, suggesting a political boundary between the Cuicatlán and polities to the north.

Iconographic evidence for warfare comes mainly from Monte Albán. During the Late/Terminal Formative approximately 300 carved stones were erected on the main plaza; most were set in the walls of Building L-sub (Figure 1.4a). These carved stones have been interpreted as victims of human sacrifice (Marcus 1976; Scott 1978a), although a recent reinterpretation of the monuments from Building L-sub argues that most were shown performing auto-sacrifice (Urcid 2008). The Building L-sub program, however, includes four clear depictions of severed heads resulting from decapitation sacrifice. There is almost certainly an element of religious and ideological representation involved in these carvings, as they would have been visible to all who entered the site's main plaza, though the fact that some are accompanied by hieroglyphic names suggests that there is also a historical element. The Building L-sub program was followed late in the Late Formative or early in the Terminal Formative by the Building J tablets, or "conquest slabs" in common parlance, which have been interpreted as places that were subjugated by Monte Albán (Caso 1938, 1947). Carved monuments at the Oaxaca Valley site of Dainzú depict the ritual ballgame (Figure 1.4b), which presupposes armed conflict, the capture of prisoners, their participation in ritual combat, and their eventual sacrifice (Orr 1997, 2003).

Much of the evidence for Late/Terminal Formative Period warfare in Oaxaca has been interpreted as the result of the militaristic expansion of the Monte Albán polity. Flannery and Marcus (2003) and Redmond and Spencer (2006; Spencer 2003) argue that territorial conquest through warfare was an important causal factor in the formation of the Monte Albán state during the Late Formative. According to Flannery and Marcus (2003:6), during Monte Albán's first 400 years the polity would "fight relentlessly to subjugate their political rivals, and raiding would give rise to full-scale war." By the Terminal Formative Period, these researchers argue that Monte Albán's rulers controlled a professional army that allowed them to expand militarily outside of the Valley of Oaxaca. Based largely

FIGURE 1.4. Late/Terminal Formative Period carved stones from Oaxaca: *a*, Sculptures from Monte Albán Building L-sub (*redrawn from Scott 1978b*); *b*, Dainzú ballplayers (*redrawn from Orr 1997: fig. 2.26*).

on interpretations of the localities depicted on the carved tablets from Building J, Marcus and Flannery (1996) argue that Monte Albán conquered regions as distant as 160 km and eventually dominated a territorial empire covering approximately 20,000 km². Although Marcus and Flannery (1996) recognize multiple

forms of imperial subjugation, especially colonization versus conquest, their model emphasizes a territorial form of imperialism whereby provinces were conquered militarily or colonized and then dominated through the establishment of new administrative centers staffed by Zapotecs from the Valley of Oaxaca which may have also included a military garrison. This form of imperialism has been argued for the Cuicatlán Cañada and suggested for other regions such as the lower Río Verde Valley and the area around Monte Negro in the Mixteca Alta (Marcus and Flannery 1996:198–207; Redmond and Spencer 2006).

Other archaeologists working in Oaxaca, however, disagree with this model of Monte Albán imperialism (Joyce 1991:548–717; 2003; Workinger 2002: 387–393; Zeitlin and Joyce 1999). These researchers argue that it is unlikely that Monte Albán could have dominated such an area, given the logistics required to conquer and control a territorial empire of this scale, especially in a region as rugged as Oaxaca. In addition, most regions within the proposed Monte Albán empire have either been insufficiently investigated or have failed to yield evidence for conquest and political control. Because of the relative lack of archaeological evidence for imperial conquest, except perhaps for the Cuicatlán Cañada, it is worth considering in greater detail the history of Marcus's interpretations of the Building J tablets, since they form the basis of the conquest state model.

Building J and the Conquest State Model

The Building J carvings are argued to represent particular places conquered by Monte Albán, as represented by a standardized "hill" (or place glyph) with another glyph directly above it signifying the name of a particular locale, such as the place of the rabbit (Figure 1.5). Beyond these two elements, the tablets vary, with some containing short hieroglyphic inscriptions. Another clear distinction is that most of the slabs depict an upside-down human head with eyes closed directly beneath the "hill" glyph, which is interpreted as the dead ruler of a conquered locality (Caso 1947). Building upon Caso's interpretation of conquest, Marcus argues that the carvings of Building J are "textual claims" of Monte Albán expansion (Marcus and Flannery 1996). These textual claims form the foundation of the conquest state model, but the specifics of her argument and interpretations have shifted over the last 30 years. It is worthwhile to consider how and why her views have changed in order to understand how her interpretation has slowly become reified and why it has directly led to the acceptance of a Terminal Formative conquest state and the primacy of the Zapotec empire without critical assessment (also see Urcid 1992).

In her initial article on the subject, Marcus (1976) explicitly accepted Caso's hypothesis that the Building J carvings represent the conquests of Monte Albán

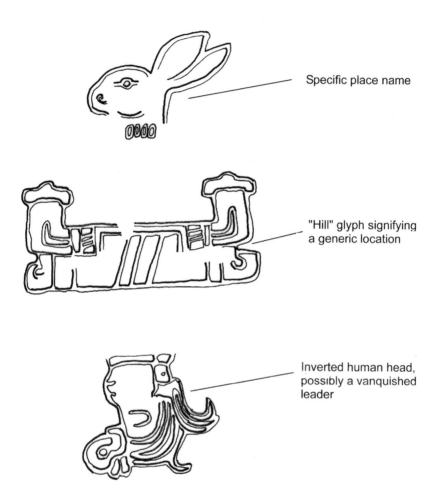

Specific place name

"Hill" glyph signifying a generic location

Inverted human head, possibly a vanquished leader

FIGURE 1.5. Common elements of the Building J carved tablets.
(*Tablet 34 redrawn from García Moll et al. 1986.*)

during the Terminal Formative Period. She took his interpretation one step further by attempting to correlate some of the place names on the carved stones with actual Terminal Formative sites in Oaxaca. To do so, she compared them to toponyms and their glosses from the sixteenth-century Aztec list of tributaries, the *Matrícula de Tributos,* and its better-known and more complete copy, the *Codex Mendoza.*[1] Both were painted 1,500 years after the Building J tablets were carved, and their use assumes continuity in town names. Marcus (1976) found that there were five close similarities between the Oaxacan tributary towns in the

Codex Mendoza (fols. 43r–44r; Berdan and Anawalt 1997:91–93) and the Zapotec glyphs on the Building J carvings. These are (with the Nahuatl gloss from similar glyphs in the *Codex Mendoza*, followed by Marcus's proposed Oaxacan equivalents): (1) Tablet 15-Etlan, or Etla, a region in the northern arm of the Valley of Oaxaca; (2) Tablet 43-Miahuaapan, or Miahuatlán, a town 85 km south of Monte Albán,[2] (3) Tablet 4-Teticpac, or Teitipac, a town in the Tlacolula arm of the Valley of Oaxaca; (4) Tablet 57-Tototepec, or Tututepec, a town on the coast of Oaxaca 160 km southwest of Monte Albán; and (5) Tablet 47-Cuicatlán, a town north of the Valley of Oaxaca, between it and the Tehuacán Valley. One further addition is made to Caso's interpretation in that a few of the Building J tablets lack the inverted head underneath the hill sign (for example, Tablet 43, identified by Marcus as Miahuatlán). Marcus believes that those locales capitulated without resistance to colonization or the threat of physical violence by Monte Albán (1976:129).

In 1980, and in more recent articles and a book (1983, 1984, 1992a, 1992b), Marcus returns to her hypotheses concerning the Building J tablets, although the list of identified tablets changes. The second list includes Miahuatlán, Cuicatlán, and Tututepec, but omits Etla and Teitipac, adding instead Tablet 23-Ocelotepec. The removal of Etla and Teitipac reflects a change in Marcus's view as to what the carved stones were intended to represent. Originally, she wrote that the tablets chronicled *all* of the conquests of the expanding Monte Albán state. However, in this, the second article, her interpretations shift, as Marcus argues that they document only the *boundaries* of the Terminal Formative Monte Albán polity (1980). Because both Etla and Teitipac are within the Valley of Oaxaca (and would therefore represent the boundaries of a polity much smaller than the empire envisioned by Marcus), they are discarded in favor of Ocelotepec, 140 km away (Urcid 1992).

Marcus's hypothesis that the Building J tablets represent only boundaries is further developed in a 1983 article. In it, she compares them to a sixteenth-century Zapotec *lienzo* from Santiago Guevea de Humboldt, located toward the Isthmus of Tehuantepec at the foot of the Sierra Mixe (Paddock 1983; Oudijk and Jansen 2000). The *Lienzo de Guevea* was written in about 1540 in response to Spanish orders to document local land claims. It is mentioned by Marcus because of the way in which it was modeled, depicting Cerro de Guevea in the center of the map surrounded by various natural landmarks. Marcus (1983) believes that this convention is analogous to the tablets of Building J. Not necessarily sites, the places depicted on Building J could also represent natural landmarks such as mountains, rivers, or even entire regions along the frontier of the Monte Albán state.

Marcus has clearly established her methodology by 1983, and the only material changes to her argument consist of adding or dropping places presumably conquered by Monte Albán. She writes, "perhaps ten [toponyms] can be matched with actual places known today" (Marcus 1992a:176), and in her next article she introduces two more (1992b). These are Tablet 32-Sosola, northwest of the Valley of Oaxaca, and Tablet 3-Chiltepec, east of Ocelotepec toward the Isthmus of Tehuantepec. Unlike Marcus's previous interpretations in which she turned to the *Codex Mendoza* for the glosses, Sosola and Chiltepec were identified by the towns' Nahuatl names ("Place of the Pierced Face" and "Hill of the Chile Plants" [Marcus and Flannery 1996:197]). It is unclear if these are Nahuatl translations of the local names or simply new names imposed by the Spanish and their Nahuatl-speaking allies in the sixteenth century. Reliance on Nahuatl designations for locations in Oaxaca is further brought into question by Smith (1973:37), who found that many Nahuatl names varied from local Mixtec ones.

The inclusion of Sosola and Chiltepec with the four other identified places forms a corridor stretching from the Cuicatlán Cañada south to the Pacific coast (Marcus 1992b), implying that Monte Albán was interested in controlling the lucrative trade passing between the Valley of Oaxaca and the Pacific coastal lowlands. It should be noted that Brockington (1966) found no evidence of Zapotec imperialism at the coastal site of Sipolite, which would have formed the terminus of Marcus's "Zapotec corridor." Slightly farther east on the southern Isthmus of Tehuantepec, investigations of Laguna Zope have identified the site as a likely supplier of marine shell to Monte Albán in the Late Formative. Return trade items from the highlands are difficult to discern, but the southern Isthmus did not receive the imported gray-ware ceramics found farther west in the lower Río Verde region (Zeitlin and Joyce 1999:387–388).

The six identifications introduced in Marcus (1992b) remain the same in recent publications dealing with the Building J tablets (for example, Marcus and Flannery 1996:195–199). It was not until recently, however, that the site of San Francisco de Arriba was specifically named as a boundary of the Zapotec state. This may have been in reaction to research on the floodplain of the lower Río Verde Valley, which found no evidence of conflict (Joyce 1991, 1993, 2003). San Francisco de Arriba, because it had only been briefly visited by archaeologists (DeCicco and Brockington 1956:51–60), still represented a possible site of conquest. But offering interpretations of the Building J carvings is only the first step for those researchers interested in possible Late/Terminal Formative Zapotec expansion. The second step consists of investigating the identified places for evidence of warfare and/or conquest and imperial control.

Archaeological Evidence for the Conquest State Model

Archaeological research in most of Monte Albán's hypothesized empire is either insufficient to support a Zapotec takeover or directly refutes the imperialism model. The conquest model put forth by Marcus and Flannery (1996) includes such sites as Ocelotepec and Chiltepec in the region to the south and east of the Valley of Oaxaca, a region yet to be explored archaeologically (there are actually at least 10 communities named Ocelotepec clustered in the southern Sierra). Miahuatlán, a region 85 km south of the Valley of Oaxaca, is another community claimed to have been incorporated into a Terminal Formative Zapotec empire. And, although a survey of the area has been completed (Markman 1981), the sampling method utilized and the lack of comprehensive excavations make the evaluation of a Zapotec imperial presence difficult.

The best case for a region conquered by Monte Albán comes from the Cuicatlán Cañada region, where Spencer and Redmond (Redmond 1983; Spencer 1982; Spencer and Redmond 1997, 2001) initiated a survey and excavation project to test Marcus's reading of Building J Tablet 47. They argue that several lines of evidence demonstrate military conquest followed by Zapotec imperial administration of the region. The surface survey showed a dramatic shift, at ca. 300 B.C., in settlement patterns from the high alluvium to defensible piedmont locations. The site of Llano Perdido was burned and suddenly abandoned. Excavations at La Coyotera exposed the remains of a skull rack, possibly exhibiting victims of warfare or sacrifice. Conquest by Monte Albán is inferred from similarities in ceramic styles and from a Oaxaca Valley-style tomb eroding from the surface at the fortified site of Quiotepec, which was argued to have been a Zapotec administrative outpost supported by a military garrison. Survey data also showed an unoccupied buffer zone separating the Cañada and the Tehuacán Valley to the north, presumably marking the frontier of Monte Albán control. New forms of political organization were inferred from changes in public architecture and settlement patterns. Spencer (1982:221–231) suggests that the development of irrigation was designed to produce surpluses in the form of tropical crops for tribute payments to Monte Albán.

While Spencer and Redmond provide a strong case for warfare in the Cuicatlán Cañada, the identification of Monte Albán as an imperial conqueror of the region can be questioned. Most damaging has been Urcid's (1994) demonstration that the indigenous Cuicatec name for the region, *Yivacu* or "Hill of the River of Houses," differs from the Aztec *Cuicatlán* or "Place of the Song," which Marcus (1976, 1983) relied on to identify the place shown on the Building J slab. Marcus's reliance on Aztec names recorded in the *Codex Mendoza* 1,500 years

after the Building J tablets were carved is a significant problem for all of the place attributions that she has proposed. The archaeological evidence for a Zapotec presence can also be questioned, since there were close affinities in ceramic styles both before and after the hypothesized conquest (Spencer and Redmond 1982), showing that there was not a dramatic shift in ceramic styles concurrent with the presumed takeover. The Zapotec-style tomb at Quiotepec dates to the Classic Period (Pareyón 1960:101–102), postdating the hypothesized conquest and period of political domination by Monte Albán. While it is possible that the Cuicatlán Cañada was conquered by Monte Albán, the subsequent territorial domination of the region can be questioned. It is also likely the Cuicatlán Cañada engaged in warfare with regions other than the Valley of Oaxaca, since there is evidence for contemporaneous interpolity warfare in both the Mixteca Alta and Mixteca Baja regions, immediately west of the Cuicatlán Cañada, and in the Tehuacán Valley to the north (Joyce 1991:558–567). Communities in the Cuicatlán Cañada may have periodically gone to war with polities in a number of different nearby regions, which is a pattern similar to that seen at the time of the Spanish Conquest (Hunt 1972:208–212).

Another region that highland researchers include in the conquest state model and which has been the focus of intensive, long-term investigation is the lower Río Verde region on the Pacific coast. Singled out for its gray-ware ceramics resembling those from the Valley of Oaxaca as well as for its proximity to the Late Postclassic site of Tututepec, whose toponym is similar to one found on a carved tablet from Building J, San Francisco de Arriba is purported to have been the southernmost Zapotec outpost (Marcus and Flannery 1996). A project combining broad excavations with full-coverage survey was undertaken specifically to test claims of highland conquest (Workinger 2002).

Excavations at San Francisco de Arriba and neutron activation analysis of ceramics revealed that trade with the highlands was abundant, particularly in the Late Formative, yet there was nothing to suggest conflict along the lines of that found in the Cuicatlán Cañada (Spencer and Redmond 1997). San Francisco de Arriba had reached its maximum extent of 94.51 ha in the Late Formative Period and, given its size and internal complexity, had probably reached the level of a chiefdom. Its size, combined with the rugged mountainous terrain separating it from the Valley of Oaxaca, would have made San Francisco de Arriba a difficult target for imperial expansion. Survey of the valley surrounding the site revealed continuity in settlement between the Late Formative and the Terminal Formative, an indication that the inhabitants felt no threat from Monte Albán and also that there was no economic reorganization on the heels of a Zapotec conquest, as was argued for the Cuicatlán Cañada (Spencer 1982).

Excavations in the most defensible areas of the site revealed residential structures dating prior to, during, and after the time of proposed conquest rather than fortifications one might expect from a threatened community (Workinger 2002). Further excavations in and around the site's main plaza failed to find evidence of Zapotec imperial administrators. Instead, the elite of San Francisco de Arriba appear to have been closely allied with fellow nobility at Río Viejo, sharing ceramics imported from the Valley of Oaxaca in the Late Formative, which all but ended by the Terminal Formative—precisely at the time when Zapotecs supposedly arrived on the coast. The Zapotecs had conquered San Francisco de Arriba, one would expect an *increase* in evidence for exchange with the Oaxaca Valley. Construction of the acropolis at San Francisco de Arriba began at an impressive scale in the Late Formative, further indicating that the community would have posed a hurdle to Zapotecs intent on acquiring coastal trade goods.

San Francisco de Arriba decreased in size during the Terminal Formative Period in response to the rise of a massive regional center on the western side of the Río Verde. There, the site of Río Viejo reached a sprawling 225 ha and was located on the floodplain with apparently little thought given to defense against foreign invasion (Joyce 2003, 2005). Throughout the lower Río Verde region, full-coverage surveys have found largely continuous occupations in the Late and Terminal Formative, and excavations at 13 Late/Terminal Formative Period coastal sites have yet to uncover indications of violence (for example, large-scale burning and/or skeletons exhibiting traumatic injuries), the "swamping" of local ceramic assemblages with highland styles, or the fortifications and the administrative buildings that would accompany territorial conquest. Neither is there evidence for an economic reorganization that might suggest the region had been converted to a tributary state supplying the Valley of Oaxaca with coastal goods such as marine shell, salt, animal pelts and feathers, cacao, and cotton (for extensive discussion of evidence bearing on Zapotec conquest of the lower Río Verde Valley, see Barber 2005; Joyce 1991, 2003; Workinger 2002; Zeitlin and Joyce 1999). The regional survey and excavation data do not indicate a shift to defensible piedmont locations or a disruption of political organization suggestive of Zapotec conquest and domination. The percentage of the occupational area in the piedmont within the 152-km^2 full-coverage survey zone fluctuated from 43 percent in the Late Formative to 20 percent in the early Terminal Formative to 38 percent in the late Terminal Formative, so there were actually fewer people living in defensible piedmont locations at the time of proposed conquest. Population and indications of social complexity also increased steadily through the Late/Terminal Formative, with the occupational area in the survey zone increasing from

297 ha in the Late Formative to 699 ha by the end of the Terminal Formative and the regional settlement hierarchy increasing from three to five tiers.

In addition to the lack of archaeological support for territorial conquest and political control in most areas of the hypothesized Monte Albán empire, it is unlikely that Monte Albán could have dominated an area of 20,000 km^2 given the logistics required to conquer and control a territorial empire of this scale, especially in a region as rugged as Oaxaca. Hassig (1988) estimates that a large pre-Hispanic army could have traveled on average 19 km a day, and probably somewhat less through very mountainous terrain. With San Francisco de Arriba situated 160 km south of Monte Albán, it would have taken the Zapotecs eight or nine days to arrive. Provisioning this far from home would have been a major issue, as it is far from clear that the Zapotecs had allies this far south (Workinger 2004) and foraging is not feasible for a sizable military force in such mountainous terrain. Even with porters dedicated to carrying food and nothing else, eight days of travel would probably have been the limit (Hassig 1988:64), with no provisions left for the time engaged in battle nor for the return march home.

Recent Arguments for the Conquest of Coastal Oaxaca

Recently several proponents of the conquest state model have contested our arguments that the lower Río Verde was not incorporated into a Monte Albán empire (Balkansky 1998:469–472; 2001; Redmond and Spencer 2006; Spencer 2007). The thrust of their argument is that conquest and imperial control over the lower Río Verde Valley is shown by significant frequencies of cream-ware ceramics imported from the Oaxaca Valley to the site of San Francisco de Arriba and evidence for a massacre at Cerro de la Cruz. These arguments rely on a brief reconnaissance by DeCicco and Brockington (1956) at San Francisco de Arriba as well as summaries of our research that include many obvious mistakes and omissions of key evidence. We urge scholars to consider the primary sources of evidence (for example, Joyce 1991, 1994, 1999; Joyce et al. 1998; Workinger 2002) rather than problematic characterizations of our work. While we have previously responded to some of the arguments contesting our interpretations (Joyce 2003; Joyce et al. 2000), recent articles by Redmond and Spencer (2006; Spencer 2007) expand misrepresentations of our work and require a response.

Redmond and Spencer (2006; Spencer 2007) cite the results of the reconnaissance by DeCicco and Brockington (1956) to argue that cream wares at San Francisco de Arriba were identical to those from Monte Albán, indicating an imperial takeover. Workinger (2002:355), however, recovered only a single redeposited cream-ware sherd during six months of survey and excavation. In the minds of

some researchers, cream wares appear to be the new gray wares. It was the latter pottery that was once claimed to mark the territorial extent of Monte Albán (Marcus and Flannery 1996), yet because of its ubiquity in Oaxaca during the Terminal Formative Period, that argument has fallen out of favor. Cream wares, on the other hand, were manufactured only in Atzompa, a site a few kilometers from Monte Albán in the Valley of Oaxaca, and are distinguished by their feldspathic temper and compositional chemistry (Joyce et al. 2006:582). Their presence in high frequencies would suggest strong ties with the Zapotecs at Monte Albán.

While San Francisco de Arriba has been singled out for Zapotec conquest or colonization (Marcus and Flannery 1996), highland archaeologists have consistently ignored the site's larger social and political context (for example, Marcus and Flannery 1996:201). San Francisco de Arriba is located in a secondary valley but shares ceramic and architectural styles, sources of obsidian, and patterns of interregional interaction with other sites in the lower Río Verde Valley, including Cerro de la Cruz and Río Viejo. Spencer (2007:68–69) suggests that the scale of the excavations and survey might have caused Workinger to miss the cream-ware sherds at San Francisco de Arriba. The 124 m^3 of excavated material (Workinger 2002:97) should, however, reveal a far more representative sample than the 28 rim sherds (including four purported cream wares) from surface collections that DeCicco and Brockington (1956:56) made over the course of a few days and which Spencer (2007) favors over Workinger's (2002) dissertation project. Moreover, the survey of the Río San Francisco valley encompasses only a portion of the larger 152-km^2 full-coverage regional survey (Joyce 2003). Valley of Oaxaca cream wares were not found in surface collections at other sites in the lower Río Verde, and extensive excavations at Cerro de la Cruz and Río Viejo have recovered only three imported cream-ware rim sherds from unmixed deposits out of a total of 7,781 rims, for a proportion of 0.0004 (compare with Spencer 2007: table 3.1).

DeCicco and Brockington (1956:55), in consultation with highland archaeologist John Paddock, describe the cream-ware sherds from San Francisco de Arriba as fitting "perfectly in the classification of Monte Albán." Spencer (2007) assumes that these sherds were from vessels imported from Atzompa, while we find the wording of DeCicco and Brockington (1956:55) to be ambiguous. Based on the illustrated examples in DeCicco and Brockington (1956:57), they were likely referring to what we call fine brown wares in the lower Río Verde Valley ceramic typology (Joyce 1991:130–132; Workinger 2002:255). The illustrated sherds do not resemble the cream wares found in the Valley of Oaxaca (Caso et al. 1967:44–49). Indeed, the cream-ware designation appears to have been applied to a wide range of ceramic pastes during the coastal reconnaissance of DeCicco and Brockington (1956). DeCicco and Brockington (1956) distinguish

between fine and coarse cream wares and report collecting fine cream wares from the site of Cerro de los Pájaros, 5 km southwest of San Francisco de Arriba, where they included examples painted with polychrome decoration (DeCicco and Brockington 1956:64). More recent investigators in the lower Verde have classified this type of paste as a locally made fine brown ware (Levine 2007:257–268). Coarse cream wares most likely refer to our coarse brown wares, which are tempered with large inclusions of granodiorite, the local bedrock (compare with DeCicco and Brockington 1956: lám. V; Joyce et al. 1998: figs. 2.7, 2.8). We believe that this may have led Paddock to mistakenly label them as cream wares.

Redmond and Spencer (2006:376; Spencer 2007) continue to cite and expand upon Balkansky's (1998) erroneous interpretation of Late Formative burials from Structure 1 at Cerro de la Cruz as a massacre, despite clear evidence that the burials had been interred in a communal cemetery used over the course of at least several generations (see Joyce 1991, 1994, 2003; Joyce et al. 1998). For example, Balkansky (2001:560) states that "the still-articulated bodies, moreover, are piled together in rooms without apparent disturbance," and Redmond and Spencer (2006:376) claim that the burials from Cerro de la Cruz were found lying on the uppermost floor of Structure 1. Published descriptions of the stratigraphy clearly show that the burials were interred *beneath* the uppermost two floors of Structure 1 (Joyce 1991:213–214; 1994:158; Joyce et al. 1998:65). Balkansky (1998) and Spencer (2007) also ignore considerable evidence for sequential intentional interments in Structure 1 as well as in other burials on the terrace on which Structure 1 was built (Joyce 1991, 1994, 2005; Joyce et al. 1998). The burials in Structure 1 included articulated primary interments oriented within 10 degrees of the cardinal directions, and disturbed and/or secondary burials (Figure 1.6). There were frequent instances of later burials having truncated earlier ones, showing that they were interred over a significant period of time, probably several generations. An analysis from the southern half of Structure 1, where stratigraphic relationships among burials could be clearly discerned, indicates that there were between 6 and 21 separate burial events (Joyce 1991:732–739). Likewise, Spencer's (2007:70) discussion of nine individuals interred one on top of the other along a section of the wall retaining the terrace on which Structure 1 was built omits the evidence of stratigraphic breaks and disturbances of earlier burials, which demonstrates that these interments involved six distinct burial events over a significant period (some were multiple interments; Joyce 1991:252–253, 339–340, 740–744).

Osteological analyses of the Cerro de la Cruz material have failed to yield evidence of traumatic wounds (Alexander Christensen, personal communication 2001; Joyce 1991: appendix 1). It is also puzzling as to why these researchers

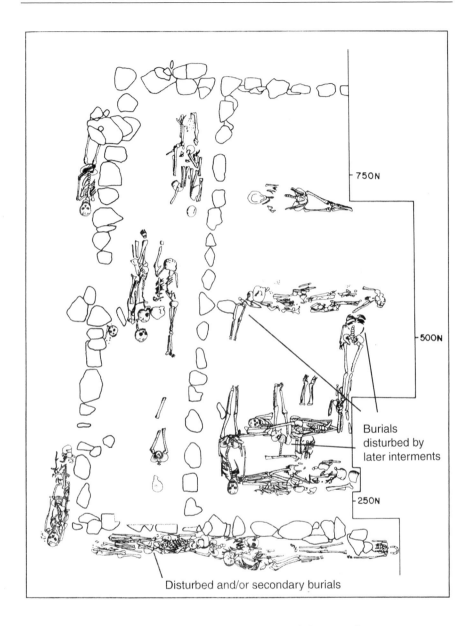

Figure 1.6. Plan of Structure 1 cemetery at Cerro de la Cruz, showing primary and secondary interments as well as skeletons disturbed by later burials.

(Balkansky 2001:560; Spencer 2007:69–70) believe that the absence of grave goods, the large number of interments, an age profile consisting almost entirely of

adults, and evidence of "intensive funerary activity" are inconsistent with a cemetery. Late/Terminal Formative burials found throughout the lower Río Verde Valley rarely have grave offerings (see Barber 2005; Joyce 1991, 1999). Large numbers of interments and intensive funerary activities seem to us to be defining characteristics of cemeteries. Joyce (1991:255; 1994:158; Joyce et al. 1998:65) estimates the rate of interment in Structure 1 to have been one every 3.7 years, which does not seem unusual for a communal cemetery. The age profile of the Cerro de la Cruz cemetery, with its preponderance of adults, is consistent with other Formative cemeteries in Oaxaca and suggests that only people who had reached adulthood were allowed to be interred in the cemetery (see Joyce 1991: 255; 1994:158; Joyce et al. 1998:65). Redmond and Spencer (2006:376; Spencer 2007) also ignore the late Terminal Formative cemetery excavated by Barber (2005) at Yugüe in the lower Río Verde Valley, demonstrating a long-term tradition in the use of communal cemeteries (see Barber and Joyce 2007).

Spencer (2007:70–71) further suggests that there is "considerable evidence for burning" associated with Structure 1, implying that the building may have been destroyed in an attack. While floors associated with three of the five building phases of Structure 1 exhibited burned patches (ranging from 0.3 to 1.5 m^2), and there were remains of one fired adobe and small quantities of burned daub (Joyce 1991:182–183, 297–299), we view these data as better explained by cooking and/or the burning of incense associated with mortuary ceremonies, rather than by the destruction of the building by fire (compare Spencer 1982: 70). Spencer (2007:70–71) further obfuscates matters when he argues that "[s]everal areas of charcoal are located as features on the plan of Structure 1; some appear much too large and irregular to have been simple hearths (Joyce, Winter, and Mueller 1998: fig. 3.3). One of these large charcoal concentrations is Elemento 1." *Elemento* or Feature 1, however, is clearly described by Joyce (1994:152) as a large hearth "containing deposits of burned wood, ash, and fire-altered rock" that was intruded 30 to 40 cm into the patio (that is, Feature 1 was not found in Structure 1). Structure 1 was part of an architectural complex on the uppermost terrace at Cerro de la Cruz that also included a granite flagstone patio, three storerooms (Structures 2–4), and a possible residence (Structure 5). We assert that the patio, large hearth (Feature 1), storerooms, and cemetery were part of a public area where communal mortuary ceremonies and ritual feasting were carried out. Spencer (2007:71) is also incorrect when he writes that Cerro de la Cruz was largely abandoned at the end of the Late Formative, since survey data show an increase in settlement from 1.0 ha in the Late Formative to 1.5 ha in the Terminal Formative. and excavations exposed numerous Terminal Formative features (Joyce 1991:236–240).

Given the evidence (for example, Barber 2005; Barber and Joyce 2007; Joyce 1991, 1994, 1999, 2003; Joyce et al. 1998; Levine 2002; Workinger 2002),[3] we find it highly unlikely that the lower Verde region was subjugated by Monte Albán via large-scale conquest and/or colonization or that Zapotecs established an administrative center in the region (see Smith and Montiel 2001:270 for a concurring opinion). We leave open the possibility that the lower Verde may have been involved in less intensive and less archaeologically visible forms of conflict that could have occasionally involved Monte Albán, although there are no data as yet that support this hypothesis. In the next section, we consider alternatives to the conquest state model in the Valley of Oaxaca, where we agree that there is evidence for warfare.

ALTERNATIVES TO LARGE-SCALE CONQUEST WARFARE

Regardless of one's position in relation to the debate over Monte Albán imperialism, the focus has been on evidence of territorial conquest, including large-scale military actions and the establishment of administrative and military garrisons to maintain control of subjugated provinces. Few researchers have considered the possibility that Late/Terminal Formative Period warfare in Oaxaca may have been variable in scale, intensity, and impact, like the patterns found with Aztec and Maya polities. In fact, it is instructive to keep in mind that territorial conquest followed by long-term political domination of the subjugated region was rare in the Maya Lowlands and even in the case of the much larger and militarily organized Aztec empire. Such domination would have been extremely costly in terms of both labor and the resources necessary to maintain garrisoned troops.

Alternative interpretations of the Oaxacan data suggest a more varied pattern of conflict. For example, Spencer and Redmond (2001; Spencer 2003) have convincingly argued that the site of El Mogote in the southern arm of the Oaxaca Valley was attacked and its main plaza partially burned by Monte Albán ca. 300 B.C. The site center was then relocated to a more defensible position at the site of El Palenque, and a defensive wall was built, although the majority of the populace remained outside the wall at El Mogote. Spencer and Redmond (2001) show how architecture and ceramics at both sites continued to diverge from patterns seen at Monte Albán for at least two more centuries, suggesting that the area continued to resist incorporation into the Zapotec polity. At ca. 20 B.C. the El Palenque site center was burned and the site abandoned, again apparently as the result of an attack by Monte Albán. By focusing on these instances of abandonment and destruction, it appears as if warfare were large-scale and "relentless." On the other hand, the fact that the inhabitants of El Mogote and El Palenque were able to hold

out for at least 300 years against the much larger polity of Monte Albán indicates that warfare may not always have been so large-scale, destructive, and relentless. Monte Albán was more than six times the size of the combined El Mogote/El Palenque site, and estimates suggest that almost 70 percent of the valley's population was concentrated near Monte Albán during the Late Formative. If warfare involved large armies, including both nobles and commoners, it is unlikely that El Mogote/El Palenque could have held out for such a long period given Monte Albán's demographic advantage.

The almost 3-km-long wall surrounding much of the main plaza at Monte Albán can also be questioned as evidence supporting a model of large-scale warfare. During the Late Formative, Monte Albán was home to approximately 15,000 people (Blanton 1978), and there were an estimated 28,500 people living in the Central and Etla areas of the Valley of Oaxaca (that is, those under the control of Monte Albán; Kowalewski 1983). While still not in complete control of the Valley of Oaxaca (see Spencer and Redmond 2001), Monte Albán had no rivals capable of mounting a serious threat if warfare involved the kinds of large-scale engagements envisioned by some scholars. Conversely, by controlling the flow of people into the city, the wall could still have served a defensive function as long as warfare was restricted to the nobility and was more rule-based (see Orr and Koontz, this volume, Introduction) than the kind of all-out aggression fought by large-scale professional armies envisioned by Marcus, Flannery, Spencer, and others. If wars were fought by smaller forces intent not on territorial conquest but on the taking of elite captives and the destruction of important political and religious buildings, then Monte Albán's nobility might still have faced significant threats that were discouraged and/or defended against through construction of a defensive wall around the site center. Rather than being solely defensive, the wall may also have been designed to control the flow of people from surrounding communities into the site during important ceremonies or for economic activities (Blanton 1978:52). The wall might then embody some degree of tension between Monte Albán's nobility and commoners within the polity. It is possible that the wall also embodied ideological messages by underscoring the idea of an external threat, real or imagined (Joyce and Winter 1996). For Mississippian chiefdoms of the American Southeast, Anderson (1994) indicates that the continual warfare recounted by the members of the De Soto expedition may have been a tool used to reinforce elite status and enhance their ability to control by effectively circumscribing the commoner population. The leadership at Monte Albán during the Formative may have taken the same approach to conflict, using it to secure their elevated status as much as a means of territorial expansion. Of course, the wall probably was used for a variety of purposes, which changed through time. At pres-

ent, the history of the construction and use of the wall is known only from survey and a single test trench (Blanton 1978:52); future research might support or refute some of these alternatives.

The iconographic data from Monte Albán can be interpreted as indicating variation in militarism. Stylistic and stratigraphic analyses of the Building L-sub monuments and the carved slabs set into the foundations of Building J show that they overlapped in time as coherent iconographic programs prior to their dismantling at the end of the Formative (Scott 1978a; Urcid 1994, 2008). The Dainzú ballplayers also overlap in time with the Building L-sub and Building J carvings. Late/Terminal Formative Period iconography therefore seems to foreground different elements of conflict. The Building J tablets are interpreted as representations of conquered places, some apparently including the decapitated head of the site's ruler. The Building L-sub and Dainzú monuments focus more on individuals than on conquered places. At least four and perhaps most of the Building L-sub monuments represent sacrificial victims, presumably captured in battle. As argued by Orr (1997, 2003), the Dainzú monuments depict one-on-one confrontations involving ritual combat, with victorious ballplayers dominating defeated ones. The Dainzú ballplayers are elaborately attired and probably represent nobles who were sacrificed once they had been defeated in ritual combat in the context of the ballgame. Since the ballplayers in the Dainzú images appear on place signs, they may also have been associated with competing polities and might represent conflict analogous to Maya ax events. Monument J-41 at Monte Albán, which does not appear to belong to either the original Building L-sub or the Building J program, depicts a ruler of Monte Albán in the act of decapitation sacrifice (Urcid and Winter 2003). In addition, while the interpretation of the Building J carvings as documents of conquest is plausible, it is not clear that the "victories" referenced on the tablets were territorial in nature. The different carved elements in the Building J slabs might reflect variation in the intensity and scale of combat, perhaps analogous to the ax and capture events in the Maya Lowlands. It is also possible that the tablets from Building J are not militaristic, but instead celebrate political or economic alliances or memorialize dead warriors (Javier Urcid, personal communication 2006).

Conclusions

Based on the comparative data from other regions of Mesoamerica as well as on the archaeological and iconographic record from Oaxaca, we question whether territorial conquest was the only form of warfare and whether it was as pervasive as Marcus, Flannery, and others have argued. The conquest state model's singular focus on

frequent, large-scale warfare brings to mind Payson Sheets's (2003) cautions against an overreliance on modern Western conceptions of warfare and territorial conquest. This type of large-scale, unrelenting warfare with professional armies bent on territorial conquest and political control may be so compelling because it reflects our own history and cultural assumptions about the nature and causes of war. The commitment to this singular Western view of warfare may explain why proponents of the conquest state model continue to insist that regions such as the lower Río Verde Valley were conquered and administered by Monte Albán (Redmond and Spencer 2006; Spencer 2003) despite 20 years of field research that has found no evidence to support such a claim (Joyce 2003; Workinger 2002).

Current models of warfare in Formative Oaxaca are also heavily evolutionist, arguing that peaceful Archaic forager farmers gave rise to agricultural villages with low-intensity raiding, and then raiding intensified with the advent of chiefdoms and gave rise to full-scale war and imperialistic conquest with the rise of the state (Flannery and Marcus 2003; Redmond and Spencer 2006; Spencer 2003; compare Marcus 1992a). In their model, this latter form of war persists until the Spanish Conquest; archaeologists have cited early colonial ethnohistories, particularly the writings of Fray Francisco de Burgoa (1989a, 1989b), in arguing for this type of intensive, large-scale conquest warfare at the time of the conquest. It seems as if the Monte Albán conquest state model suggests that cultural evolution leads inexorably toward modern, Western forms of warfare.

Yet a closer reading of Burgoa's writings suggests a similar range of variability in Oaxacan warfare practices at the time of the conquest, as has been indicated for pre-Hispanic Aztec and Maya polities. In addition to mentioning instances of conquest warfare involving "fuego y sangre" (fire and blood), he also states that "the motives for wars, generally among the Indians, were not pillaging or taking of tribute, they were only occasions for fighting and vengeance" (Burgoa 1989a: 376; also see Dahlgren 1990:154–160; translation by the authors). This is very similar to ethnohistoric reports of conflict from the southeastern United States: "Almost all the provinces that these Spaniards traversed were at war with each other. . . . One should know that this was not a conflict of force with an organized army or with pitched battles, except in rare instances, or a conflict instigated by the lust and ambition of some lords to seize the estates of others" (Vega in Anderson 1994:65). Likewise, Mary Elizabeth Smith identifies three variants of the Late Postclassic Mixtec glyph for conquest, perhaps suggesting variation in conflict (Smith 1973:33–34).

In considering the comparative data on pre-Columbian warfare in Mesoamerica as well as the archaeological and ethnohistoric evidence from Oaxaca, we question whether intensive, large-scale conquest warfare was as important or frequent as is assumed by the Monte Albán conquest state model.[4] Our view of the evidence is that Monte Albán may have controlled a much smaller hegemonic

empire, subjugating weak polities within and immediately surrounding the Oaxaca Valley and perhaps at times raiding more distant areas. Indeed, as Marcus (1992a:353) cautions, "We have perhaps overlooked the significance of small-scale raids [in Mesoamerica], partly because it is more difficult to detect them archaeologically, and partly because we have used Aztec imperial expansion as the 'ideal model' or standard by which we evaluate the impact of other kinds of military activity." Taking heed of this warning, it is clear that Oaxacan archaeologists need to consider a broader range of warfare practices, similar to what has been found in other regions of Mesoamerica.

ACKNOWLEDGMENTS

We would like to thank Rex Koontz and Heather Orr for the opportunity to participate in the session on organized violence at the 70th meeting of the Society for American Archaeology in Salt Lake City, Utah, and this volume, which grew out of that symposium. We thank Javier Urcid for commenting on this chapter and for helpful input on Zapotec epigraphy. We also appreciate the input of Cathy Cameron, Steve Lekson, Payson Sheets, Paola Villa, and two anonymous reviewers. Our research in Oaxaca has been carried out under the auspices of the Consejo de Arqueología, Instituto Nacional de Antropología and its president, Joaquín García-Bárcena, and the Centro INAH Oaxaca, directed by Eduardo López Calzada. Funding for our investigations in the lower Río Verde region has come from the National Science Foundation (Grant Nos. 9729763 and 8716332), the Foundation for the Advancement of Mesoamerican Studies (#99012), the National Geographic Society (Grant No. 3767–88), the Vanderbilt University Research Council and Mellon Fund, the Fulbright Foundation, the H. John Heinz III Charitable Trust, the University of Colorado, the Wenner-Gren Foundation (Gr. 4988 and 6419), Sigma Xi, the Explorers Club, Vanderbilt University, and an anonymous donor. During the writing of this chapter, Joyce was supported by an ACLS/SSRC/NEH International and Area Studies Fellowship and a Faculty Fellowship from the Council on Research and Creative Work, University of Colorado at Boulder.

NOTES

[1] Marcus's methodology assumes that the iconicity of the signs on the Building J slabs is transparent, which leads to an obvious semantic reading. Caso (1947:25; 1965:938–939) and Urcid (1992:61) caution that Zapotec script, like other Mesoamerican writing systems, may have had phonetic elements that resist such a transparent reading.

2 Urcid (personal communication 2006) argues that the toponym from the *Codex Mendoza*
 that Marcus used in the identification of Tablet 43 was actually from Miahuapan, a trib-
 utary town in the province of Tuxpan, northern Veracruz. This calls into question Mar-
 cus's identification of Miahuatlán, the valley south of the Oaxaca Valley.

3 Our work in the lower Río Verde Valley has now included 22 years of field research,
 including a regional full-coverage survey over 152 km^2 that has recorded 85 sites, and a
 nonsystematic reconnaissance over the entire region. Spencer (2007:68) omits the fact
 that Workinger's (2002) survey around San Francisco de Arriba was part of a larger full-
 coverage regional survey of the lower Río Verde Valley. The regional survey in the lower
 Río Verde uses the same methods as full-coverage surveys in the Oaxacan Highlands,
 including a reliance on opportunistic samples (for example, Balkansky 2002:29; Blanton
 et al. 1982:7–8). Detailed topographic maps have been made for major Late/Terminal
 Formative sites like Río Viejo (250 ha total site area), San Francisco de Arriba (92 ha),
 and Cerro del Chivo (29 ha). Major horizontal and/or block excavations have been car-
 ried out at five Late/Terminal Formative sites, with test excavations at another eight sites
 from this period.

4 In a recent article, Spencer and his colleagues (2008:337–338) leave room for more var-
 ied forms of interaction between Monte Albán and surrounding regions, although they
 emphasize the model of territorial conquest.

REFERENCES CITED

Anderson, D. G.
 1994 Factional Competition and the Political Evolution of Mississippian Chiefdoms
 in the Southeastern United States. In *Factional Competition and Political Devel-
 opment in the New World*, edited by E. M. Brumfiel and J. W. Fox, pp. 61–76.
 Cambridge University Press, Cambridge.

Aoyama, K.
 2005 Classic Maya Warfare and Weapons: Spear, Dart, and Arrow Points of Agua-
 teca and Copan. *Ancient Mesoamerica* 16(2):291–304.

Balkansky, A. K.
 1998 Origin and Collapse of Complex Societies in Oaxaca (Mexico): Evaluating the
 Era from 1965 to the Present. *Journal of World Prehistory* 12(4):451–493.

 2001 On Emerging Patterns in Oaxaca Archaeology. *Current Anthropology* 42(4):
 559–561.

 2002 *The Sola Valley and the Monte Albán State: A Study of Zapotec Imperial Expan-
 sion.* Memoirs of the Museum of Anthropology No. 36, University of Michigan,
 Ann Arbor.

Barber, S.
 2005 Heterogeneity, Identity, and Complexity: Negotiating Status and Authority in
 Terminal Formative Coastal Oaxaca. Ph.D. dissertation, Department of
 Anthropology, University of Colorado at Boulder.

Barber, S. B., and A. A. Joyce
 2007 Polity Produced and Community Consumed: Negotiating Political Centraliza-
 tion in the Lower Rio Verde Valley, Oaxaca. In *Mesoamerican Ritual Economy*,

edited by E. C. Wells and K. L. Davis-Salazar, pp. 221–244. University of Colorado Press, Boulder.

Berdan, F. F., and P. R. Anawalt
1997 *The Essential Codex Mendoza*. University of California Press, Berkeley.

Blanton, R. E.
1978 *Monte Albán: Settlement Patterns at the Ancient Zapotec Capital*. Academic Press, New York.

Blanton, R. E., S. A. Kowalewski, G. Feinman, and J. Appel
1982 *Monte Albán's Hinterland*, Part 1: *Prehispanic Settlement Patterns of the Central and Southern Parts of the Valley of Oaxaca, Mexico*. Prehistory and Human Ecology of the Valley of Oaxaca, Vol. 7. Memoirs of the University of Michigan, No. 15, Museum of Anthropology, Ann Arbor.

Braswell, G. E. (editor)
2003 *The Maya and Teotihuacan: Reinterpreting Early Classic Interaction*. University of Texas Press, Austin.

Brockington, D.
1966 *The Archaeological Sequence from Sipolite, Oaxaca, Mexico*. Archives of Archaeology 28. Society for American Archaeology and University of Wisconsin Press, Madison.

Brown, M. K., and J. F. Garber
2003 Evidence of Conflict during the Middle Formative in the Maya Lowlands: A View from Blackman Eddy, Belize. In *Ancient Mesoamerican Warfare*, edited by M. K. Brown and T. M. Stanton, pp. 91–108. AltaMira Press, Walnut Creek, CA.

Brown, M. K., and T. M. Stanton (editors)
2003 *Ancient Mesoamerican Warfare*. AltaMira Press, Walnut Creek, CA.

Burgoa, Fray Francisco de
1989a [1674] *Geográfica descripción*. Vol. 1. Editorial Porrúa, Mexico, D.F.
1989b [1674] *Geográfica descripción*. Vol. 2. Editorial Porrúa, Mexico, D.F.

Caso, A.
1938 *Exploraciones en Oaxaca, quinta y sexta temporadas 1936–1937*. Instituto Panamericano de Geografía e Historia, Publicación 34. Mexico, D.F.
1947 Calendario y escritura de las antiguas culturas de Monte Albán. In *Obras Completas de Miguel Othón de Mendizábal*, Vol. I, pp. 15–143. Mexico, D.F.
1965 Zapotec Writing and Calendar. In *Handbook of Middle American Indians*, Vol. 3, edited by Gordon R. Willey, pp. 931–947. University of Texas Press, Austin.

Caso, A., I. Bernal, and J. R. Acosta
1967 *La cerámica de Monte Albán*. Memorias del Instituto Nacional de Antropología e Historia No. 13, Mexico, D.F.

Chase, D. Z., and A. F. Chase
2003 Texts and Contexts in Maya Warfare: A Brief Consideration of Epigraphy and Archaeology at Caracol, Belize. In *Ancient Mesoamerican Warfare*, edited by M. K. Brown and T. M. Stanton, pp. 171–188. AltaMira Press, Walnut Creek, CA.

Clark, J. E., R. D. Hansen, and T. Pérez Suárez
 2000 La zona Maya en el preclásico. In *Historia antigua de México*, Vol. 1: *El México antiguo, los orígenes y el horizonte preclásico*, edited by L. Manzanilla and L. López Luján, pp. 437–510. Instituto Nacional de Antropología e Historia, Mexico.

Coe, M. D.
 1999 *The Maya*. Thames and Hudson, New York.

Conrad, G. W. and A. A. Demarest
 1984 *Religion and Empire*. Cambridge University Press, Cambridge.

Cowgill, G. L.
 1997 State and Society at Teotihuacan, Mexico. *Annual Review of Anthropology* 26: 129–161.

Dahlgren, B.
 1990 *La Mixteca: Su cultura e historia prehispánicas*. Universidad Nacional Autónoma de México, Mexico, D.F.

DeCicco, G., and D. Brockington
 1956 *Reconocimiento arqueológico en el suroeste de Oaxaca*. Dirección de Monumentos Prehispánicos Informe No. 6. Instituto Nacional de Antropología e Historia, Mexico, D.F.

Demarest, A. A.
 1978 Interregional Conflict and "Situational Ethics" in Classic Maya Warfare. In *Codex Wauchope: Festschrift in Honor of Robert Wauchope*, edited by M. Giardino, B. Edmonson, and W. Creamer, pp. 101–111. Tulane University, New Orleans.

Fash, W. L.
 2004 Toward a Social History of the Copán Valley. In *The History of an Ancient Maya Kingdom*, edited by E. W. Andrews and W. L. Fash, pp. 99–101. SAR Press, Santa Fe.

Flannery, K. V., and Marcus, J.
 2003 The Origins of War: New [14]C dates from Ancient Mexico. *Proceedings of the National Academy of Sciences* 100(20):11801–11805.

Freidel, D.
 1986 Maya Warfare: An Example of Peer-Polity Interaction. In *Peer-Polity Interaction and Sociopolitical Change*, edited by C. Renfrew and J. Cherry, pp. 93–108. Cambridge University Press, Cambridge.

Freidel, D., and L. Schele
 1989 Dead Kings and Living Mountains: Dedication and Termination Rituals of the Lowland Maya. In *Word and Image in Maya Culture*, edited by W. F. Hanks and D. S. Rice, pp. 233–243. University of Utah Press, Salt Lake City.

Freidel, D., L. Schele, and J. Parker
 1993 *Maya Cosmos: Three Thousand Years on the Shaman's Path*. William Morrow, New York

García Moll, R., D. W. Patterson Brown, and M. C. Winter
 1986 *Monumentos escultóricos de Monte Albán*. Verlag C. H. Beck, Munich.

Hassig, R.

1988 *Aztec Warfare: Imperial Expansion and Political Control.* University of Oklahoma Press, Norman.

1992 *War and Society in Ancient Mesoamerica.* University of California Press, Berkeley.

Hodge, M. G.

1996 Political Organization of the Central Provinces. In *Aztec Imperial Strategies,* edited by F. F. Berdan, R. E. Blanton, E. H. Boone, M. G. Hodge, M. E. Smith, and E. Umberger, pp. 17–46. Dumbarton Oaks, Washington, D.C.

Hunt, E.

1972 Irrigation and Socio-Political Organization of Cuicatec Cacicazgos. In *The Prehistory of the Tehuacan Valley*, Vol. 4: *Chronology and Irrigation*, edited by Frederick Johnson, pp. 162–259. University of Texas Press, Austin.

Joyce, A. A.

1991 *Formative Period Occupation in the Lower Río Verde Valley, Oaxaca, Mexico: Interregional Interaction and Social Change.* Ph.D. dissertation, Department of Anthropology, Rutgers University. University Microfilms, Ann Arbor.

1993 Interregional Interaction and Social Development on the Oaxaca Coast. *Ancient Mesoamerica* 4(1):67-84.

1994 Late Formative Community Organization and Social Complexity on the Oaxaca Coast. *Journal of Field Archaeology* 21(2):147–168.

2000 The Founding of Monte Albán: Sacred Propositions and Social Practices. In *Agency in Archaeology*, edited by M. Dobres and J. Robb, pp. 71–91. Routledge, London.

2003 Imperialism in Pre-Aztec Mesoamerica: Monte Albán, Teotihuacan, and the Lower Río Verde Valley. In *Ancient Mesoamerican Warfare*, edited by M. K. Brown and T. M. Stanton, pp. 49–72. AltaMira Press, Walnut Creek, CA.

2005 La arqueología del bajo Río Verde. *Acervos: Boletín de los Archivos y Bibliotecas de Oaxaca* 7(29):16–36.

2008 Los origenes de sacrificio humano en Mesoamérica Formativo. In *Ideología política y sociedad en al Período Formative: Ensayos en homenaje al doctor David C. Grove*, edited by A. Cyphers and K. G. Hirth. Universidad Nacional Autónoma de Mexico, Mexico City.

Joyce, A. A. (editor)

1999 El Proyecto Patrones de Asentamiento del Río Verde. Technical report submitted to the Consejo de Arqueología, Instituto Nacional de Antropología e Historia, Mexico.

Joyce, A. A., and M. Winter

1996 Ideology, Power, and Urban Society in Pre-Hispanic Oaxaca. *Current Anthropology* 37:33–47.

Joyce, A. A., M. Winter, and R. G. Mueller

1998 *Arqueología de la costa de Oaxaca: Asentamientos del período formativo en el valle del Río Verde inferior.* Estudios de Antropología e Historia No. 40. Centro INAH Oaxaca. Oaxaca, Mexico.

Joyce, A. A., R. N. Zeitlin, J. F. Zeitlin, and J. Urcid
 2000 On Oaxaca Coast Archaeology: Setting the Record Straight. *Current Anthropology* 41(4):623–625.
Joyce A. A., H. Neff, M. S. Thieme, M. Winter, J. M. Elam, and A. Workinger
 2006 Ceramic Production and Exchange in Late/Terminal Formative Period Oaxaca. *Latin American Antiquity* 17(4):579–594.
Kowalewski, S.A.
 1983 Valley-Floor Settlement Patterns during Monte Albán I. In *The Cloud People*, edited by K. V. Flannery and J. Marcus, pp. 96–97. Academic Press, New York.
Levine, M. N.
 2002 Ceramic Change and Continuity in the Lower Río Verde Region of Oaxaca Mexico: The Late Formative to Early Terminal Formative Transition. Unpublished M.A. thesis, University of Colorado, Boulder.
 2007 *Linking Household and Polity at Late Postclassic Period Yucu Dzaa (Tututepec), A Mixtec Capital on the Coast of Oaxaca, Mexico.* Ph.D. dissertation, Department of Anthropology, University of Colorado at Boulder. University Microfilms, Ann Arbor.
Lounsbury, F. G.
 1982 Astronomical Knowledge and Its Uses at Bonampak, Mexico. In *Archaeoastronomy in the New World*, edited by A. Aveni, pp. 143–168. Cambridge University Press, Cambridge.
Marcus, J.
 1976 The Iconography of Militarism at Monte Albán and Neighboring Sites in the Valley of Oaxaca. In *Origins of Religious Art and Iconography in Preclassic Mesoamerica*, edited by H. Nicholson, pp. 125–139. UCLA Latin American Studies Center, Los Angeles.
 1980 Zapotec Writing. *Scientific American* 242:50–64.
 1983 The Conquest Slabs of Building J, Monte Albán. In *The Cloud People*, edited by K. Flannery and J. Marcus, pp. 106–108. Academic Press, New York.
 1984 Mesoamerican Territorial Boundaries: Reconstructions from Archaeology and Hieroglyphic Writing. *Archaeological Review from Cambridge* 3:48–62.
 1992a *Mesoamerican Writing Systems*. Princeton University Press, Princeton.
 1992b Political Fluctuations in Mesoamerica. *National Geographic Research and Exploration* 8:392–411.
Marcus, J., and K. V. Flannery
 1996 *Zapotec Civilization*. Thames and Hudson, London.
Markman, C. W.
 1981 *Prehispanic Settlement Dynamics from Central Oaxaca, Mexico: A View from the Miahuatlán Valley*. University Publications in Anthropology No. 26. Nashville.
Martin, S., and N.Grube
 2000 *Chronicle of the Maya Kings and Queens*. Thames and Hudson, London.
Oudijk, M., and M. Jansen
 2000 Changing History in the Lienzos de Guevea and Santo Domingo Petapa. *Ethnohistory* 47(2):281–331.

Orr, H. S.

1997 *Power Games in the Late Formative Valley of Oaxaca: The Ballplayer Sculptures at Dainzú*. Ph.D. dissertation, Department of Art and Art History, University of Texas. University Microfilms, Ann Arbor.

2003 Stone Balls and Masked Men: Ballgame as Combat Ritual, Dainzú, Oaxaca. *Ancient America* 5:73–104.

Paddock, J.

1983 Comments on the Lienzos of Huilotepec and Guevea. In *The Cloud People*, edited by K. Flannery and J. Marcus, pp. 308–313. Academic Press, New York.

Pareyón, E.

1960 Exploraciones arqueológicas en la Ciudad Vieja de Quiotepec, Oaxaca. *Revista Mexicana de Estudios Antropológicos* 16:97–104.

Pohl, M. E. D., and J. M. D. Pohl

1994 Cycles of Conflict: Political Factionalism in the Maya Lowlands. In *Factional Competition and Political Development in the New World*, edited by E. M. Brumfiel and J. W. Fox, pp. 138–157. Cambridge University Press, Cambridge.

Redmond, E. M.

1983 *A Fuego y Sangre: Early Zapotec Imperialism in the Cuicatlán Cañada, Oaxaca*. Memoirs of the Museum of Anthropology No. 16, University of Michigan, Ann Arbor.

Redmond, E. M., and C. S. Spencer

2006 From Raiding to Conquest: Warfare Strategies and Early State Development in Oaxaca, Mexico. In *The Archaeology of Warfare: Prehistories of Raiding and Conquest*, edited by E. N. Arkush and M. W. Allen, pp. 336–393. University Press of Florida, Gainesville.

Santley, R. S.

1989 Obsidian Working, Long-Distance Exchange, and the Teotihuacan Presence on the Southern Gulf Coast. In *Mesoamerica after the Decline of Teotihuacan*, edited by R. A. Diehl and J.C. Berlo, pp. 131–151. Dumbarton Oaks Research Library and Collection, Washington, D.C.

Schele, L., and D. Freidel

1990 *A Forest of Kings: The Untold Story of the Ancient Maya*. William Morrow, New York.

Schreiber, K. J.

1992 *Wari Imperialism in Middle Horizon Peru*. Anthropological Paper No. 87, Museum of Anthropology, University of Michigan, Ann Arbor.

Scott, J. F.

1978a *The Danzantes of Monte Albán*. Part I: *Text*. Dumbarton Oaks, Studies in Pre-Columbian Art and Archaeology No. 19, Washington, D.C.

1978b *The Danzantes of Monte Albán*. Part II: *Catalogue*. Dumbarton Oaks, Studies in Pre-Columbian Art & Archaeology No. 19. Washington, D.C.

Sharer, R. J.

1994 *The Ancient Maya*. Fifth edition. Stanford University Press, Stanford.

Sheets, P. D.

 2003 Warfare in Ancient Mesoamerica: A Summary View. In *Ancient Mesoamerican Warfare*, edited by M. K. Brown and T. M. Stanton, pp. 287–302. AltaMira Press, Walnut Creek, CA.

Smith, Mary E.

 1973 *Picture Writing from Ancient Southern Mexico: Mixtec Place Signs and Maps.* University of Oklahoma Press, Norman.

Smith, Michael E.

 1996 The Strategic Provinces. In *Aztec Imperial Strategies*, edited by F. F. Berdan, R.E. Blanton, E. H. Boone, M. G. Hodge, M. E. Smith, and E. Umberger, pp. 137–150. Dumbarton Oaks, Washington, D.C.

 2003 *The Aztecs.* Second edition. Blackwell, Oxford.

Smith, Michael E., and L. Montiel

 2001 The Archaeological Study of Empires and Imperialism in Pre-Hispanic Central Mexico. *Journal of Anthropological Archaeology* 20(3):245–284.

Spencer, C. S.

 1982 *The Cuicatlán Cañada and Monte Albán.* Academic Press, New York.

 2003 War and Early State Formation in Oaxaca, Mexico. *Proceedings of the National Academy of Sciences* 100(20):11185–11187.

 2007 Territorial Expansion and Primary State Formation in Oaxaca, Mexico. In *Latin American Indigenous Warfare and Ritual Violence*, edited by R. J. Chacon and R. G. Mendoza, pp. 55–72. University of Arizona Press, Tucson.

Spencer, C. S., and E. M. Redmond

 1982 Appendix: Ceramic Chronology for the Cuicatlán Cañada. In *The Cuicatlán Cañada and Monte Albán*, by C. S. Spencer, pp. 261–307. Academic Press, New York.

 1997 *Archaeology of the Cañada de Cuicatlán, Oaxaca.* Anthropological Papers No. 80. American Museum of Natural History, New York.

 2001 Multilevel Selection and Political Evolution in the Valley of Oaxaca, 500–100 B.C. *Journal of Anthropological Archaeology* 20:195–229.

Spencer, C. S., E. M. Redmond, and C. M. Elson

 2008 Ceramic Microtypology and the Territorial Expansion of the Early Monte Albán State in Oaxaca, Mexico. *Journal of Field Archaeology* 33(3):321–341.

Spores, R.

 2005 El Pueblo Viejo de Teposcolula Yucundaa. A Report and Discussion of the Results of the First Two Seasons of Archaeological Investigations of the City. Paper presented at Royal Netherlands Academy of Arts and Sciences Colloquium "Mixtec Writing: Historical Development and Social Context." Amsterdam, The Netherlands.

Stark, B. L.

 1990 The Gulf Coast and the Central Highlands of Mexico: Alternative Models for Interaction. *Research in Economic Anthropology* 12:243–285.

Stein, G.

 1999 *Rethinking World Systems: Diasporas, Colonies, and Interaction in Uruk Mesopotamia.* University of Arizona Press, Tucson.

Stuart, D.

 2000 "The Arrival of Strangers": Teotihuacan and Tollan in Classic Maya History. In *Mesoamerica's Classic Heritage: From Teotihuacan to the Aztecs,* edited by D. Carrasco, L. Jones, and S. Sessions, pp. 465–524. University Press of Colorado, Niwot.

Urcid, J.

 1992 *Zapotec Hieroglyphic Writing.* Ph.D. dissertation, Department of Anthropology, Yale University. University Microfilms, Ann Arbor.

 1994 Building J and the Early Political Geography of Monte Albán. Paper presented at the 59th Annual Meeting of the Society for American Archaeology, Anaheim, California.

 2008 The Writing Surface as a Cultural Code: A Comparative Perspective of Scribal Traditions from Southwestern Mesoamerica. Paper presented at the Symposium *Scripts and Notational Systems in Pre-Columbian America,* Dumbarton Oaks, Washington, D.C.

Urcid, J., and M. Winter

 2003 Nuevas variantes glíficas zapotecas. *Mexicon* 25:123–128.

Vencl, S.

 1984 War and Warfare in Archaeology. *Journal of Anthropological Archaeology* 3: 116–132.

Walker, D. S.

 1998 Smashed Pots ad Shattered Dreams. In *The Sowing and the Dawning,* edited by S. B. Mock, pp. 81–99. University of New Mexico Press, Albuquerque.

Webster, D. L.

 1975 Warfare and the Origin of the State. *American Antiquity* 40:464–471.

 1977 Warfare and the Evolution of Maya Civilization. In *Origins of Maya Civilization,* edited by R. E. W. Adams, pp. 335–373. University of New Mexico Press, Albuquerque.

 1993 The Study of Maya Warfare: What It Tells Us about the Maya and about Maya Archaeology. In *Lowland Maya Civilization in the Eighth Century A.D.,* edited by J. Sabloff and J. Henderson, pp. 415–444. Dumbarton Oaks, Washington, D.C.

 1998 Warfare and Status Rivalry: Lowland Maya and Polynesian Comparisons. In *Archaic States,* edited by G. M. Feinman and J. Marcus, pp. 464–470. School of American Research Press, Santa Fe.

 1999 Ancient Maya Warfare. In *War and Society in the Ancient and Medieval Worlds,* edited by K. Raaflaub and N. Rosenstein, pp. 333–360. Center for Hellenic Studies, Washington, D.C.

2000 The Not So Peaceful Civilization: A Review of Maya War. *Journal of World Prehistory* 14:65–119.

Webster, D., J. Silverstein, T. Murtha, H. Martinez, and K. Straight

2004 *The Tikal Earthworks Revisited*. Occasional Paper in Anthropology No. 28. Department of Anthropology, Pennsylvania State University, University Park.

Workinger, A.

2002 *Coastal/Highland Interaction in Prehispanic Oaxaca, Mexico: The Perspective from San Francisco de Arriba*. Ph.D. dissertation, Department of Anthropology, Vanderbilt University. University Microfilms, Ann Arbor.

2004 Review of *The Sola Valley and the Monte Albán State* by Andrew Balkansky. *Latin American Antiquity* 15:241–243.

Zeitlin, R. N., and A. A. Joyce

1999 The Zapotec Imperialism Argument: Insights from the Oaxaca Coast. *Current Anthropology* 40(3):383–392.

CHAPTER 2

WARRIOR QUEENS
AMONG THE CLASSIC MAYA

Kathryn Reese-Taylor, Peter Mathews,
Julia Guernsey, and Marlene Fritzler

The importance of women in Maya society is no longer in question. Recent studies have highlighted the important roles played by women, particularly those in the royal courts (Ardren 2002; Joyce 2000). Not only were alliances between kingdoms solidified by marriage to royal women, but royal women occasionally ruled kingdoms in their own right (Bell 2002; Josserand 2002; Schele and Mathews 1991). Furthermore, queens were often ambassadors for their respective kingdoms (Freidel and Guenter 2003; Schele and Mathews 1991).

A case in point is recounted in the hieroglyphic inscriptions from a panel attributed to the site of Sak Nikte' (La Corona), which record the arrival of three royal women from the Kaan kingdom to this small center, the first in 520, the second in 679, and the final in 721.[1] The earliest queen and the final queen to arrive at Sak Nikte' are portrayed in the imagery on the relief carving (Freidel and Guenter 2003; Martin 2008) (Figure 2.1). Ix ? Naah Ek',[2] the first Kaan queen and wife of Tuun K'ab' Hiix, stands in a battle palanquin formed by a large standing jaguar.[3] Ix Ti',[4] the wife of an unknown Sak Nikte' ruler and the daughter of Yuknoom Took K'awiil, stands in a palanquin crowned by a watery serpent. The panel, commissioned to commemorate the arrival of Ix Ti', uses the earlier arrivals to contextualize this important royal visit. Texts describing all of the women refer to their husbands and include parallel parentage statements identifying both their fathers and mothers, royal couples from the Kaan polity (Martin 2008)

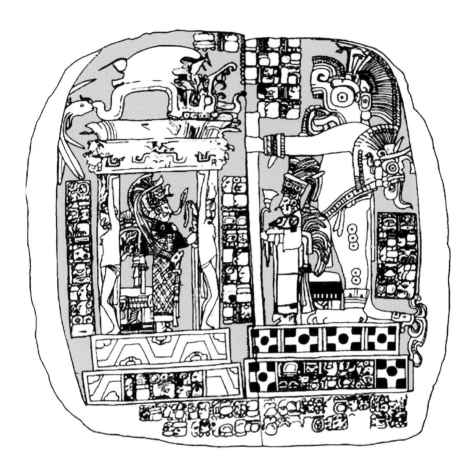

FIGURE 2.1. La Corona panel. (*Drawing by Linda Schele.*)

Interestingly, this retrospective account of the arrival of Ix Naah Ek' in 520 to Sak Nikte' in a battle palanquin is the earliest recorded event linking a royal woman with warfare. Moreover, when royal women are depicted in association with war, historically archaeologists and art historians have interpreted their role as one of support rather than direct participation. Lintel 26 from Yaxchilan, for example, portrays Ix K'ab'al Xook assisting her husband, Itzamnaaj Bahlam II, in his ritual preparations for war (Tate 1999).

Recently, however, exceptions to this supporting role have been identified in the iconographic and epigraphic corpus of the Late Classic Period (600–800). Inscriptions reveal that women, like men, can carry the *kaloomte'* title, perhaps the most high-ranking title in Maya politics, connoting an elevated degree of authority and responsibility. To illustrate, in the inscriptions on Stela 34 from Waka' (El

Peru), the queen, Ix K'ab'el, is named as an *ix kaloomte'*. As the sister of Yuknoom Yich'aak K'ahk', the king of Kaan, Ix K'ab'el's marriage to Kinich Bahlam of Waka' solidified the alliance between these two kingdoms in the late seventh century.

In addition, a sizable group of stelae from Calakmul, Coba, Naachtun, and Naranjo (Figure 2.2) actually portray queens standing atop named captives. These stelae, along with other iconographic and epigraphic evidence, support the proposition that Maya queens not only ruled independently at times, but also

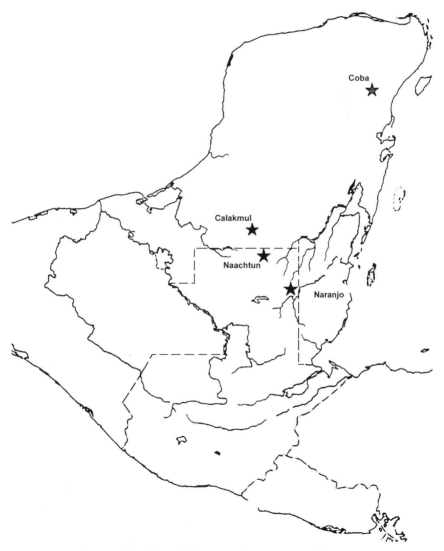

FIGURE 2.2. Map of Maya area showing sites with stelae.

took an active role in the organized violence within Maya society. We argue that these formidable women served as warrior queens, taking leadership roles in military engagements.

What remains unclear from the pictorial and epigraphic corpus, however, is whether rulers who were portrayed as warriors engaged directly in battle. Unfortunately, we have little evidence for direct participation of rulers in battle. The capture of a king, which would provide support for active military engagement by royals, is recorded in few contexts. One such example is Tonina Monument 122, which depicts K'inich K'an Joy Chitam II of Palenque as a captive of a battle in which, we presume, he personally participated (Graham and Mathews 1999:153). Yet, despite the lack of explicit evidence for firsthand combat, there is little doubt that when kings were presented as warriors, they were to be perceived as taking part in war, if not directly on the battlefield, at least as symbolic military commanders. We argue that queens depicted as warriors also were to be perceived as actively engaged in warfare in the same manner as their male counterparts.

Donning the Beaded Net Skirt

Since Proskouriakoff's (1961) pioneering study of women in Maya art, the identification of gender roles in Maya iconography has been fraught with difficulties. The identification of the gender and the role of individuals who donned the beaded net skirt in ceremonial contexts has been particularly vexing because of the transgendered character of the costume, precluding an exclusive association with one only one sex.

Among deities, the beaded net skirt was associated with both the Maize God and the Moon Goddess (Looper 2002:174; Schele and Mathews 1998:348; Stone 1988, 1990, 1991). Joyce (1992:65, 1996) and Quenon and LeFort (1997) suggest that the diamond pattern of the netting symbolizes the turtle carapace out of which the Maize God was resurrected. Quenon and LeFort (1997) also propose that the *xok* fish belt worn over the jade net skirt referred to the watery underworld location of the rebirth of the Maize God prior to his resurrection. However, several scholars argue that other accoutrements, including the *Spondylus* shell dangling from the xok fish belt, were affiliated with women (Miller 1974:154; Taube 1985) or with female deities, specifically the Moon Goddess (Taylor 1992:522).

Royal men and women also donned the beaded net skirt to impersonate the Maize God and the Moon Goddess during ceremonial performances. Kings embodying the Maize God wore a short net skirt that accentuated the male physique (Looper 2002:178). For example, the adult Kan Bahlam is portrayed on

the carvings from the Temple of Foliated Cross wearing a short, tight, jade net skirt. Waxaklajuun Ubaah K'awiil is also depicted in a tight jade net skirt on Copán Stela H, although his skirt is considerably longer than that depicted on Kan Bahlam, which is possibly a regional variation in style.

While the beaded net skirt depicted on men emphasized the male form, the net skirt depicted on women served to camouflage the female figure. It generally fell below the knees, was looser, and covered more of the body (cf. Joyce 2001:116). According to Looper (2002:180), among others, queens who donned the net skirt were performing as the Moon Goddess. For example, on Palenque Temple 14, the mother of Kan Bahlam was rendered wearing a jade net skirt that falls well below her knees (Figure 2.3). Her portrait head and the lunar sign on the accompanying text suggest that she is attired as the Moon Goddess (Schele and Miller 1986: fig. VII.2). In this scene, she is offering an effigy of the deity K'awiil to her son in what is likely an heir-designation ceremony (Bassie-Sweet 1991). Naranjo Stela 24 also portrays Ix Wak Chan Ajaw in a long and loosely fitting jade net skirt and standing atop a captive. Moreover, the accompanying text specifies that she is impersonating the Moon Goddess (Graham and von Euw 1975:63; Grube and Martin 2004:2–46; Stuart et al. 1999:55).

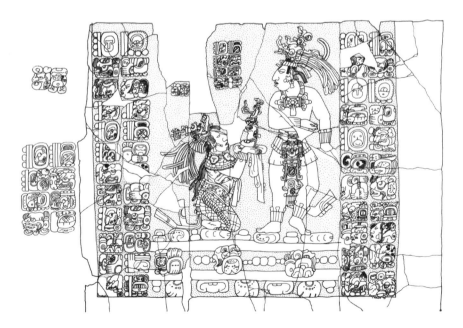

FIGURE 2.3. Fresco from Temple 14, Palenque. (*Drawing by Linda Schele.*)

The corpus of stelae that constitutes our sample likewise depicts royal women wearing the beaded net skirt. In most cases, the identification of the primary individual within the composition as a queen is based on hieroglyphic texts naming women as the protagonist in the imagery. This, however, is not always a secure manner in which to identify the main subject within Maya art. In some instances, Maya scribes have recorded events in the lives of individuals who are not portrayed on the stela. Therefore, we use specific elements in the costume as secondary support for the identification of the gender of the main figure.

This secondary line of evidence was particularly useful in the examination of two stelae from Coba, as all of the texts were unclear. In these specific cases, we depended entirely on the iconographic elements to identify the gender of the individual carved. Generally, women were depicted in longer net skirts than those of their male counterparts, with the exception of several stelae from Coba, where both men's and women's net skirts fell below the knees. However, in all instances, women's net skirts were always fuller below the knees than those of men.

DESCRIPTION OF CORPUS

Coba

Four major public zones characterize the site of Coba, Quintana Roo, Mexico. One of these, the Macanxoc group, is located southeast of the main plaza and contains four stelae that portray royal women positioned above vanquished enemies: In chronological order, they are Stelae 4, 2, 5, and 1.[5] Stela 29 is situated in the centrally located Las Pinturas group (Figure 2.4). However, these locations may represent secondary contexts for the

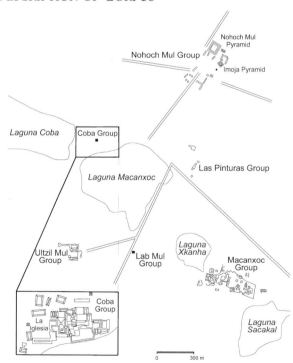

FIGURE 2.4. Map of Coba.

stelae. According to Thompson (1932:132), all Coba stelae were reset in small shrines covered by thatch roofs during the Postclassic Period. Despite the fact that their primary context is unclear, all five stelae were located in prominent positions by the end of the site's occupation.

Stela 4

The front panel of Stela 4 records the date of 9.9.10.0.0, 2 Ajaw 13 Pop (March 19, 623), the earliest recorded example of a queen standing on a captive. Stela 6, located near Stela 4, depicts a male ruler and shares this same period-ending date. In all probability, Stelae 4 and 6 comprise a pair depicting Coba's ruling couple in 623. Stela 4 is also the tallest carved stela found at the site, with an approximate height of 2.1 m (Figure 2.5).

Erected in a prominent location within the ceremonial plaza, Thompson (1932:146) documents finding Stela 4 "inside a small shrine-like structure with corbelled roof, at the base of the stairway" leading to Structure A-1. Stela 4 was placed directly in front of Altar A10, a small square monument approximately 50 cm in width and about 30 cm in height (Thompson 1932:175). Excavation around the base of the monument revealed a number of shells that, according to Thompson, formed a dedicatory cache. However, noting the cache's lack of jade and other precious materials, Thompson suggested that the stela was moved from its original location and re-erected inside Structure A-1 (Thompson et al. 1932:149).

Stela 4 is characterized by pitting and flaking on its rather poor-quality limestone surface. However, in spite of

FIGURE 2.5. Coba Stela 4.
(*From Graham and von Euw 1997:31.*)

weathering and erosion, the imagery, carved in low relief, persists with remarkable distinction and legibility.

The main figure on Stela 4 wears a long, full skirt that falls below her knees. She holds a double-headed serpent bar and stands in the same pose as her male counterpart on Stela 6. One named captive kneels near her right foot, and she stands on two others. Each of the captives is bound and wears only a loincloth and a simple headband.

Although the names of the captives are difficult to identify because of erosion damage to the texts, the captive on the viewer's right appears to have a calendar name, while the captive to the viewer's left may also have a calendar name at S1b. Additionally, two emblem glyphs are discernible at S2b and T2a in the inscriptions directly above the captives on which the queen is standing. This suggests that each of these individuals was a high-ranking noble in their respective kingdoms.

Stela 2

Stela 2 dates to 9.10.10.0.0, 13 Ajaw 18 K'ank'in (December 4, 642) (Figure 2.6). Although this initial series date is reasonably secure, virtually no other details of the lengthy Stela 2 text survive (Proskouriakoff 1950:187; Thompson et al. 1932:144). Stela 2 is carved on only the front surface, like Stela 4.

Stela 2 was placed in the middle of the second tread of Structure A-7, a small temple. Moreover, Stela 2 was erected in isolation and not as part of stelae pair, suggesting that this woman may have ruled in her own right.

The queen on Stela 2 holds a double-headed serpent bar and wears a long skirt and huipil, with the connecting bead motif falling within the confines of her skirt. She stands atop a bound and

Figure 2.6. Coba Stela 2.
(*From Graham and von Euw 1997.*)

prostrate captive, who is dressed in a loincloth, sandals, and a headdress. Three glyph blocks were placed directly above his head (C18–C20) and his feet (H1–H5), likely containing his name and indicating that he held a high rank in his kingdom.

Another captive kneels directly to the queen's right, directly in front of the captive lying under her feet. He too is wearing a loincloth and headdress and is bound. Glyph blocks were placed behind him (A19–A22) and possibly give his name and titles.

Stela 29

Stela 29 is a badly broken monument carved on both the front and the back (Figure 2.7). Enough survives on the front of Stela 29 to identify a female ruler standing over two seated captives. The text on the back includes the female prefix IX in glyph blocks B5 and D7. Mathews suggests that the name of the woman is possibly Ix Ch'en Nal (D7), and that this is the name of the woman portrayed on the front of the monument.[6] The stela currently stands on a platform at the base of Temple D-33, a central location within the Las Pinturas group. The stela is not part of a stelae pair, indicative of independent rule by this queen.

Too little survives to enable a secure reconstruction of the dates of Stela 29. There is a clear 7 Ajaw at Bp7, and it is quite likely that this is a reference to a period-ending date. The Distance Number recorded at Dp1(?)–Cp2a records 13 tuns plus an unknown number of winals and kins "since the accession." This DN leads forward to a date of which only the month survives, 18 Kej. It is possible that this also is a reference to a period-ending date, of which 9.10.18.0.0, 7 Ajaw

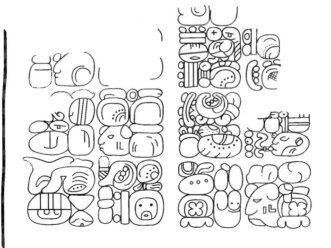

Figure 2.7. Coba Stela 29. (*After Graham.*)

18 Kej (October 22, 650) is the most likely candidate. If this date is correct, then it would place the accession on 9.10.4.x.x.

Interestingly, the dedication dates of Stela 2 (9.10.10.0.0.) and Stela 29 (9.10.18.0.0?) fall within an eight-year range, and both stelae portray queens without consorts. Quite possibly, a single queen, Ix Ch'en Nal, acceded to the throne on 9.10.4.x.x and then celebrated two period-endings on 9.10.10.0.0 and 9.10.18.0.0 during her autonomous reign over Coba.

Stela 5

Coba's Stela 5, dated to 9.11.10.0.0, 11 Ajaw 18 Ch'een (August 20, 662), demonstrates a slight deviation in carving program (Figure 2.8). Here, the artist represented both male and female figures on the same monument, with the queen portrayed on the back. On the viewer's left, one captive is depicted kneeling at her feet; another is possibly pictured on the right; however, this is difficult to discern because of damage in this section. And while the name of the queen on Stela 5 is not recognizable in the eroded inscriptions, five additional dates are

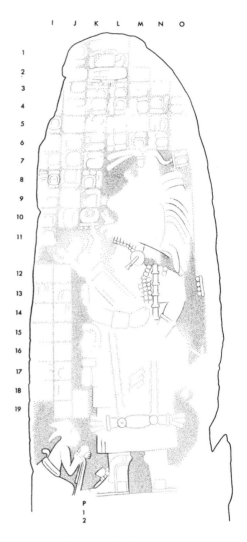

FIGURE 2.8. Coba Stela 5.
(*From Graham and von Euw 1997:34.*)

recorded. Of these, the most notable is the date 13.0.0.0.0, 4 Ajaw 8 Kumk'u (September 9, 3114 B.C.), which appears on the right side. This significant mythical date is also recorded on the back of Stela 1.

Significantly, this stela illustrates the complementary nature of rulership. Joyce (1992) has argued that the complementary gender pair is the basic unit of Maya society. Bassie-Sweet (2000) has documented sexual complementarity found among Classic Maya deities, while Joyce has observed the use of comple-

mentary gender roles in the organization of labor during the Classic, colonial, and contemporary periods, as well as the deployment of both male and female symbolism in the construction of political power. Remarkably, Coba Stela 5, with the king on one side and the queen on the other, each wearing the same transgendered beaded net skirt, exemplifies within a single monument the binary essence of royal authority.

Stela 1

Although several dates are recorded on the front and back panels of Stela 1, the dedication of the monument dates to 9.12.10.5.12, 4 Eb' 10 Yax (August 27, 682), and it is the final stela depicting a queen standing on captives erected at Coba (Figure 2.9). The principal subject of Stela 1 is a woman we have dubbed Ix K'awiil Ek'.[7] Her name is noted several times within the associated text. On the front of Stela 1, a possible kaloomte' title is located at G20, followed at H20 by a female prefix, **IX**, and the sign for **K'AWIIL**, surmounted by two eroded dots, possible signifying **AJAW**.[8] The glyph block located at H21 contains three dots above the main sign and three dots below the main sign. The main sign is a jaguar head with three dots above it and a **MA** suffix. One possible reading of this glyph block could be *Ox Ek'*. The glyph block at H22 is considerably weathered and may be a possible emblem glyph.[9]

The final two glyphs on the right side, W21–W22, contain a head prefix with two signs affixed to the top, followed by a **K'AWIIL** and an **EK'**. Her name

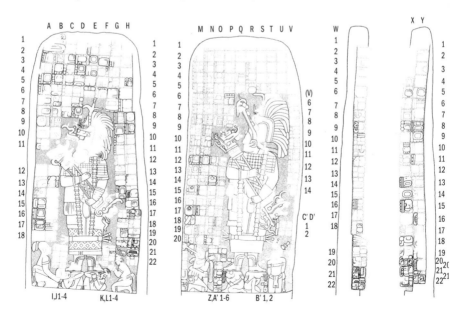

Figure 2.9. Coba Stela 1. (*From Graham and von Euw 1997.*)

also appears in glyphs C8–D8 on the front and O20 and V6–V7 on the back. Unfortunately, a number of inscriptions have been weathered beyond recognition.

The image of Ix K'awiil Ek', however, is in a much better state of preservation. She appears on both front and back panels—a unique occurrence for a queen. She holds an elaborate ceremonial bar across her chest on both sides and stands atop two diminutive, bound captives. Indeed, Ix K'awiil Ek' is never portrayed with a male counterpart, husband or son, suggesting that she ruled in her own right.

Interestingly, Stela 1 most closely resembles the iconographic program carved on Stela 5, twenty years earlier. However, in this case, the sexual complementarity of political power is not expressed by a royal couple, but inherent within a solitary female ruler—the queen.

Kneeling beside and stooped below the dominant principal figure of Ix K'awiil Ek' are smaller-scale bound captives. These captives literally act as buttresses for the rulership of Ix K'awiil Ek'. Two captives on either side support the crushing weight of the ruler on their heads, necks, and shoulders. All the captives are minimally dressed in loincloths and have bound wrists and banded or free-falling coiffures.

The back of Stela 1 presents one exception. The royal individual kneeling to the ruler's right wears a cape, a belt with varied objects hanging from it, and a headdress. The head of the kneeling figure on the opposite side also seems to carry a headdress. Both of these male figures are rendered in a somewhat larger scale than the two that function as pedestals. This artistic device, incorporating a triangular hierarchical arrangement of figures, indicates that these two captives may hold a higher social rank.

In sum, the five stelae from Coba were dedicated between 623 and 682 by, in all likelihood, four queens. Of the five, two (Stelae 4 and 5) are portrayed with their male counterparts, while Stelae 2, 29, and 1 are single monuments commemorating the reign of two queens. Stela 29 and, likely, Stela 2 portray Ix Ch'en Nal as the ruler who celebrated the two period-endings, while Stela 1 represents Ix K'awiil Ek' as a remarkable warrior queen.

Calakmul

At Calakmul, located in southern Campeche, Mexico, there are numerous carved stelae. To date, excavation efforts have exposed more than 117 monuments, 106 of them carved. Of these, Stelae 28, 23, and 9 depict royal women standing on hapless warriors.[10] Moreover, all three stood in highly visible locations within Calakmul's central plaza (Figure 2.10).

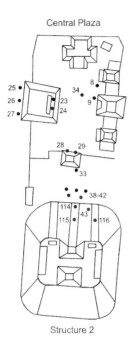

Central Plaza

Structure 2

Figure 2.10. Map of Calakmul.
(*After Martin and Grube 2000:100.*)

Figure 2.11. Calakmul Stela 28. (*From Ruppert and Denison 1943: pl. 49.*)

Stela 28

Stela 28 is a monument containing noteworthy features and decipherable text (Figure 2.11). Marcus (1987:150) reports it to be the earliest of Calakmul monuments to depict women and, with its partner, Stela 29, bears the third oldest date at the site. Interestingly, the dedication of both stelae occurs on exactly the same period-ending date as that from Coba's Stela 4: 9.9.10.0.0 (March 19, 623).

The stelae are situated immediately in front of the north side of Structure V, clearly associating them with the temple complex. Set next to each other, Stela 28 stands at 2.95 m and 1.12 m wide, with a depth of 33 cm; Stela 29 is of comparable size.

Text on Stelae 28 and 29 takes the form of L-shaped configurations that contain the names of each protagonist. A king occupies Stela 29 and the queen dominates Stela 28. Glyphs frame the faces of both figures and touch elements of their headdresses. The female name phrase is easily identified on Stela 28, with the presence of an **IX** glyph. Additional glyphs, now illegible, occupied the left side of Stela 28 as well as the sides of the monument, while the back is plain.

At the opposite end of the stela, a captive's feet, back, and head support the narrow platform on which his conqueror rests. The figure's smaller-scale, troll-like,

twisted body fills the confining space of the lower register. He appears totally naked, although the drawn outline indicates some type of head covering or headdress. While there is no clear visual sign of bound ankles or wrists, Stela 29, the partner stela rendered in the same style, depicts captives with wrappings around the wrist in the same position.

Stela 9

Stela 9 from Calakmul was dedicated on 9.12.0.0.0, 10 Ajaw 8 Yaxk'in (June 29, 672) during the reign of Yuknoom Ch'een II and is the only stela at the site carved from slate. It stood in front of Temple IV in the central plaza on the north end of a linear arrangement. The stela measures 3 m in height, 50 cm in width, and only 15 cm in depth (Ruppert and Denison 1943:101).

According to Martin (2000; Martin and Grube (2000:109), this stela is one of the pieces of evidence that points to a joint reign between Yuknoom Ch'een II and his son during the elder's later years, as it is the portrait of Yuknoom Yich'aak K'ahk' that graces the front face of Stela 9.[11] An unidentified queen, presumably either the mother or the wife of Yuknoom Yich'aak K'ahk', is depicted on the back. The queen wears the traditional beaded net skirt with xok fish belt. A dangling *Spondylus* shell, a nibbling fish, and part of a flattened fish head are affixed to the belt (Fritzler 2005:70; Marcus 1987:157). Although the queen's name remains unclear, it is recorded in two prominent places within the inscriptions: in the text above her portrait and in the horizontal band of inscriptions placed near the hem of her skirt (Marcus 1987:140).

The lower register on the back panel records an indecipherable calendar round date (Marcus 1987:158; Ruppert and Denison 1943:102), followed by the verb **CHUK**, "he/she was captured." The phrase continues with what appears to be the female head prefix, **IX**, followed by a proper name (Figure 2.12). However, while Marcus (1987:159) interprets the name phrase as referring to the standing queen, Mathews argues that the gram-matical order denotes the name of the captive, not the queen. Indeed, the glyph block containing the name and title is

Figure 2.12. Calakmul Stela 9 inscription. (*After Marcus 1987.*)

placed directly adjacent to the head of the prisoner, a convention used in other ste-lae when labeling captives. This name phrase, along with the figure's long, coiffed hair, identifies the captive as a woman. Therefore, Stela 9 depicts the unique occurrence of a queen capturing another high-ranking noblewoman during war. Within this program, remarkably, women function literally both as victor and captive in warfare.

Stela 116[12]

Originally erected during the rule of Yuknoom Yich'aak K'ahk', Stela 116 was found broken in approximately three pieces and placed in a cache located under the plat-form midway up the staircase of Structure II (Marcus and Folan 1994). Stela 116 is part of a stelae pair with Stela 115, which was also broken and used as a door jamb for a small outer chamber located two tiers below the platform in which Stela 116 was buried. Both stelae were dedicated in 9.12.10.0.0 (June 29, 672).

Stela 116 depicts a woman standing over a single captive. Looking out over her right shoulder, the woman holds her right hand down by her side and appears to be in the act of scattering. She wears the long netted skirt of the Moon God-dess. Although the name of this queen is not known, we presume that she was the wife of Yuknoom Yich'aak K'ahk', who is named on Stela 115.

Stela 23

Despite the fact that Stela 23 exhibits considerable weathering, its historical record is not entirely lost. Documentation of data, published by Ruppert and Denison (1943), rely on Morley's epigraphic notes of 1924. At that time, Stela 23 stood flanking the staircase on the east side of Structure VI, whereas its pair, Stela 24, had fallen. A small, plain, round altar sat between them. The front panel text reveals the date of Stela 23, and its royal pair, Stela 24, to be 9.13.10.0.0 (January 24, 702).

Stela 23 has a commanding height of 3.44 m and measures 96 cm in width. It depicts one of Yuknoom Took K'awiil's wives.[13] She wears a long skirt with a beaded fringe at the hem. Below this is a border of hieroglyphs, with one block containing a female head or **IX** glyph. Both the queen and her husband stand on bound individuals. Regrettably, that is the extent of information to be gleaned from the imagery, with the majority of glyphs too badly eroded to read. Although we can confidently include Stela 23 in the corpus of monuments depicting queens situated above prostrate captives, the absence of additional information limits its contributions as a source of significant data.

The three stelae from Calakmul are all part of compositions depicting both male and female rulers, a common convention seen at the site from 623 to 731 (Marcus 1987:149). While the royal couple on the earliest pair—Stelae 28 and 29,

dated to 623—are unidentified, the succeeding stelae—Stela 9 dated to 672 and Stelae pair 23 and 24 dated to 702—portray well-known rulers of the Kaan polity.

Naranjo

The site of Naranjo, in eastern Guatemala, occupied a key position between some of the most powerful Classic kingdoms: Tikal, Caracol, and Calakmul. Forty stelae, one lintel, and a hieroglyphic stairway contribute to our knowledge of its complex political affairs, its triumphs and defeats (Figure 2.13). Of the known stelae, two— Stelae 24 and 29—depict women standing on unfortunate prisoners.

Stela 24

Stela 24 records two important dates in the history of Naranjo. Its dedication dates to 9.13.10.0.0 (January 24, 702). However, the stela also documents another important date—12.10.5.12, 4 Eb' 10 Yax (August 30, 682), the arrival of Ix Wak Chan Ajaw of Dos Pilas to the kingdom of Naranjo (Figure 2.14). Not too surprisingly, this arrival date is also recorded on Naranjo's Stela 29, and remarkably, on Coba's Stela 1, as well.

Stela 24 stood alone in a strategic position, at the base on the north side of Structure C-7. Graham and von Euw (1975:63) remind us that while Maler found the stela unbroken, it was later demolished and removed from the site in the mid-1960s. Subsequent reconstruction achieved a state of "quite good condition, marred only by the numerous cracks running across it."

Stela 24 measures 1.92 m in height, with a width of 87 cm and a depth of 32 cm. The maximum depth of the relief is 4 cm, and carving occurs on the front and both sides, with image and text clear and legible. The monument faces Stela 22, across the courtyard, which depicts Ix Wak Chan Ajaw's son, K'ahk' Tiliw Chan Chaak, who, at the age of five (May 31, 693), acceded to the throne.

Ix Wak Chan Ajaw occupies the left side of the front panel. A broken, vertical line of glyphs covers much of the remaining space to her right, with the lower grouping that

Figure 2.13. Map of Naranjo, East Group. (*After Martin and Grube 2000:68.*)

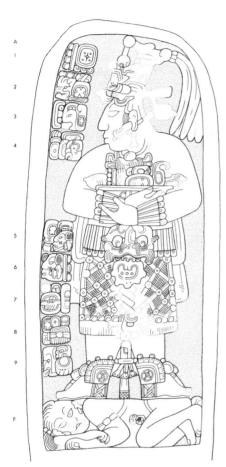

FIGURE 2.14. Naranjo Stela 24.
(*From Graham and von Euw 1975:63.*)

contains her name phrase (A6–A7) overlapping her costume. The glyph following her name phrase also serves to confirm her eminent status as kaloomte'. Along with elements associated with bloodletting, Ix Wak Chan Ajaw adorned herself with a large belt, carrying a xok head and *Spondylus* shell. A complex apron, comprised of beads, shells, and serpent heads, hangs down to her heels. Framing the xok head and *Spondylus* shell is a beaded net overskirt. Glyph blocks E4–D5 state that she is impersonating the Moon Goddess (Grube and Martin 2004:2–46; Looper 2002; Stuart et al. 1999:55). She also wears a large plumed headdress featuring the trapeze and ray war symbols, the Mexican year sign (Looper 2002:183; Schele and Miller 1986: 213). Beneath Ix Wak Chan Ajaw Kaloomte' cowers her vanquished enemy, Lord Kinichil Kab from Ucanal.

Stela 29

Stela 29 at Naranjo also depicts Ix Wak Chan Ajaw, although this event is 15½ years later than that of Stela 24 (Figure 2.15). Here we have an ox-tun ending date of 9.14.3.0.0 (November 15, 714); her arrival date also recurs on this monument. Stela 29 is paired with Stela 30, which commemorates the first katun anniversary of K'ahk' Tiliw Chan Chaak's accession. These stelae occupy the first and second positions, from the viewer's left, within the front row of four monuments located at the base of the west side of Structure C-9.

Although only two stelae at Naranjo depict a queen standing on captives, both commemorate the same powerful ruler. Ix Wak Chan Ajaw ruled from 682 to 741, both independently and as co-regent with her son. Moreover, the historic records omit the name of K'ahk' Tiliw Chan Chaak's father, "clear evidence there

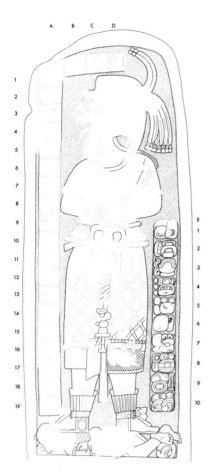

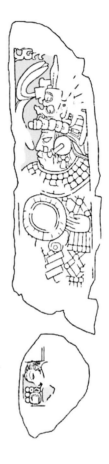

FIGURE 2.15. Naranjo Stela 29.
(*From Graham and von Euw 1975.*)

FIGURE 2.16. Naachtun Stela 18.
(*From Ruppert and Denison 1943.*)

was to be no continuity with the old royal patriline" (Martin and Grube 2000:75).

Naachtun

Stela 18
Finally, at Naachtun, a queen is also shown standing on a captive. Stela 18 is part of a royal pair and shows an unnamed queen of Naachtun standing on a Calakmul captive (Figure 2.16).

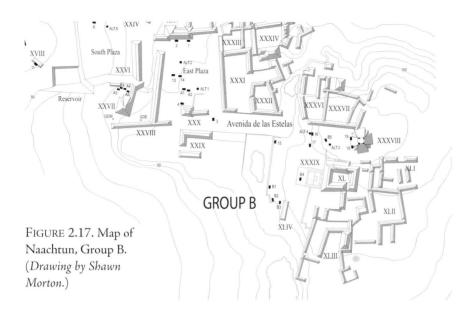

FIGURE 2.17. Map of
Naachtun, Group B.
(*Drawing by Shawn
Morton.*)

Naachtun is located in the north-central Peten about 40 km south–southeast of Calakmul. Comprising the ruins are many plazas, courts, and mounds, with substantial defensive walls surrounding Structures VII–XII. Archaeologists have documented a total of 47 stelae, and one—Stela 18—represents a woman crushing a confined Uxtetun (Calakmul) captive beneath her. This queen is part of a royal pair, her partner being depicted on Stela 19, situated to her right.[14] Morley discovered both monuments fallen, but not removed from their original location flanking the central staircase of Structure XXXVIII, a radial pyramid on the east side of center. More specifically, they sit at the apex of La Avenida de las Estelas, an elongated, long east–west plaza lined with stelae (Figure 2.17). Interestingly, the buildings in this sector of the site were constructed in the Central Yucatecan architectural style, suggesting a strong influence from the north during the later seventh and early eighth centuries. At this time, Naachtun is the most southerly site in which this style can be found.

Stela 18 is a colossal 4.5 m high, 90 cm wide, and 83 cm thick (Morley 1937–1938:339). Only the front and sides of this immense monument were carved, while the back was, apparently, left plain. The inscriptions on Stela 18 are poorly preserved, causing uncertainty with regard to the date. Morley proposed a date of 9.11.0.0.0 (652), while Proskouriakoff proposed a much later date of 9.15.10.0.0 (741). However, even after careful examination, Mathews was unable to confirm either date. He has proposed a date in the early eighth century based on style. Therefore, at this time, the Naachtun stela appears to have been the final stela erected depicting queens and their captives.

Further Evidence for Queens as Warriors

In addition to the corpus of stelae described above, there are provocative tidbits of iconographic and epigraphic information that further support the role of queen as warrior in Late Classic Maya society. Specifically, the use of the title kaloomte', the appearance of female captives, and the link between the Moon Goddess and warfare all point to a heretofore unrecognized martial status that certain noble women attained.

Kaloomte' Titles

As noted previously, in several instances queens carry the *kaloomte'* title more commonly associated with kings. The title is not clearly understood at this time, but is often associated with militarism in the Maya Lowlands.[15] It was first recorded during the early fifth century in association with two individuals, Siyaj K'ahk' and Spearthrower Owl. It is also used again when referring to Ix Yok'in of Tikal, who is referred to as an *ix kaloomte'* at C5 on Stela 12, which is dated to 9.4.13.0.0 (August 527). However, this appears to have been a rare instance, as the phrase is not repeated until the late seventh century. Then, in a very short period of time, from 682 to 709, five queens carried the *ix kaloomte'* title. Two of these queens are also portrayed standing atop prisoners of war. They were Ix K'awiil Ek' of Coba (Stela 1 [682]) and Ix Wak Chan Ajaw of Naranjo (Stela 24 [699]). Although we assume that these women were closely related, given the cross-reference of the date 9.12.10.5.12, 4 Eb' 10 Yax on Coba Stela 1 and Naranjo Stela 24, we do not understand the nature of their relationship at this time. Others include Ix K'ab'el of Waka' (Stela 34 [692]) and Ix Ik Skull of Yaxchilan (Stela 10 [xxx]), who is named as a *lak'in* (east) *kaloomte'* (Figure 2.18). Both of these queens were from the Kaan kingdom ruling lineage. And finally, Ix K'ab'al Xook is named as an *ix kaloomte'* twice on Yaxchilan Lintel 24, dated to 681, and Lintel 25, dated to 709.

Female Captives

In the current analysis, we identified a female captive on Calakmul Stela 9; however, she was not the lone woman captured during warfare. Maricela Ayala

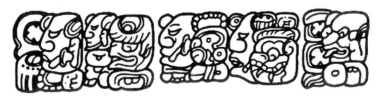

Figure 2.18. Text from Yaxchilan Stela 10. (*Drawing by Linda Schele.*)

(2002:107) has recorded a female prisoner in torn clothes with ropes around her arms carved on Tonina Monument 99. Mathews dates the monument to 9.11.16.0.0, 13 Ajaw 8 Mol, or two days before the accession of Bahlam Way (Ruler 2).[16] The accompanying text refers to a sacrifice, but it is unclear if it is an auto-sacrifice by the king or the sacrifice of the prisoner.

Female captives also are found on portable art during the Late Classic period. For example, both male and female captives were incised onto a large conch shell, sadly unprovenienced due to looting. The woman sits nude from the waist up with her arms bound behind her back. Accompanying glyphs include her name, implying that she was of noble birth. Additionally, a standing nude female figurine from the Island of Jaina may be an example of a captive. Captives frequently are portrayed without clothing, in a state of humiliation. Indeed, the total lack of costume and the extremely rare depiction of female genitalia in the figurine suggest that the woman was a prisoner of war.

Finally, although not a captive, the broken lower half of a stela depicting a royal woman was used in the construction of a Late Classic staircase in the walled compound of Naachtun. The stela fragment comprised the lowest tread and measured approximately 1 m in length, 65 cm in width, and 35 cm in depth. The fragment was in the exact centerline of the staircase and had been intentionally cut to fit in this position. Cut marks were notable on the right side of the stela, which became the front edge of the riser.

The image on the stela consists of a standing figure in a long, beaded net skirt with a xok fish belt and dangling *Spondylus* shell. The figure has ankle bracelets but otherwise appears to be barefoot. The arms of the figure are bent upward, and only the elbows are showing at the waist. The figure is standing atop a series of at least four glyph blocks, which are poorly preserved.

This figure most closely resembles the style and composition of images of royal women wearing the jade net skirt, such as Calakmul Stela 29 and Naranjo Stelae 24 and 29. Therefore, we argue that this figure is a Naachtun queen.[17] And she must have been an infamous figure in history, as it is her stela that was desecrated. The wear on Stela 27 suggests that this fragment was left open and stepped upon for many years in a display of humiliation, albeit symbolic, shown only to captives.

Embodying the Moon Goddess

Looper (2002:182–183) astutely observes that Maya women cloaked themselves in the persona of the Moon Goddess for purposes of war. Not only did queens don the beaded net skirt when trampling captives, but they also dressed as the Moon Goddess when holding military paraphernalia or when named as an *ix kaloomte'*. The Oval Palace Tablet depicts Ix Sak K'uk' of Palenque, dressed as the

Moon Goddess, presenting the martial mosaic headdress to her son, K'inich Janaab' Pakal I, during his accession ritual (Looper 2002:182). In a parallel statement carved on the Palace Tablet, Ix Tz'akbu Ajaw, wife of K'inich Janaab' Pakal I and mother of K'inich K'an Joy Chitam II, sits on the left side of her son. She wears the beaded net skirt of the Moon Goddess and offers him the flint and shield war symbols. Additionally, Waka' Stela 34 portrays Ix K'ab'el, an *ix kaloomte'*, in a long, beaded net huipil and holding a shield and a war banner (Figure 2.19). And finally, Ix Wak Chan Ajaw, Ix Kaloomte' of Naranjo wears a trapeze and ray war symbol in her headdress on Stela 24.

Additionally, there is iconographic evidence pointing to a link between the Moon Goddess and warfare, although the precise nature of the association remains obscure. In their study of the role of women in the Postclassic and colonial periods, Vail and Stone (2002:225, fig. 11.1d) comment that one of the major roles of Chac Chel, the aged Moon Goddess, or Goddess O, was that of world destroyer and "slayer of men," symbolized by the cross bone pattern on the death god (Stone 1990; Vail and Stone 2002: fig. 11.5). Interestingly, however, it is not Chac Chel, but the Postclassic version of Goddess I who wears the netted skirt in the *Madrid Codex* (cf. Stone 1990; Taube 1988).[18] During the Classic Period, there indeed seems to have been some degree of conceptual overlap between aspects of the old, powerful warrior goddesses and the youthful fertility goddess, both of whose iconography references the Moon Goddess and Maize God.

During the Late and Terminal Classic Periods, the crescent moon appears on war shields embellishing

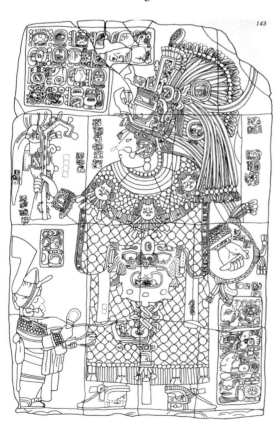

Figure 2.19. Waka' Stela 34. (*Drawing by Ian Graham.*)

the architecture of Chichén Itzá (Milbraith 1999:117). In the murals of the Upper Temple of the Jaguars, a military leader standing with feathered serpent carries a shield with multiple crescents, while some of the enemy warriors carry shields with a single crescent moon (Coggins 1984: fig. 205; Tozzer 1957: fig. 60). The same temple's cornice relief depicts shields with lunar crescents; shields on the relief from the Nunnery have them as well (Bolles 1977:232).

This lunar symbolism on shields in the northern Maya Lowlands may be a counterpart to the symbolism of the Jaguar God of the Underworld (JGU) that appears on shields in the central lowlands (Milbraith 1999:124). Milbraith (1999:124) argues that the JGU is associated with the dry season, the season of war. She further proposes that Goddess I, portrayed on the north column of the Lower Temple of the Jaguars wearing a netted skirt, represents the dry-season moon.

Ayala (2002:108) identifies the Moon Goddess, in her aged form, on a Late Classic altar located on the east side of the Great Ball Court at Tonina. Depicted as nude from the waist up, the Moon Goddess grabs a prisoner with her left hand and holds an obsidian knife in her right hand, poised on the brink of executing a captive.

Therefore, there is a great deal of evidence that substantiates the emergence of warrior queens during the Late Classic Period. Scholars have long observed the general association between the Moon Goddess and warfare. And when royal women embodied this deity, they were transformed into warriors. Queens carried the *kaloomte'* title, often associated with warfare, in the inscriptions, and noble women were captured during military encounters. They also captured and sacrificed their own prisoners. All of this attests to the role of Maya queens as military commanders-in-chief during the Late Classic Period.

Dynastic Politics and Warrior Queens

Political Affairs of Warrior Queens

In addition to the obvious similarities in composition and style, the group of stelae depicting queens with their prisoners cross-refer to one another, suggesting that a political relationship may have existed among these kingdoms. First, the earliest date noted for the appearance of queens with captives is the period ending 9.9.10.0.0 (March 19, 623). This event is recorded on Coba Stela 4 and Calakmul Stelae 28 and 29. Moreover, the appearance of the warrior queen on Calakmul Stela 28 corresponds to the beginning of a surge in monument production in the city (Martin 2005a).

Second, Coba Stela 1 and Naranjo Stelae 24 and 29 all record the date of 9.12.10.5.12 (August 30, 682). This date commemorates an important historical event, the arrival of Ix Wak Chan Ajaw of Dos Pilas at Naranjo.

Third, Naachtun declares a victory over Calakmul on Stela 18. Stela 18 shows the subjugation of a Calakmul lord by a Naachtun queen and is rendered in a style identical to that of the prominently displayed stelae pairs at Calakmul. This stela specifically refers to the captive as an unnamed Uxtetun (Calakmul) lord.

So, what does this particular subset of stelae imply about the role of royal women and the political ties that were forged through them during the Late Classic Period? Because Coba has the earliest date and the most representations, particularly of warrior queens portrayed without male counterparts, we can infer that the northern lowlands were the likely source of the behavior. Interestingly, the timing of the warrior queen stelae, the *ix kaloomte'* titles, and the appearance of female captives correspond well with the presence of the Kaan emblem glyph on stelae at Calakmul. Recently, Martin (2005b) has proposed that the Kaan polity occupied the site of Calakmul from 633 to 734/736. Given that the presence of Kaan at Calakmul coincides with a heretofore unprecedented appearance of women in martial roles within the iconographic and epigraphic corpus, we suggest that a change in status of royal women was linked to a Yucatecan lineage moving south and entering into royal marriages with other ruling families.

The appearance of the warrior queen on Stela 28 at Calakmul corresponds to the beginning of a surge in monument production in the city (Martin 2005a). Moreover, it is only a short decade later when the first of the Kaan kings is mentioned at the site in association with an unequivocal Kaan emblem glyph (Martin 2005b). The last known example of a Kaan emblem glyph at Calakmul was recorded in 731.

Shortly after the dedication of this stela, Yik'in Chan K'awiil of Tikal recorded a defeat of the Kaan king, Yuknoom Took K'awiil on Tikal Stela 21 (Martin 2005b). The primary event on Stela 21 is a period-ending ceremony conducted in 9.15.5.0.0 (736), with a secondary event recorded marking Yik'in Chan K'awiil's accession in 734 (Martin 2005b). Although no specific date is given for his victory over Yuknoom Took K'awiil, these two other events bookend the conflict and provide a time range for the conquest (Martin 2005b).

Arguably, Naachtun Stela 18, depicting the defeat of an Uxtetun (Calakmul) lord, is the final warrior queen stela erected in the Maya Lowlands. If Proskouriakoff's date of 9.15.10.0.0 (741) is correct, then this defeat of Calakmul by Naachtun falls after the defeat of Kaan's last king, Yuknoom Took K'awiil, by Yik'in Chan K'awiil of Tikal. However, even if the date is earlier—as predicted by Mathews based on the style of the inscriptions—it would still fall close to the range of dates (734–736) that Martin (2005b) has suggested for the final defeat of the Calakmul Kaan kings. Therefore, it is possible that the reason why the captive on Naachtun Stela 18 is referred to simply as a Uxtetun (Calakmul) lord is because Kaan was no longer present at Calakmul.

Status of Royal Women after 623

But would the presence of Kaan in the central low-land cause such a shift in the manner in which women were portrayed in the historic record? Indeed, it appears to have had such an impact. Prior to 623, examples of queens rendered in prominent public art are extremely limited. Ix Ayiin, wife of Sihyaj Chan K'awiil and mother of K'an Chitam, is depicted on El Zapote on Stela 5 (9.0.4.0.0 [439]) (Figure 2.20) and on Tikal Stela 40 (9.1.13.0.0 [468]) (Martin and Grube 2000; Valdes and Fahsen 1998; Schele et al. 1992; Stone 1990). Ix Tzutz Ajaw, the wife of K'an Chitam and mother of Chak Tok Ich'aak II, is depicted on Naachtun Stela 26.[19] And, finally, Ix Yok'in, Chak Tok Ich'aak II's daughter who ruled from 511 to 527(?), is depicted on Tikal Stela 25. Ix Yok'in was an enigmatic figure who was named as an early ix kaloomte', but it is doubtful that she ever ruled independently (Martin 1999, 2005a; Martin and Grube 2000:38). Nonetheless, she is mentioned on three stelae, 6, 12, and 23, during her reign and may be depicted on a fourth, Stela 25, which was commissioned by her husband and co-regent, Kaloomte' Bahlam.

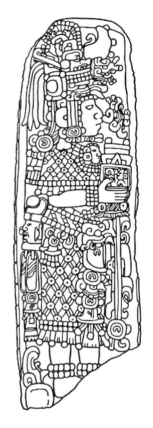

FIGURE 2.20. El Zapote Stela 5. (*Drawing by Linda Schele.*)

In contrast, beginning in 623 we see an increase in the number of queens represented in public art. In fact, almost all monuments depicting women were dedicated after the beginning of the seventh century. For example, all images of Ix K'ab'al Xook of Yaxchilan, the powerful queen married to Itzamnaaj Bahlam II, postdate 623.[20] Temple 23 was dedicated to her in 726 and, in addition to the lintels above the three principal doors that portray her in public rituals, an all-glyphic lintel above a side door describes her genealogy (Martin and Grube 2000:126). This is unique in Maya carving and signifies the authority held by Ix K'ab'al Xook and her lineage.

Like her counterpart at Yaxchilan, Ix K'atun Ajaw of Piedras Negras also gained unprecedented power at this time. A princess from the site of Namaan, Ix K'atun Ajaw's marriage to K'inich Yo'nal Ahk in 686 was "the most celebrated in Maya history" (Martin and Grube 2000:145), denoting the importance of her lineage. Moreover, her portrait is rendered on Stelae 1, 2, and 3. Stela 3, dated to

711, actually illustrates Ix K'atun Ajaw and her daughter, Ix Huntahn Ahk. The birth of the small princess in 708 is recorded in the texts of Stela 3 as well, suggesting that she was the intended heir. Martin and Grube (2000:147) observe that a forceful matriline may have emerged at Piedras Negras at this time. Sadly, however, Ix Huntahn Ahk did not succeed after the death of her father.

Other little-known monuments record still-unidentified, but powerful queens in the guise of the Moon Goddess. The Chicago Art Institute stela, dated to 9.13.10.0.0 (702), illustrates an aged queen from an unknown polity wearing a beaded net skirt (Palka and Buechler 2003). And, dated to 761, the De Young Museum stela portrays an Ix Mutul Ajaw in a beaded net skirt holding a snake from which emerges the god K'awiil.

Matrilineal Descent and Dynastic Politics

All of these changes, including the appearance of warrior queens, the use of *ix kaloomte'* titles, female captives, and an increased emphasis on queens and their lineages in public art, denote a real shift in the status of royal women that coincided with the appearance of Kaan in the central lowlands. We propose that this was instigated by the power and influence of the Kaan state, which appears to have emphasized—or at the very least given representational priority to—the political power of women and, perhaps, a preference for matrilineal or ambilineal descent (see Chase, Chase, and Haviland 2002; Haviland 1997).

We are not the first, however, to suggest the importance of the matriline in the northern lowlands. Krochok (2002) first recognized that the relationship expressions at Chichén Itzá differed from those in the central lowlands, emphasizing descent from the mother. She noted that when an individual's mother is clearly identified, the identity of the father is either not given or implied in oblique ways (Krochok 2002:153–154). Grube, Lacadena, and Martin (2003:II-4) expanded upon these observations, commenting on the lack of "child of father" phrases in the inscriptions of the Yucatan, in general. They noted its presence only at the sites of Edzna, Itzimte, and Ek' Balam. In contrast, they found that the "child of mother" phrase is more widespread, appearing in the texts from Edzna, Uxmal, Itzimte, Ek' Balam, and Chichén Itzá. These authors were the first to propose that matrilineal descent may have been more important than patrilineal descent in the royal families of the northern lowlands (Grube et al. 2003:II-4).

These new gender roles seem to have been adopted initially by the allies of Kaan and then spread throughout the central lowlands. As discussed above, royal women held more significant roles in court, with greater political and military authority, after 623. This coincides with inscriptions and imagery placing new-found emphasis on a ruler's matriline.

One of the earliest examples of texts that emphasize the matriline is found on Caracol Stela 3. Commissioned to celebrate K'an II's victory over Naranjo on 9.9.18.16.3, 7 Muwan 16 Akbal (December 25, 631), the scribes devoted much of the text to his mother, Ix Batz' Ek'. Grube and Martin (2000:164) suggest that Ix Batz' Ek', who married Caracol ruler Yajaw Te' K'inich in September 584, following the defeat of Tikal by the Caracol-Kaan coalition, was, in fact, a princess of the Kaan royal family or "at least, a closely related family." Yet despite being from a powerful family, there is no doubt that the 18-year-old princess was a junior wife, as Yajaw Te' K'inich had been in office for 31 years by that time.

Not only do texts focus more on matrilineal relationships, but also iconographic representations of mother–son interactions become more common after 623. Well-known examples include K'inich Janaab' Pakal and Kan Joy Chitam of Palenque and K'ahk' Tiliw Chan Chaak of Naranjo, who portray themselves with their mothers in prominent public works of art. Others include Ruler 4 of Piedras Negras, who acceded to the throne in November 729. Interestingly, one of his first monuments, Stela 40 dated to 746, shows Ruler 4 scattering into a psychoduct that led to an underground tomb housing his mother's mummy bundle (Martin and Grube 2000:148), stressing his ability to communicate with his female ancestors.

Additionally, Bird Jaguar of Yaxchilan, whose mother was Ix Ik' Skull of the Kaan polity, promoted his matrilineal heritage on a series of monuments. Stela 11 documents the participation of Bird Jaguar, his wife, Ix Great Skull, and his mother, Ix Ik' Skull, in a bloodletting and vision-quest ritual that conjured serpents expelling images of the god K'awiil. And Stela 35 depicts Ix Ik' Skull in scenes of sacrificial rites parallel to those of Ix K'ab'al Xook 30 years earlier (Martin and Grube 2000:129).

Finally, the single parentage statement at Tonina is a "child of mother" expression on Monument 138. K'inich Ich'aak Chapat, who ruled from 723 to 739(?), states that he is the son of Ix Winik Timan K'awiil (Ayala Falcon 2002:109; Martin and Grube 2000:186). This relationship must have been extremely important politically to the Late Classic king, given the absence of other such statements at historic texts of the site.

While the previous discussion of mother–son relationships is not exhaustive, it does suggest that the matriline was prominent in the northern lowlands during the Classic Period and increased in significance in the central lowlands between 623 and 761. Moreover, this amplification coincided with the occupation of Calakmul by the Kaan polity. Previously, scholars have suggested that kings whose mothers were junior wives needed to justify their political authority by elevating the stature of their mothers (Martin and Grube 2000). We, however, propose that the matrilines were stressed due to newly formed political alliances with the Kaan kingdom through the marriage of central lowland rulers to Kaan princesses.

Conclusions

The results of our analysis have allowed us to greatly increase our understanding of Maya women's roles during the Classic Period. Most significantly, we can now assert that during the later part of the seventh and early part of the eighth centuries, queens actually ruled independently, participated in battles, and captured enemies. In other words, for several women, the role of a Maya warrior queen was identical in all ways to that of warrior king.

Moreover, the visibility of women in the historic records grew after 623. The manner in which they were portrayed—conducting rituals, dedicating stelae, capturing prisoners—and, indeed, even the manner in which they were dressed, in the transgendered costume of the Maize God/Moon Goddess, all signify the power and authority royal women commanded in state politics.

In other chapters in this volume, kings also are portrayed as participants in organized violence in a number of other contexts, such as during important rituals related to the ballgame, gladiatorial combat, captive sacrifice, and investiture rites. According to Orr and Koontz (this volume, Introduction), renderings of these ritual acts provide examples of ordered violence that reinforced cultural norms and power relations (for example, Whitehead 2004:9). Likewise, portraits of individuals in military costume and carrying military paraphernalia also conveyed implicit messages about power and social order. Accordingly, imagery of both queens and kings portrayed as warriors, carrying a warrior title or standing in triumph over a captive enemy, conveyed the authority that the ruling elite held in the cultural order in exactly the same manner. Moreover, these portraits of queens and their accompanying texts also revealed the shifting nature of power relations between the genders and the newly acquired clout wielded by women in the southern Maya Lowlands during the Late Classic Period.

But more than merely documenting another aspect of ordered violence, this study highlights the evolving nature of gender identity within these social constructs. It is naïve to think that the manner in which men and women are perceived would remain static for over 600 years in a complex society. Our analysis has demonstrated that at the beginning of the seventh century, the roles of royal women in the central lowlands shifted dramatically.

We have attributed this transformation to the influence of the Kaan dynasty on elite culture at that time. Moving from the northern lowlands to the central lowlands, the Kaan dynasty occupied Calakmul from 623 to 734/736(?) and forged political alliances with powerful central lowlands city-states, often through the marriage of Kaan princesses with indigenous rulers.

Concomitantly, new ideas regarding descent and inheritance may have spread through the intermarriage of the royal houses. According to Krochok (2002) and

Grube et al. (2003), matrilineal descent appears to have been more important than patrilineal descent in the northern lowlands. We have also recognized an increased importance placed on matrilineal heritage in the texts and images of public art from 623 to 761. This implies a reformation in kinship systems during this period, at least among the elite of the central lowlands.

While additional research needs to be done to more fully understand Maya kinship systems, as well as gender identities, through this study we have detected a previously unrecognized link between two. Little doubt remains in anthropological studies that the manner in which descent is reckoned affects the gender roles of individuals within any society. But the precise nature of the association between shifting gender roles and descent systems in the Maya Lowlands remains ill defined. While, undeniably, warrior queens, and the power and authority invested in them, emerged in the central lowlands after 623, the simultaneous transformation of Classic Maya kinship systems from patrilineal to ambilineal remains debatable, yet, based on our analysis, increasingly probable. Nonetheless, what is clear is that the shared representational systems—pictorial and textual—that existed in the corpus of Maya Lowland art are a rich source for continued investigation into gender roles, kinship systems, and expressions of political and military authority.

NOTES

[1] Given the uncertainty of the location of the Kaan capital during the Classic Period (Martin 2005b), we have decided to use the polity name, Kaan, in all references to the state when its location is not specifically tied to one site.

[2] We make an effort to use Maya names and titles whenever possible. In keeping with this, we have chosen to use the Maya title *Ix* instead of *Lady* when identifying royal women. Further, to maintain consistency within the volume, spelling of Maya names follow the conventions used by David Mora Marín and John Hoopes in Chapter 11.

[3] Simon Martin (personal communication 2008) notes that although these palanquins did have strong military associations, they may not have been used exclusively for military purposes.

[4] This may not be a complete reading of the name of this queen, as the text is very eroded in this location (Martin, personal communication 2008).

[5] Unless otherwise noted, all stelae are presented chronologically from oldest to most recent.

[6] It is certainly plausible from the shape of the glyphs that Bp5 is also Ix Ch'en Nal. The glyph immediately before is **ajaw** and before that **kaloomte'**, so we would expect it to be the name of a ruler, with titles preceding rather than following, in Yucatec fashion. But possibly problematic, the glyph after Ix Ch'en Nal is **Yoat**—more commonly associated with men. Nevertheless, as **Yoat** is generally part of a proper name, it is not inconceivable that a woman, as well as a man, might carry it, just as the names of the women from Chichén Itzá include **Ton**.

[7] This reading is tentative and may change with further analysis of this weathered inscription.

[8] Alternatively, Simon Martin (personal communication 2008) proposes that these two dots may read **TI'**.

[9] Dave Stuart (personal communication 2008) suggests that the glyphs at H21 may actually be part of the emblem.

[10] Marcus (1987:161) notes that Calakmul Stela 88 also depicts a royal queen. Proskouri-akoff (1950) dates the stela to 9.11.0.0.0. ± (?) [652 ± (?)] based on style. The lower register is of interest because it is similar in size to those others that hold captives. Marcus (1987:165) observed that a captive might, indeed, have been carved below the queen's feet, but the stela is now too eroded to confirm its presence.

[11] Stela 9 also records the long count date of 9.10.16.16.19, which Mathews (1979) identifies as the birth date of Yich'aak K'ahk'.

[12] We would like to thank Simon Martin (personal communication 2008) for pointing out this stela to us.

[13] A wife of Yuknoom Took K'awiil is also depicted on Calakmul Stela 54.

[14] Stela 19 also shows the king standing atop a captive; however, the glyph block adjacent to the captive is too eroded to read.

[15] The current understanding of the *kaloomte'* title indicates that it is a very high-ranking title with no inherent martial connotations. Yet it was often used as a title by individuals depicted as military leaders.

[16] The accession of Bahlam Way is recorded on Monument 113 as 9.11.13.0.1.

[17] We realize that this is one interpretation. Another possibility is that this monument was a spoil of war depicting a queen from another site. However, it does appear as though Stela 26 were damaged at approximately the same time, suggesting an attack on Naach-tun in which stelae were targeted.

[18] Vail and Stone (2002:210) propose that the Postclassic glyph for Goddess I's name should be read as Ixik Kab (Lady Earth). They further stress her association with the earth and fertility.

[19] The identification of this individual as an early queen is based upon the presence of a glyph block in the headdress. Dave Stuart (personal communication 2005) suggests that the first glyph, while definitely a name glyph, may actually be read as **IXIM** and not as a female agentive.

[20] Lintel 25 illustrates the queen celebrating her husband's accession in 681 by conjuring a warrior emerging from the jaws of a half-decayed Mexican-style serpent. Lintel 24, dated to 709, depicts Ix K'ab'al Xook in a bloodletting scene, pulling a thorny rope through her tongue. Lintel 26 shows the queen handing Itzamnaaj Bahlam II a jaguar helmet for an unidentified military ceremony in 724 (Martin and Grube 2000:125).

ACKNOWLEDGMENTS

We would like to thank Simon Martin and two anonymous reviewers for their comments. Their reviews helped us to strengthen our arguments and conclusions. As always, however, we take full responsibility for the ideas and content presented in the chapter. Finally, we would like to thank Heather Orr and Rex Koontz for the opportunity to present this paper in the original SAA session.

REFERENCES CITED

Ardren, T. (editor)
 2002 *Ancient Maya Women*. AltaMira Press, Walnut Creek, CA.

Ayala Falcon, M.

2002 Lady K'awil, Goddess O, and Maya Warfare. In *Ancient Maya Women*, edited by T. Ardren, pp. 105–113. AltaMira Press, Walnut Creek, CA.

Bassie-Sweet, K.

1991 *From the Mouth of the Dark Cave*. University of Oklahoma Press, Norman.

2000 Corn Deities and the Complementary Male/Female Principle. Paper presented at La Tercera Mesa Redonda de Palenque, July 1999, Palenque, Chiapas, Mexico.

Bell, E.

2002 Engendering a Dynasty: A Royal Woman in the Margarita Tomb, Copán. In *Ancient Maya Women*, edited by T. Ardren, pp. 89–104. AltaMira Press, Walnut Creek, CA.

Bolles, J. S.

1977 *Las Monjas, A Major Pre-Mexican Architectural Complex at Chichén Itzá*. University of Oklahoma Press, Norman.

Chase, A. F., D. Z. Chase, and W. A. Haviland

2002 Maya Social Organization from a "Big Site" Perspective: Classic Period Caracol, Belize and Tikal, Guatemala. In *La Organización social entre los Mayas prehispánicos, coloniales, y modernos*, edited by V. Tiesler, R. Cobos and M. Greene Robertson. Instituto Nacional de Antropología e Historia, Mexico, D.F.

Coggins, C.

1984 *Stucco Decoration and Architectural Assemblage of Structure 1-Sub, Dzibilchaltun, Yucatan, Mexico*. Publication 49. Tulane University, Middle American Research Institute, New Orleans, LA.

Freidel, D., and S. Guenter

2003 Bearers of War and Creation. *Archaeology* January 23, 2003. www.archaeology. org/online/features/siteq2/.

Fritzler, M.

2005 Late Classic Maya Warrior Queens: A New Gender Role. Unpublished M.A. thesis, Department of Art and Department of Archaeology, University of Calgary.

Graham, I., and E. von Euw

1975 *Naranjo. Corpus of Maya Hieroglyphic Inscriptions*, 2(1). Peabody Museum of Archaeology and Ethnology, Harvard University, Cambridge, MA.

1997 *Coba. Corpus of Maya Hieroglyphic Inscriptions*, 8(1). Peabody Museum of Archaeology and Ethnology, Harvard University, Cambridge, MA.

Graham, I., and P. Mathews

1999 *Tonina. Corpus of Maya Hieroglyphic Inscriptions*, 6(3). Peabody Museum of Archaeology and Ethnology. Harvard University, Cambridge, MA.

Grube, N., and S. Martin

2000 Tikal and Its Neighbors. In *Notebook for the XXIV Maya Hieroglyphic Forum at Texas*, edited by L. Schele, N. Grube, and S. Martin, pp. II-1–II-78. University of Texas at Austin.

2004 Patronage, Betrayal, and Revenge: Diplomacy and Politics in the Eastern Maya Lowlands. In *Notebook for the XXVIIIth Maya Hieroglyphic Forum at Texas, March, 2004*, edited by N. Grube, pp. II-1–II-95. Maya Workshop Foundation, University of Texas at Austin.

Grube, N., A. Lacadena, and S. Martin
 2003 Chichen Itza and Ek Balam: Terminal Classic Inscriptions from Yucatan. In *Notebook for the XXVIIth Maya Hieroglyphic Forum at Texas, March 2003*, edited by N. Grube, pp. II-1–II-84. Maya Workshop Foundation, University of Texas at Austin.

Haviland, W. A.
 1997 The Rise and Fall of Sexual Inequality: Death and Gender at Tikal, Guatemala. *Ancient Mesoamerica* 8(1):1–12.

Josserand, J. K.
 2002 Women in Classic Maya Hieroglyphic Texts. In *Ancient Maya Women*, edited by Traci Ardren, pp. 114–151. Altamira Press, Walnut Creek, CA.

Joyce, R.
 1992 Images of Gender and Labor Organization in Classic Maya Society. In *Exploring Gender through Archaeology: Selected Papers from the 1991 Boone Conference*, edited by C. Claassen, pp. 63–70. Monographs in World Archaeology, no. 11, Prehistory Press, Madison, WI.
 1996 The Construction of Gender in Classic Maya Monuments. In *Gender and Archaeology*, edited by R. P. Wright, pp. 167–195. University of Pennsylvania Press, Philadelphia.
 2000 *Gender and Power in Prehispanic Mesoamerica*. University of Texas Press, Austin.
 2001 Negotiating Sex and Gender in Classic Maya Society. In *Gender in Pre-Hispanic America*, edited by C. Klein, pp. 109–141. Dumbarton Oaks Research Library and Collection, Washington, D.C.

Krochok, R.
 2002 Women in the Hieroglyphic Inscriptions of Chichén Itzá. In *Ancient Maya Women*, edited by T. Ardren, pp. 152–170. AltaMira Press, Walnut Creek, CA.

Looper, M. G.
 2002 Women-Men (and Men-Women): Classic Maya Rulers and the Third Gender. In *Ancient Maya Women*, edited by T. Ardren, pp. 171–202. AltaMira Press, Walnut Creek, CA.

Marcus, J.
 1987 *Inscriptions of Calakmul: Royal Marriage at a Maya City in Campeche, Mexico*. University of Michigan Museum of Anthropology Technical Report 21. University of Michigan, Museum of Anthropology, Ann Arbor.

Martin, S.
 1999 The Queen of Middle Classic Tikal. *Pre-Columbian Art Research Institute Journal* 27:4–5.
 2000 Los Senores de Calakmul. *Arqueología Mexicana* 7(42):40–45.
 2005a Caracol Altar 21 Revisited: More Data on Double Bird and Tikal's Wars of the Mid-Sixth Century. *Pre-Columbian Art Research Institute Journal* 6(1):1–9.
 2005b Of Snakes and Bats: Shifting Identities at Calakmul. *Pre-Columbian Art Research Institute Journal* 6(2):5–13.
 2008 Wives and Daughters on the Dallas Altar. Mesoweb. www.mesoweb.com/articles/martin/Wives&Daughters.pdf

Martin, S., and N. Grube
 2000 *Chronicle of the Maya Kings and Queens: Deciphering the Dynasties of the Ancient Maya.* Thames and Hudson, New York.
Mathews, P.
 1979 Notes on the Inscriptions of "Site Q". Manuscript on file in the Department of Archaeology, University of Calgary.
Milbraith, S.
 1999 *Star Gods of the Maya: Astronomy in Art, Folklore, and Calendars.* University of Texas Press, Austin.
Miller, J.
 1974 Notes on a Stelae Pair Probably from Calakmul, Campeche, Mexico. In *Primera Mesa Redonda de Palenque, Part 1, 1973*, edited by M. Greene Robertson, pp. 149–161. Robert Louis Stevenson School, Pre-Columbian Art Research, Pebble Beach, CA.
Morley, S. G.
 1937–38 *The Inscriptions of the Peten.* Publication 437. Carnegie Institution of Washington, Washington, D.C.
Palka, J., and J. Buechler
 2003 Monument to a Matriarch: A Classic Maya Stela at the Art Institute of Chicago. *Mesoamerican Voices* 1(1):41–64.
Proskouriakoff, T.
 1950 *A Study of Classic Maya Sculpture.* Publication 593. Carnegie Institution of Washington, Washington, D.C.
 1961 Portraits of Women in Maya Art. In *Essays in Pre-Columbian Art and Archaeology*, edited by S. K. Lothrop. Harvard University Press, Cambridge, MA.
Quenon, M., and G. LeFort
 1997 Rebirth and Resurrection in Maize God Iconography. In *The Maya Vase Book*, 5, edited by J. Kerr, pp. 884–902. Kerr Associates, New York.
Ruppert, K., and J. H. Denison, Jr.
 1943 *Archaeological Reconnaissance in Campeche, Quintana Roo, and Peten.* Publication 543. Carnegie Institution of Washington, Washington, D.C.
Schele, L., F. Fahsen, and N. Grube
 1992 El Zapote and the Dynasty of Tikal. *Texas Notes on Precolumbian Art, Writing, and Culture* 34. Center of the History and Art of Ancient American Culture, University of Texas at Austin.
Schele, L., and P. Mathews
 1991 Royal Visits and Other Intersite Relationships among the Classic Maya. In *Classic Maya Political History: Hieroglyphic and Archaeological Evidence*, edited by T. P. Culbert, pp. 226–252. Cambridge University Press, Cambridge, England.
 1998 *Code of Kings: The Language of Seven Sacred Maya Temples and Tombs.* Simon and Schuster, New York.
Schele, L., and M. E. Miller
 1986 *Blood of Kings: Dynasty and Ritual in Maya Art.* Kimbell Art Museum, Fort Worth, TX.

Stone, A.

1988 Sacrifice and Sexuality: Some Structural Relationships in Classic Maya Art. In *The Role of Gender in Precolumbian Art and Architecture*, edited by V. E. Miller, pp. 75–103. University Press of America, Inc., Lanham, MD.

1990 The Two Faces of Eve: The Grandmother and the Unfaithful Wife as a Paradigm in Maya Art. Paper presented at the 89th Annual Meeting of the American Anthropological Association, Nov. 28– Dec. 2, New Orleans, LA.

1991 Aspects of Impersonation in Classic Maya Art. In *Sixth Palenque Round Table, 1986*, edited by M. Greene Robertson and V. M. Fields, pp. 194–202. University of Oklahoma Press, Norman.

Stuart, D., S. Houston, and J. Robertson

1999 Recovering the Past: Classic Maya Language and Classic Maya Gods. In *Notebook for the XXIIIrd Maya Hieroglyphic Forum at Texas*, Part II, pp. 1–96. Maya Workshop Foundation, University of Texas Press, Austin.

Tate, C.

1999 Writing on the Face of the Moon: Women's Products, Archetypes, and Power in Ancient Maya Civilization. Paper presented at the XXIIIrd Maya Hieroglyphic Forum, University of Texas at Austin.

Taube, K.

1985 Classic Maya Maize God: A Reappraisal. In *Fifth Palenque Round Table, 1983*, edited by V. M. Fields, pp. 171–182. Pre-Columbian Art Research Institute, San Francisco.

1988 The Ancient Yucatec New Year Festival: The Liminal Period in Maya Ritual and Cosmology. Ph.D. dissertation, Department of Anthropology, Yale University.

Taylor, Dicey

1992 Painted Ladies: Costumes for Women on Tepeu Ceramics. In *The Maya Vase Book*, 3, edited by J. Kerr, pp. 513–525. Kerr Associates, New York.

Thompson, J. E.

1932 Monuments of the Cobá Region. In *A Preliminary Study of the Ruins of Cobá, Quintana Roo, Mexico*, compiled by J. E. Thompson, H. E. D. Pollock, and J. Charlot, pp. 131–184. Carnegie Institution of Washington, Washington, D.C.

Thompson, J. E., H. E. D. Pollock, and J. Charlot

1932 *A Preliminary Study of the Ruins of Cobá, Quintana Roo, Mexico*. Carnegie Institution of Washington, Washington, D.C.

Tozzer, A.

1957 *Landa's Relación de las Cosas de Yucatan: A Translation*. Papers of the Peabody Museum of American Archaeology and Ethnology, Harvard University, Vol. 18. Peabody Museum, Cambridge, MA.

Vail, G., and A. Stone

2002 Representations of Women in Postclassic and Colonial Maya Literature and Art. In *Ancient Maya Women*, edited by T. Ardren, pp. 203–228. AltaMira Press, Walnut Creek, CA.

Whitehead, N. L.

2004 *Violence*. School of American Research Press, Santa Fe.

CHAPTER 3

INVESTITURE AND VIOLENCE AT EL TAJÍN AND CACAXTLA

Rex Koontz

INTRODUCTION

The open wounds, spear thrusts, elaborate costumes, and glimpses of human viscera assure us that the Battle Mural of Cacaxtla (details, Figure 3.1) is one of the most complex and detailed descriptions of organized violence in the corpus of Mesoamerican monumental art (Diehl and Berlo 1989). Yet it is that very complexity that has helped produce widely divergent iconographic readings of the imagery (García Cook et al. 1995). To compound matters, there is little else like this imagery in Central Mexico during the period, leaving one to posit long-distance relationships in the subject matter and style of the imagery, especially but not exclusively with the Maya area (McVicker 1985; Quirarte 1983). Without wanting to downplay these Maya connections or to ignore those posited for Teotihuacan (Foncerrada de Molina 1980), this chapter highlights elements in the mural's iconography that relate directly to the art of the contemporary Gulf Coast. Other scholars have pointed out general connections between Gulf Coast and Cacaxtla image systems (Foncerrada de Molina 1978a), but this chapter proposes the exchange of specific iconographic conventions. By comparing specific motifs, costumes, and gestures found in the Cacaxtla murals with those found at El Tajín and other Gulf Coast centers from the same period, I argue that key Battle Mural imagery was quoted directly from and played on the imagery of the Gulf Coast.

The interpretation of the Battle Mural has long been a touchstone for understanding the public presentation of organized violence in Central Mexico during

the Epiclassic (ca. A.D. 650–900/1000). That said, there is still considerable controversy surrounding the nature and function of the violence depicted. When the program was uncovered in the mid-1970s, the identification of violence in the imagery was an important part of mounting evidence that challenged earlier ideas of social organization and conflict in Central Mexico. Previous scholarship on the rise of Mesoamerican violence centered on the Toltec (ca. A.D. 900–1200) as the catalyst for increased militarism and an insistence on bloody sacrificial rites. The Cacaxtla evidence clearly predated the rise of the Toltec and seemed to point to earlier, extensive violent acts at the highest levels of Mesoamerican society. While there had long been archaeological and iconographic evidence for earlier conflict in the region (Hassig 1992; Webster 2000), there was nothing like the detailed, naturalistic gore of the Cacaxtla murals. Naturalistic scenes of explicit human violence are specifically absent from the art of Teotihuacan, the main producer of Central Mexican mural painting in the period immediately preceding the rise of Cacaxtla.[1] In this way, the murals of Cacaxtla acted to some extent like the discovery of the equally detailed and violent murals of Bonampak did for the Maya, where previous conceptions of a rather idyllic, peaceful culture were leavened with the rather stark evidence for violence and conflict presented in the murals (Miller 1986:3–7).

For several of the early scholars who treated the mural, the detailed naturalism, so foreign to earlier artistic styles in the region, led quickly to the presumption that the mural was a snapshot of a real battle (López de Molina 1979; Kubler 1980; McVicker 1985). This striking naturalism encouraged a literal approach to the murals, where the iconographer attempted to identify a specific battle event and to extrapolate a historical and social context for the scene. Especially interesting and fundamental were attempts to identify the two major mural groups with ethnic groups mentioned in the postconquest histories of the area (Graulich 1990; McVicker 1985).

Against the background of the literal approach, Miller (1986:102) noted that the costumes of each group at Cacaxtla were remarkably consistent and that these uniforms had little to do with what they would have worn into actual battle (see also Lombardo de Ruiz 1986). For Miller, there was a battle, and there may have been real ethnic factions, but they have here been transformed into a clearly delineated metaphor for the struggle of cosmic forces. Graulich (1990) also explored the Mesoamerican symbolism of the binary oppositions apparent in the struggle between bird and jaguar warriors. In the same vein and taking the idea of a staged struggle further, Baird (1989) posited that the scene does not represent a battle at all but instead depicts a battle's aftermath, with the attendant sacrificial rites associated with the "star" glyphs seen in texts and imagery here and throughout Mesoamerica (see also Carlson 1993).

While these interpretations rely on a certain verisimilitude with real events at some level, Nagao (1989) critiqued all literal interpretations, pointing out that monumental public art such as the Cacaxtla Battle Mural should not be analyzed as a report of a battle or a rite. Instead, these works may be seen as "public proclamations," constructed specifically to elicit certain responses in an audience. For Nagao, the desire of the patrons and the social context of the work are primary fields of investigation, not appendices to the historical truth communicated in the murals (Nagao 1989:84). This is not to say that the mural scene does not have a historical basis, but Nagao's stance brackets the question of historical truth in order to focus on the analysis of the strategies used by patrons and designers to obtain specific desired effects in an audience. This sophisticated view of the communicative process inherent in public art is central to this chapter, which follows Nagao in analyzing the Cacaxtla Battle Mural as a strategic public statement meant to invoke certain associations in the audience.

On the whole, then, scholars have moved away from a literal interpretation of the mural as illustrating a battle and toward the search for the historical context in which this statement would have functioned, especially in terms of a political strategy and a specific audience. Given the rigorous organization of motifs and the staged quality of the figures in the Battle Mural, as well as the restricted environment of the presentation, these critiques seem well placed. But the analysis of the Battle Mural as a political statement begs the existence of a set of conventions undergirding the statement and making it understandable. If we are to analyze the historical and political context of the statement, then the conventions used may be able to tell us a great deal about the contexts, by pointing to basic communicative strategies used in the murals. While studies of style, stylistic influence, and iconographic borrowing at Cacaxtla abound, including superb studies of the origins of particular iconographic elements (Foncerrada de Molina 1993) and numerous accounts of the style (Kubler 1980), it is in the grammar or structure of the iconography that the previous analyses have been less developed. Certainly the eclectic nature of the Cacaxtla image system (Foncerrada de Molina 1978b; Kubler 1980; Nagao 1989) has not lent itself to building a coherent system of iconographic conventions, although again it is Nagao (1989:83) who has noted that, in the end, such a public iconography must have been coherent to the audience for whom it was made.

The focus on the iconographic conventions of Cacaxtla's image system leads us to examine more closely just how violence is presented. Of fundamental significance to this essay is the hypothesis that the conceptualization of violence in the Battle Mural must be seen in a larger discourse of violence which may be tracked in several key areas of Mesoamerica during this period. Specifically, we examine

the iconographic conventions associated with the depictions of violence in contemporary sites on the Gulf Coast and their relation to the battle scene at Cacaxtla. I argue that the Cacaxtla battle scene speaks directly to Gulf Coast rites of violent sacrifice, power, and investiture current during this period, but it does so by inverting the symbolism of those rites. The Cacaxtla scene involves the humiliation of a figure who in Gulf Coast iconography would be the ruler. That the Cacaxtla battle scene may or may not have a historical basis is not at issue here. What is important is that the staging of what on the Gulf Coast is a scene of investiture is here shown as the humiliation of a particular group. These two representations of power and violence are not trivially or casually connected, but instead may be seen to form a discursive system, a point that has fundamental consequences for the iconography of power and violence in those two areas and generates an exemplary and previously unidentified case of Epiclassic interregional interaction.

Context of the Battle Murals

Cacaxtla sits atop a fortified hill in the part of the Puebla-Tlaxcala region known as the Bloque Xochitecatl-Nopalucan-Nativitas (Foncerrada de Molina 1993:9). The area experienced a florescence during the Early Texcalac phase (A.D. 650–850), with Cacaxtla playing a dominant role (García Cook 1981:270; Santana Sandoval and Delgadillo Torres 1990). The Great Platform of Cacaxtla sits in the center of an impressively fortified system of walls and other barriers. It is on this Great Platform that the Battle Mural program is found, amid large courts and surrounding elite architecture that may be characterized as an extended elite residence (Foncerrada de Molina 1993:10). Immediately adjacent to the site and connected to it by a series of largely unexplored mounds is the contemporary hilltop ceremonial complex of Xochitecatl, part of the extended polity whose elite center was Cacaxtla (Serra Puche 2001:258).

The Battle Mural of Cacaxtla decorates the *talud* (sloping wall) of a platform that gives onto a central court. A stairway splits the composition in two, with roughly equal numbers of figures on either side. The mural contains 47 figures divided into two warrior groups, one associated with jaguars and the other with birds. Jaguar and bird figures are arranged together in small groups, with the jaguar figures clearly having the upper hand, as they are standing and spearing or otherwise attacking the fallen bird figures.

Amid the chaos of the battle scene, two bird-warrior figures stand erect on either side of the stairway, near the balustrade (Figure 3.1) and thus form a central focal point of the composition as seen from any vantage on the plaza. All

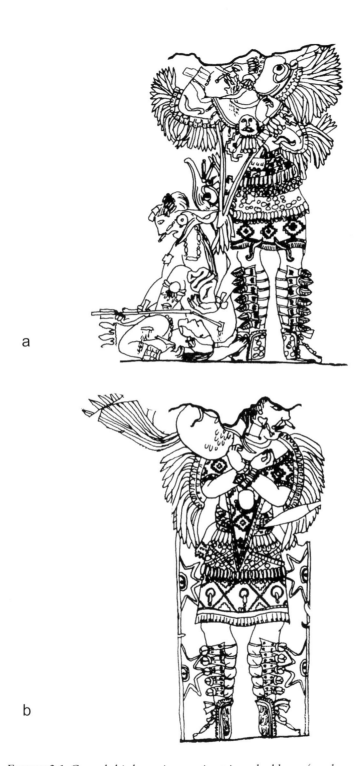

a

b

FIGURE 3.1. Cacaxtla bird-warrior wearing triangular blouse (*quechquemitl*) usually asso-
ciated with females. (*All drawings by Rex Koontz.*)

other bird figures are falling or already down, further marking these figures as somehow more central than the others. Both of the standing figures are shown frontally from the neck down, unlike all other bird-warrior figures in the mural, who are depicted with the body in profile. These standing, frontal, bird figures are given elaborate costuming and, in one case, a unique frame consisting of half-star motifs. Clearly these figures are key to the composition, and one must assume, given their centrality and unusual postures, that they are fundamental to the meaning of the program.

The close similarity in facial, body, and costume characteristics in the two standing bird figures strongly suggests that this is the same figure represented twice (Carlson 1993:219). While the single identity of these two representations is fairly certain, the gender of the figure is less clear. Although the figure is surrounded by male warriors, the triangular blouses (quechquemitl) are indicative of female garments at Cacaxtla (in the figurines of Xochitecatl; Serra Puche 2001) and throughout later Central Mexican art. Further, no loincloth is evident for this figure, although it is the male marker *par excellence* and is clearly visible in the great majority of the other Cacaxtla warrior figures of both groups. McCafferty and McCafferty (1994) rightly point out numerous gender female associations in this central bird figure and suggest that the entire program revolves around the capture of this figure. The authors hypothesize that the figure is a biological female who is possibly the link between the jaguar and bird groups in the form of a maternal ancestor.

The ceramic figures from Xochitecatl also present female clothing in contexts that are approximately contemporary with the painting of the Battle Mural (Serra Puche 2001). Many of these figures wear the quechquemitl, but both the pose and the context differ significantly from those of the Cacaxtla figure. The predominant poses are with the hands held in the air to either side of the body, or the hands held at the sides near the hips. No published examples show the specific crossed-arm pose of the Cacaxtla figure. Further, these female figures are cached in a stairway and form what Serra Puche has described as a female life cycle when taken together. Even the enthroned warrior women, the type that most resembles the Cacaxtla figure in subject matter, have none of the other key diagnostic characteristics of that figure, such as the bird headdress, the crossed arms, or the feathered wings. All this suggests that the Cacaxtla figure is not a direct quotation of Xochitecatl ceramic figure elements, nor does it seem to be involved directly in the same narrative as that of the Xochitecatl caches where these figures were found.

While the Cacaxtla quechquemitl figure may not be directly connected to the Xochitecatl figures, I agree with McCafferty and McCafferty (1994) that the

quechquemitl does indicate important female gender associations. The earlier identification of the figure as biologically female and thus a maternal ancestor is more problematic, especially given what I argue are striking similarities in dress and presentation between the Cacaxtla figure and acceding male Gulf Coast rulers, and the attendant possibility that the Cacaxtla artists are identifying region and/or ethnic affiliation with this garment.

INVESTITURE AT EL TAJÍN AND THE BATTLE MURAL

The evidence for Gulf Coast–Cacaxtla resemblances begins with a scene from the Mound of the Building Columns at El Tajín, a major public program at the center of the site. Recent reconstructive work by Patricia Castillo Peña (1995) and Sara Ladrón de Guevara (1999) has given us a crucial figure in its entirety (Figure 3.2a). The figure wears a cape, a sign of high rank and rare in the iconography of the site, and a quechquemitl, even rarer in the iconography of Tajín. The costume is very similar to one example of the principal Cacaxtla bird figures (Figure 3.2b; Finegold 2004). Further, the crossed-arm pose combined with a frontal presentation is also very similar to the stance of the Cacaxtla figure. The combination of female costume associations and pose in the two programs is striking and cannot be explained by coincidence or chance. All these elements are rare in the respective iconographies of the sites: at Tajín, in the dozens of scenes shown in the public iconography of the site, there is only one other depiction that includes a possible quechquemitl (Kampen 1972: fig. 38). This latter scene is lamentably fragmentary but does form part of the same series of rites in which the preserved quechquemitl-wearer appears. At Cacaxtla, the quechquemitl seems to be unique to the bird-warrior figure. In sum, one may say that the particular quechquemitl-wearer whose pose includes crossed arms is restricted to these two contexts and that the similarities between the Cacaxtla and Tajín figures far outweigh the similarities they share with any other figure in their respective iconographies.

That said, however, the narrative contexts in which the figures occur are very different. We have already remarked that the Cacaxtla figure is shown amidst a violent rite to which the fellow bird-warriors are clearly subjected. The Tajín figure, by contrast, is not subjected to any such sacrifice, but instead is undergoing the final act of an elaborate investiture ceremony. To explore this further, we need to look closely at the narrative context of the Tajín figure and compare our reading to that of Cacaxtla.

The Tajín figure is the central actor in a three-figure composition (Figure 3.3b). The figure to the left of our protagonist grasps a baton with both hands,

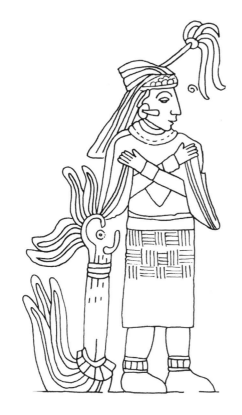

a

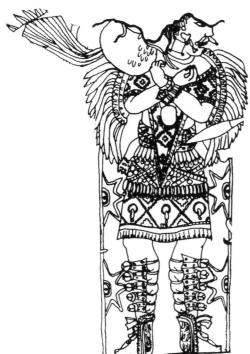

b

FIGURE 3.2. Quechquemitl-wearers at Tajín: *a*, Mound of the Building Columns, detail; *b*, Cacaxtla, Battle Mural, detail.

while the figure on the right presents a long, rectangular object that seems very pliable. The piece has a woven pattern that also appears in elements of costume at the site, suggesting that the material is cloth. The figure holding the cloth wears the mask of a very specific deity figure at Tajín. This same deity is found, along with the baton and another version of the cloth, in the culminating scene from the main ball court at the site (Figure 3.3a).[2] Here the deity presents both objects to a human figure on the left, much as the figures in the initial Tajín scene present the objects to the figure in the quechquemitl. These two items—the baton and cloth—occur together only in these two scenes. Further, the same Tajín deity manipulates one or both in each of the scenes, strongly suggesting that the ball court and column scenes are cognate. These two objects are central not only to the single ball-court scene but to the entire ball-court narrative, appearing separately in other scenes in the ball-court program. I have argued (Koontz 2008), building on the work of Wilkerson (1984) and others, that this scene represents the investiture of the human figure with the sacralized baton and cloth, the latter given by the gods. If this argument is accepted—and the donation of the principal power items by a chief deity after sacrificial acts by the humans certainly follows Mesoamerican norms—then it follows that both the ball-court scene and the columns scene are representations of the Tajín investiture rites. Further, the figure with the quechquemitl in the columns scene (Figure 3.3b) is the person being invested, given that he or she is the figure to whom the other two figures are presenting the objects.

From our close iconographic reading of the El Tajín scene with quechquemitl, then, we have a narrative context in which the quechquemitl-wearer is being invested with the objects of political power at the site. The costume and pose of the invested Tajín figure not only link the imagery directly with Cacaxtla, but also raise the question of the gender of the invested figure, due largely to the quechquemitl as a central part of the costume. We have noted the female costume associations and the hypothesis that the Cacaxtla figure is a biological female. I believe the similar Tajín figure may be identified as male, however, based on evidence internal to Tajín monumental art. The most important evidence for a male identification is the feathered staff headdress worn at the forehead. At the Mound of the Building Columns, this headdress is associated exclusively with an otherwise clearly male figure identified glyphically in this program as 13 Rabbit, as indicated by his name glyph directly above the image of a figure, with the loincloth that marks males in Tajín art (compare Figures 3.2a and 3.4b).[3]

In the end, it may not be surprising that a garment strongly marked as gender female appears on the Gulf on a ruling male. The quechquemitl in its public representations may have been as much about referencing certain female deities as it was about identifying biological females. It has been argued that this was the

FIGURE 3.3. Accession ceremonies at El Tajín with baton and cloth: *a*, South Ball Court Panel 5; *b*, Mound of the Building Columns.

case in the art of northern Yucatan during this period and slightly later, where rulers donned female dress and the quechquemitl to impersonate female deities and thus associate themselves with the wealth (from weaving), creation myths around the goddess, and even military power that seems to have been associated with the complex in this area (Kowalski and Miller 2006; Stone 1999). Classic Maya rulers from the central lowlands also donned women's clothing (Looper 2002), and the auto-sacrifice of the male member so prevalent in Classic Maya art and text has been interpreted as the appropriation by the male ruler of female fecundity (Stone 1988). Quechquemitl representations in the art of Teotihuacan also display patterns that may indicate something beyond simply indicating

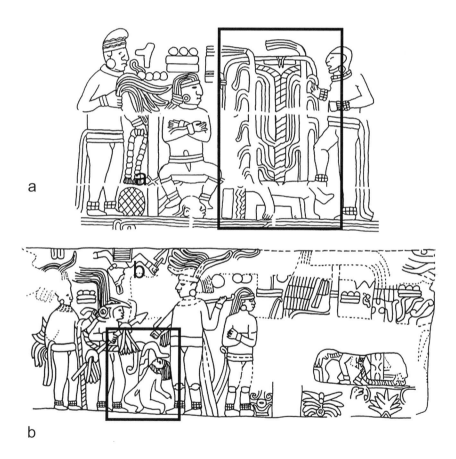

FIGURE 3.4. Evisceration at Tajín (Mound of the Building Columns, detail).

female gender. Séjourné (1966) notes that Teotihuacan female figurines of any sort make up a very small part of her corpus (310 of over 22,000), and yet with six exceptions the females all wear the quechquemitl. The small number of female figurines has indicated to some scholars that the female figures are not ritualists but deities, and indeed there is a vital literature on the centrality of a female deity complex at the site (Berlo 1992). Both major founts of Cacaxtla imagery, Teotihuacan and the Maya, seem to employ the quechquemitl and other female costume elements in public art, not only or even mainly to designate human females, but also to indicate female supernaturals and female fertility associations.

Anawalt (1982) notes that for the later Mexica, the quechquemitl was restricted to ritual and was not worn as an everyday garment, female or otherwise. The Mexica associated the quechquemitl exclusively with female deities and their impersonators. Rather than tying the garment to some earlier Teotihuacan or Toltec tradition, however, the Mexica associated the garment with the Gulf Coast and specifically with a female deity (Tlazolteotl) that they associated with the Gulf Huasteca. Further, Anawalt and especially Stark et al. (1998) note the importance of cotton to the political and economic structure of the Gulf Coast. The weaving of fine garments such as the quechquemitl, as well as the importance accorded patron deities associated with the activity, indicate how cloth and weaving play an integral part in both the female and economic spheres. In this same context, recall that the manipulation of cloth is a basic component of political investiture at El Tajín (Figure 3.3a–b).

Another important path to understanding Gulf Coast female deities is through their association with fecundity. Building on the relationships between the Postclassic Gulf Coast and female deities associated with fecundity already articulated by Nicholson (1971), Hasel (1997) has posited a Gulf Coast cult of related female deities associated with fecundity and human reproduction that may be traced back to the period that is our concern, the Epiclassic. All this data taken together supports the notion that Gulf Coast rulers were calling on supernatural female associations when they donned the quechquemitl. What is less clear given the arguments above is how these female deity cults formed part of a larger religio-political whole manipulated to varying degrees by elites up and down the coast. Characterizations of cult meanings using almost exclusively highland materials (mainly Aztec) could be misleading. Highland peoples often construed the Gulf Coast peoples as the fecund, oversexed "other," ripe for association with fecund, oversexed female deities but not necessarily in line with the more variegated roles of those deities in the Gulf Coast cultures themselves.

The importance of female deity cults on the Epiclassic Gulf Coast helps us contextualize the quechquemitl worn by the (male) Tajín ruler on investiture,

although the deity system behind these associations has yet to be adequately explained. The uniform of the comparably posed Cacaxtla quechquemitl-wearer is not simply women's dress, however: there are also the avian characteristics that clearly identify the figure as part of the bird-warrior group.

The avian characteristics of the Cacaxtla quechquemitl-wearer include a bird helmet mask (Figure 3.1a; now largely lost) and feathers lining the upper part of the arms. One or both of these items are found on all other bird-warriors who have not been significantly dismembered, and neither is found on the victorious jaguar-warriors, indicating that these are indeed diagnostic markings. There is one other example of feathered arms in the Cacaxtla corpus that forms an interesting comparison with the quechquemitl-wearer: in the earlier "Star Chamber," a figure who is clearly female holds her hands up in the pose of the Xochitecatl figures while she dances or otherwise moves behind a frame lined with star motifs. Her upper arms are clearly lined with feathers, not unlike those of the quechquemitl-wearer, and the star motifs behind the figure are comparable to those lining the frame behind that figure. Carlson (1991) has suggested that these figures with feathered arms and star frames may be associated with a cult of war tied to Venus. That said, the Star Chamber figure does not wear a quechquemitl or any other upper garment, making an equation of the two figures doubtful. It is likely that the later artists of the Battle Mural were drawing on an indigenous association of the feathered arm figures with war and ritual violence, but this does not explain the full iconographic complex seen in the later example.

Beyond the confines of Cacaxtla iconography, the feather-lined arms are also diagnostic of a host of elite personages depicted on Southern Veracruz pottery of the period (Von Winning and Gutiérrez Solana 1996); and an important pre-sacrificial dance with a similar avian figure is celebrated throughout the Gulf Coast and into Oaxaca (Koontz 2008; Urcid 1993). It is interesting to note that Cacaxtla has long been thought to occupy a central place in the trade routes that would have crossed the Gulf Coast to Oaxaca. While the avian figure in the dance identified by Urcid does not wear the quechquemitl or other identifiably female garb, the figure does consistently appear in scenes of elite gatherings and investiture ceremonies, the latter most clearly at El Tajín. In this way, the avian markings of the Cacaxtla figure are, like the quechquemitl itself, a sign of very high rank in the public art of the Gulf Coast and specifically may be connected to political investiture.

While the Cacaxtla figure is dressed in elite Gulf Coast dress, it would be difficult to argue that this quechquemitl-wearer is undergoing an investiture rite, as is the case in the Tajín quechquemitl figure. The Tajín figure appears in a scene depicting the culmination of sacrificial rites and the presentation of key power

objects, whereas at Cacaxtla the quechquemitl-wearer is the key figure in a group being tortured and sacrificed. In one depiction of the quechquemitl-wearing figure in the murals (Figure 3.1a), the figure is being stabbed just below the eye with a lance, while all around him fellow bird figures are being eviscerated, including the figure directly at his feet.

One of the most striking and grisly features of the Cacaxtla Battle Mural is the evisceration of the defeated bird figures (Figure 3.1a, lower figure; Foncerrada de Molina 1993). The removal of entrails from the sacrificial victim is yet another common point between the Cacaxtla murals and the Tajín investiture program. In the sacrifices leading up to the investiture with quechquemitl at Tajín, figures are consistently eviscerated (Figure 3.4). Two examples are outlined in the single composition seen here; at least four other examples may be cited throughout the program. Sacrifice by evisceration was crucial to the rites of investiture described in this program, but they do not appear elsewhere at Tajín. In Tajín imagery, the evisceration sacrifice is paired specifically with the quechquemitl-wearing personage, here in the person of 13 Rabbit, shown several times in this scene, who accedes to power later in the program. What is important to note here is that the example of organized violence centered around evisceration at Tajín is not a generalized symbolic complex, but one specifically related to investiture at that site.

When we return to the Cacaxtla imagery (Figure 3.1a), then, we see that the combination of a central quechquemitl-wearing figure and evisceration is directly analogous to the Tajín investiture ceremonies documented at the Mound of the Building Columns. The difference is the status of the quechquemitl-wearer: whereas in the Tajín imagery the quechquemitl-wearer comes to power through the evisceration sacrifice (and other rites), in Cacaxtla this figure and the entourage are tortured, humiliated, and sacrificed. In short, the Cacaxtla program may be read as an inverse image of the Tajín accession—a specific statement that inverts all the crucial terms of Gulf Coast power imagery. Here appropriation seems to be employed to denigrate the symbol system appropriated.

Other Cacaxtla imagery may be related to Gulf Coast political symbol systems. In the murals of Cacaxtla's Red Temple, we see a personage costumed in what has been rightly identified as the costume of the Classic Maya God L, a merchant and underworld deity (Baird 1989; Taube 1992; Carlson 1993). These Maya identifications, however, may also be read as Gulf Coast power symbols and goods (Figure 3.5a). For example, close observation reveals that the staff the figure is carrying is not the walking stick often carried by the Maya deity, but a short baton, which, as we have already seen, is a crucial item in Gulf Coast investiture ceremonies (Figure 3.5b). Even more widespread in Gulf Coast imagery is the

string of beads that hangs from the Cacaxtla figure's chest. These blue-green beads —almost certainly jade—are seen in this configuration as a key offering or tribute item up and down the Gulf Coast during this period (Figure 3.6a–b). The string of beads is often paired with a bunch of feathers in Classic Veracruz iconography from Tajín to south-central Veracruz (Figure 3.7a–b; Koontz 2008).

A bunch of feathers very similar to that appearing as tribute in Veracruz appears prominently in the array of goods in the Cacaxtla backpack (Figure 3.8a–b; Finegold 2004). Together with the string of beads, the Cacaxtla figure is bringing two of the major items used in Gulf Coast political ceremonies. Add to this the baton he is carrying, a key item specifically in the Gulf Coast investiture ceremonies (Figure 3.5), and the Cacaxtla backpacker carries close to a full complement of Gulf Coast political gear. This is not to say that the earlier identification with the Maya God L is mistaken: on the contrary, the Classic Veracruz and Maya iconographic systems shared a number of fundamental elements. The point of this brief iconographic foray into the Cacaxtla backpack figure is that he may be seen to have Gulf Coast connections in addition to the Maya relations already cited. The Gulf Coast elements in this figure may be directly connected to items and rites of political power, but here the imagery affirms Gulf Coast ideals of power, rather than negating or inverting them, as we saw in the Battle Mural. It is interesting to note that this backpack figure is earlier than the Battle Mural (Santana Sandoval and Delgadillo Torres 1990), and at some time in the interim, the attitude toward Gulf Coast power imagery seems to have shifted, at least as expressed in this very public imagery. Complicating this historical scenario further is the fact that both Cacaxtla works are done in a similar style, and there seems to be no great shift in the material culture of the site during this period (López de Molina 1979; Santana Sandoval and Delgadillo Torres 1990). In the interim, however, a shift in the attitude toward Gulf Coast political iconography has taken place, suggesting that a simple scenario of Olmeca-Xicalanca hegemony during the Epiclassic, or rule by any other Gulf Coast group, is suspect. Instead, it seems that the designers of Cacaxtla could use Gulf Coast symbolism in a variety of ways without thereby indicating Gulf Coast rule.

What we can conclude from this iconographic analysis is that Cacaxtla and the Gulf Coast shared a number of significant iconographic elements, as several earlier scholars have intimated. Here we identified especially close relations with the public programs at Tajín, but large amounts of the iconography may also be found in contemporary south-central Veracruz imagery. This is hardly surprising: there is a long history of scholarship tying Cacaxtla to the Olmeca-Xicalanca (Foncerrada de Molina 1993; McVicker 1985; Muñoz Camargo 1972), a little-understood group with important south-central Veracruz ties. That said, it is clear that even when the

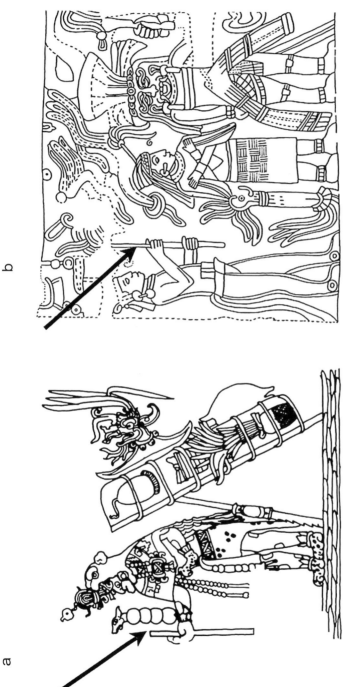

FIGURE 3.5. Power objects at Cacaxtla: *a*, Red Temple Murals, detail; *b*, Tajín, Mound of the Building Columns, detail.

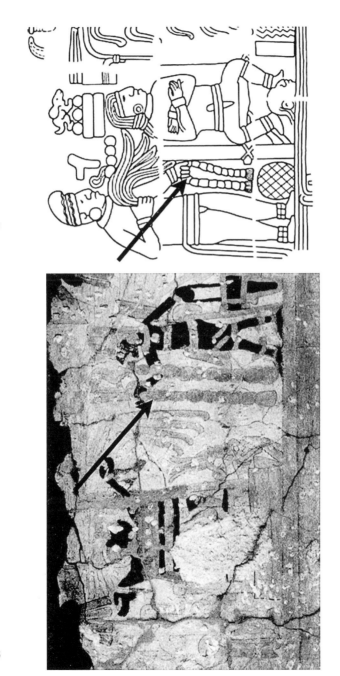

FIGURE 3.6. Strings of beads as tribute or offering on the Gulf Coast: *a*, Las Higueras, Structure 1 Murals, detail; *b*, Tajín, Mound of the Building Columns, detail.

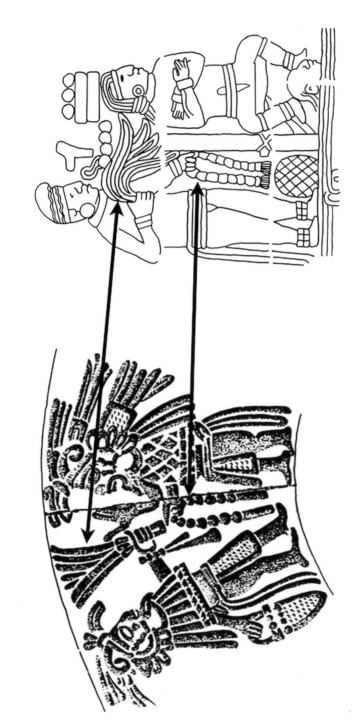

FIGURE 3.7. Strings of beads paired with feather bundle as tribute or offering on the Gulf Coast: *a*, Relief ceramic, Rio Blanco region; *b*, Tajín, Mound of the Building Columns, detail.

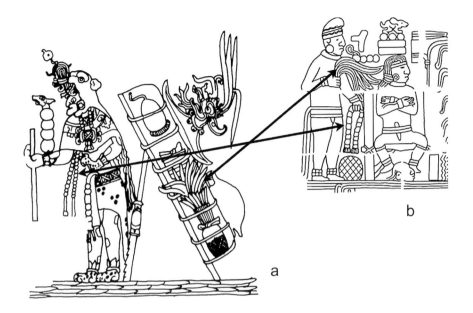

FIGURE 3.8. Beads and feather bundles at Cacaxtla: *a*, Red Temple Murals, detail; *b*, Tajín, Mound of the Building Columns, detail.

borrowings are identified, Cacaxtla's imagery does not simply mimic that of the Gulf Coast. The style remains indigenous and much more reminiscent of the Maya, and the borrowed iconography is inserted into situations very different from those in which they are found in Gulf imagery. The designers of Cacaxtla's program could play with and even invert principles of Gulf Coast iconography, such as the investiture of the quechquemitl-wearer. What this may mean for Cacaxtla history and the role of the Olmeca-Xicalanca, El Tajín, and other Gulf polities remains an open question.

NOTES

1 Metaphorical or other allusions to violence have been identified at the site (Headrick 2003), but nothing like the naturalistic renditions of Cacaxtla.

2 Scholars continue to debate the identity of this deity. The curved fang, other characteristics around the mouth, and the relationship to lightning suggest the Central Mexican Storm God, later called Tlaloc by the Aztec. At the same time, the deity performs the functions later associated with the Central Mexican god Quetzalcoatl, especially in that deity's role as creator god.

3 John Machado (2000) notes that the feathered staff headdress is associated with a Tajín Maize God in a program (Structure I) that is concerned with supernaturals.

REFERENCES CITED

Anawalt, P. R.
 1982 Analysis of the Aztec Quechquemitl: An Exercise in Inference. In *The Art and Iconography of Late Post-Classic Central Mexico*, edited by E. H. Boone, pp. 37–72. Dumbarton Oaks, Washington, D.C.

Baird, E.
 1989 Stars and Wars at Cacaxtla. In *Mesoamerica after the Decline of Teotihuacan, A.D. 700–900*, edited by R. A. Diehl and J. C. Berlo, pp. 105–122. Dumbarton Oaks, Washington, D.C.

Berlo, J. C.
 1992 *Art, Ideology, and the City of Teotihuacan.* Dumbarton Oaks, Washington, D.C.

Carlson, J. B.
 1991 *Venus-Regulated Warfare and Ritual Sacrifice in Mesoamerica: Teotihuacán and the Cacaxtla "Star Wars" Connection.* University of Maryland Center for Archaeoastronomy, College Park.
 1993 Venus-Regulated Warfare and Ritual Sacrifice in Mesoamerica. In *Astronomies and Cultures: Papers Derived from the Third Oxford International Symposium on Archaeoastronomy*, edited by C. Ruggles and N. Saunders, pp. 202–252. University Press of Colorado, Boulder.

Castillo Peña, P.
 1995 *La expresión simbólica del Tajín.* Instituto Nacional de Antropología e Historia, Mexico.

Diehl, R.. and J. C. Berlo.
 1989 *Mesoamerica after the Decline of Teotihuacan, A.D. 700–900.* Dumbarton Oaks, Washington, D.C.

Finegold, A.
 2004 Cacaxtla: Iconographic Interactions with El Tajín. Senior honors thesis, University of Houston.

Foncerrada de Molina, M.
 1978a Reflexiones en torno a la pintura de Cacaxtla. *Comunicaciones del Proyecto Puebla-Tlaxcala* 15:103–130.
 1978b The Cacaxtla Murals: An Example of Cultural Contact? In *Ibero-amerikanisches Archiv., neue Folge*, pp. 141–160. Berlin.
 1980 Mural Painting in Cacaxtla and Teotihuacán Cosmopolitism. In *Third Palenque Round Table*, edited by M. Greene Robertson, pp. 183–198. University of Texas Press, Austin.
 1993 *Cacaxtla: La iconografía de los olmeca-xicalanca* 1. Universidad Nacional Autónoma de México, Instituto de Investigaciones Estéticas, Mexico.

García Cook, A.
 1981 The Historical Importance of Tlaxcala in the Historical Development of the Central Highlands. In *Handbook of the Middle American Indians*, Supp. 1, edited by J. Sabloff, pp. 244–276. University of Texas Press, Austin.

García Cook, A., B. L. Merino Carrión, and L. Mirambell (editors)
 1995 *Antología de Cacaxtla*, Vol. 1. Instituto Nacional de Antropología e Historia, México, D.F.
Graulich, M.
 1990 Dualism at Cacaxtla. In *Mesoamerican Dualism/Dualismo Mesoamericano*, edited by R. van Zantwijk, R. d. Ridder, and E. Braakhuis. RUU-ISOR, Utrecht.
Hasel, U.
 1997 Die Grosse Göttin der Golfküste. In *Mexiko: Präkolumbische Kulturen am Golf von Mexiko*, edited by J. Rickenbach. Museum Rietberg, Zurich.
Hassig, R.
 1992 *War and Society in Ancient Mesoamerica*. University of Oklahoma Press, Norman.
Headrick, A.
 2003 Butterfly War at Teotihuacan. In *Ancient Mesoamerican Warfare*, edited by M. K. Brown and T. Stanton, pp. 149–170. Rowman Altamira Press, Lanham, MD.
Koontz, R.
 2008 Iconographic Interaction between El Tajín and South Central Veracruz. In *Classic Veracruz: Cultural Currents in the Ancient Gulf Lowlands*, edited by P. J. Arnold III and C. A. Pool. Dumbarton Oaks, Washington, D.C.
Kowalski, J., and V. E. Miller
 2006 Textile Designs in Sculptured Facades of Northern Maya Architecture. *Ancient America* (Special Publication 1):154–183.
Kubler, G.
 1980 Eclecticism at Cacaxtla. In *Third Palenque Round Table, 1978*, pp. 163–172. University of Texas Press, Austin.
Ladrón de Guevara, S.
 1999 *Imagen y pensamiento en El Tajín*. Universidad Veracruzana, Xalapa.
Lombardo de Ruiz, S.
 1986 *Cacaxtla: El lugar donde muere la lluvia en la tierra*. Secretaría de Educación Pública, Mexico City.
López de Molina, D.
 1979 Excavaciones en Cacaxtla, Tercera Temporada. *Comunicaciones* 16:141–148.
Looper, M.
 2002 Women-Men (and Men-Women): Classic Maya Rulers and the Third Gender. In *Ancient Maya Women*, edited by T. Ardren, pp. 171–202. AltaMira Press, Walnut Creek, CA.
Machado, J.
 2000 The Structure "I" Murals of El Tajín: Standing at the Edge of the Underworld. M.A. thesis, University of Texas at Austin.
McCafferty, S., and G. McCafferty.
 1994 The Conquered Women of Cacaxtla: Gender Identity or Gender Ideology? *Ancient Mesoamerica* 5:159–172.

McVicker, D.

1985 The "Mayanized" Mexicans. *American Antiquity* 50(1):82–101.

Miller, M. E..

1986 *The Murals of Bonampak*. Princeton University Press, Princeton.

Muñoz Camargo, D.

1972 *Historia de Tlaxcala*. Porrúa, Mexico City.

Nagao, D.

1989 Public Proclamation in the Art of Cacaxtla and Xochicalco. In *Mesoamerica after the Decline of Teotihuacan, A.D. 700–900*, pp. 83–104. Dumbarton Oaks, Washington, D.C.

Nicholson, H. B.

1971 Religion in Pre-Hispanic Central Mexico. In *Archaeology of Northern Mesoamerica*, edited by G. F. Ekholm and I. Bernal, pp. 395–446. Handbook of Middle American Indians Vol. 10, R. Wauchope, general editor. 16 vols. University of Texas Press, Austin.

Quirarte, J.

1983 Outside Influence at Cacaxtla. In *Highland-Lowland Interaction in Mesoamerica*, pp. 201–221. Dumbarton Oaks, Washington, D.C.

Santana Sandoval, A., and R. Delgadillo Torres

1990 Cacaxtla durante la transición del período Clásico al Postclásico. In *Mesoamérica y Norte de México: Siglo IX–XII/ Seminario de Arqueología "Wigberto Jiménez Moreno,"* pp. 281–288. Museo Nacional de Antropología/Instituto Nacional de Antropología e Historia, Mexico City.

Séjourné, L.

1966 *El lenguaje de las formas en Teotihuacán*. México: Fondo de Cultura Económica.

Serra Puche, M. C.

2001 The Concept of Feminine Places in Mesoamerica: The Case of Xochitécatl, Tlaxcala, Mexico. In *Gender in Pre-Hispanic America*, edited by C. Klein, pp. 255–283. Dumbarton Oaks, Washington, D.C.

Stark, B., L. Heller, and M. Ohnersorgen

1998 People with Cloth: Mesoamerican Economic Change from the Perspective of Cotton in South-Central Veracruz. *Latin American Antiquity* 9(1):7–36.

Stone, A.

1988 Sacrifice and Sexuality: Some Structural Relationships in Classic Maya Art. In *The Role of Gender in Pre-Columbian Art and Architecture*, edited by V. E. Miller, pp. 75–103. University Press of America, Lanham, MD.

1999 Architectural Innovation at the Temple of the Warriors, Chichen Itza. In *Mesoamerican Architecture as a Cultural Symbol*, edited by J. K. Kowalski, pp. 298–319. Oxford University Press, Oxford.

Taube, K. A.

1992 *The Major Gods of Ancient Yucatan*. Dumbarton Oaks Research Library and Collection, Washington, D.C.

Urcid, J.
 1993 Pacific Coast of Oaxaca and Guerrero: The Westernmost Extent of Zapotec Script. *Ancient Mesoamerica* 4(1):141–165.

Von Winning, H., and N. Gutiérrez Solana
 1996 *La iconografía de la cerámica de Río Blanco, Veracruz.* Universidad Nacional Autónoma de México/Instituto de Investigaciones Estéticas, Mexico.

Webster, D.
 2000 The Not So Peaceful Civilization: A Review of Maya War. *Journal of World Prehistory* 14(1):65–119.

Wilkerson, S. J. K.
 1984 In Search of the Mountain of Foam: Human Sacrifice in Eastern Mesoamerica. In *Ritual Human Sacrifice in Mesoamerica*, edited by E. H. Boone, pp. 101–132. Dumbarton Oaks, Washington, D.C.

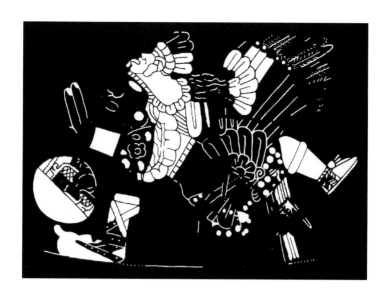

Section II
Ballgames and Boxing

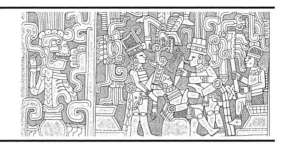

HUMAN SACRIFICE IN THE ICONOGRAPHY OF VERACRUZ BALLGAME SCULPTURES

John F. Scott

Human sacrifice is frequently represented in reliefs on the ritual rubber-ball game of ancient Mesoamerica and in the portable stone paraphernalia associated with the game. The reliefs are generally late, culminating in the Epiclassic, while the portable stone paraphernalia appear earlier in burials—probably of ballplayers. In this article, I review the evidence for ritual violence first in the stone paraphernalia through time, then in the late reliefs showing the ballgame-related rituals. The ballgame has long been recognized as one of the principal features of the Mesoamerican culture area. Although it is not restricted solely to Mesoamerica (Kirchhoff 1981 [1952]:6–7)—being found also in Amazonia, the Greater Antilles, and parts of the Greater Southwest—competitive versions of the game played in architectural ball courts are purely Mesoamerican. The ball courts also served as places of ritual human sacrifice, although such sacrifice may not *always* have been directly associated with the game itself. Pre-Columbian ritual manuscripts feature deities engaged in sacrifice within I-shaped ball courts, while early colonial manuscripts painted by native artists show mortals playing the game in those courts. The texts of these manuscripts emphasize the use of ball courts as places of sacrifice.

YUGUITOS

The earliest documented depiction of ballgame players comes from a step-and-chamber tomb in western Mexico. Found in the Early Formative site of El Opeño in Michoacán state (Oliveros 1974), a group of ceramic figurines together are interpreted as males playing a game, watched by some reclining female spectators (Figure 4.1). In this same tomb was placed a plain stone *yuguito*, or "little yoke" (Figure 4.2), an object long associated with undocumented finds in northern Olmec-related cultures. A plain, full-size stone yoke and rubber balls

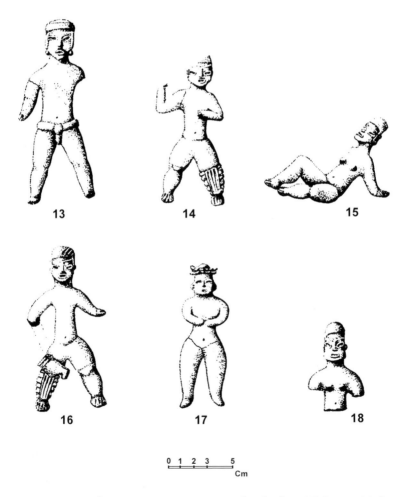

FIGURE 4.1. Ceramic figurines, 13.5 cm maximum height, from El Opeño. Michoacán, Mexico, 1500–800 B.C. (*Museo Nacional de Antropología, Mexico. Drawing after Oliveros 1974: fig. 16.*)

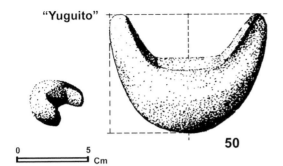

"Yuguito"

0 5
Cm

50

FIGURE 4.2. Stone yuguito, 8 × 11 cm, from El Opeño, Michoacán, Mexico, 1500–800 B.C. (*Museo Nacional de Antropología, Mexico. Drawing after Oliveros 1974: fig. 21.*)

FIGURE 4.3. Dark gray granite yuguito with wounded face, 13 × 13 cm, from Veracruz, 900–500 B.C. (*Princeton University Art Museum, museum purchase, gift of Wallace S. Whittaker Foundation, in memory of Wallace S. Whittaker, Yale Class of 1914. Photo courtesy of the Princeton Art Museum, by Bruce M. White.*)

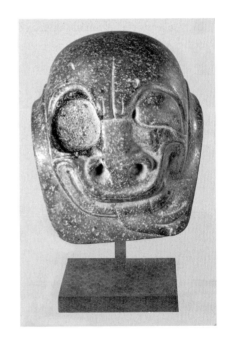

from El Manatí document that the game was also played in the Southern Veracruz heartland of the Olmec culture.[1] Several yuguitos that have carved faces on one side are very informative because of their iconography and the orientation of their reliefs. An example from the Princeton University Art Museum (Figure 4.3) has a grotesque face carved in relief, showing early evidence of violence linked to ballgame paraphernalia. The features on the face suggest the pain and physical mutilation of a player, presumably the opponent: one eyeball has been knocked out, the other eyelid looks puffy from being wounded, and the mouth is

skewed in a grimace, with the tongue split and lolling out in pain. A prime expla-
nation for many pieces of stone equipment is as protection against the solid rub-
ber ball hitting soft tissue directly. This face appears to have been repeatedly hit,
like a hockey goalie prior to the use of face masks. Exactly what part of the body
this yuguito protected can be debated, since the figurines from El Opeño with
which a plain yuguito was found do not appear to wear such objects. Figurine 13
(in Figure 4.1) seems to wear a simple belt and loincloth, which reflects a simpler
version of the game. Present-day hip-ball players from the northwestern Mexi-
can state of Sinaloa still wear such equipment: a deerskin loincloth held in place
by a cotton belt; sometimes an extra heavy leather flap protected the right hip
(Leyenaar 2001:126). The remainder of the ceramic El Opeño players carry
padded handstones (*manoplas*) and wear thick padding around one knee and
upper calf. Some researchers have suggested that the yuguito could fit around the
knee (for example, Bradley 2001:146); however, the orientation of the face on the
Princeton and other carved examples does not support this theory, nor would it
have been possible to keep it attached to the knee while moving. More likely it
served as a fist protector or kind of handstone, suggesting a version of the game
in which the ball could be hit by the stone, not just by the player's torso. Later,
during the Protoclassic, a differently shaped handstone placed within the curve
of the El Carrizal gray yoke (illustrated on the left side of Figure 4.9) and anoth-
er, smaller handstone from a different burial (both seen in Figure 4.4) are
smoothly cylindrical, yellow stones carved with looped handles at one end (Scott
1976:43). On a larger handstone (32.2 cm long) attributed to the Papaloapan

FIGURE 4.4. Yellow stone cylindrical handstones (*bottom*), buried at El Carrizal, Ver-
acruz, Mexico. The larger one, associated with left yoke in Figure 4.9, is 16 cm long.
(*Museo de Arqueología de la Universidad Veracruzana. Photo by author.*)

River basin (Scott 1976: fig. 14), a wrap-around low relief has a feline head with human hands facing the rounded end of the stone opposite the handle, suggesting that it was raised toward the opponent after hitting the ball. Another functional possibility for the yuguito's use was as an early, hollow version of the solid stone, full-round heads known in the Classic Period, discussed below (see Figure 4.5). If yuguitos were used the same way as these were, the U-shaped form could have been looped over a flexible, horizontal torso protector or thick belt. In the cases where one side of the yuguito has a face, it would look at the opponent, as if warning him of his fate.[2]

Notched Stone, Full-Round Heads and *Hachas*

The Early Classic Period produced evidence for the first excavated solid stone head from the Central Veracruz site of El Viejón (Figure 4.5), at which it was associated in a burial with a full-size, smooth stone yoke (Medellín 1960: lám. 110). The head is that of an old man with deeply furrowed wrinkles, placed on top of one half of a yoke already intentionally broken to "kill" it. The heavy lidded, closed eyes of the head indicate that the man is dead and that this sculpture represents his decapitated head. Contemporaneous Maya renderings also show belts

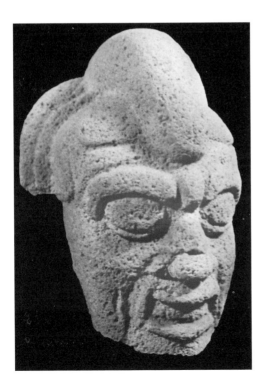

FIGURE 4.5. Stone full-head hacha, 20.5 cm high, from Viejón, Veracruz, Mexico, A.D. 250–550. (*Museo de Antropología de la Universidad Veracruzana. Photo by author.*)

carrying similar small, closed-eye heads, probably made of jade in most cases. The underside of the Viejón head is notched, permitting it to sit on the top of the yoke like a trophy, with the jaw of the head hanging over one outer side.[3] The connection of such heads to the yokes would have been quite unstable, however, and would have required either manual restraint or significant strapping that would partially obscure the imagery.

Decapitation and its display provide more evidence of violence in the service of the ruling elite. Christopher Moser's seminal study found depictions of decapitation in the Late Formative (1973:9–12), although none associated with the ballgame. The Cerro de las Mesas rich Burial II-18 combines a smooth yoke with a possibly decapitated body (Drucker 1943:9). During the Classic Period, many other artistic representations of men wearing trophy heads suggest they represent real heads tied with cords and worn inverted on the chests of triumphant figures (Moser 1973:14). Nevertheless, the connection long proposed for the stone heads as firmly attached to the side of a yoke is supported by representations on numerous figurines throughout Mesoamerica (for example, Whittington 2001: nos. 50, 100) and on a pottery effigy bowl from near Cerro de las Mesas, south-central Veracruz, not from a controlled excavation but probably Late Classic, in which a thin head is shown firmly attached to a yoke (Figure 4.6). Found in the same burial and of the same design is a thin stone *hacha*, a word meaning "ax" in Spanish (Figure 4.7). Of course, this is a misnomer for its function, but the term can be most meaningfully applied to the blade-like form of objects like this one.

My study of the Middle Classic yokes and stone heads from El Zapotal (Scott 1997:123–124), an excavated but incompletely published site also near Cerro de las Mesas, led me to conclude that the lateral tapering of these stone heads began around A.D. 600. It was only fully realized later in the Late Classic, perhaps by A.D. 750, as evinced by an excavated thin stone hacha at Napatecuhtlan, in Central Veracruz (Wilkerson 1990:169–170). The El Zapotal stone heads include some with animal features and open eyes, marking a transition to heads of symbolic character that no longer represent just decapitated victims, although some continue to do so. The thin hacha already discussed from near Cerro de las Mesas (Figure 4.7), even though attributable to the later Late Classic, still represents a trophy head of a kind most commonly rendered in earlier, full-round heads with closed eyes. It has what appears to be a ring through the nose. Although nose rings were commonly worn in life by indigenous peoples of the Intermediate Area, they are not found in Mesoamerica except in West Mexico, where they are worn by ceramic funerary figures along with multiple earrings. The copper and low-arsenic bronze originals rendered in West Mexican figurines probably were introduced from Ecuador directly by a sea route, early in

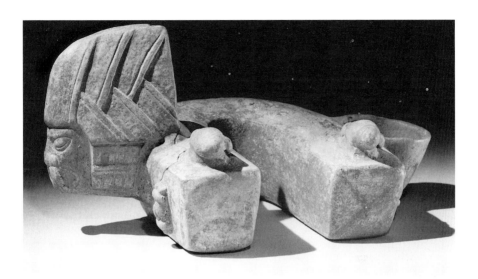

FIGURE 4.6. Pottery effigy vessel of a yoke with an hacha attached, 13 × 22 × 18 cm, found in a tomb near Cerro de las Mesas, Veracruz, Mexico, A.D. 550–750. (*American Museum of Natural History, New York #30.3/2363. Photo by Rota, courtesy American Museum of Natural History Library, negative no. 332084.*)

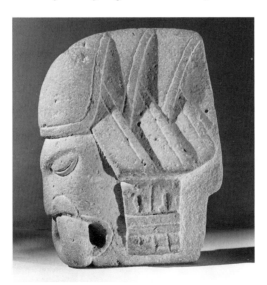

FIGURE 4.7. Stone hacha, 23.5 cm high, found in the same tomb as Figure 4.6, near Cerro de las Mesas, Veracruz, Mexico, A.D. 550–750. (*American Museum of Natural History, New York #30.3/2364. Photo by Rota, courtesy American Museum of Natural History Library, negative no. 332085.*)

the Classic, along with the metallurgical technology (Hosler 1994:89–92), skipping over the rest of Mesoamerica. The use of nose rings may have come into West Mexico from the same Ecuadorian trade. Whittington (2001:190) offers a good alternative suggestion that the thick ring rendered on this Cerro de las Mesas–area hacha was a rope by which it was suspended inverted.[4] Such a rope would have replaced the horizontal nose plug once inserted in the living man as a sign of high rank but then removed by his executioners as a humiliation.

At El Zapotal, in addition to the burials with yokes and hachas, an ossuary was unearthed that may indicate ritual sacrifice. Disarticulated bones were accompanied by sculptures of laughing young boys and richly dressed "Mayoid" women (Figure 4.8). Both of these mold-made figure types associated with the Nopiloa style of south-central Veracruz have a broad head deformation, different from the narrow skulls found in the ossuary. The site has not yet been fully published;[5] however, an analysis of the majority of the skulls by Arturo Romano revealed that all were of adults, mostly women with a specific narrow head deformation caused during infancy (Gutiérrez and Hamilton 1977:31). Therefore, the skulls are not the sacrificed remains of people represented by the ceramic figures accompanying them. The ceramic figures of laughing young boys—and also young girls at other sites—have been interpreted as inebriated children prior to their sacrifice to the god of music and dance. Those richly dressed adult women, perhaps goddess impersonators, were also forced to dance prior to their sacrifice (Heyden 1971:37). It is suggestive that these bones in the ossuary may be of those women. However, they and other figures in the ossuary have no relationship with the ballgame.

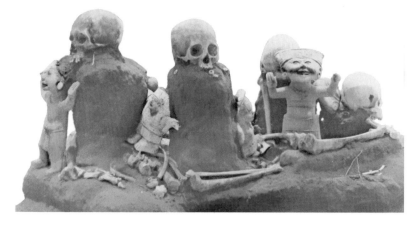

FIGURE 4.8. Ossuary burial with hollow ceramic mold-made figurines of laughing boys and richly dressed women, El Zapotal, Veracruz, Mexico, A.D. 550–750. (*Reconstructed in the Museo de Antropología de la Universidad Veracruzana. Photo by author.*)

Yokes

Full-size yokes, which easily slip sideways around the player's stomach and small of his back, are plain (smooth) or have low-relief images of underworld beings, most commonly toads or jaguars, wrapping around them. The earliest documented yokes with such relief imagery date to the Protoclassic at El Carrizal, Central Veracruz (Figure 4.9), which I published in 1976 and later hypothesized could actually have been worn in the game because of their incurving sides (1991:211). Late Classic yokes are parallel-sided and have a much wider range of iconography; for example, a Cleveland Museum piece has a central human face emerging from interlaced scrolls containing two skulls (Figure 4.10). While the compositional format of the yoke still derives from the wrap-around images of archetypical underworld beings, the specific human figure on this yoke is related to the diadem-wearing pulque god rendered in low relief on the walls bounding El Tajín's South Ball Court (in both celestial friezes, floating over the pulque vat scenes) (García Payón 1973:53). Wilkerson (1984:125) notes that the wrap-around double-body format of these two pulque gods parallels the composition of yokes.[6] The death imagery represented by the two skulls on the sides of the Cleveland yoke relates strongly with a skeletal god half-emerging from a rounded jar observing the heart sacrifice of a ballplayer in the adjoining frame of the northeast panel of the South Ball Court at El Tajín (Figure 4.11). The form of the rounded jar is the same as that carried by the man appearing before the pulque vat in the north-central panel

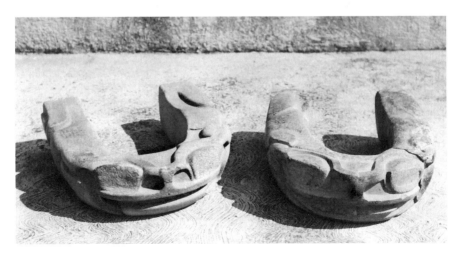

FIGURE 4.9. Pair of toad-relief yokes from adjoining tombs in El Carrizal, Veracruz, Mexico. (*Left*): Gray stone 41 × 39 × 11.5 cm; (*right*): green stone 41 × 35 × 12.5 cm, 100 B.C.–A.D. 100. (*Museo de Antropología de la Universidad Veracruzana. Photo by author.*)

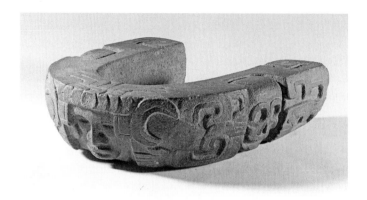

FIGURE 4.10. Stone yoke with anthropomorphic face in center and skulls on the side, 40.6 × 38.2 × 11.8 cm, Veracruz, A.D. 750–950. (*Cleveland Museum of Art, purchase from J. H. Wade fund, #1943.662. Photo ©, courtesy of Cleveland Museum of Art.*)

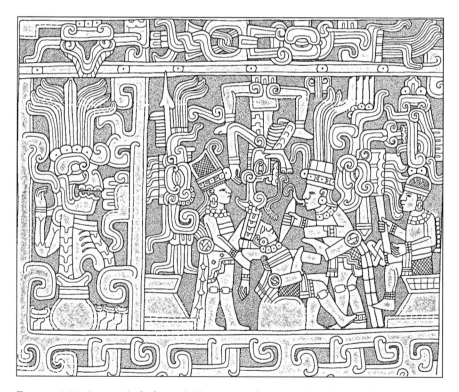

FIGURE 4.11. Stone relief of post-ballgame sacrifice scene from the northeastern wall of the South Ball Court, El Tajín, Veracruz, Mexico, 156 × 198 cm, A.D. 850–1100. (*Drawing by Michael E. Kampen.*)

of the South Ball Court, and similar to the jar associated with the enema ritual of self-sacrifice on Late Classic Maya painted pottery (Scott 1987: no. 63).

Palmas

The aforementioned relief is one of six carved on the vertical sides of the South Ball Court at El Tajín, north-central Veracruz, a site whose main occupation dates are A.D. 850–1100, thereby straddling the Epiclassic and Early Postclassic. I consider these South Ball Court reliefs to belong to the Epiclassic, also called the Terminal Classic, because of the *palmas* worn by the players. Excavations in Veracruz have found palmas only in Epiclassic contexts. At Santa Luisa in 1974, Wilkerson excavated a short palma with a representation of a harpy eagle in an elite burial of the Epiclassic (1984:117–118). He notes that palmas with harpy eagles and vultures, both carrion-eating raptors, are related to sacrifice, specifically documented on Building Columns Sculpture 9 showing the eagle tearing at the entrails of a soon-to-be-decapitated victim (Kampen 1972: fig. 34d). Two tall palmas excavated by Arellanos and Beauregard in 1980 at Rancho El Paraíso in Banderilla, Central Veracruz, were dated by them (1981:158) to the end of the Late Classic or possibly the very beginning of the Postclassic, the transitional period here called the Epiclassic. One of the palmas depicts an aggressive nude male holding a mace and standing atop a very Tajín-like staircase. The other palma is of the same triple-webbed fan design specifically shown worn on each of the five stelae from El Aparicio, north-central Veracruz. I have argued the stelae's Early Postclassic placement based on the site's archaeology (Scott 1982:16).[7] The stelae's iconography correlates very well with the ballplayer decapitation scenes in the Great Ball Court at Chichén Itzá, of the tenth century A.D. Both sites' reliefs show ballplayers whose heads have been removed and seven streams of blood morphing into serpents spraying out from each neck.[8] Each ballplayer at El Aparicio wears a yoke-like belt with a triple-webbed, fan-shaped palma attached to the front. Agüero and Daneels (this volume, Chapter 5) point out that these decapitated men play central roles in these reliefs and are richly dressed, not humiliated like war prisoners. Mural painting 4053 from Las Higueras, in the El Tajín region of north-central Veracruz, shows the triumphant executioner holding up his adversary's severed head (Machado 2003), as do the ball-court reliefs at Chichén. A palma from the Central Veracruz site of Coatepec (Annick Daneels, personal communication 2007) also illustrates such a figure on its back side, although his victim's body is absent.

Numerous palmas show scenes of ritual violence. On a Detroit Institute of Arts example (Figure 4.12), an anthropomorphic figure with a skeletal face stands

on top of a slain man. Maize stalks grow prolifically behind this tableau, suggesting they benefit from the shed blood. Another palma in the Museo Nacional de Antropología converts its entire splayed front into the twisted body of a young man in a loincloth whose hands are tied behind him and whose heart has been excised from an open wound in his chest (Bernal 1968: fig. 91). While these

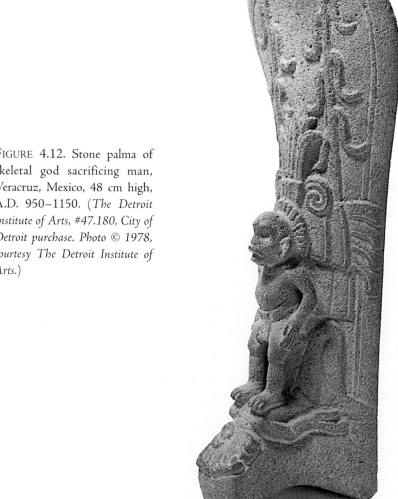

FIGURE 4.12. Stone palma of skeletal god sacrificing man, Veracruz, Mexico, 48 cm high, A.D. 950–1150. (*The Detroit Institute of Arts, #47.180, City of Detroit purchase. Photo © 1978, courtesy The Detroit Institute of Arts.*)

scenes are not specifically located with ballgame paraphernalia or in a ball court, the game is implied because the scenes are on palmas, the only known function of which was to be worn on ballgame belts in ceremonies. We have assumed that these ceremonies preceded and followed the game itself, since Aztec accounts have focused on such dedication ceremonies for a ball court on the night prior to the first game (De la Garza and Izquierdo 1980:326). The Aztecs also made a distinction between an ordinary ball court and the gods' ball court, in which sacrifices were held prior to the beginning of fiestas (Torquemada 1969 [1615]:152, 282, 553). However, recent research has concluded that the relationship between the ballgame and the small stone objects may be more symbolic than functional, in which the ball court and the stone objects express the same cosmology: the yokes represent the underworld, the thick stone heads death and sacrifice, and the palmas and later hachas the upperworld (Roose 2006:251). The court itself is the place where the surface of the earth and the underworld come together (Gillespie 1991:341). The court becomes an *axis mundi*, and the players become cosmograms (Orr and Koontz, this volume, Introduction).

Conclusion

Sacrifice, whether within the gods' ball courts or outside by people wearing equipment associated with the ritual ballgame, clearly is the emphasis of the iconography of the small stone objects throughout Veracruz as well as the architectural reliefs associated with ball courts in north-central Veracruz. The imagery on palmas and some yokes of the Epiclassic are plainly the most specific as to the nature of the sacrificial violence and the context in which it occurred. Earlier stone paraphernalia from the Formative and Classic emphasize the battered heads displayed like trophies when attached to the body of a ballplayer, either around his fist, as I propose yuguitos were used, or hooked over his belt, as were hachas during the Classic and palmas during the Epiclassic. Those worn prior to and after the game would certainly be set to one side, possibly employed as markers on the court and as a reminder to the spectators of the serious consequences to the loser in this sport. As an extension, rulers and other high elites could have worn these objects in other ceremonies as a reminder to their viewers of their role in bringing into balance the forces of the upperworld and the underworld. Yokes and other equipment marked their owners as elite administrators who oversaw sacrifice (Koontz n.d.). Agüero and Daneels (this volume, Chapter 5) similarly conclude that since the Protoclassic the elite attached ritual onto the ballgame in order to present themselves as specialized intermediaries with the gods for the well-being of their community.

NOTES

[1] Ortiz et al. (1992:61–65) excavated several rubber balls, the two largest of which were found next to wooden staffs, while the greenstone smooth yoke was found elsewhere at the site by farmers as part of a double burial.

[2] During the symposium at the 2005 Annual Meeting of the Society for American Archaeology, at which my preliminary version of this paper was presented, Karl Taube and Marc Zender presented a paper, "American Gladiators: Ritual Boxing in Ancient Mesoamerica," proposing that Mesoamericans had a form of boxing in which hand protectors and helmet masks could be worn. Afterward I suggested that yuguitos could have served that purpose. A revised, expanded version of that paper appears in this volume. Reviewing the evidence in the expanded paper, I find the lack of reference to boxing in contact documents problematic, even though images of handstones are cited in Postclassic codices. However, a Nahua form of boxing has been reported ethnologically in Acatlán, Guerrero (illustrated in Zorich 2008).

[3] Another full-round, notched and crested stone head from Coyol, near Cerro de las Mesas, is illustrated by Drucker (1943: pl. 58a) but not discussed; presumably it is from a purchase collection. In Trench 34 at Cerro de las Mesas, Drucker did excavate a rounded animal head of coarse diorite stone he called an hacha (1943:80, pl. 58b), which he placed in his Lower II phase. For this reason, it has been considered Protoclassic. However, I have argued (Scott 1991:208) that Drucker's Lower II includes Early Classic material as well. Of unidentified breadth, its deep proportions and very shallow notch make it a form so aberrant it perhaps should not be considered an hacha at all. Similarly, a very irregular head of porous basalt from El Trapiche excavated in Middle Preclassic contexts (García Payón 1966:180) may serve functionally as a trophy head, as do the hachas, but would not form a set with a yoke.

[4] Other full-round dead-man's heads with nose rings known in the literature include three stone hachas now in the Dumbarton Oaks collection (Lothrop et al. 1957:237, cat. 26, 27A, 29), and a ceramic miniature hacha in a private collection (Goldstein 1987:81, no. 159).

[5] Manuel Torres Guzmán's initial published report of the ossuary accompanying the large Death God in El Zapotal (1972) made no mention of the bones' age or sexing. Gutiérrez and Hamilton state that three skulls were found among the bones, accompanied by four smiling figurines, two articulated, and three Mayoid whistle-rattles (1977:29). In a recent but brief article, Torres (2004:209) contradicts this information, saying there were three smiling figures and one Mayoid woman found with two primary burials and the bones of others.

[6] Koontz, in a forthcoming study (n.d.), suggests that the waterbird beak on these two El Tajín deities relate them to wind gods. Following Wilkerson (1984), he also relates these figures' posture with one bent leg to common positions of low-relief humans wrapped around the exterior of yokes. He relates the position to a "flying impersonator" of the Mixteca in charge of human sacrifices.

[7] The Epiclassic or even Early Postclassic placement seems very hard for many people to accept. As a testament to this resistance, the catalog of the exhibition *The Sport of Life and Death*, containing my chapter and specifically stating their late placement (2001:61), consistently dates all palmas and the El Aparicio stelae in the show to the Late Classic, except in the captions to their two illustrations accompanying my chapter.

8 At El Tajín itself, the shattered trapezoidal relief from the Pyramid of the Niches (Sculpture 7 in Kampen 1972:53) has been reconstructed by Wilkerson (1984) to represent a severed head with blood streams morphing into serpents' heads. Fragments of only three of these serpents' heads remain.

References Cited

Arellano[s], R., and L. Beauregard
 1981 Dos palmas totonacas: Reciente hallazgo en Banderilla, Veracruz. In *La palabra y el hombre*, Vols. 38/39, pp. 144–160. Universidad Veracruzana, Xalapa.

Bernal, I.
 1968 *Three Thousand Years of Art and Life in Mexico, As Seen in The National Museum of Anthropology, Mexico City.* Abrams, New York.

Bradley, D. E.
 2001 *Yuguito*: Kneepad. In *The Sport of Life and Death*, edited by E. M. Whittington, p. 146. Mint Museum of Art, Charlotte, NC.

De la Garza, M., and A. L. Izquierdo
 1980 El *ullamaliztli* en el siglo XVI. *Estudios de cultura náhuatl*, Vol. 14, pp. 315–333. Universidad Nacional Autónoma de México, Mexico, D.F.

Drucker, P.
 1943 *Ceramic Stratigraphy at Cerro de las Mesas, Veracruz, Mexico.* Smithsonian Institution Bureau of American Ethnology, Bulletin 141, Washington, D.C.

García Payón, J.
 1966 *Prehistoria de Mesoamérica: Excavaciones en Trapiche y Chalchuite, Veracruz, México, 1942, 1951, y 1959.* Cuadernos de la Facultad de Filosofía Letras y Ciencias 31, Xalapa.
 1973 *Los Enigmas de El Tajín, 2: Chacmool en la apoteosis del pulque*, pp. 31–57. Colección Científica, Arqueología 3, Instituto Nacional de Antropología e Historia, Mexico, D.F.

Gillespie, S. D.
 1991 Ballgames and Boundaries. In *The Mesoamerican Ballgame*, edited by V. L. Scarborough and D. R. Wilcox, pp. 317–345. University of Arizona Press, Tucson.

Goldstein, M. M.
 1987 *Ceremonial Sculpture of Ancient Veracruz.* Hillwood Art Gallery, Long Island University—C.W. Post Campus, Brookville, NY.

Gutiérrez Solana, N., and S. K. Hamilton
 1977 *Las esculturas en terracota de El Zapotal, Veracruz.* Instituto de Investigaciones Estéticas, Universidad Nacional Autónoma de México, Cuadernos de Historia del Arte 6, Mexico, D.F.

Heyden, D.
 1971 A New Interpretation of the Smiling Figures. In *Ancient Art of Veracruz*, edited by O. Hammer, pp. 37–38. Ethnic Arts Council of Los Angeles at the Los Angeles County Museum of Natural History, Los Angeles.

Hosler, D.
 1994 *The Sounds and Colors of Power: The Sacred Metallurgical Technology of Ancient West Mexico.* M.I.T. Press, Cambridge, MA.
Kampen, M. E.
 1972 *The Sculptures of El Tajín, Veracruz, Mexico.* University of Florida Press, Gainesville.
Kirchhoff, P.
 1981 Mesoamerica: Its Geographic Limits, Ethnic Composition, and Cultural Character. In *Ancient Mesoamerica: Selected Readings*, edited by J. A. Graham, pp. 1–10. Peek Publications, Palo Alto, CA. Translated by Norman McQuown in *Heritage of Conquest*, edited by S. Tax, New York: Macmillan, 1952.
Koontz, R.
 n.d. Social Identity and Cosmology at El Tajín. In *The Art of Urbanism: How Mesoamerican Cities Represented Themselves in Architecture and Imagery*, edited by W. Fash and L. López Luján. Dumbarton Oaks, Washington, D.C. In press.
Leyenaar, T. J. J.
 2001 The Modern Ballgames of Sinaloa: A Survival of the Aztec Ullamaliztli. In *The Sport of Life and Death*, edited by E. M. Whittington, pp. 122–129. Mint Museum of Art, Charlotte, NC.
Lothrop, S. K., W. F. Foshag, and J. Mahler
 1957 *Robert Woods Bliss Collection [of] Precolumbian Art.* Phaidon, New York.
Machado, J. L., Jr.
 2003 Veracruz Mural Traditions: Las Higueras, Mexico. Crystal River, FL: Foundation for the Advancement of Mesoamerican Studies, Inc. www.famsi.org/reports/00035/index.
Medellín Zenil, A.
 1960 *Cerámicas de Totonacapan.* Universidad Veracruzana, Xalapa.
Moser, C. L
 1973 *Human Decapitation in Ancient Mesoamerica.* Studies in Precolumbian Art and Archaeology 11. Dumbarton Oaks, Washington, D.C.
Oliveros, J. A.
 1974 Nuevas exploraciones en El Opeño, Michoacán. In *The Archaeology of West Mexico*, edited by B. Bell, pp. 182–201. Sociedad de Estudios Avanzados del Occidente de México, Ajijic, Jalisco.
Ortiz, P., M. del Carmen Rodríguez, and A. Delgado
 1992 Las ofrendas de El Manatí y su possible asociación con el juego de pelota: Un yugo a destiempo. In *El juego de pelota en Mesoamérica*, edited by M. T. Uriarte, pp. 55–67. Siglo XXI, Mexico, D.F.
Roose, N.
 2006 Le Complexe jougs-haches-palmes en Mesoamérique. Thèse de doctorat en Préhistoire, Ethnologie et Anthropologie. Université de Paris—Panthéon Sorbonne.
Scott, J. F.
 1976 Los primeros "yugos" veracruzanos. *Anales del Instituto de Investigaciones Estéticas* 13(46):25–48. Universidad Nacional Autónoma de México, Mexico, D.F. [cover erroneously dated 1978]

1982 The Monuments of Los Ídolos, Veracruz. *Journal of New World Archaeology,* 5(1):10–23. UCLA Institute of Archaeology, Los Angeles.

1987 *Ancient Mesoamerica: Selections from the University Gallery Collection.* University Presses of Florida, Gainesville.

1991 The Evolution of Yokes and Hachas in Central Veracruz. In *The Mesoamerican Ballgame,* pp. 203–213. Mededelingen van het Rijksmuseum voor Volkenkunde, No. 26, Leiden.

1997 Die Entwicklung der Yugos und Hachas im Präkolumbischen Veracruz. In *Präkolumbischen Kulturen am Golf von Mexico,* edited and translated by J. Rickenbach, pp. 119–126. Museum Rietberg, Zurich.

2001 Dressed to Kill: Stone Regalia of the Mesoamerican Ballgame. In *The Sport of Life and Death: The Mesoamerican Ballgame,* edited by E. M. Whittington, pp. 50–63. The Mint Museum of Art, Charlotte, NC.

Torquemada, J. de

1969 [1615] *Monarquía Indiana.* Facsimile edition, Porrúa, Mexico City.

Torres Guzmán, M.

1972 Hallazgos en El Zapotal, Ver. *Boletín del Instituto Nacional de Antropología e Historia* II(2):308–311. Mexico City.

2004 Los entierros multiples en la zona arqueológica de El Zapotal, Veracruz. In *Prácticas funerarias en la costa del Golfo de México,* edited by Y. Lira López and C. Serrano Sánchez, pp. 203–212. Instituto de Antropología de la Universidad Veracruzana and Instituto de Investigaciones Antropológicas de la UNAM, Jalapa and Mexico City.

Whittington, E. M. (editor)

2001 *The Sport of Life and Death: The Mesoamerican Ballgame.* Mint Museum of Art, Charlotte, NC.

Wilkerson, S. J. K.

1984 In Search for the Mountain of Foam: Human Sacrifice in Eastern Mesoamerica. In *Ritual Human Sacrifice in Mesoamerica,* edited by E. H. Boone, pp. 101–132. Dumbarton Oaks, Washington, D.C.

1990 El Tajín: Great Center of the Northeast. In *Mexico: Splendors of Thirty Centuries,* edited by J. Jones, pp. 155–181. Metropolitan Museum of Art, New York.

Zorich, Z.

2008 Fighting with Jaguars, Bleeding for Rain. *Archaeology* 61(6) (Nov.–Dec.): 46–52.

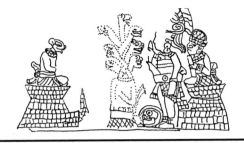

CHAPTER 5

PLAYING BALL— COMPETITION AS A POLITICAL TOOL

Adriana Agüero and Annick Daneels

INTRODUCTION

This paper proposes that Veracruz elites used the drawing power of the ball-game to gain followers and legitimate their status. This political strategy was directly associated with a fertility ritual that included human sacrifice by decapitation. Our interpretation is based on a combination of settlement pattern and iconographic data that speak to Central Veracruz sociopolitical relationships and how political control was achieved by the elites during the Classic Period, which here corresponds roughly to the first millennium A.D. The predominance of the ballgame as an iconographic theme and the ubiquity of ball courts in the region indicate the popularity enjoyed by this form of organized competition, which may be shown to correlate closely with the rise of elite power in the region.

Several archaeological patterns link ballgames and ball-court ritualism with the rise of the elite. Ball courts appear in the principal compound of high-ranking sites, variants of which occur throughout Central Veracruz during at least the Middle and Late Classic Periods, indicating a relationship between power and the ballgame. On the other hand, an iconographic analysis ranking male figures from Protoclassic to Late Classic Central Veracruz also shows the widespread distribution of elements associated with the ballgame, with a large percentage of high-ranking individuals wearing ballplayer attire. We will also emphasize that ritually beheaded ballplayers retain a protagonist role in the imagery. Using these lines of

evidence, we propose that from the Protoclassic Period on, the ballgame in Central Veracruz was inserted into an elite-controlled ritual that involved high-cost paraphernalia (the so-called yoke, *hacha* and *palma* sculptures, discussed in depth by Scott, this volume, Chapter 4), the scroll style, and human sacrifice by decapitation in a principal architectural compound, as a political strategy to achieve and maintain a popular following. Transformed from an apparently secular game or sport (secular in both its connotations of non-religious and very old) into a system of formalized competition, and drawing support from the population through a hierarchical system of teams from local centers, the ballgame allowed elites heading different political entities to gather power, legitimate their position, organize interaction, and resolve both internal and external conflicts during most of the Classic Period. Thus, the Central Veracruz ballgame would clearly be a case in which violence, in the form of a sport, is a fundamental expression of the culture and serves to maintain and reinforce it (see the introduction to this volume). The increase in frequency of war imagery toward the very end of the Classic Period, particularly in north-central Veracruz (Tajín area), would reflect a shift in the political strategy of the elites, which resulted in only a short-lived success: by the end of this period, either the ballgame had worn out its efficiency as an organizing principle in society, or a more heavy-handed control by elites turned out to alienate the support until then granted by the population. In either case, after the first millennium A.D., the Central Veracruz ballgame ceased to play the central role it held in the Classic.

The Territorial Organizations of Central Veracruz

In earlier works (Daneels 2002, 2008), we discussed the presence of small-scale, state-level entities in Central Veracruz during the Classic Period. Based on a settlement pattern study of a 1,200-km^2 survey in the Lower Cotaxtla Basin (Figure 5.1), we argued that the the small size of the territories was due to the relative autonomy of a dispersed population living on estates large enough for self-sufficiency in a low-risk environment. Two types of sociopolitical systems functioned simultaneously during the Classic Period: some were centralized (mainly those that evolved from earlier, Late Formative territories along the alluvial terraces), and others were segmentary (those that arose on newly colonized areas, on less fertile soils). Ball courts occur in both types of system, in every first- and second-order center, but the way they are distributed within the territories varies significantly. In the centralized entities, there was one large ball court at the capital, drawing the population from the whole territory, while second-rank sites were relegated to the frontiers, their small court thus probably used only to mediate

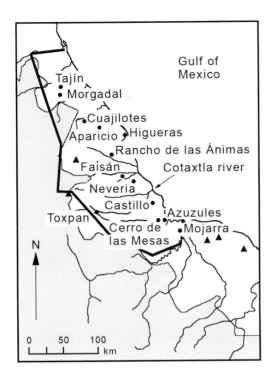

FIGURE 5.1. Map of Classic Period Central Veracruz, showing the principal sites mentioned in the text.

interterritorial interaction (in the way proposed by Kowalewski et al. 1991). In the segmentary entities, the second-rank centers would be distributed throughout the territory, each with tertiary centers nearby, and surround a capital often sporting several ball courts. The size of these political entities was very small, on the order of a 100 km^2, which suggests that the control and promotion of the ballgame, while effective in gathering and maintaining local support, did not allow a major power concentration (much as anticipated by Santley et al.'s 1991 model) (Figure 5.2). Thus, we reached the conclusion that in the particular case of Central Veracruz, the observed political entities were the result of a balance achieved between the centrifugal forces of a large, self-sufficient and dispersed population, with little need for a central government, and the centripetal forces created by the attraction of the ballgame. This interpretation is argued at greater length elsewhere (Daneels 2008), where we stress the relationship between the conditions of ecological abundance and the need for a consensus strategy in order to gather political power. Here we emphasize the role of the ballgame in implementing this strategy.

In the Lower Cotaxtla Basin, the ball courts are part of a standardized architectural layout, called the *standard plan*, which seems to appear probably during

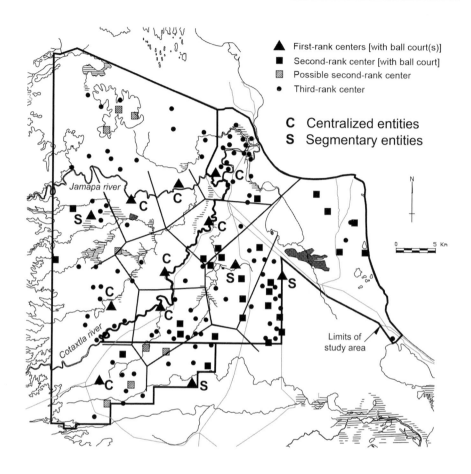

FIGURE 5.2. Classic Period settlement in the lower Cotaxtla Basin, showing differential pattern of distribution of ball courts in centralized (C) and segmentary (S) entities.

the Early (A.D. 100–300) and certainly by the Middle Classic (A.D. 300–700). The main compound consists of a square plaza delimited on the north by the principal pyramid, on the south by a ball court, and on the sides by elongated platforms (Daneels 1997, 2002). The presence of both pyramid and ball court as places of ritual action, and the possible astronomical arrangement of the lateral platforms (Daneels 2002), situates the function of this layout in the realm of the sacred. Other components of the standard plan are a group of subordinate structures that form a secondary plaza adjoining the principal one, limited by low mounds (with possibly administrative and/or commercial functions), one or sev-

eral water reservoirs, and a large platform at some distance from the main pyramid which may have been the elite residence of the ruler.

No courts occur outside this pattern in the Lower Cotaxtla Basin, so their construction is firmly linked to the most important architectural compound of the centers and to the ritual sphere (as administrative or residential compounds are subordinate both in location and volume). They are a mark of political power, as they only exist in first- and second-rank centers, both in centralized and in segmentary entities. They are also very numerous, as no one lived more than one hour away from a court, most at less than half an hour. This pattern suggests that the game was popular, unsurprisingly, considering the continued attraction potential of ballgames even in our modern, jaded society. The form and size of the court and flanking structures suggest the ballgame played was a variant of the hip-ball game, one of the many forms of ballgames practiced in Mesoamerica. This local variant has courts without rings, with players wearing protective gear around the middle (yoke) and occasionally front (palma) and back (hacha) (Ekholm 1946, 1949). The imagery associated with these objects alludes to the underworld (yokes), death (hachas), and heaven (palmas) (Scott, this volume, Chapter4); these symbols reflect the role of the ball court as an *axis mundi* and the game as a way of transiting from the underworld to the divine realm through death.

The pattern of ball courts associated with the main plaza of high-ranking sites, as part of the major ritual architectural compound, seems valid for all Central Veracruz. Although the general orientation of the centers, or the position of the court, may vary (the latter on the side of the major plaza or alongside the principal pyramid), the pattern remains in which ball courts always occur associated with the main architectural compound and the principal pyramid, and only in first- and second-rank centers. This pattern has been observed wherever sufficient survey is available (Daneels 2002): besides the lower Cotaxtla Basin, it is found in the Mixtequilla (Stark 1999), the upper Cotaxtla Basin (Miranda and Daneels 1998), the Nautla Valley (Cortés 1994; Wilkerson 1994,), and the Tlahuanapa Valley around Tajín (Jiménez 1991; Pascual 1998) (Figure 5.3). While the presence of several ball courts at a segmentary capital is not uncommon, Tajín is exceptional with 17 ball courts (Brüggemann 1992). Outside Central Veracruz, this pattern is not repeated: ball courts may occur just outside the major compound but are not part of it; paraphernalia of yokes, hachas, and palmas are absent or exceptional.

As mentioned above, the game itself wasn't new, as courts and balls are known as early as the second millennium B.C. in the lowlands: the rubber balls from Manatí in Southern Veracruz (Rodríguez and Ortiz 1997) and the Paso de la Amada court in Chiapas (Hill and Clark 2001) are dated around 1600 B.C.,

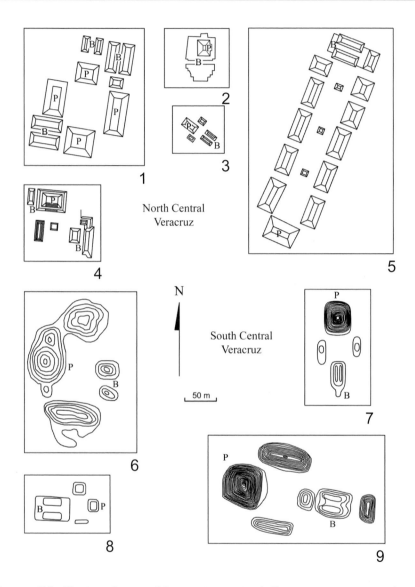

FIGURE 5.3. Classic architectural layouts integrating ball courts into main ritual compound of high-ranking centers: Tajín: *1*, Plaza del Arroyo; *2*, South Ball Court alongside Pyramid 5; *3*, court in axis of pyramid within the Great Xicalcolhuiqui; *4*, Morgadal: courts alongside pyramid and plaza; *5*, Cuajilotes; *6*, Nevería; *7*, Castillo; *8*, Toxpan; *9*, Azuzules: court in axis with pyramid. P stands for pyramid, B for ball court. All sites drawn to scale and oriented to north. (*Figures redrawn from Cortés 1994 [Cuajilotes], Daneels 2002 [Castillo], Krotser and Krotser 1973 [Tajín], Miranda and Daneels 1998 [Toxpan], Stark 1999 [Azuzules], Pascual 2000 [Morgadal], and Zolá 1986 [Nevería].*)

in a context of emerging hierarchies. However, these early games lacked a ball-game-related ritual, which is why we consider them to be secular in nature. (The Olmec ballplayer figures and the so-called *yuguitos*, whose relation to the ballgame is still a matter of controversy, are anyhow later—that is, after 1200 B.C.; see Scott, this volume, Chapter 4). But in the Classic Period, the ballgame is immersed in a specific ritual context, as architecture, sculpture, and iconography combine to show. We believe it was precisely because the game was so popular that it was promoted by the elite and integrated into a ritual that only they could perform, with expensive paraphernalia at the centers of power. Beyond the sport, the ritual reinforced the group cohesion and legitimated the elites' position as divine intercessors, a function that can be derived from a reading of Tajín's South Ball Court panels, as we argue below.

We know through iconography that the rite occasionally included sacrifice by decapitation, but we think decapitation events must have been rare, occurring only in exceptional circumstances, such as dates of particular calendrical signifi-cance or moments of crisis (internal or external). The hypothesis that every game would have been followed by a sacrifice is difficult to reconcile with the large number of courts, their omnipresence, and their long chronology, which suggests both continuing popular attendance and practice. Also, too-frequent sacrifices would probably deter and eventually deplete the ballplayers.

The first evidence for the presence of this characteristic Central Veracruz ballgame rite comes from Cerro de las Mesas, in the Mixtequilla, where a Proto-classic burial consecrating the building of a platform associated with the main compound contains the remains of three individuals, one headless and two with severed heads, among whose offerings were a plain yoke and a turtle shell incised with a head encircled by two interlocking serpents and decorated with scrolls. This is the earliest case known where yokes, beheading, scrolls, and, by inference, the ballgame are found together as part of an elite ritual practice (Daneels 2005, 2008). From then on, the existence of the ritual is attested through iconography until the very end of the Classic Period.

THE CENTRAL VERACRUZ ICONOGRAPHY

Iconography can be a powerful tool to understand past cultures, including social and political aspects of society. As mentioned previously, we analyzed the iconog-raphy of male figures in order to determine the hierarchical relationship among Central Veracruz inhabitants of the Classic Period represented specifically in elite media: architectural stone reliefs, mural painting, and fancy ceramics (Agüero

2004).[1] In this analysis, 181 bidimensional figures were selected from published and unpublished sources, based on the criteria of being evidently male (discarding female or ungendered beings), human (that is, not divine or hybrid), and sufficiently complete (from head to feet) to appreciate dress and other attributes.

We assume that the human figures wearing the most complex and rich attire belong to the highest hierarchic position, whereas those individuals whose costume and jewelry are less ornamented are positioned within lower ranks. Therefore, a database was developed using attributes of dress (headdress, loincloth or *maxtlatl*, skirts, capes, sandals, and so on), adornment (earrings, bracelets, anklets, necklaces with or without pectoral, and so on), paraphernalia (yugos, hachas, palmas), and manipulated attributes (scepters, knives, batons, bags, fans). A complementary parameter defined the position of the personage within the scene, deriving their relationship of subordination or dominance from the size, position, and gestures. Any figure represented singly in stelae (not in a multi-figure scene) would automatically be ranked as dominant, having achieved the prerogative of a one-man showing. We describe the categories from fancy to simple.

TABLE 5.1. CATEGORIES ESTABLISHED WITH DISCRIMINATING CRITERION OF DRESS ELEMENT

Categories	Distinctive element	Dress	Adornment (jewelry)	Position in scene
1	Cape	Ornamented headdress; sandals (often)	Complex earrings and necklaces	Dominant
2	Skirt	Ornamented headdress; sandals and kneepads (often); yokes occur	Complex earrings and necklaces	Dominant
3	Decorated *maxtlatl*	Complex or simple headdress; sandals and kneepads occur; yokes occur	Simple or complex earrings and necklaces	Dominant
4	Simple *maxtlatl*	Simple or complex headdress; barefooted; yokes occur	Simple earrings, necklaces, anklets (often)	Subordinate
5	Nude and tied	Simple or no headdress; helmets occur	Simple earrings, necklaces, anklets (often)	Subordinate

In general, the figures from these five categories occur in three different kinds of thematic scene: ballgame, warfare, and ritual scenes unrelated to either the ballgame or warfare, where processions seem to predominate (Figure 5.4). All three themes occur throughout Central Veracruz, the first two from the Protoclassic Period on, retaining their respective attributes and scene composition through time, showing the underlying unity of symbolic discourse of the Classic Period culture area.

Each thematic register has its own hierarchy of male figures. In the case of the ballgame scenes, which are defined by the presence of a yoke around the ballplayer's hips, there are three ranks of figures: the first rank corresponds to ballplayers represented singly on stelae or in dominant or central position in scenes, the second rank to ballplayers as supporting actors in scenes, and the third to subordinate figures that appear around them (assistants, referees, costumed dancers, and fancily dressed musicians playing maracas and drum). The different figures belong to categories 2–4, meaning that cape wearers (category 1) and nudes (category 5) are absent from this kind of scene.

War scenes are identified by the presence of warriors—that is, individuals carrying weapons or shields. The depiction of violence is rather rare and formalized, with a dominant figure wielding a mace or a knife over a subordinate captive (sometimes beheaded).[2] In these scenes there are four levels of rank, with a discrepancy between ruler and warriors on one side and (generally) nude captives and sacrificial victims on the other.

The ritual scenes also have four ranks, with the highest-ranking figures often clothed with a cape; third-rank figures include (copal?)-bag carriers and bird-costumed men; the fourth rank includes parasol carriers and "second-class" musicians, barely clad and playing trumpet and conch (not maracas and drums, as in the ballgame scenes). Among these scenes no actual sacrifice has been depicted, nor are there naked captives. This is why in Figure 5.4 we depict the last group of the war scenes as inferior in rank to the fourth rank of the ritual scenes: in terms of sociopolitical hierarchy within the community, captives, even high-ranking prisoners, would be below the level of attendants, as we consider their nakedness to represent a mark of inferiority in relation to the wearing of a simple maxtlatl by the attendants.

The Ballgame

The identification of ballgame scenes was based on the presence of figures wearing yokes. In some cases, we found, in addition, representations of hachas, palmas, manoplas, kneepads (which may be symmetrical or not), balls, or images of the architectonic structures delimiting the field, like those of Panels 2 and 4 of the

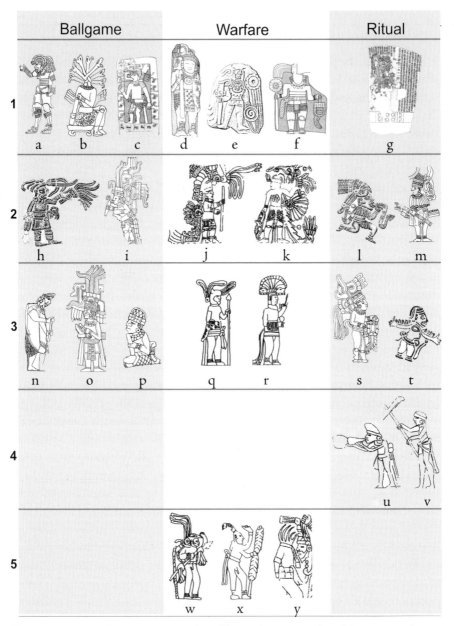

	Ballgame	Warfare	Ritual
1	a b c	d e f	g
2	h i	j k	l m
3	n o p	q r	s t
4			u v
5		w x y	

FIGURE 5.4. Central Veracruz sociopolitical hierarchies: Examples of figures according to rank within the three iconographic themes. Figures referenced by theme, from left to right: *a*, Estela de Tepatlaxco (*redrawn from Batres 1905*); *b*, Aparicio stela (*redrawn from Beverido 2006*); *c*, Tajín sculpture 2 (*redrawn from Kampen 1972: fig. 39c*); *d*, Tajín sculpture 1 (*redrawn from Kampen 1972: fig. 17a*); *e*, Cerro de las Mesas Stela 7 (*redrawn from Miller 1991: fig. 2.16*); *f*, Tajín piece no. 40 (*redrawn from Piña and Castillo 1999: fig. II.1*); *g*, La Mojarra stela (*redrawn from Justeson and Kaufmann 1993*); *h*, relief-decorated bowl from Los Angeles collection (*redrawn from Von Winning and Solana 1996: fig. III.9*); *i*, northeast panel of South Ball Court (*redrawn from Ladrón de Guevara 1999: 55*); *j–k*, Tajín,

South Ball Court and the Pyramid of Niches Panel 7 of Tajín, or in the two or three ballgame scenes of Higueras. In these representations, we also have decapitated personages with five to seven serpents emerging from their necks, wearing the characteristic ballplayer attire: yoke, palma, and kneepads, as in the Aparicio stelae (Figure 5.5).

The ballplayers usually appear in what we call "confrontation scenes"—that is, two figures facing each other, in an attitude of dialogue (see the speech scrolls in the Columns Building or the panels of Tajín South Ball Court) or kneeling in the characteristic ballplaying stance, as in the relief-molded vessel of Ranchito de las Ánimas (Von Winning and Solana 1996), known also from Maya iconography.

We calculated that 27.1 percent of all analyzed male figures could be identified as ballplayers; the percentage rises to 33.7 percent when we include the personages associated with ballgame scenes, such as the judges or referees (people carrying a baton in some reliefs of Tajín), musicians, and ritual attendants. Actually, this percentage should be even higher, owing to the fact that the Higueras murals with ballgame scenes are fragmented toward the top and the figures are incomplete, and thus these individuals were excluded from the database. So when viewed regionally, ballgame scenes are predominant and quite regularly spaced throughout Central Veracruz, in keeping with the ubiquity of the ball courts.

The repetition of ballgame scenes in relief sculpture, ceramics, and mural painting confirms the great importance that this ritual had at a religious and political level during the Classic Period in all of Central Veracruz. The ballgame decapitation ritual iconography is characterized by five to seven serpents sprouting from the neck of the victim. We must emphasize the great importance accorded the decapitated player recurrently appearing as protagonist, since he is represented singly (Aparicio) or positioned centrally in the scene, of the same size as the sacrificer, in full paraphernalia, sometimes held by a peer but never tied, seated or leaning on a ball (Tajín, Higueras) or a throne (Aparicio), and

Figure 5.4, *continued*

Building of the Columns, central column (*redrawn from Ladrón de Guevara 1999:77*); l, relief-decorated bowl (*redrawn from Von Winning and Solana 1996: fig. V.6a*); m, Tajín Altar 4 (*redrawn from Castillo 1990: fig. 184*); n, Estela de Tepatlaxco (*redrawn from Batres 1905*); o, Tajín, southwest panel of South Ball Court (*redrawn from Ladrón de Guevara 1999:53*); p, Tajín, panel of Building 7 (*redrawn from Ladrón de Guevara 1999:62*); q–r, Tajín, Building of the Columns, North Column (*redrawn from Ladrón de Guevara 1999: 76*); s, Tajín Altar 4 (*redrawn from Castillo 1990: fig. 184*); t, relief-decorated bowl from Beverly Hills collection (*redrawn from Von Winning and Solana 1996: fig. V.3*); u–v, Higueras mural painting (*redrawn from Morante 2005: fragments 4088, 4986*); w–x, Tajín, Building of the Columns, North Column (*redrawn from Ladrón de Guevara 1999: 76*); y, Los Cerros stela (*redrawn from Sánchez 1999:14*) .

without evidence of subjugation or humiliation. In this respect, we consider that the ballgame imagery of Central Veracruz is particular and different from the Maya iconography in the interpretation offered by Baudez (this volume, Chapter 10). The decapitation ritual is depicted at least nine times, once in Tajín (on Panel 7 from the Pyramid of the Niches, related to the Northeast Panel of the South Ball Court), at least three times at Higueras (with the snakes painted in either red, blue, or yellow), and five times at Aparicio (a group of similar stelae which may have been a series of ball-court markers) (Figure 5.5).

The colors used in the Higueras murals reveal that the snakes may have represented not only blood (red), but also water (blue), as in other aquatic scenes, and maybe corn (yellow), referring to a fertility aspect that also arises in the interpretation of Tajín's South Ball Court panels. According to a reading by Wilkerson (1987, 1991), the sacrificed player becomes a messenger interceding before the gods on behalf of his community to obtain the water of life. This interpretation implies two things: first, that the winning player was sacrificed, as the gods would be more willing to grant a petition to a winner than a loser (especially if the concession of the petition implied the consequent painful auto-sacrifice of one god's genitals); and second, that the sacrificed player entered a glorious afterlife as a semi-divine being allowed into the presence of gods (different from the dark, unhappy place where undistinguished dead gather in most Mesoamerican belief systems). Thus, as mentioned above, while we consider that actual sacrifices were exceptional, the ritual context may have made them acceptable to the participating players.

Warfare

The iconographic analysis showed that another third of the male figures seems to be related to warfare or military endeavors. To identify the scenes related to war, we considered first the presence of weapons—that is to say, lances, arrows, hafted knives (different from the unhafted, leaf-shaped sacrificial blades wielded by ballplayers), clubs, and shields—and in some cases, the presence of helmets (yelmo). Another distinctive feature is the presence of kneepads. Usually, kneepads have been considered characteristic of ballplayers. However, 45 percent of the figures identified as warriors use kneepads, while none of them wear a yoke, and they are, by and large, represented in warlike scenes. Finally, the scenes in which these personages appear involve submission (mostly nude captives tied with ropes or grasped by their hair), sacrifice (hit on the head with a cudgel, or decapitated with a hafted knife, blood spurting as peaks from the neck, or disemboweled), confrontation, or processions.

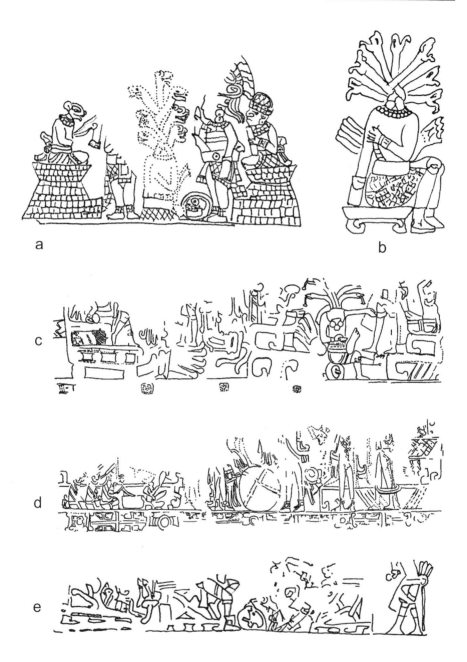

FIGURE 5.5 Scenes of decapitation associated with the ballgame: *a*, Tajín: Panel 7 of Pyramid of the Niches (*redrawn from Ladrón de Guevara 1999:62*); *b*, Aparicio stela (*redrawn from Beverido 2006*); *c-e*, Higueras murals (*redrawn from Morante 2005: fragments 4041, 4042, and 4053; see also Machado 2003*).

It is important to note that sacrificial victims in war scenes differ from those in ballgame scenes. In the former, the victims are not peers, but humiliated captives, mostly naked, tied or held by their hair, and represented smaller in size and/or kneeling; in decapitated victims, the blood sprouting from their neck does not represent snakes.

The warrior imagery constitutes a rather larger proportion of the corpus. While only 21 percent of the total number of analyzed individuals are identified as warriors, the percentage of figures appearing in war-related scenes—including warriors, captives, standard-bearers, and ritual attendants (but no musicians!)—comes to 33.1 percent of the corpus, almost as many as in the ballgame scenes. Thus, war seems to represent another viable mechanism of the elite group to demonstrate its control, from very early on (if the Los Cerros stela is Protoclassic or Early Classic; Figure 5.6a) (see also note 2). But it is important to note that more than 60 percent of the war scenes come from the site of Tajín and belong to the Late Classic. The majority even belongs to the latest stage of the site, from the Building of the Columns, probable palace of ruler 13 Rabbit and generally agreed to be one of the latest buildings of the site, at the very end of the Classic Period (well into the tenth or even eleventh century) (Figure 5.6b) (Lira 1995). This point suggests that at the end of Tajín's "splendor," militarism is increasing as an alternative mechanism of control.

Ritual Scenes

The third theme corresponds to one (or more) ritual(s) that appear to be unrelated to either war or the ballgame. One major character of such scenes is a figure wearing a cape-like garment that covers the upper body (chest, arms, and back), apparently made of woven or sewn segments (cloth, feathers, jade plaques?) and associated mostly with complex feathered headdresses. Such figures may occur singly, as in the La Mojarra stela, indicating their importance, or in a procession, carrying a variety of attributes, among which are (copal?) bags, serpents, and stick-like objects that have been interpreted as scepters (Figure 5.7a); in some cases they can be associated with dancers in bird costume and masked figures (Figure 5.7b).

Because of their virtual absence from ballgame and military scenes and their recurrent association with copal bags, generally considered an attribute of priestly dignity, we view these cape-wearers as representations of high priests.[3] In these scenes, the cape-wearers carry different kinds of object that suggest to us elements of power or scepters.

Cape-bearing figures are comparatively rare: only 15 of them were identified (8.3% of the corpus). Yet, if we include all males figures in scenes not associated

with war or the ballgame (whether a cape-wearer is present or not), then the percentage increases to 33.2 percent.

Viewed regionally, in south-central Veracruz cape-wearers occur in processions carrying scepter-like objects and copal bags, or snakes and maracas. By contrast, while procession scenes are common in Higueras, cape-wearers are absent; instead there are bag bearers, standard-bearers, parasol carriers, second-class

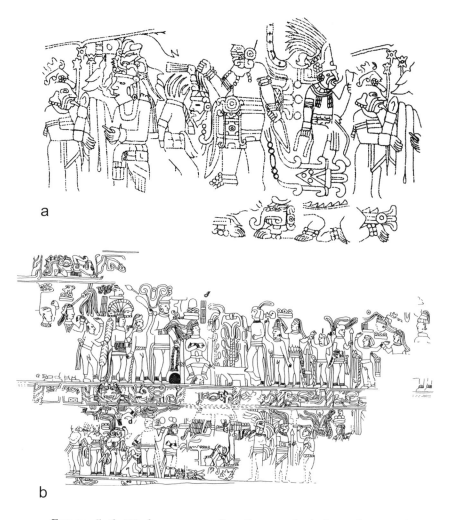

FIGURE 5. 6. Warfare scenes: *a*, Los Cerros stela (*redrawn from Sánchez 1999:14*); *b*, Tajín's Building of the Columns, North Column (*redrawn from Ladrón de Guevara 1999: 76*).

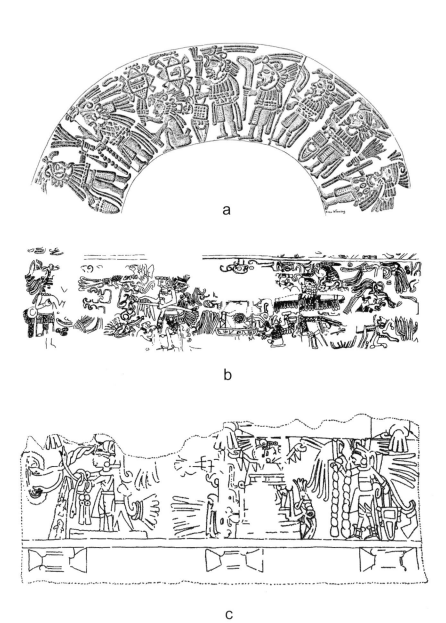

FIGURE 5.7. Processions: *a*, relief-decorated bowl (*redrawn from Von Winning and Solana 1996: fig. V.1*); *b*, Tajín's Building of the Columns, Central Column (*redrawn from Ladrón de Guevara 1999:77*); *c*, Higueras mural (*redrawn from Morante 2005: fragment 4049*).

musicians, and possible captives (not nude); and in Tajín's Columns Building, the processions also feature men in bird costume and fancily dressed males with feathered headdress and sticks (scepters?) (Figure 5.7b).

Cape-wearers occur from the early part of the Classic Period (La Mojarra stela, about A.D. 150 (Figure 5.4g) all the way to the end of the period (relief-molded ceramics), and from north-central to south-central Veracruz, indicating they form part of a commonly understood high-ranking function in society. While it is generally accepted that in Classic Period Mesoamerican societies the ruler functioned as both the temporal and spiritual chief, king and high priest, this doesn't seem to have always been the case. In Central Veracruz, the caped individual of the very early La Mojarra stela has generally been interpreted as a ruler, mainly because of the format in which he is represented, closely paralleling the later Maya ruler stelae. On the basis of our iconographic analysis, we would interpret him as a ruler who also functioned as a high priest (because of the cape). On the other hand, Tajín's presumably last ruler, 13 Rabbit, easily identified through his name glyph or headdress (Ladrón de Guevara 1999), is represented sometimes with the attire of ballplayer and other times as a warrior, but never with a cape. In this case, we can confirm that 13 Rabbit was never a participant of the third type of ritual, presumably headed by a high priest. From this evidence we can infer that at least by the end of the Classic Period, the ritual functions of the ruler had been assumed by a separate high-ranking individual.

A last point indicating changes in the sociopolitical organization during the Late Classic is that the majority (about 60%) of the procession scenes, pertaining to this "third" ritual, separate from ballgame and war imagery, comes from Higueras's Mound 1, a pyramid temple with four building stages spanning the Late Classic (A.D. 600–900), according to Arellanos (1985) (Figure 5.7c). After sharing the general ballgame ritual iconography, at the close of the Classic, Higueras increases its procession scenes, instead of increasing war imagery, as at Tajín.

Conclusion

Central Veracruz during the Classic Period displayed a strong preference for the ballgame. The characteristic sculptures known as yokes, hachas, and palmas, which together with the scroll style originally defined Central Veracruz as a Mesoamerican culture area, have been associated with the ballgame. Ball courts are virtually ubiquitous throughout the territory, pointing up the popularity of the game. They are always associated with the main ritual compound, marking the integration of the game into the realm of the sacred. As the presence of courts is restricted to first- and second-rank centers, it is clear that the game is

linked to power and political organization. Iconography bears this out: ballgame scenes are found in elite media representations from the Protoclassic to the Late Classic throughout Central Veracruz, and they reflect the integration of the game into a specific ritual (including expensive paraphernalia of yokes, hachas, and palmas), controlled by the elite. We propose that the promotion of the ballgame was used by elites as an integrating mechanism, obtaining a following by consensus based on support of the home team. This strategy was developed in order to gain a following among a dispersed population that could afford to resist other, more coercive ways of control. The ritual grafted onto the ballgame, shown to exist since the Protoclassic Cerro de las Mesas burial, legitimates the position of elites as specialized intermediaries, mediating with the gods for the well-being of the community. The ballgame iconography shows the importance of the ballgame ritual associated with decapitation: ballplayers, both alive and decapitated, occur as single or dominant figures in stelae, while in friezes sacrificed players occupy a central place in the scenes, with red and blue serpents emerging from their neck, relating to the fertility symbols of blood and water; afterward they rise to the level of demigods, negotiating with the gods for the water of life. The pervasiveness and the formal coherence of the ballgame, from its insertion into the architectural layout of high-ranking centers to its elite-produced sculpture and imagery, show that the ballgame ritual was a central part of the values of society.

Throughout the Classic Period, two other iconographic themes appear parallel to the ballgame scenes: war imagery and procession rituals. Both also have their inception in the Protoclassic Period. They occur in almost the same frequency as the ballgame scenes, when considered on the whole of Central Veracruz, and share also a consistent array of imagery through time and space. The appearance of a common corpus of symbolic and iconographic themes in elite media during this period again confirms that Central Veracruz functioned as a single culture area, in which the elite used the same political discourse. Yet when viewed in particular, war and processions are proportionally much more strongly represented in Tajín and in Higueras, respectively, which are late sites in the Classic sequence; this seems to suggest that these themes increase at the end of the Classic Period.

Given the rise of other representations toward the end of the Classic Veracruz sequence, one may suppose that either the ballgame has lost its effectiveness as a form of ritualized competition to control and organize society at a political level, or that alternate expressions of power have arisen, leading elites to increase demands through coercion. Whatever the cause, when ballgame iconography declines in favor of processions or militarism, the end of Classic Central Veracruz culture is near.

Notes

1 We excluded terracotta figurines, though abundant in Central Veracruz and frequently associated both with domestic contexts and major ceremonial and elite residential architecture, because the iconographic repertoire is mostly different, indicating they may originate from non-elite contexts.

2 An example of what looks like an actual battle scene comes from outside Central Veracruz: the stone cist of Tres Zapotes Monument C, in the northern Tuxtlas region (Stirling 1943, pl. 18 a-b). Its date is a matter of debate, but we consider that it could stylistically fit into Tres Zapotes's period of apogee, 400–1 B.C. (Late Formative) and A.D. 1–300 (Protoclassic) (Christopher Pool, personal communication, October 4, 2006).

3 Tajín's Altar 4 (Ladrón de Guevara 1999:96) seems to be an exception to the rule, as it combines distinctive elements of the three types of scenes, whereas normally the repertoires are separate. The leaf-shaped sacrificial knife and the interlaced serpents similar to the North Ball Court panel suggest a relation to the ballgame (some have even suggested that the circular hole in the middle functioned as a ball-court ring). Other elements are associated with war: the large centrally placed *chimalli* (shield) crossed by a sheaf of arrows. Finally, the principal figure wears a cape and two of the secondary men carry a bag, elements associated with the third ritual. Thus far, this is the only case we know of in which a cape-wearer appears with iconographic elements related to the ballgame and warfare.

References Cited

Agüero Reyes, A. O.
 2004 La función social de los personajes masculinos en el centro de Veracruz: Un estudio iconográfico. Tesis de licenciatura en Arqueología. Escuela Nacional de Antropología e Historia, Mexico, D.F.

Arellanos Melgarejo, R.
 1985 Las Higueras—Acacalco. Dinámica cultural de un sitio en el Totonacapan barloventino. Tesis de maestría en Antropología, Universidad Veracruzana, Xalapa, Veracruz.

Batres, L.
 1905 *La lápida arqueológica de Tepatlaxco*. Inspección y Conservación de los Monumentos Arqueológicos de la República Mexicana. Tipología de Fidencio Soria, Mexico, D.F.

Beverido Duhalt, M.
 2006 La lápida de Aparicio. *Arqueología Mexicana*, Edición Especial 22:47.

Brüggemann, J. K.
 1992 El juego de pelota. In *Tajín*, by J. K. Brüggemann, S. Ladrón de Guevara, and Juan Sánchez Bonilla, pp. 84–98. Citibank, El Equilibrista and Turner Libros, Mexico, D.F., and Madrid.

Castillo Peña, P.
 1990 *La expresión simbólica de El Tajín*. Colección Científica Serie Arqueología 306. INAH, Mexico.

Cortés Hernández, J.
 1994 *Filobobos. Guía.* Salvat / INAH, Mexico, D.F.
Daneels, A.
 1997 Settlement History in Lower Cotaxtla Basin. In *Olmec to Aztec: Settlement Patterns in the Ancient Gulf Lowlands*, edited by B. L. Stark and P. J. Arnold III, pp. 206–252. University of Arizona Press, Tucson.
 2002 El patrón de asentamiento del Período Clásico en La Cuenca Baja del Cotaxtla, Centro de Veracruz. Un estudio de caso de desarrollo de sociedades complejas en tierras bajas tropicales. Tesis de doctorado en Antropología. Facultad de Filosofía y Letras, UNAM, Mexico, D.F.
 2005 El Protoclásico en el centro de Veracruz. Una perspectiva desde la cuenca baja del Cotaxtla. Arqueología Mexicana. In *IV Coloquio Pedro Bosch Gimpera*, Vol. II: *Veracruz, Oaxaca y Mayas*, edited by E. Vargas, pp. 453–488. Instituto de Investigaciones Antropológicas, UNAM, Mexico, D.F.
 2008 Ballcourts and Politics in the Lower Cotaxtla Valley: A Model to Understand Classic Central Veracruz? In *Classic-Period Cultural Currents in Southern and Central Veracruz*, edited by P. Arnold III and C. A. Pool, pp. 197–223. Pre-Columbian Studies. Dumbarton Oaks, Washington, D.C.
Ekholm, G. F.
 1946 The Probable Use of Mexican Stone Yokes. *American Anthropologist* 48:593–606.
 1949 Palmate Stones and Stone Heads: Suggestion on Their Possible Use. *American Antiquity* 15(1):1–9
Hill, W. D., and J. E. Clark
 2001 Sports, Gambling and Government: America's First Social Compact? *American Anthropologist* 103(2):331–345.
Kampen M. E.
 1972 *The Sculptures of El Tajín, Veracruz, Mexico.* University of Florida Press, Gainesville.
Jiménez Lara, P.
 1991 Reconocimiento de superficie dentro y fuera de la zona arqueológica del Tajín. In *Proyecto Tajín*, Tomo II, edited by J. K. Brüggemann, pp. 5–63, Cuaderno de Trabajo de la Dirección de Arqueología 9. Instituto Nacional de Antropología e Historia, Mexico, D.F.
Justeson, J. S., and T. Kaufmann
 1993 A Decipherment of Epi-Olmec Hieroglyphic Writing. *Science* 259 (5102): 1703–1711.
Kowalewski, S. A., G. M. Feinman, L. Finsten, and R. E. Blanton
 1991 Pre-Hispanic Ballcourts from the Valley of Oaxaca, Mexico. In *The Mesoamerican Ballgame*, edited by V. L. Scarborough and D. Willcox, pp. 25–44. University of Arizona Press, Tucson.
Krotser, R., and P. H. Krotser
 1973 Topografía y cerámica de El Tajín. *Anales del Instituto Nacional de Antropología e Historia*, Epoca 7a, T.III, 1970–1971, No. 51 de la colecci⸱n: 177⸱ ⁕⁕⁕

Ladrón de Guevara, S.
1999 *Imagen y pensamiento en El Tajín.* Universidad Veracruzana and Instituto Nacional de Antropología e Historia, Mexico, D.F.

Lira López, Y.
1995 El palacio del Edificio de las Columnas en El Tajín. In *El Tajín. Estudios Monográficos,* by H. Cuevas Fernández, J. Sánchez Bonilla, A. García y García, Y. Lira López, and R. Ortega Guevara, pp. 85–124. Universidad Veracruzana, Xalapa, Veracruz.

Machado, J.
2003 *Veracruz Mural Traditions: Las Higueras, Mexico.* www.famsi.org/reports/00035/index.html

Miranda Flores, F. A. and A. Daneels
1998 Regionalismo cultural en el valle del río Atoyac. In *Contribuciones a la historia prehispánica de la región Orizaba-Córdoba,* edited by C. Serrano Sánchez, pp. 53–72. Cuadernos de divulgación 2, UNAM/IIA and H. Ayuntamiento de Orizaba, Mexico, D.F.

Miller, M. E.
1991 Rethinking the Classic Sculptures of Cerro de las Mesas, Veracruz. In *Settlement Archaeology of Cerro de las Mesas,* edited by B. L. Stark, pp. 26–37. Institute of Archaeology Monograph 34, University of California, Los Angeles.

Miranda Flores, F. A., and A. Daneels
1998 Regionalismo cultural en el valle del río Atoyac. In *Contribuciones a la historia prehispánica de la región Orizaba-Córdoba,* edited by C. Serrano Sánchez, pp. 53–72. Cuadernos de divulgación 2, UNAM/IIA and H. Ayuntamiento de Orizaba, Mexico, D.F.

Morante López, R.
2005 *La pintura mural de Las Higueras, Veracruz.* Universidad Veracruzana, Xalapa.

Pascual Soto, A.
1998 *El arte en tierras de El Tajín.* Consejo Nacional para la Cultura y las Artes. Mexico, D.F.
1998 *El arte en tierras de El Tajín.* Círculo de Arte. Dirección General de Publicaciones. Consejo Nacional para la Cultura y las Artes. Mexico, D.F.
2000 El Tajín en vísperas del Clásico Tardío: Arte y cultura. *Universidad de México. Revista de la Universidad Nacional Autónoma de México* 590 (marzo):30–39.

Piña Chan, R., and P. Castillo Peña
1999 *Tajín, la ciudad del Dios Huracán.* Fondo de Cultura Económica, Mexico.

Rodríguez, C., and P. Ortiz
1997 Olmec Ritual and Sacred Geography at Manatí. In *Olmec to Aztec: Settlement Patterns in the Ancient Gulf Lowlands,* edited by B. L. Stark and P. J. Arnold III, pp. 68–97. University of Arizona Press, Tucson.

Sánchez Bonilla, J.
1999 Estela de Los Cerros. In *Antropología e Historia de Veracruz,* pp. 11–22. Gobierno del Estado de Veracruz-Llave. Instituto de Antropología e Historia de la Universidad Veracruzana, Xalapa, Mexico.

Santley, R. S., M. J. Berman, and R. T. Alexander
 1991 The Politicization of the Mesoamerican Ballgame and Its Implications for the
 Interpretation of the Distribution of Ballcourts in Central Mexico. In *The
 Mesoamerican Ballgame*, edited by V. L. Scarborough and D. Willcox, pp. 3–24.
 University of Arizona Press, Tucson.
Stark, B. L.
 1999 Formal Architectural Complexes in South-Central Veracruz, Mexico: A Capi-
 tal Zone? *Journal of Field Archaeology* 26(2):197–225.
Stirling, M. W.
 1943 *Stone Monuments of Southern Mexico*. Bureau of American Ethnology, Bulletin
 138. Smithsonian Institution, Washington, D.C.
Von Winning, H., and N. Gutiérrez Solana
 1996 *Iconografía de Río Blanco*. Estudios y fuentes del arte en Mexico LIV, Instituto
 de Investigaciones Estéticas, Universidad Nacional Autónoma de Mexico, Mex-
 ico, D.F.
Wilkerson, S. J. K.
 1984 In Search of the Mountain of Foam: Human Sacrifice in Eastern Mesoamerica.
 In *Ritual Human Sacrifice in Mesoamerica*, edited by E. H. Boone, pp. 101–132.
 Dumbarton Oaks, Washington, D.C.
 1987 *Tajín. A Guide for Visitors*. Museum of Anthropology of Xalapa and City Coun-
 cil of Papantla. Xalapa.
 1991 And Then They Were Sacrificed: The Ritual Ballgame of Northeastern
 Mesoamerica through Time and Space. In *The Mesoamerican Ballgame*, edited
 by V. L. Scarborough and D. Willcox, pp. 45–72. University of Arizona Press,
 Tucson.
 1994 The Garden City of El Pital: The Genesis of Classic Civilization in Eastern
 Mesoamerica. *National Geographic Research and Exploration* 10(1):56–71.
Zolá Báez, M. G.
 1986 Aménagement préhispanique des zones inondées du Veracruz (Mexique).
 Cahier des Sciences Humaines. Géoarchéologies régionales en milieux tropicaux 22
 (1):83–95 (avant-propos et traduction Jean-Yves Marchal). Suite des Cahiers
 ORSTOM, Série Sciences Humaines.

CHAPTER 6

GAMES, COURTS, AND PLAYERS AT COTZUMALHUAPA, GUATEMALA

Oswaldo Chinchilla Mazariegos

Commenting on the famous group of Cotzumalhuapa stelae at the Ethnographic Museum of Berlin, now known as Bilbao Monuments 1–8, Eduard Seler (1892) identified the objects worn on the waist by the main actors as stone yokes. At that early date, they were not associated with the ballgame. Seler's interpretation of these objects provided an early indication that yokes were worn on the waist, eventually leading scholars to suggest that either stone or wooden yokes were used as deflectors and protectors by ballplayers during the games. Since then, the ballgame has become increasingly associated with Cotzumalhuapa art, to the point that in much of the available literature, the two seem inextricably linked. J. E. S. Thompson (1948:19) first identified explicitly the actors of the Bilbao stelae as ballplayers. Stephen de Borhegyi (1961) and Lee Parsons (1969) made detailed analyses of their physical attributes and accessories. For art historian Barbara Braun (1977:421), "the ball game cult represented a major expenditure of energy in the Cotzumalhuapa culture." For Michael Coe (1966: 104), it was their "obsession."

Recent research on the archaeology and monumental art of Cotzumalhuapa raises questions about the accuracy of these statements. Little is known about the Cotzumalhuapa ballgame beyond the iconographic program of the Bilbao stelae. These monuments do not show actual confrontations between players, but instead, they show rituals enacted by individuals who were dressed as ballplayers. Therefore, they do not provide information on the setting or practice of the

139

game itself, although the trappings of the apparent players offer some hints that are explored in this paper. Furthermore, no formal ball-court architecture had been investigated until recently at Cotzumalhuapa. Lee Parsons identified as such certain compounds at Bilbao and El Baúl, but his archaeological evidence is problematic at best. Excavations conducted by the author in 1998 were the first to reveal an unmistakable ball court at Cotzumalhuapa.

This paper addresses these issues in the light of recent breakthroughs in the interpretation of organized violence in ancient Mesoamerica. Cotzumalhuapa sculptures embody the three major forms of violent conflict that were represented in Mesoamerican art, as summarized in this volume: the ballgame; gladiatorial matches; and human sacrifice. Special attention will be placed on the monumental corpus of Bilbao, interpreted in terms of (a) their potential to reveal details about the practice of the game, as indicated by the players' accoutrements; and (b) the role of the ballplayers within a wide complex of religious ideas that are articulated in the monuments' iconography. Recent research by the author (Chinchilla Mazariegos n.d.b, 2008) has shown that the sculptures of Bilbao largely center on mythological and ritual subjects that involve human sacrifice, music and chant, the invocation of gods or ancestors, the cult of supernatural places of abundance and brilliance, and the cult of the sun. The participation of ballplayers highlights the intrinsic role of confrontation and violence in these religious rituals, also made evident by the prominence of human sacrifice. Moreover, some sculptures may now be related to forms of boxing that were practiced throughout Mesoamerica (Taube and Zender, this volume, Chapter 7). Because of its monumental format and high artistic quality, El Baúl Monument 27 is one of the most remarkable representations of this type of gladiatorial match in Mesoamerican art.

These interpretations benefit from our enhanced knowledge of ancient Cotzumalhuapa, now understood as an extensive city that included three major architectural compounds: the acropolises of El Baúl and Bilbao, and the probable plaza of El Castillo (Figure 6.1). An extensive system of causeways and bridges integrated these compounds with one another and with surrounding settlements, covering about 10 km^2. This was the largest Late Classic city in southern Guatemala, a major center of political power and cultural innovation whose influence spread extensively over the Pacific coast and adjacent highlands, as indicated by the distribution of Cotzumalhuapa-style sculptures over that area. The main expansion of the city, and the development of its sculptural style, took place during the Late Classic Period (Chinchilla Mazariegos et al. n.d.). This paper concentrates on that period, in an effort to reassess the role of the ballgame and other forms of organized violence in Classic Cotzumalhuapa society.

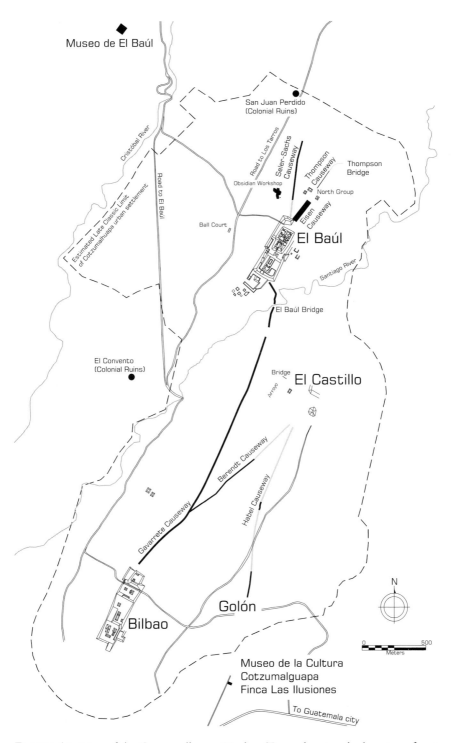

FIGURE 6.1. Map of the Cotzumalhuapa Nuclear Zone, showing the location of major architectural compounds, causeways, and the estimated limits of urban settlements.

The El Baúl Ball Court

Franz Termer (1930:98) and Eric Thompson (1948:37–38) interpreted a large sunken court located at the northern end of the El Baúl acropolis as a ball court (Figure 6.2). Termer also reported a stone ring found somewhere in the vicinity, but its association with the sunken court remains unclear. The sunken court measures about 47 × 26 m and reaches a depth of 3 m, making for a rather large ball court. Parsons (1969:61–63) opened a trench on the southern slope of this court, finding what he considered to be the remains of a bench and playing wall. This was a hasty excavation, as Parsons himself admitted. He managed to excavate a 1.5 × 7.5 m trench in one day, with three workmen, reaching a depth of 2 m in places. The El Baúl sunken court certainly deserves a more detailed investigation. I consider Parsons's evidence inconclusive, but this may well prove to be the main ball court at Cotzumalhuapa.

Even less conclusive is Parsons's interpretation of the Monument Plaza at Bilbao. This is the place of origin of the majority of monuments taken to Berlin in the nineteenth century. In Parsons's reconstruction, the stelae were set up in two rows, on either side of a sunken court that may have served as a ball-playing area, or perhaps a setting for important pre- or post-ballgame ceremonies. He based his interpretation on the presence of a shallow depression in the area, and the location of the sawed-off bases of three stelae that seemed to form an alignment. However, his reconstruction runs counter to every one of the early reports, which assert that the depression that Parsons noted was an excavation made in the 1860s, when the monuments first came to light. The 1884 plan of Bilbao by engineer Albert Napp (Chinchilla Mazariegos 1996a:328) shows the outline of the excavation and the monuments fallen in an east–west direction at the eastern side of the court, where they probably stood in a single row. A large stone basin (Monument 26) stood somewhere on the plaza, obstructing the supposed playing area. Parsons was probably as puzzled as we are by the absence of a clearly defined ball court at Bilbao, in stark contrast with the apparent abundance of ballplayer imagery on the sculptures.

In 1998, while investigating a supposed residential sector, 300 m west of the El Baúl acropolis, our excavations revealed a sunken court, enclosed by stone-faced vertical walls, preserved to a height of 1.90 m in some places (Chinchilla Mazariegos 2002b). The court is rectangular, measuring 31 × 12.5 m (Figure 6.3). Two large stone staircases located on the northeastern and southeastern corners provided access to the court's earthen floor (Figure 6.4). Evidence that this was indeed a ball court was provided by the earthen benches that ran along its long sides, rising 60 cm above the playing floor. The fact that the stone walls on

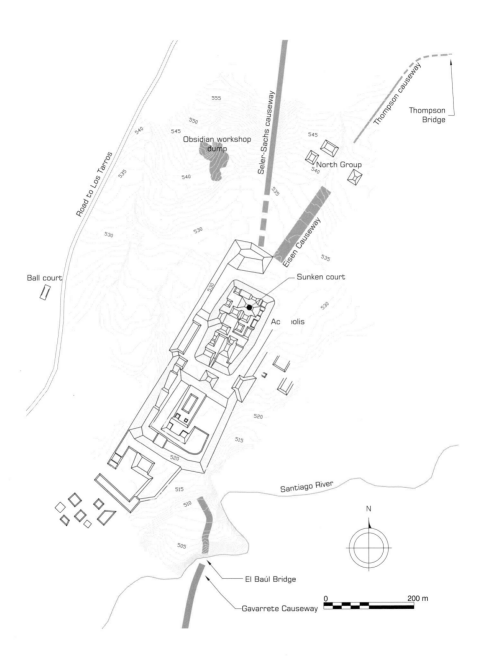

FIGURE 6.2. Plan of El Baúl and its environs, showing the location of the sunken court on the acropolis and the ball court excavated 300 m west of the acropolis. (*All illustrations by Oswaldo Chinchilla, unless indicated.*)

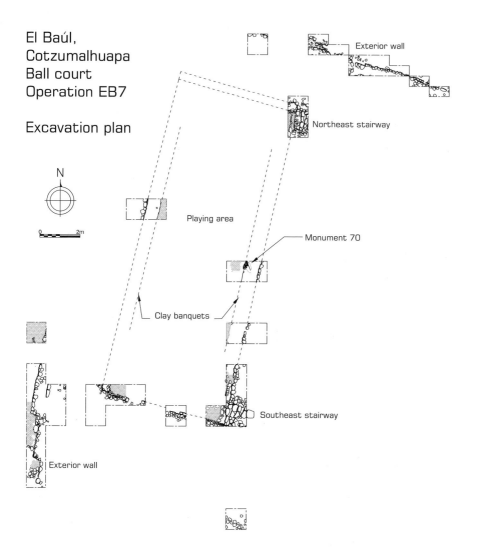

El Baúl, Cotzumalhuapa Ball court Operation EB7

Excavation plan

N

0 2m

Exterior wall

Northeast stairway

Playing area

Monument 70

Clay banquets

Southeast stairway

Exterior wall

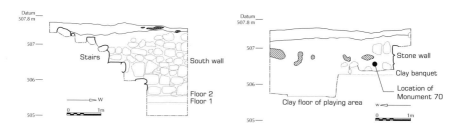

Profile of southeast stairway

Datum
507.8 m

507 —

Stairs

South wall

506 —

Floor 2
Floor 1

505 —

0 1m

Axial profile of east banquet

Datum
507.8 m

507 —

Stone wall

Clay banquet

506 —

Location of
Monument 70

Clay floor of playing area

505 —

w

0 1m

FIGURE 6.3. Excavation plan and profiles of the ball court at El Baúl.
(*Drawings by Mario Vásquez and Oswaldo Chinchilla.*)

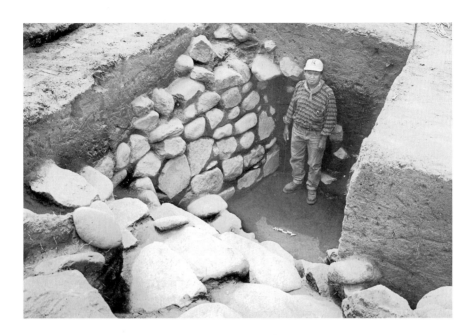

FIGURE 6.4. The southern stairway and wall of the El Baúl ball court. Archaeologist Mario Vásquez is standing on the earthen playing floor.

either side did not go below the surface of these benches proved that they were part of the court's original design (Figure 6.5). Furthermore, one of the ball-court markers was found fallen on the eastern bench, precisely on the court's middle axis. Labeled El Baúl Monument 70, this beautiful sculpture shows a mythologi-cal character with a human face and the snout and ear of an animal, most proba-bly a coyote or dog (Figure 6.6). There are six known examples of horizontally tenoned heads that depict this character, all of which originated from El Baúl, but not necessarily from ball courts. The so-called Bilbao Monument 32 and Pan-taleón Monuments 8–10 were all removed from unknown locations at El Baúl in the nineteenth century (Chinchilla Mazariegos 1996b). El Baúl Monument 71 was recently found by local inhabitants in the southern precinct of El Baúl, with no apparent ball-court architecture.

The location of the El Baúl court, outside the site's major architectural com-pounds, is intriguing. Yet this problem may be more apparent than real. The central core of El Baúl is much more extensive than previously imagined. We now know that a 40-m-wide causeway extended 200 m northward from the acropolis to the "North Group," which should be considered an integral part of the major architectural nucleus of the site. Likewise, the El Baúl ball court may

FIGURE 6.5. Western wall and earthen banquet of the El Baúl ball court. The white line marks the approximate edge of the banquet.

have been well integrated with the site center. There is a good possibility that there are other ball courts elsewhere at Cotzumalhuapa, buried under the thick soils that have resulted from centuries of eruptions of the adjacent Fuego volcano.

Sunken courts are commonplace in Late Classic sites of the highlands and Pacific coast of Guatemala. The closest example is found at Palo Gordo, an important site with Cotzumalhuapa-style monuments (Chinchilla Mazariegos

2002a). Franz Termer excavated an enclosed court in the main precinct of Palo Gordo, measuring 35 × 15 m, and located a horizontally tenoned marker shaped as a skull. These and other sunken courts throughout the Pacific coast and highlands have been commonly associated with the ballgame. Recently, Taladoire (2003) advanced the hypothesis that they were settings for a game variety that resembled the modern *pelota mixteca*, in which a small ball is hit with a hard glove high into the air, to be returned by members of the opposing team. As large as they are by comparison with ball courts from other regions, both the El Baúl and Palo Gordo courts seem to be rather short for the long stretches used in modern pelota mixteca fields, which normally reach between 70 and 100 m long (Taladoire 2003:320). In his article, Taladoire assigns a length of 91 m to the Palo Gordo sunken court, based on surface information gathered by Shook (1965). However, Termer's excavation data yielded a size of 15 × 35 m for this court (Termer 1973:42–46, 128). If the Palo Gordo and El Baúl courts were used in a hand-hit ballgame, the distance between teams—and therefore, the range of flight of the ball—must have been significantly shorter than in modern pelota mixteca. Further indications on the types of games played at these courts derive from the iconography of the sculptured monuments.

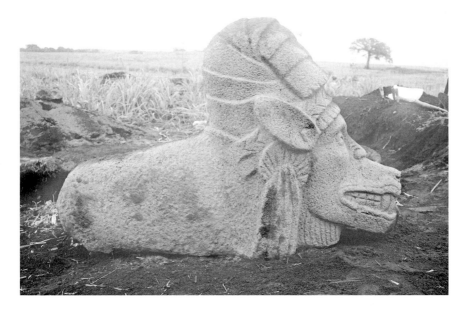

Figure 6.6. El Baúl Monument 70. Height: 76 cm.

The Bilbao Ballplayers

The El Baúl ball court provides the first concrete evidence of the formal architectural setting for the game or games played at Cotzumalhuapa. What were those games like, and how were they represented in the sculptural art?

The characters shown on Bilbao Monuments 1–8 (Figure 6.7a–b) have three elements that identify them as participants in some sort of game:

1. The wide, stiff belts that Seler identified as yokes, carved with figures of animals or supernatural beings, much like the stone yokes found all over the highlands and Pacific coast of Guatemala and El Salvador (Shook and Marquis 1996).[1]

2. The characters on Monuments 2–6 and 8 wearing special, head-shaped objects, fastened to their left hands with wide bandages, arranged in alternating diagonal and transversal directions, covering the hands completely. These objects are sharply turned at an angle from the players' hands, and their distal ends are flat. Borhegyi (1961) first interpreted these objects as handstones, while others prefer to see them as gloves (Parsons 1969:109; Braun 1977:433). Yet, the clearly depicted fastening bands belie their identification as gloves.

3. The left knee of the characters being swollen and calloused, especially on Monuments 3, 4, 5, 6, and 8. Parsons (1969) observed that this was most probably the result of their engagement in the ballgame. The same feature is shared by the main character of the magnificent Bilbao Monument 21, a closely related rock carving located a short distance from the Monument Plaza.

The characters on Monuments 1, 3, and 4 wear only one sandal, always on the left foot, while the right foot is bare. Borhegyi (1961) and Parsons (1969: 109) observed that these features followed "a meaningful pattern relating to their function in the ball game. . . . The left hand is always gloved, the left knee calloused, and the left foot well protected."

What kind of game were they dressed for? If the objects wrapped around the players' left hands are indeed handstones, they may have served to deflect the ball and protect the players' hands. Yet, the heavy yokes worn by the Bilbao ballplayers suggest a game where the ball was hit with the waist. Was this a game that allowed hitting the ball with both hand and waist? This is not inconceivable, but to my knowledge, there is no documented variety of the game that involves such a mixture. I prefer to see the objects in the hands of these characters simply as protectors for the left hands of players, when they fell to the ground trying to recover low balls. This type of situation is usual in modern forms of *ulama* still played in Sinaloa (Leyenaar and Parsons 1988:134).

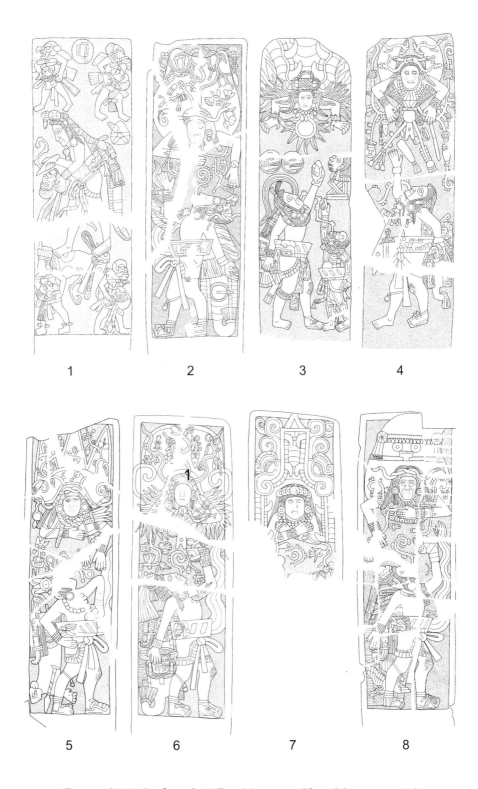

FIGURE 6.7. Stelae from the Bilbao Monument Plaza: Monuments 1–8.

A possible clue to the function of these objects appears on an incised black-ware vessel in Classic Veracruz style, published by Borhegyi (1980:7), which shows a ballplayer falling to the ground in front of a ball (Figure 6.8). He sustains his weight with the left hand, sharply turned frontward and protected with a round-ended object that is tightly fastened to his hand and arm with a long band. The fastening band is placed in an alternating diagonal and transversal pattern, the same employed at Bilbao, especially noticeable on Monument 8. If this was indeed their function, they must have been made with a material softer than stone, perhaps an organic material that provided a cushion for the players' hands.

None of the Bilbao stelae depicts a playing ball, with the possible exception of Stela 1, which shows a scene of sacrifice by decapitation and dismemberment. Decapitation is frequently associated with the ballgame in Mesoamerican art, and therefore the sacrifices and offerings presented by the Bilbao ballplayers are conceivably related to the game. A circle that appears on the upper part of this monument might be a ball, but the inverted headdress incised on this circle is reminiscent of the offerings presented by the ballplayers on the other stelae, and it may also be interpreted as a glyphic notation. The missing Bilbao Monument 11, drawn by Siméon Habel in 1863, depicted two confronting players, complete with yokes and hand protectors (Figure 6.9). No ball is visible, unless the player on the viewer's right is ready to hit a glyph standing in place of the ball. However, the submissive attitude of the other participant suggests that once again, these players may be interacting outside the context of an actual game.

Instead of engaging in the game, the ballplayers depicted on Bilbao Monuments 2–8 appear in the act of presenting offerings—decapitated human heads,

FIGURE 6.8. Polished black-ware sherd in Classic Veracruz style. (*Drawing by the Oswaldo Chinchilla, after a photograph by Gordon Eckholm, in Borhegyi 1980:7.*)

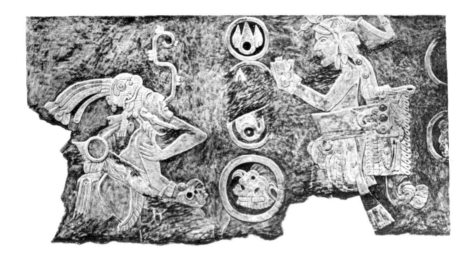

FIGURE 6.9. Bilbao Monument 11. (*Drawing by Siméon Habel, after Habel 1878, pl. V.*)

headdresses, and game animals—to the paramount beings that emerge from supernatural locations above. These are most probably gods or deified ancestors, invoked by the ballplayers through offerings and sacrifices. However, it should be noted that the subject matter of the Bilbao monuments is not invariably tied to the ballgame. This is apparent in Monuments 1–3 from the site of Palo Verde (Figure 6.10), whose actors are devoid of yokes or hand protectors, yet they appear in a similar stance, elevating offerings high above their heads. Despite their lack of specific ballgame attributes, these characters have often been characterized as "ballplayers," presumably because of their similarity to their counterparts at Bilbao. Their common features with the Bilbao assemblage are best explained by their depiction of similar rituals that involve the presentation of offerings, which may or may not relate to ballgames.

The ballplayers in all the stelae have the appearance of being human, suggesting that they represent historic players—nobles or kings of ancient Cotzumalhuapa. Yet they interact actively with supernatural beings. Monument 3 includes a distinct supernatural in the role of a ballplayer, the so-called death manikin, possibly the Cotzumalhuapa death god. Like human participants, he is bedecked with yoke and hand protector, as he raises his hand toward a paramount being above, possibly the sun god. He stands in front of a human ballplayer, but instead of playing, they seem to be engaged in conversation or, perhaps more likely, chant, indicated by the speech scroll that joins their lips.

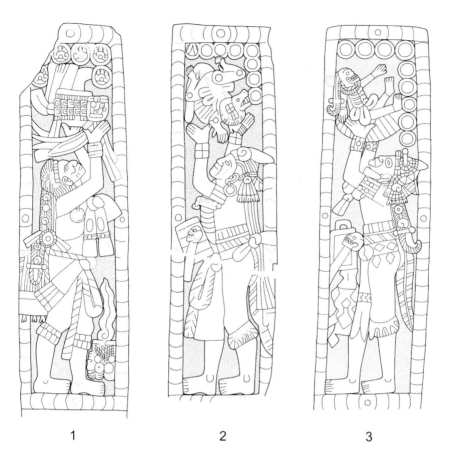

1 2 3

Figure 6.10. Palo Verde Monuments 1–3. Average height: 2.30 m. Notice the absence of yokes and handstones.

In fact, all of the ballplayers on Bilbao Monuments 2–8 have speech scrolls in their mouths. Chanting is part of the rituals that apparently result in the invocation of the paramount beings above. This attribute brings them close to the central personage on Bilbao Monument 21, also a ballplayer, judging from his swollen knee (Figure 6.11). The speech scrolls that come out of his mouth, and from the mouth of a skull placed on his chest, grow to become long vines, ripe with supernatural flowers, fruits, and precious objects—the same that accompany the paramount beings on Bilbao Monuments 2, 4, 5, 6, and 8. This character is not only singing, but also dancing to the rhythm of a kettledrum played by another participant. At the same time, he harvests human-faced fruits that grow from his oversized speech scroll, in clear allusion to human sacrifice. Further analysis of this great monument is the subject of other papers (Chinchilla

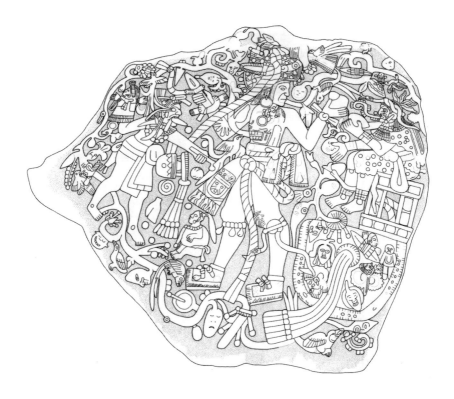

FIGURE 6.11. Bilbao Monument 21. Dimensions: 4.02 × 3.38 m.

Mazariegos n.d.b, 2008). Briefly, I interpret this extraordinary scene as a representation of the Cotzumalhuapa "flower world," a bountiful place of abundance, associated with music, human sacrifice, the spirits of the dead, and possibly the sun god, who appears as the paramount figure on Bilbao Monument 3. Likely, all the paramount figures on Bilbao Monuments 2–8 are denizens of the flower world, as suggested by the supernatural vegetation that surrounds them, and by the presence of the sun god among them. This interpretation follows Karl Taube's (2004, 2005) identification of images of supernatural, flowering mountains in Maya and Teotihuacan art, and comparative evidence from other regions (Carlsen and Prechtel 1991; Hill 1992; López Austin 1994).

A full description of this argument goes beyond the scope of this paper, but it should be stressed that the characters on Bilbao Monuments 1–8 and 21 are engaged in ritual activities related with human sacrifice, the flower world, the evocation of the souls of the dead, and the solar cult. The ballgame was clearly part of this broad complex of ideas and practices. Evidence of the actual practice of the

game at the Bilbao acropolis is still missing, but the straightforward representation of the Bilbao ritual performers with ballplayers' trappings highlights the importance of ballgame confrontation in this ritual complex. In a more subtle way, another form of violent confrontation also found a place in the Cotzumalhuapa flower world complex: a gladiatorial confrontation best characterized as a form of boxing.

BOXERS

El Baúl Monument 27 (Figure 6.12) is one of the most expressive images of confrontation anywhere in Mesoamerican art. The adversaries appear to be in close contact, one of them falling on his back at the feet of the triumphant victor, whose aggressive stance is underscored by the liquid—perhaps vomit or blood—that flows down from his mouth toward his wretched opponent. In contrast with the ritual themes of the Bilbao monuments, this is an actual confrontation, depicted with dramatic realism, except for the small female figure that seems to emerge from the clouds above, presenting the winner with a bag or ornament.

The participants' dress and accessories are radically different from those on the Bilbao stelae. The shape of the playing gear that they wear on both hands is noticeably different from that of the Bilbao characters. Instead of the flat-ended *manoplas* tied to the hands with wide bands, these appear to be gloves, tied at the wrists, with which the participants hold small round balls. The flat distal side of the Bilbao manoplas is entirely missing. Moreover, the characters do not wear yokes or other significant waist or hip protectors. No callousness is visible on their knees, and their feet are bare. Both wear masks—possibly representing a jaguar and a howler monkey—which cover their faces and heads, with large openings for the eyes.

Since the discovery of El Baúl Stela 27, its characters have been described as ballplayers. I agree with Taube and Zender (this volume, Chapter 7) and Orr (2003:84) that they are instead participants in another kind of organized confrontation, a type of boxing with the aid of handheld stones, which required heavy protection of the head and face. The marked contrast between the characters on Bilbao Stelae 1–8 and those of El Baúl Stela 27 suggests that they are attired for different games. Conceivably, the latter's accessories might have been used in some kind of ballgame that involved both hands. However, growing evidence points to a persistent tradition of boxing throughout Mesoamerica, whose participants used both handheld stones and masks covering the entire head and face (Orr 2003:84). Stone balls of the appropriate size have been reported at Cotzumalhuapa (Parsons 1969:79). A particularly fine example was excavated by the author at

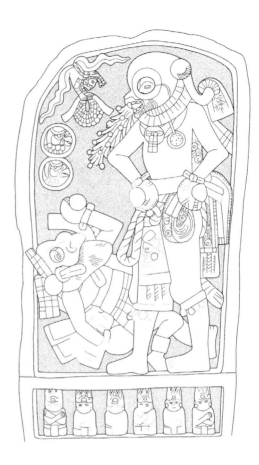

Figure 6.12. El Baúl Monument 27. Height: 2.60 m.

El Baúl in 2006 (Figure 6.13). This finely ground stone is 9.5 cm in diameter and is provided with an encircling groove, slightly offset from the stone's midsection. The placement of the groove seems especially appropriate for grasping the ball firmly with the fingers, and it may also have served to tie it securely to the hand or to a glove. Very likely, this is the type of stone held by the adversaries on El Baúl Monument 27.

Elsewhere in Cotzumalhuapa art, there is another set of images that Taube and Zender (this volume) identify as boxers. El Baúl Monument 35 (Figure 6.14) shows a masked face, tied with heavy ropes that protrude above and drop on both sides. This face is essentially identical to the character dubbed "god(?) with mask" by Hasso von Winning (1987), which appears in numerous examples of figurines and some sculptures at Teotihuacan. Sue Scott (1993) showed that earlier interpretations of this character as a form of Xipe Totec are untenable. Following Taube and Zender's insight, these boxers cover their faces with plain

FIGURE 6.13. Grooved stone ball found in excavations at an architectural compound, 150 m north of the El Baúl acropolis. Diameter: 9.5 cm.

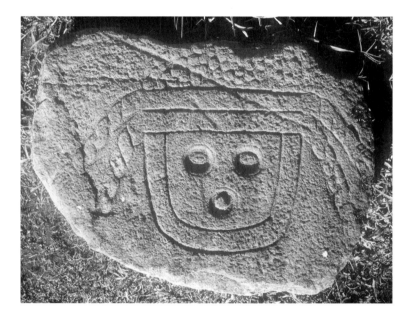

FIGURE 6. 14. El Baúl Monument 35. Dimensions: 0.66 × 1.00 m.

masks, provided with three simple holes for the eyes and mouth. Thick ropes above the head and on both sides served to tie them securely to the head, while providing extra padding. The ropes are also evident on the three-dimensional examples of Monuments 2 and 3 from the site of Aguná, located about 10 km southwest of Cotzumalhuapa (see photographs in Parsons 1969: pl. 55).

The similarity of these depictions with Teotihuacan examples is striking, despite the fact that the Cotzumalhuapa monumental corpus is clearly Late Classic in date. In fact, Cotzumalhuapa is the only place outside Teotihuacan where such figures are found (Scott n.d.). This headgear may have been part of the cultural baggage of the Early Classic migrants who brought Teotihuacan cultural elements to the Pacific coast in the Early Classic Period (Bove and Medrano 2003; Hellmuth 1975; Berlo 1984; Chinchilla n.d.a.). If so, it remained essentially unchanged until the Late Classic florescence of Cotzumalhuapa sculpture. However, the great antiquity of gladiatorial matches across Mesoamerica casts doubt on the idea that they were not practiced on the Pacific coast before the Early Classic Teotihuacan presence in the region.

Germane to the present study is the appearance of boxing iconography on the same monuments that commemorate the flower world complex and the related rituals of human sacrifice, music, and the ballgame. The hand protector worn by the ballplayer on Bilbao Monument 6 is a reduced version of a boxer's masked head (Figure 6.7). The significance of this feature is hard to estimate, since every performer in this group of stelae has a different representation on its hand protector. However, there is another image of a boxer's mask associated with the flower world complex, painted or embroidered on the loincloth of the central character on Bilbao Monument 21 (Figure 6.11). If nothing else, these images suggest that together with other symbols, the masked faces of boxers were fitting elements in the ritual symbolism associated with the Cotzumalhuapa flower world.

CONCLUSION

Archaeological and iconographic research sheds light on the practice of the ballgame and its ritual significance at Cotzumalhuapa. The question remains whether this was a critical aspect of Classic Cotzumalhuapa culture, as suggested by earlier observers. Based on current documentation of Cotzumalhuapa-style sculptures, I believe that the relative importance of the ballgame in the area has been overstated. For all their magnificence, Bilbao Monuments 1–8 and 11 form a unique sculptural program of rituals enacted by ballplayers, and all of them come from a restricted sector at Bilbao. Ballplayers appear nowhere else in the extensive sculptural corpus of Cotzumalhuapa, assuming that the confronted players on El Baúl Monument 27 are indeed boxers. Furthermore, the corpus includes a variety of subjects that are not explicitly related to the ballgame, including portraits of kings and nobles, transmission of symbols of power, marital alliances, and mythological scenes. The ballgame was obviously important in Classic Cotzumalhuapa, as it was for other contemporary peoples throughout Mesoamerica. Like them, the Cotzumalhuapa

artists placed special emphasis on the participation of ballplayers in ritual events, thus highlighting the role of the game within broader religious beliefs and practices that also involved other forms of violent confrontation—gladiatorial matches and human sacrifice. All were inextricable parts of a religious complex that also included music, dance, chanting, and the presentation of offerings to gods or ancestors residing in a flowering paradise.

NOTE

[1] This paper contains few references to the artifactual record, which does include a number of stone objects that have been related in one way or another to the ballgame. These include yokes, *hachas*, stone balls, and different types of manoplas, some of which may now be related to other games and forms of confrontation, besides the ballgame. Yokes and hachas are indeed important at Cotzumalhuapa and related sites, but the maps in Shook and Marquis's catalog (1996) show that these objects are widely distributed in southern Mesoamerica, and there is no indication that their distribution correlates with Cotzumalhuapa cultural or political influence. In an earlier article (Chinchilla Mazariegos 2002a), I reported the remains of a stone yoke workshop—to my knowledge, the only one known so far anywhere in Mesoamerica—found by workmen while razing a small mound at Palo Gordo, an important site with Cotzumalhuapa-style sculptures, located about 40 km west of Cotzumalhuapa.

REFERENCES CITED

Berlo, J. C.
 1984 *Teotihuacan Art Abroad: A Study of Metropolitan Style and Provincial Transformation in Incensario Workshops.* 2 vols. BAR International Series, Oxford.

Borhegyi, S. de
 1961 Ball-Game Handstones and Ball-Game Gloves. In *Essays in Pre-Columbian Art and Archaeology*, edited by S. K. Lothrop, pp. 126–151. Harvard University Press, Cambridge.
 1980 *The Pre-Columbian Ballgames: A Pan-Mesoamerican Tradition.* Contributions in Anthropology and Historia, No. 1. Milwaukee Public Museum.

Bove, F. J., and S. Medrano
 2003 Teotihuacan, Militarism, and Pacific Guatemala. In *The Maya and Teotihuacan: Reinterpreting Early Classic Interaction*, edited by G. Braswell, pp. 45–79. University of Texas Press, Austin.

Braun, B.
 1977 Ballgame Paraphernalia in the Cotzumalhuapa Style. *Baessler-Archiv, Neue Folge* 25:421–457.

Carlsen, R. S., and M. Prechtel
 1991 The Flowering of the Dead: An Interpretation of Highland Maya Culture. *Man* 26:23–42.

Chinchilla Mazariegos, O.

1996a "Peor es Nada": El origen de las esculturas de Cotzumalguapa en el Museum für Völkerkunde, Berlin. *Baessler-Archiv, Neue Folge* 44:295–357.

1996b Las esculturas de Pantaleón, Escuintla. *U-Tz'ib* 1(10): 1–23. Asociación Tikal, Guatemala.

2002a Palo Gordo, Guatemala, y el estilo artístico Cotzumalguapa. In *Incidents of Archaeology in Central America and Yucatan: Essays in Honor of Edwin M. Shook*, edited by M. Love et al., pp. 147–178. University Press of America.

2002b Investigaciones por medio de Radar de Penetración al Suelo (GPR) en la Zona Nuclear de Cotzumalguapa. In *XV Simposio de investigaciones arqueológicas en Guatemala*, edited by J. P. Laporte et al., pp. 493–511. Instituto de Antropología e Historia/Asociación Tikal, Guatemala.

2008 El Monumento 21 de Bilbao, Cotzumalguapa. In *XXI Simposio de Investigaciones Arqueológicas en Guatemala*, edited by J.P. Laporte et al., pp. 989-1005. Instituto de Antropología e Historia/Asociación Tikal, Guatemala.

n.d.a. Los estilos artísticos del Período Clásico en la Costa Sur de Guatemala: ¿Reflejos de identidad étnica? Paper presented at the V Mesa Redonda de Palenque, 2004. Palenque, Chiapas, Mexico.

n.d.b. El cacao y el sacrificio humano en Mesoamérica. Manuscript.

Chinchilla Mazariegos, O., F. Bove, and J. V. Genovez

n.d. La cronología del Período Clásico en la Costa Sur de Guatemala y el fechamiento del estilo escultórico Cotzumalguapa. Forthcoming in *V Coloquio Pedro Bosch Gimpera*. Universidad Nacional Autónoma de México.

Coe, M. D.

1966 *The Maya*. Thames and Hudson, London.

Hellmuth, N.

1975 *The Escuintla Hoards: Teotihuacan Art in Guatemala*. Progress Reports, 1 (2). Foundation for Latin American Anthropological Research, St. Louis.

Hill, J. H.

1992 The Flower World of Old Uto-Aztecan. *Journal of Anthropological Research* 48:117–143.

Leyenaar, T., and L. A. Parsons

1988 *Ulama: The Ball Game of the Mayas and Aztecs*. Spruyt, Van Mantgem and De Does bv, Leiden.

López Austin, A.

1994 *Tamoanchan y Tlalocan*. Fondo de Cultura Económica, Mexico, D.F.

Orr, H.

2003 Stone Balls and Masked Men: Ballgame as Combat Ritual, Dainzú, Oaxaca. *Ancient America* 5:73–104. Center for Ancient American Studies, Barnardsville.

Parsons, L. A.

1969 *Bilbao, Guatemala: An Archaeological Study of the Pacific Coast Cotzumalhuapa Region*, Vol. 2. Publications in Anthropology 12. Milwaukee Public Museum, Milwaukee.

Scott, S.

1993 *Teotihuacan Mazapan Figurines and the Xipe Totec Statue: A Link between the Basin of Mexico and the Valley of Oaxaca.* Vanderbilt University Publications in Anthropology No. 44. Vanderbilt University, Nashville.

n.d. The Teo-Cotz Guy: The Teotihuacan Terracota Masked Figure and the Cotzumalguapa Connection. Manuscript.

Seler, E.

1892 Los relieves de Santa Lucía Cotzumalguapa. *El Centenario. Revista Ilustrada. Organo Oficial de la Junta Directiva, Encargada de Disponer las Solemnidades que han de Conmemorar el Descubrimiento de América* 3:241–252. El Progreso Editorial, Madrid.

Shook, E.

1965 Archaeological Survey of the Pacific Coast of Guatemala. In *Archaeology of Southern Mesoamerica,* Part 1, edited by G. R. Willey, pp. 180–194. Handbook of Middle American Indians Vol. 2. University of Texas Press, Austin.

Shook, E. M., and E. Marquis

1996 *Secrets in Stone: Yokes, Hachas and Palmas from Southern Mesoamerica.* American Philosophical Society, Philadelphia.

Taladoire, E.

2003 Could We Speak of the Super Bowl at Flushing Meadows? La Pelota Mixteca, a Third Pre-Hispanic Ballgame and Its Possible Architectural Context. *Ancient Mesoamerica* 14:319–342.

Taube, K.

2004 Flower Mountain: Concepts of Life, Beauty, and Paradise among the Classic Maya. *Res, Anthropology and Aesthetics* 45:69–98.

2005 Representaciones del paraíso en el arte cerámico del Clásico Temprano de Escuintla, Guatemala. En *Iconografía y escritura teotihuacana en la Costa Sur de Guatemala y Chiapas,* edited by O. Chinchilla Mazariegos and B. Arroyo, pp. 35–54. U tz'ib, Serie Reportes, Vol. 1, No. 5. Asociación Tikal, Guatemala.

Termer, F.

1930 Archäologische Studien und Beobachtungen in Guatemala in den Jahren 1925–29. In *Tagungsberichte der Gesellschaft für Völkerkunde, herausgegeben vom Vorstand.* Bericht über die I. Tagung 1929 in Leipzig, Leipzig.

1973 *Palo Gordo. Ein Beitrag zur Archäologie des Pazifischen Guatemala.* Monographien zur Völkerkunde, Herausgegeben vom Hamburgischen Museum für Völkerkunde, 8. Kommissionsverlag Klaus Renner, Munich.

Thompson, J. E. S.

1948 *An Archaeological Reconnaissance in the Cotzumalhuapa Region, Escuintla, Guatemala.* Contributions to American Anthropology and History, 44. Carnegie Institution of Washington, Washington, D.C.

Von Winning, H.

1987 *Iconografía de Teotihuacán: Los dioses y los signos,* 2 vols. Universidad Nacional Autónoma de México, Mexico.

CHAPTER 7

AMERICAN GLADIATORS: RITUAL BOXING IN ANCIENT MESOAMERICA

Karl Taube and Marc Zender

INTRODUCTION

O ver the years, a great deal of research has been devoted to the Mesoameri-can ballgame, which already had important religious as well as social roles by the Early Formative Olmec occupation of San Lorenzo (ca. 1150–900 B.C.). It is also clear that aside from hip ball played in masonry courts, a variety of other ballgames were played, including stickball and a Classic Maya version played with large balls against stairways (Coe 2003; Taladoire 2003; Taube 2004; Zender 2001a). However, the ballgame was by no means the only competitive sport played in ancient Mesoamerica. Another important but little-studied sport was boxing, a native tradition that continues in Nahua communities of highland Guerrero (Orr 1997, 2003; Taube 2004:84–85; Zender 2004:7–8). In the region of Tixtla, Chilapa, Acatlán, and Zitlala, men in jaguar dress fight in early May to bring the rains. The recent research by Heather Orr (1997, 2003) is the most ambitious to date concerning the ritual and symbolic role of boxing in ancient Mesoamerica. Much of her work has focused on the Late Preclassic Zapotec reliefs from Dainzú, Oaxaca. Orr (1997, 2003) has compared the Dainzú sculp-tures not only to Classic Maya scenes of boxing, but also to the contemporary cer-emonies of highland Guerrero. According to Orr, the reliefs at Dainzú portray men fighting with stone balls. She cogently argues that at Dainzú, the ritual com-bat concerned rainmaking and mountain worship, as it still does today for the

inhabitants of Zitlala, Acatlán, and other communities of the Montaña de Guerrero.

In contemporary Mesoamerica, ceremonial boxing is well documented in the Montaña de Guerrero and typically occurs during or near the Day of the Cross, widely identified with the beginning of the rainy season (Calles Travieso 1994; Díaz Vásquez 2003; Matías Alonso 1997:158–166; Obregón Téllez and Martínez Resclavo 1991; Olivera 1994:88–90; Sánchez Andraka 1983:53–54; Sepúlveda Herrera 1982:51; Williams-García 1997). Although such ritualized combat does occur in town centers, a major focus and *locus* for boxing is on mountaintops, the traditional abode of the forces of rain and lighting. As Rosalba Díaz Vásquez (2003:66–67) notes in her recent volume concerning boxing in Acatlán, Guerrero, this ceremonial combat appears to be entirely indigenous and constitutes a native form of rain ceremony and mountain worship with no formal ties to the Catholic Church. A basic, underlying theme is rain ritual, with the blows compared to thunder and the ensuing blood to rain, events clearly related to the advent of the rainy season in early May. The players frequently wear heavy, leather helmet masks portraying jaguars, with their open mouths serving as horizontal visors for the fighters (Figure 7.1; see Díaz Vásquez 2003: 81, 91, 124). In addition, the leather masks have projecting jaguar ears, and it should be noted that both the horizontal visors and jaguar ears are present in the boxing helmet masks of Classic Period Mesoamerica. In both appearance and attendant symbolism, the boxers of Classic Mesoamerica share many traits with contemporary traditions of ritualized combat documented ethnographically for the Montaña de Guerrero.

Following the original insights of Orr, this study presents further evidence for the ancient identification of boxing with rainmaking. However, we also take a slightly different tangent. Although Orr (1997, 2003) recognizes the Dainzú reliefs as scenes of ritualized combat, she nonetheless refers to the sport as a form of "handball," due to the fact that stone balls were apparently employed. By contrast, we argue that, whether fashioned of wood or stone, these balls were not objects to be manipulated across a playing field, but rather boxing weapons intended to maim or kill. In this ritualized blood sport, a variety of weapons were used, including stone spheres, at times wrapped in cloth, *manoplas*, conch shells, and short stone clubs. Although these ritualized forms of boxing and combat are entirely distinct from the ballgame, the sports overlap both thematically and with respect to the types of gear and apparel employed, and it is likely that ball courts were frequent loci for boxing events. In addition, aside from its sacred role, boxing was also a form of entertainment and frequently appears in the context of drinking alcoholic beverages.

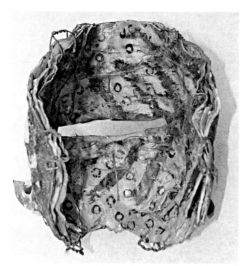

FIGURE 7.1. Three views of a contemporary jaguar boxing mask from highland Guerrero, Mexico. The mask is composed of several layers of hardened leather bound with metal wire. The left cheek is marked with daubs of red paint, probably to indicate blood.

MASKED BOXERS AND RITUAL COMBAT

The first published images of ancient Mesoamerican boxers appeared in a monograph by T. A. Joyce (1933) concerning ceramic figurines from the Classic Maya site of Lubaantun, Belize. No fewer than 27 of the figurines portray males wearing helmet masks (Figures 7.2, 7.6c). Resembling medieval jousting helmets, these devices are supplied with a horizontal slit to provide sight for the wearer, a feature also found on contemporary leather boxing masks from Guerrero (Figure 7.1). The Lubaantun figures frequently have a broad shoulder frame projecting above the helmet mask, a rectangular bib-like element, a wide loincloth, and a garment hanging from the waist to protect the hips and outer thighs. Similar hip garments are commonly depicted on Classic Maya ballplayers and were probably fashioned of thick leather. According to Joyce (1933:19–22), the masked Lubaantun figures are in fact ballplayers. However, Norman Hammond (1976) rightly noted that the costume of these figures is entirely distinct from known ballplayer figurines at Lubaantun. Hammond (1976:106) also mentioned that two of the figurines apparently portray pairs of figures engaged in combat (Figure 7.2d–e). Hammond (1976:107) identified the Lubaantun helmeted figures as fighters, although he was reluctant to state whether this combat concerned warfare or sport:

> They are shown either just standing fully accoutred, or in a close active juxtaposition that might reasonably be called "combat": whether this is the combat of warriors in battle, the controlled combat of a sport or the quasi-combat of a ritual, we have no way of telling.

Figurine molds of the helmeted boxers were found at Lubaantun, indicating that they were made locally (Hammond 1976:104). In addition, Hammond (1976:106–107, fig. 6) noted that a polychrome vase in the British Museum portrays the same helmeted figures engaged in combat. The vessel derives from either Lubaantun or nearby Pusilha; clearly this sport was of considerable importance in the Lubaantun region.[1]

Aside from the vessel in the British Museum, several other Late Classic Maya vases explicitly portray the sport of boxing. In one scene, a pair of gods or deity impersonators face an opposing team of four, with one of the latter already lying stunned or dead (see Robicsek and Hales 1981: fig. 17 [K700]).[2] With their long, bound hair, projecting upper lip, and knotted belt pieces, the pair of figures probably represents embodiments of Chaak, the rain god (Figure 7.3a). The team of four fighters has helmet masks with jaguar ears and the facial "cruller" element of the Jaguar God of the Underworld, and the same helmets are also worn on the backs of the two Chaaks. David Stuart (1998:408) has suggested that the Jaguar God of the Underworld was both the night sun and "the supernatural patron of

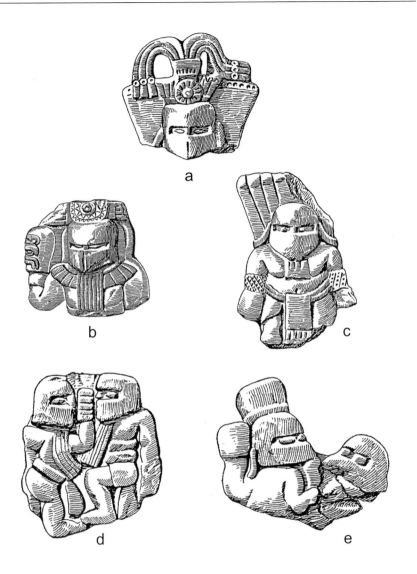

FIGURE 7.2. Helmeted and padded Maya boxers, Late Classic ceramic figurines from Lubantuun, Belize. (*All from Joyce 1933: pls. 7–8.*)

fire and fire making." It is thus possible that the combat reflects a basic dual opposition between igneous and aquatic gods, recalling the Aztec phrase for war, *atl-tlachinolli*, "water and fire." A number of the players wear thick belts, probably to protect their midsection from the weapons they wield in both hands. Although Robicsek and Hales (1981:116) stated that the white objects are of flint, the small circles on these weapons suggest that they are conch.

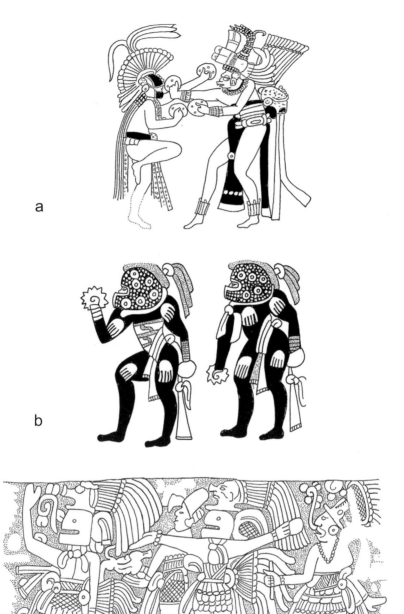

FIGURE 7.3. Late Classic vessel scenes of Maya boxing: *a*, helmeted boxers sparring with conch shells, Late Classic vessel (*after Robicsek and Hales 1981: fig. 17b*); *b*, helmeted and padded boxers wielding conch shells, Late Classic vessel (*after Kerr 1989:19 [K500]*); c, heavily padded and helmeted boxers wielding stones, detail from incised vessel (*after a photograph by Justin Kerr [K8545]*).

Another Late Classic vessel scene portrays three boxers wielding conch shell weapons in their right hands (Figure 7.3b). One fragmentary Lubaantun boxer figurine with the aforementioned bib element holds a probable conch in his left hand (see Joyce 1933: pl. 3, no. 9). As in the case of the aforementioned vase, one of the figures has binding high on the abdomen, probably to protect the torso from heavy blows (Figure 7.3a–b). In the vessel scene, the left hands are covered with a form of mitt similar to examples appearing with the Lubaantun figurines. Although it is conceivable that these mitts are of soft material to serve as defensive shields, they are pulled back behind the body as if in preparation to strike. It is quite possible that the left arms are bound to a hard and heavy material, such as stone, for giving crushing blows. Whereas one Lubaantun figurine portrays a boxer with the mitt raised menacingly behind his head, another depicts a fighter striking his opponent with this device (Figure 7.2d–e). The helmet masks are very similar to those worn by the Lubaantun figurines, which also have visor-like eye slits. Although not mentioning Lubaantun, Justin Kerr (1989:13) compared the three vessel figures to the sculptures of Dainzú as well as to a Classic Maya figurine attributed to the Peten (see Berjonneau et al. 1985: pls. 368–369). The helmet masks worn by the vessel players are spotted, probably to suggest jaguar pelage. With their spots and visor-like eye opening in the mouth area, these Late Classic examples are also very similar to the leather jaguar helmet masks worn by the boxers in contemporary Guerrero (see Díaz Vázquez 2003:81, 91, 118–119, 123–124).

A carved Late Classic vase provides an especially elaborate scene of four masked boxers accompanied by two other figures, probably musicians (Figure 7.3c; for the entire scene, see [K8545]). Whereas one of the unmasked individuals is singing and grasps what might be a flute, the other figure holds out a probable feather-tasseled conch trumpet (Figure 7.3c). Another song scroll emerges from the mouth slit of one of helmet masks, indicating that the boxer is also singing. The other three boxers hold their arms out in gestures of dance. One boxer has the spherical mitt bound to his left hand, recalling the aforementioned vessel scene (Figure 7.3b–c). Although all boxers wield weapons, the immediate event is a dance rather than direct combat.

Dating to the Late Preclassic Period (ca. 200 B.C.–A.D. 200), Zapotec reliefs at Dainzú, Oaxaca, feature 31 figures in dynamic poses wearing helmet masks and grasping a ball with a glove in one hand (Figure 7.4). In a discussion of the Dainzú monuments, Ignacio Bernal and Andy Seuffert (1979:26) briefly mention a contemporary Mixtec ballgame, or *pelota mixteca*, but make no specific comparisons to the Dainzú figures: "Up to the present time in what is now the state of Oaxaca the 'Mixtec ballgame' takes place on an open field and has certain elements that can

only be survivals from prehispanic times." In pelota mixteca, the ball is struck with a heavily padded mitt. In a recent detailed reappraisal of the relation of the Dainzú reliefs to pelota mixteca, Eric Taladoire (2003) concludes that the Late Preclassic carvings portray an ancient form of the contemporary Mixtec game. In his study, however, he notes that research by Heiner Gillmeister (1988) indicates a European origin for much or all of the Mixtec game. Although Taladoire (2003:328) acknowledges that "[t]he validity of Gillmeister's argument cannot be denied," he considers the appearance of the Dainzú ballplayers too similar to the contemporary pelota mixteca for it to be coincidence.

In his discussion of the Dainzú reliefs, Taladoire (2003:326) mentions that both Heather Orr and Karl Taube identify the Dainzú figures as boxers. Taladoire (2003:326–327), however, does not concur with this interpretation for several reasons: such ritual combat is not known for the Aztec, it is "poorly documented ethnographically and ethnohistorically," and the Dainzú mitts and kneepads would be more compatible "with game ritual than with simple fighting." Although it is true that Aztec boxing is not documented in the sixteenth-century Spanish accounts, this can also be said of the pelota mixteca. Although Bernardino de Sahagún, Diego Durán, and other early chroniclers provided detailed accounts of the 20-day *veintena* celebrations, many aspects of Aztec ceremonial life and games probably were not recorded. In addition, it is entirely possible that although ritual boxing may not have been present among the Late Postclassic Aztec, it could have been performed in other regions and periods in ancient Mesoamerica. Although boxing is indeed poorly known for Contact Period sixteenth-century Mesoamerica, this is not the case for contemporary Guerrero. As we note in our introduction, ritual boxing in the context of rainmaking is very well documented for contemporary highland Guerrero, including a monograph entirely devoted to this topic (Díaz Vásquez 2003).

The physical appearance of the contemporary Guerrero boxers is very similar to Classic Period Zapotec and Maya examples. It was noted that the modern leather boxing masks portray jaguars with feline ears, and indeed most of the Dainzú masks have these features as well:

No less than twenty-one figures still show an ear—not a human ear but that of a jaguar—and this forms part of the headgear. (Bernal and Seuffert 1979:16)

Norman Hammond (personal communication 2005) notes that one Lubaantun boxer figure also has an explicit jaguar ear at the side of the head (Figure 7.4c). In addition, two of the Dainzú figures have long tails, quite possibly those of jaguars (Figure 7.4e; see also Bernal and Seuffert 1979: drawing 7). Like modern boxers, the Dainzú athletes are dressed as jaguars.

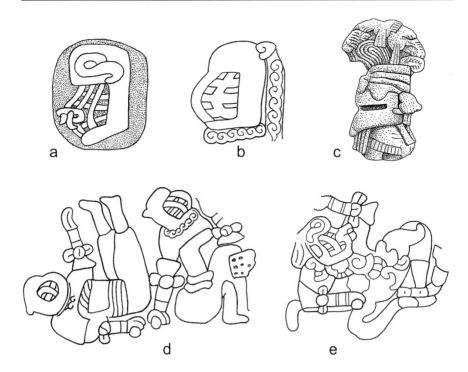

FIGURE 7.4. Zapotec and Maya portrayals of helmeted boxers: *a*, bas-relief of Zapotec boxer with Cocijo mouth and S-shaped cloud scroll on brow, examples from Monte Albán, (*after Bernal and Seuffert 1979: drawing 51*); *b*, head of boxer with jaguar ear and cloud or water scrolls, Dainzú (*after Bernal and Seuffert 1979: drawing 51*); *c*, Late Classic Maya boxer with probable jaguar ear, Lubaantun figurine fragment (*drawn after photo courtesy of Norman Hammond*); *d*, Dainzú boxers with probable jaguar ears and cloud or water scrolls (*after Bernal and Seuffert 1979: drawing 18*); *e*, Dainzú boxer with Cocijo mouth and S-shaped cloud sign on brow (*after Bernal and Seuffert 1979: drawing 3*).

In the Dainzú reliefs, the most striking item worn by the players is the helmet mask. Not only is the helmet mask not worn in the modern pelota mixteca, but it is also difficult to explain why such an item would be of use and not a hindrance in this form of ballgame. In a discussion of the Dainzú sculptures, Bernal (1973:19) notes that "ballplayers wearing visored helmets . . . are found in very few places, such as Lubaantun." It has been noted that the Classic Maya figures wearing visored helmets at Lubaantun and in vessel scenes are clearly boxers, not ballplayers. Aside from the helmet masks, the Dainzú figures grasp balls in their gloves, which is decidedly unlike pelota mixteca, where the ball is not held but punched with the heavy mitt. With the thick, pelota mixteca mitts, it is impossible to even grasp a ball (see Taladoire 2003: fig. 20). In addition, one Dainzú relief shows two figures simultaneously wielding balls, an event that would not occur in

any known Mesoamerican ballgame (Figure 7.4d). Taladoire (2003:329) notes that the Dainzú reliefs are frequently compared to Monument 27 of El Baúl, Guatemala (Figure 7.6d). This scene also portrays two opponents wearing helmet masks and mitts, although in this case at least one figure grasps balls in both hands. The lower figure has one hand raised as if to strike his opponent, who appears to have blood streaming from his mouth.

As has been mentioned, Heather Orr (1997, 2003) was the first to compare the Dainzú reliefs to the contemporary boxers in the Montaña de Guerrero. According to Orr, the Dainzú sculptures also concern rain and mountain worship. In support, Orr notes that a series of helmet masks was carved on a rock outcrop atop Cerro Dainzú, recalling the contemporary boxing atop mountains in Guerrero (Figure 7.4b). Moreover, Orr notes that some Dainzú figures display rain attributes, such as the S-shaped motif known to represent clouds at Middle Formative Chalcatzingo and among the Classic and Postclassic Maya (Figure 7.4a, e). Following an initial identification by Javier Urcid, Orr (2003:84) notes that a number of Dainzú and related Zapotec helmet masks portray Cocijo, the Zapotec god of rain and lightning (Figure 7.4a, e). In addition, it is likely that the scrollwork edging found with many of the Dainzú helmets also refers to water or clouds, as this element commonly portrays waves and water in ancient Mesoamerica and is painted on the walls of the roughly contemporaneous Tomb 103 at Monte Albán (see Caso 1938: plan 5). In Early Classic Teotihuacan iconography, such scrolls denote clouds and frequently appear against lightning bolts (see Taube 2004: fig. 37).

Among the contemporary Nahua peoples of the Montaña de Guerrero, the relation of boxing to lightning and thunder is explicit, as can be seen in the following account by Marcos Matías Alonso (1997:160) for Acatlán: "[S]e dice que los golpes imitan a los truenos y los relámpagos." The masks and jaguar suits worn by the contemporary boxers probably reflect the predilection of cats to strike with their front paws, much like boxers, and as noted earlier, a number of Late Classic Maya boxers wear jaguar helmets (Figures 7.3a–b, 4c). However, the identification of boxers with jaguars in Guerrero may also derive from the ancient and widespread relation of Mesoamerican rain gods to jaguars, including the Zapotec Cocijo, Tlaloc of Central Mexico, and Chaak of the Maya (Covarrubias 1957:60–63; Taube 1995, 2004:29–32).

Aside from the reliefs at Dainzú and other related Late Preclassic sites, the Zapotec boxers also appear in the Late Classic murals at Huijazoo, Oaxaca (Figure 7.17b; see Miller 1995:189–190, fig. 30, pl. 41). Both the east and west walls of the main tomb chamber portray six figures wearing the same type of helmet appearing at Dainzú, along with the bars or coarse netting across the face. For

both series, the boxers wear distinct headdresses that appear in the same order. On the east and west walls, the leading helmeted boxer wears a jaguar or puma headdress, recalling the jaguar boxers from Classic Maya scenes, Dainzú, and the contemporary Montaña de Guerrero. The final sixth figure on the east wall wears cloth or paper marked with the S-shaped cloud motif noted by Orr for Dainzú-type boxers (for example, Figure 7.4b, d). The fourth and fifth individuals on both walls have long bones on their clothing and wear headdresses related to death and sacrifice. Thus, whereas the fourth in both series has the head of the flayed god Xipe Totec in his headdress, the fifth wears a skull. In addition, both of the fifth figures have inverted trophy heads hanging from their belts. In an aforementioned Late Classic vessel scene, one of the boxers also wears an inverted trophy head hanging from his back (see Robicsek and Hales 1981: fig. 17, far left).

In Mesoamerican studies, the Dainzú masked figures are widely believed to be ballplayers rather than boxers. Clearly enough, the primary reason for this identification is the hand-held balls. If there are balls, the reliefs must depict the ballgame. Thus, in his first publication of the Dainzú reliefs, Bernal (1968:250) states that because the figures hold balls, they are ballplayers:

> I think that there is little doubt that ball players are depicted, since as already mentioned, each holds a ball in his right hand, wears a face guard and protection for the hands and knees, besides displaying vigorous motion.

Similarly, although Hammond (1976:108, n. 1) compares the Lubaantun helmeted fighters to the Dainzú reliefs, he considers the Zapotec figures to be ballplayers. As has been mentioned, Orr (1997, 2003) interprets the Dainzú reliefs as portrayals of ritual combat. However, because of the ball held in the hands, she also views the scenes as portrayals of a type of ballgame. Although the English term "ball" is often interpreted as an item used in sports, this is not the only meaning; the word can refer more generally to a round, spherical object. Whether held in the hand or wrapped in cloth as "saps," stone spheres were very effective weapons for ritual combat in ancient Mesoamerica.

Along with their portrayals by the ancient Zapotec and the Classic Maya, helmeted boxers also appear in the art of Early Classic Teotihuacan. Many Teotihuacan figurines portray a male wearing a mask widely cut around the mouth and eyes (Figure 7.5). Aside from one exception to be discussed later, the nose is not portrayed, suggesting that the mask is of thick or hard material. Bands of leather or cloth typically encircle the brow and head, and rings of padding also commonly appear on the limbs. In addition, the figures wear broad belts and a diagonal item extending from the right shoulder to the waist (see Scott 2001: pls. 99–103; Von Winning 1987, I: chap. 12b, fig. 1). Due to the obvious mask, Eduard Seler (1912:196) related this figurine type to Xipe Totec

and Teteo Innan, later Aztec gods who wear masks and body suits of flayed human skin. Although the Xipe Totec identification has been widely accepted, Hasso von Winning (1987, I:147–149) noted that there is no evidence that the mask is of human skin or that the figure even portrays a deity. According to Von Winning (1987, I:147–149), this figure appears to be related to rain and water. In support, Von Winning illustrates two Teotihuacan vessels portraying the masked head, one with Tlaloc and Quetzalcoatl, and the other, falling rain-drops.

For one example of the Teotihuacan figurine, the mask is composed of coarse netting, quite like the Zapotec examples from Monte Albán, Dainzú, and Huija-zoo (Figure 7.4a). Based on their similarity to the Dainzú reliefs, the Teotihua-can figurines were initially identified as "ballplayers" by Taube (1988:118). Sub-sequently, Sue Scott (2001:41) also noted that the figures are not gods, but

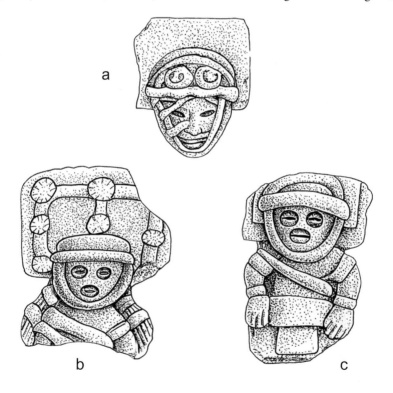

FIGURE 7.5. Early Classic Teotihuacan figurines of probable masked boxers: *a*, figurine fragment with broad strips crossing face; compare with Zapotec masked helmets appear-ing in Figure 7.4. (*from Caso 1967: fig. 33a*); *b*, masked figurine with bound elements hanging from side of head (*after Scott 2001: 103*); *c*, masked figurine with broad belt and thick bindings on arms (*after Scott 2001: pl. 101*).

ballplayers. However, Scott (2001:41) also mentioned that the heavy padding suggests an especially violent game:

> If the padding held in place by the belt of our "masked face" figure was meant to protect the solar plexus from blows, then we might infer the game, or whatever activity, was more physically threatening than that of our other loincloth-wearing figurines.

Rather than a ballplayer, the Teotihuacan masked figure is probably a boxer, a theme consistent with the rain symbolism suggested for this entity. Scott (2001:41) noted that the Teotihuacan masked figurines have a frame above the head (Figure 7.5b). As mentioned earlier, this is also a common feature with the Lubaantun boxers (Figure 7.2a, c). Scott (2001:41) also mentioned that the Teotihuacan headdresses can have "side drapes" (Figure 7.5b). Similar pendant elements are commonly found on the sides of Lubaantun helmet masks and might portray rope or leather flaps to protect the neck and temporal area (Figure 7.2a, c, e). It is also possible, however, that this material is the thickly matted hair or "dreadlocks" of the boxer, which would serve as effective padding against blows to the side of the head.

As noted by Scott (in press), masked figures virtually identical to the Teotihuacan figurines appear in monumental stone sculpture in the Cotzumalhuapa region of southern Guatemala (Figure 7.6a–b). El Baúl Monument 35 portrays a helmet headdress with ropes or twisted hair hanging from the sides, which Scott (in press) compares to the "side drapes" of the Teotihuacan figures. In fact, at least one Lubaantun figurine displays a vertical strand of twisted hair or rope in the temporal region of the helmet mask (Figure 7.6c). A pair of tenoned sculptures found near Hacienda Aguna, Guatemala, also have this material hanging from the sides of the helmet masks (see Parsons 1969: pl. 55e–f; Thompson 1948:20–21, fig. 11a–b). One of the boxers is supplied with a rectangular rack behind the helmet (Figure 7.6b). Marked with five circular elements, this rack is almost identical to an example appearing on a Teotihuacan figurine (Figure 7.5b). Although it is conceivable that the Hacienda Aguna examples are contemporaneous with Early Classic Teotihuacan, such helmet masks continued during the Terminal Classic florescence of the Cotzumalhuapa style. One of the best-known Cotzumalhuapa monuments is Bilbao Monument 21, a boulder sculpture featuring a complex scene of three figures amid flowering vines (see Parsons 1969: pl. 31). The head of a masked, Teotihuacan-style boxer appears on the loincloth of the principal, central figure. Although of somewhat different appearance, the helmeted figures on El Baúl Monument 27 are also Terminal Classic boxers (Figure 7.6d; see also Chinchilla this volume, Chapter 6).

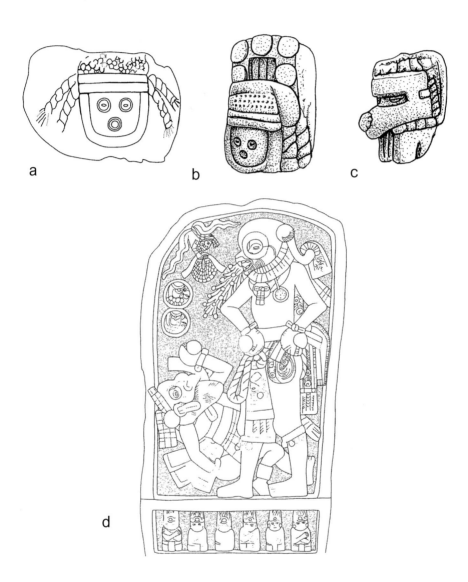

FIGURE 7.6. Helmeted boxers from the Cotzumalhuapa region of southern Guatemala: *a*, helmeted boxer with rope elements hanging from side of head, El Baúl Monument 35 (*drawing courtesy of Oswaldo Chinchilla Mazariegos*); *b*, helmeted boxer with thick rope or hair at sides of head on tenoned sculpture from Hacienda Aguna; compare headdress to Figure 7.5b (*after Thompson 1948: fig. 11b*); *c*, Classic Maya Lubaantun figurine of helmeted boxer with rope at side of head (*from Joyce 1933: pl. 7:4*); *d*, helmeted boxers sparring (note spheres held in hands), El Baúl Monument 27 (cf. fig. 7.30c for format) (*drawing courtesy of Oswaldo Chinchilla Mazariegos*).

THE SOCIAL CONTEXT OF MESOAMERICAN BOXING

As with the ballgame, ancient Mesoamerican boxing was both ritual and enter-taining sport. In many ways, boxing overlapped with the ballgame, and it is likely that ritual combat formed part of ballgame events. A Late Classic relief from the K-6 Ball Court at Piedras Negras features two men wearing ballgame gear, including belts and kneepads (Figure 7.7). However, what they are definitely *not* doing is playing ball. Not only is there no ball, but the two athletes intently face each other as if sparring. As will be noted, the cloth-wrapped items in their hands are combat weapons. Since this relief was found in an actual ball court, it is like-ly that such boxing events may have been performed in ball courts, which would serve as excellent arenas for watching the sport. Mention was made earlier of the two tenoned boxer sculptures from Hacienda Aguna, Guatemala (Figure 7.6b). According to Parsons (1969:136), the pair may have been ball-court markers. Dating to the Protoclassic Period (ca. 100 B.C.–A.D. 250), a number of ceramic sculptures attributed to the Ixtlan del Río region of Nayarit feature detailed scenes of ballgames being performed in ball courts, including spectators atop the sides of the court. In one example, however, another sport is being played in the court:

> The exception depicts two men fighting in the middle of the playing field, suggesting activities other than ballgames may have taken place on the courts. (Day 2001:68–69)

Lorna Walker (personal communication 2000) suggests that especially small courts may have been specifically used for combat between a pair of opponents, such as is depicted in the Piedras Negras relief. Aside from the interlocked com-batants, two other figures stand in the court intently watching the event (see Day 1998: fig. 22; 2001: fig. 68). It is quite possible that these individuals are the per-sonal assistants or "seconds" for the fighters.

A Late Classic carved *tecali* vase portrays a pair of men engaged in fierce, hand-to-hand combat with bone daggers (Figure 7.8; see Kerr 2000:1006 [K7749]). The paper earpieces and ropes around their necks suggest that they are captives, while the associated text reveals that they carry titles typical of ballplayers (Zender 2001b). Tonina Monument 83 portrays a pair of captives fighting each other while in virtually identical attire, with neck ropes and strips of paper through their ears (Figure 7.8b). The pose of these Tonina captives, with arms upraised and clenched into loose fists, is entirely consistent with the wielding of boxing stones, but the condition of the monument and our current documentation of it preclude any cer-tainty (for photos and xerographic images of Monument 83 fragments, see Gra-ham and Mathews 1996:113). Rather than warfare, the tecali vase clearly concerns

Figure 7.7. Late Classic Maya boxers wearing typical "ballgame" gear. Relief sculpture from the K-6 Ball Court, Piedras Negras. (*Drawing courtesy of Stephen Houston.*)

bloodsport, as two attendants or "seconds" hold out additional daggers for the fighters. Whereas one of the attendant figures is dressed in Teotihuacan costume, the other is entirely in Maya regalia and wears the "Jester God" of Maya rulership (Zender 2001b). It is quite possible that the attendant figures are the owners or sponsors of the combatants. The individual in Maya dress is smoking a cigar, suggesting a festive event, as smoking commonly appears in scenes of feasting and drinking in Maya art (Barrera and Taube 1987; Grube 2004).

Another Late Classic vessel portrays a similar scene, although in this case the struggling fighters appear to be boxers armed with stones (Figure 7.9a; for the entire scene, see Kerr 1992:399 [K3264]). The victor grasps the hair and kicks his falling opponent. Two rotund women serve as the seconds and partly support the combatants with their hands. With her other hand, one woman holds out a probable stone to her fighter, recalling the tecali vessel scene. However, the woman behind the defeated combatant has her empty palm upraised, as if calling off the fight. Along with the fighters and their assistants, there are four other figures in the vessel scene, another corpulent woman and three men. Whereas one man smokes a cigar, the woman drinks from a cup, probably containing an alcoholic beverage from the prominently displayed large vessel. The three standing men gesture wildly, quite possibly indicating inebriation as well as the thrill and drama of the sport. Evidently, tobacco and alcoholic beverages were commonly consumed at Classic Maya boxing events.

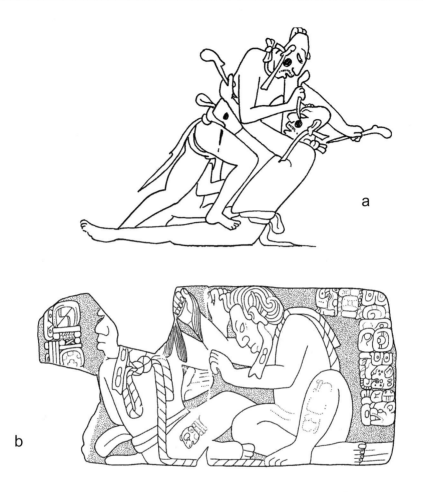

FIGURE 7.8. Late Classic Maya combat scenes: *a*, two combatants spar with bone daggers, detail of carved tecali vase (*after Kerr 2000:1006 [K7749]*); *b*, two captives engaged in combat, Tonina Monument 83 (*from Graham and Mathews 1996:113*).

Another Late Classic Maya vessel portrays ritual fighting in the context of drinking (Figure 7.9b). One portion of the vase depicts a pair of fighting figures, one armed with a conch, blood dripping from his face. The other figure grasps his opponent by the hair while brandishing a weapon in his left hand. Although it is possible that the weapon is of stone, such as a *manopla*, it may also be another conch portrayed at a different angle. The other portion of the vessel portrays three males. Whereas the central figures holds up a cup—probably an alcoholic beverage—the two flanking figures wear deer headdresses. and one is even bent over and defecating in deer fashion, quite possibly onto the apparently defeated

combatant. The significance of this act remains obscure, although it certainly could be a gesture of disrespect.

Given the apparent importance of alcohol in Classic Maya boxing events, it is noteworthy that such drinking is not well documented for contemporary boxing in the Montaña de Guerrero. Nonetheless, while observing the May 2 festival of Zitlala in 1973, Roberto Williams-García (1997:322) noted that the feline boxers appeared to be inebriated. Of course, it is another matter whether the spectators of such events commonly drink alcoholic beverages. For the mountain summit celebration atop Cruzco, or Hueyepetl, mezcal and beer are consumed (Díaz Vásquez 1997:97; Williams-García 1997:321). Nonetheless, it is unclear whether such drinking is an especially important component of the boxing events. The role of alcohol with ritual boxing in contemporary Guerrero remains a subject requiring further ethnographic research.

The sixteenth-century Codex Xolotl may portray a rare Central Mexican scene of boxing in relation to pulque drinking (Figure 7.10). It has been noted that Map 10 of the Codex Xolotl depicts a scene of stickball (Taube 2000: fig. 26). Each of the three players has one forearm heavily bound in cloth, probably to guard against heavy blows from the sticks. The scene immediately above portrays a pair of athletes drinking from a foaming vessel of pulque, one of them glyphically labeled as Nezahualcoyotl, the famed king of Texcoco. The accompanying cuauhxicalli vessel denotes the game and drinking in the context of human heart sacrifice. Both players raise a bound forearm above their head, a common boxing gesture probably denoting strength and aggression, as well as preparation to strike (Figures 7.2b, d, e, 7.3b, 7.13).

Although it may seem unusual for a ruler to engage in such a potentially dangerous game, it is well known that the Mesoamerican ballgame often played by elites was also a violent sport, with a blow from the ball occasionally resulting in death (Stern 1949:61). Given the fineness of certain of the stone weapons used in gladiatorial boxing, it is entirely possible that it may at times have constituted an elite martial art, similar to fencing in eighteenth-century European courts. In addition, certain Classic Maya stone weapons are labeled with the names of particular kings (see Figure 7.29d–e). Some of these handstones also bear texts referring to dance; as noted earlier, one Late Classic Maya vessel portrays figures in boxing garb singing and dancing to music (Figure 7.3c). As highly theatrical and dramatic events, boxing matches probably overlapped with the spectacle of performance and dance. In ancient Greece, Hellenistic kings frequently performed as actors and participants in victory celebrations and other festival events (Von Hesberg 1999). According to Roman sources, the emperors Caligula, Nero, and Commodus all performed within the gladiatorial arena (Wiedemann 1992: 131). Similarly, Mesoamerican elites may have also inserted

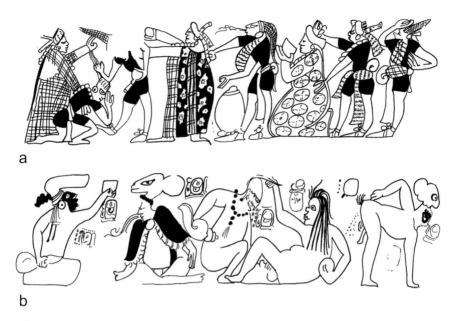

a

b

FIGURE 7.9. The relation of boxing with drinking and smoking: *a*, combat scene with sec-
onds providing weapons, as spectators imbibe alcohol and smoke cigars (*detail after Kerr*
1992:399 [K3264]); *b*, combat scene with drinking and spectators (*detail after Kerr 1989:*
41 [K728]).

FIGURE 7.10. Aztec
boxers and stickball
players associated
with pulque drinking,
Codex Xolotl Map 10
(*from Taube 2000: fig.*
26).

themselves as real or symbolic participants in the arena of ritual battle, thereby acquiring public recognition as courageous and physically powerful leaders as well as munificent sponsors (see also Orr and Koontz this volume, Introduction).

STONE WEAPONS USED IN RITUAL BOXING

As in contemporary versions of boxing in Guerrero, it is possible that ancient Mesoamerican boxers fought with gloves or with cloth or leather wrappings to protect their hands. However, it is also clear that handheld weapons were frequently used to augment the force of the blow, items that would clearly increase the risk of serious injuries or fatalities. Mention has been made of the use of conch shells in Classic Maya boxing. In addition, various stone weapons were also employed, and given the relatively permanent nature of stone, such objects do appear in the archaeological record. These handheld stone weapons tend to have spherical or rounded striking surfaces. As with spherical hammerstones widely used in Mesoamerican lithic production, such stone weapons provide a focused impact when struck.

Manoplas

It is quite possible that the large mitts seen for the Lubaantun figures and other Classic Maya portrayals of boxers are cloth or leather wrappings covering a heavy stone object held in the hand. In Mesoamerican studies, this weapon is commonly referred to as a *manopla*. Although this terms means "mitten" or "heavy glove" in European Spanish, it has the historical/technical meaning of "gauntlet" and specifically signifies "knuckle-duster" in Latin American Spanish (*Collins Dictionary* 2000:627). Carved from a single piece of stone, the manopla is typically pierced with a large hole to accommodate the hand, with the principal, spherical mass of the object covering the knuckle region (see Figures 7.15, 7.17a). Stone manoplas are found widely in ancient Mesoamerica and are known for Teotihuacan, Oaxaca, and Veracruz as well as the Maya region (de Borhegyi 1961, 1967; Fewkes 1907:266). In an especially early description of manoplas in Veracruz, Jesse Walter Fewkes (1907:266) stated that they were "weapons" and noted that contemporary native peoples referred to them as *chimalles*, a general name for shields or weapons. Although it is conceivable that this term had a more general meaning in the early twentieth century, in sixteenth-century Nahuatl, *chimalli* specifically signifies a shield. Nonetheless, as a weapon, the manopla could be readily used to shield blows as well as to strike. Prescott Follett (1932) also considered manoplas as weapons, although oddly adding that they "were thrown like hand grenades at the enemy." Aside from the

fact that manopla stones are not explosive, they were not intended to be thrown as missiles. Instead, they clearly served as "stone knuckles" to both protect the hand and augment the blow.

The fanciful interpretation of manoplas as "hand grenades" is probably one reason that manoplas have generally not been regarded as weapons in subsequent studies. Thus, in a detailed study of Mesoamerican manoplas, Stephen de Borhegyi (1961) notes that these items would not be effective throwing weapons, although he does not discuss them as handheld boxing implements. According to de Borhegyi, manoplas were to strike the rubber ball during the ballgame. Following a critique of this interpretation by Francis Clune (1963), Borhegyi (1967) subsequently suggested that manoplas may have been grasped as weights in competitive feats of jumping, a tradition known for ancient Greece. Nonetheless, the use of manoplas in the ballgame has received widespread acceptance, especially in exhibitions and studies of the Mesoamerican ballgame (for example, Fernando 1992: nos. 13–15, 27; Leyenaar 2002:123; Miller 1989:30; Parsons 1988:27, 46). But despite the abundant portrayals of ballgame scenes in ancient Mesoamerica, there are virtually no portrayals of players using manoplas to strike the ball. Two possible exceptions are the zoomorphic items held in the hands of ballplayers from the reliefs in the Great Ball Court at Chichén Itzá, and by Waxaklajuun Ubaah K'awiil on the central marker of the main Copán ball court (see de Borhegyi 1961:129–130; Schele and Miller 1986: pl. 102). However, both of these examples have forms distinct from the spherical manoplas under discussion. In addition, manoplas appear in a number of contexts distinct from the ballgame.

One Late Classic Maya vessel portrays a pair of gesturing males holding manoplas in their left hands. One of the figures holds a rattle in his other hand, indicating that they are probably engaged in dance (Figure 7.11a). Hellmuth (1991) notes that these individuals portray the hunting god, a being identified by his long lower lip and aged, sharp features (see also Taube 2003:473–475). Because of the jaguar pelt hip-cloths, Hellmuth identifies the figures as ballplayers. However, despite the fact that both lean forward on one knee, they lack the kneepads worn in the ballgame. According to Hellmuth, the major ballplayer attribute displayed by these performers is the "feline hide" hanging between their legs. However, this jaguar skin could also be a protective garment for boxers; recall that some of the Lubaantun fighters wear hip garments identical to that of ballplayers (for example, Figure 7.2c).

Aside from lacking kneepads, the pair of hunting god figures wear a form of knotted cloth high on the abdomen rather than the thick belts worn by ballplayers. As mentioned earlier, this binding may have protected fighters from heavy blows. The garb worn by the two figures is quite similar to a Late Classic figurine attributed to Jaina (Figure 7.11b). Seated cross-legged, this athlete also lacks a kneepad and has binding and padding covering much of his abdomen. Schele and

Miller (1986:256) note that a jaguar hide hangs from the back side of the body garment. The young male also wears bracelets on the upper arms. Probably fashioned from small snail shells, these items are also worn by the two hunting gods (Figure 7.11a). However, the most noteworthy trait shared between the pair of aged figures and the seated young male is the handheld manopla. In the case of the figurine, it is grasped at the side of the right hip in a tense pose that suggests that the figure is prepared to strike. The hair covering the neck is thick and matted, recalling the aforementioned boxers with possible hair hanging down the sides of the head. Above the ruff of thick hair, the head of the figurine is relatively small and lacks a headdress. It is quite possible that it was originally supplied with a detachable helmet mask, such as is frequently worn by Classic Maya boxers. One such boxer figurine with a removable helmet mask is also portrayed in a cross-legged seated position (see Berjonneau et al. 1985: pls. 368–369). Although ren-

a

FIGURE 7.11. Manopla-wielding Maya boxers sporting snail-shell bracelets on upper arms: *a*, boxer brandishing manopla and rattle, detail of Late Classic vessel (*after Hellmuth 1991: fig. 12*); *b*, cross-legged boxer wielding manopla, Jaina-style figurine (*after Schele and Miller 1986: pl. 99*).

b

dered in a different style, the modeled figurine has the visored helmet and a thick, pendant bib similar to many of the Lubaantun examples.

The pair of hunting gods and the seated Jaina figurine under discussion are probably boxers. Nonetheless, as athletes engaged in a violent and very physical sport, they have some of the protective clothing found on ballplayers, such as the leather hip garments. There are also, however, Late Classic Maya scenes where manoplas are wielded as weapons by figures not dressed as athletes. One elaborately carved Late Classic vessel portrays seven figures converging on a temple (see Kerr 1992:443 [K3844]). Although none of them wear ballplayer gear, two wield manoplas. One of them grasps a manopla marked with the dotted *cauac* motif denoting stone, explicitly denoting it as an item carved from hard stone (Figure 7.12a). In his other hand, the canine figure holds an ax. Although not an item used in the ballgame, axes are commonly wielded by Chaak as a symbol of lightning (see Figure 7.12b–c). In addition, many Classic Maya vessel scenes portray Chaak wielding both his ax and a stone manopla in the other hand (Figure 7.12b–c; Taube 2004:84–85). Just as the ax symbolizes lightning, the stone manopla may have been Chaak's weapon of thunder. In contemporary Acatlán, Guerrero, the ritual boxing blows are compared to thunder and lightning. In one Late Classic vessel scene, a pair of Chaaks flank the maize god emerging from a cleft turtle shell (Figure 7.12d). One of the Chaaks grasps a serpentine lightning ax, while the other wields a burning manopla (see Taube 1986:56–57, fig. 4; 1993:66–67; Zender 2006:9–10, fig. 10a). This scene portrays the widespread Mesoamerican myth of lightning striking the rock of sustenance to reveal and provide maize for mankind. In this scene, the manopla clearly serves as the burning lightning weapon of Chaak.

Aside from the finely incised red-background vase, another Late Classic vessel depicts four men wielding manoplas as weapons (see [K9073]). The costume worn by these figures is notably similar to that appearing on the incised vase, including headdresses with jaguar tails and a shank of hair pulled through a zoomorphic mouth, the "stacked bow tie" of penitential bloodletting hanging between their legs, and belt pieces dangling from beaded chains at the back of the legs (Figure 7.20d). In addition, the figures appear to be generally naked, although they wear "garters" around their upper arms and thighs. In the case of the painted vessel, two of the belt pieces are in the form of Chaak. Whereas two of the figures wield spears and manoplas, another holds up a massive, long-handled ax in the form of the lightning god, K'awiil. In addition, a fourth figure holds a pair of manoplas out in both hands as if preparing to spar. Again, the theme appears to be ritual combat in the context of rain and lightning.

Along with the ax and stone manopla, the conch serves as another lightning weapon of Chaak, recalling the Late Classic portrayals of boxers fighting with conch shells (Figures 7.3a–b, 7.9b). Uxmal Stela 14 portrays Lord Chaak as the

FIGURE 7.12. Portrayals of Chaak with manoplas in Classic Maya art: *a*, masked figure brandishing manopla and ax, detail of Late Classic vessel (*after Kerr 1992:443 [K3844]*); *b*, Chaak wielding manopla and ax, detail of Late Classic codex-style vessel (*after Kerr 1992:452 [K4013]*); *c*, Chaak with conch and ax, detail of Late Classic codex-style vessel (*after Kerr 1992:485 [K4385]*); *d*, emergence of the maize god from the earth, flanked by Chaak figures wielding lightning weapons (*from Taube 1993:66*).

FIGURE 7.13. The Yopaat Lightning God wielding manoplas and boxing stones: *a*, "First Ax wielder," a late sixth-century king (*after Martin and Grube 2000:104, [K4829]*); *b*, portion of hieroglyphic name of K'ahk' Tiliw Chan Yopaat, Quirigua Stela A, west, C7 (*after Maudslay 1889–1902, II: pl. 7*); *c*, portion of full-figure glyphic name of Yax Pasaj Chan Yopaat, hieroglyphic bench of Copán Structure 9N-82 (*after Webster 1989: fig. 16*); *d*, full-figure glyphic name of K'ahk' Tiliw Chan Yopaat, Quirigua Zoomorph B (*after Maudslay 1889–1902, II: pl. 14, block 16*); *e*, portion of full-figure glyphic name of Yax Pasaj Chan Yopaat, Copán Structure 9N-82 (*after Webster 1989: fig. 71*); *f*, portion of full-figure name of Yax Pasaj Chan Yopaat, Copán Altar D' (*after Maudslay 1889– 1902, I: fig. 45*); *g*, glyphic name of Yopaat Bahlam, Late Classic vessel (*after Robicsek and Hales 1981:203, I [K1335]*); *h*, glyphic name of Yaxchilan's "interregnum" ruler, Yopaat Bahlam II, Piedras Negras Panel 3 (*after Martin and Grube 2000:122*); *i*, mythological jaguar strikes a human opponent (*after Robicsek and Hales 1981:25, [K1653]*).

rain god, and he holds his lightning weapons up behind his head (see Taube 1992: fig. 4e). Along with the lightning ax, he also wields a conch (for the relation of conch boxing weapons to rain, see Taube 2004:83–85). One codex-style vessel portrays Chaak wielding a conch in place of the stone manopla (Figure 7.12c). In the vessel scene, the exposed phallus of Chaak drags on the ground. The significance of Chaak's prominent genitalia remains obscure, although perhaps it refers to the sexual virility of Chaak or boxers more generally.

During the Classic Period, one specific aspect of Chaak is especially identified with boxing weaponry, particularly the stone manopla and sphere (Figure 7.13). Along with wielding these weapons, this being invariably has sparks or flames in his hair. This cranial element often has been misinterpreted as the syllabic sign **to** (Jones 1994; Schele 1995), yet it is evident from more elaborate examples that it merely represents the sparking of flaming hair of the Yopaat deity (see Miller and Martin 2004:102, and Taube 1989: fig. 24-17, for the iconographic use of this symbol as flames or sparks). David Stuart (personal communication 2000) first disentangled the bewildering array of variant spellings of this entity's name, which can include the signs **YOP**, **a**, **AAT/AT** and **ti/ta** (see Lounsbury 1989:87 for a number of examples). Stuart further demonstrates that all of these variants are either contextual or chronological variants of the name Yopaat (later Yopat).[3] Despite his distinct name, however, Yopaat is clearly an aspect of Chaak and commonly wears the cross-band shell diadem, *Spondylus* earpieces, and other attributes of the Classic Maya god of rain and lightning (Figure 7.13).

Importantly, upon their coronation many Maya kings adopted Yopaat as a key part of their royal names, among the earliest being an individual who ruled Calakmul during the late sixth century (Figure 7.13a). Among the more famous rulers bearing this name was K'ahk' Tiliw Chan Yopaat of Quirigua, whose name signifies "Yopaat Burns the Sky with Fire" (Figure 7.13b, d). At Copán, the sixteenth and final ruler was named Yax Pasaj Chan Yopaat, or "Yopaat Dawns Anew in the Sky" (Figure 7.13c, e–f). In the glyphic names of Classic Maya kings, the Yopaat figure holds the manopla behind his head, as if preparing to strike (Figure 7.13b–c). In the full-figure glyphic text from Structure 9N-82 at Copán, Yopaat strikes the head of his zoomorphic phonetic complement, the vulture **ti** glyph, with a manopla (Figure 7.13e). In return, "Mr. Ti" lands an upper left to Yopaat's chin. Similarly, in the full-figure glyphic name of K'ahk' Tiliw Chan Yopaat from Quirigua Zoomorph B, Yopaat holds his manopla menacingly aloft above a supine serpent-headed being, who appears to hold up an arm to ward off the blow (Figure 7.13d). Perhaps this glyphic compound portrays Yopaat "burning the sky" with his manopla lightning striker. In these remarkable glyphic compounds, where aesthetic flair was more valued than orthographic stricture, Yopaat appears in lively supernatural boxing matches writ in miniature.

In glyphs, the Yopaat figure can also hold a spherical stone behind his head, and it is shown later that such stones were commonly wielded in boxing events (Figure 7.13f–h). Another relevant royal name is Yopaat Bahlam, or "Yopaat Jaguar," carried by kings at Yaxchilan and Nakbe. Although the Yopaat character occasionally holds a stone weapon in such name phrases, the name is more commonly written in a conflated fashion, where it is the jaguar that holds the weapon in combat readiness behind his head (Figure 7.13g–h). Intriguingly, neither the jaguar nor Yopaat holds a manopla in such spellings, only the stone sphere. This may be an intentional reflection of the simple stone weapons frequently wielded by jaguars in Classic Maya art, particularly the Jatz'al Tok Ek' Hix, or "Striking Spark-Star Jaguar" so frequently depicted on codex-style ceramics (Figure 7.25c; see Zender 2004:7). As has been noted, jaguars are widely identified with boxing in Mesoamerican thought. In addition, fighting with a handheld stone resembles the swiping strike of the jaguar's paw. Clearly, the appearance of Yopaat in royal names provides much food for thought with respect not only to the symbolism and imagery of Classic Maya boxing, but also to the connection between violence and political power in ancient Mesoamerica (see Orr and Koontz this volume, Introduction).

The appearance of Chaak with boxing weapons is not limited to the Classic Period, and in the Late Postclassic Dresden Codex, Chaak holds both his lightning ax and another object in his other hand (Figure 7.14). Given its irregular

FIGURE 7.14. The rain god Chaak wielding his lightning ax and shell manopla: *a*, Dresden Codex, page 66c; *b*, Dresden Codex, page 68c; *c*, Dresden Codex, page 66c; *d*, Dresden Codex, page 62.

edging, it is likely that the item is a conch shell, like those that appear in Classic Maya scenes of boxing (Taube 2004:85). At times, pendant elements resembling jade beads appear on the undulating edge of the weapon (Figure 7.14d). Rather than representing ornaments, these beads probably denote drops of blood and, by extension, rain. On page 34c of the Dresden Codex, one such bead is affixed to the lightning ax of Chaak.

Because manoplas are powerful weapons for delivering bone-shattering blows, it is not surprising that they often portray imagery pertaining to death and gore. An elite Early Classic burial in Caracol, Belize, contained a magnificent limestone manopla in the form of a human skull (Anderson 1958; Gallenkamp and Johnson 1985: no. 146). The mandible of the skull's widely open mouth serves as the handle of the weapon (Figure 7.15a–b). The open mouth suggests a ravenous and devouring being, and it is possible that the blows from such a weapon were conceptualized metaphorically as the skull's "bite." The excavator of the skull manopla noted that it weighs some 5 pounds and 4 ounces, making it a formidable fighting weapon indeed (Anderson 1958:496). A similar, Early Classic skull manopla was discovered in a burial in the Oztoyahualco compound at Teotihuacan (Figure

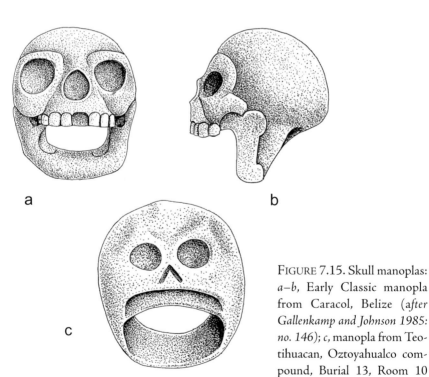

a

b

c

FIGURE 7.15. Skull manoplas: *a–b*, Early Classic manopla from Caracol, Belize (*after Gallenkamp and Johnson 1985: no. 146*); *c*, manopla from Teotihuacan, Oztoyahualco compound, Burial 13, Room 10 (*after Ortiz Díaz 1993: figs. 389–391*).

7.15c; Ortiz Díaz 1993:527, figs. 389, 391). As in the case of the Caracol example, the upper teeth were probably once rendered with shell or stone inlays.[4]

Unfortunately, the bones in both the Caracol and Oztoyahualco burials were poorly preserved, making it impossible to determine whether the bodies bore evidence of trauma, such as would probably occur with seasoned boxers. However, the individual within the Early Classic Hunal tomb—widely believed to be the founder of the Copán dynasty, K'inich Yax K'uk' Mo'—shows extensive evidence of blunt force trauma, including healed broken ribs, a damaged sternum, and "a 'parry' or 'nightstick' fracture at the midpoint of the right forearm" (Buikstra et al. 2004:196). In addition, the heavily damaged left scapula suggests that he suffered a heavy blow to the shoulder, such as could have occurred in such sports as stickball or hockey (Buikstra et al.:197–200). Although it has been suggested that these wounds were caused by the rubber-ball game (Buikstra et al.:197), another very likely possibility would be boxing with stone weapons.

Among the more curious variant forms of the manopla are the "padlock" stones known for the highlands of Guatemala. A number of these items portray the head of an old, wrinkled man, with elements falling from the eyes (Figure 7.16a). According to de Borhegyi (1961:134), these carvings "undoubtedly illustrate the god, Quetzalcoatl." Borhegyi may have based this interpretation on a mythic episode concerning the departure of Quetzalcoatl from Tollan. During his journey, the face of Quetzalcoatl became old, and he wept as he looked back at his city (Sahagún 1950–1982, bk. 3:33–35). However, although Borhegyi (1961:136–137) mentions that the aged faces on the "padlock" stones have "weeping" eyes, he cites a discussion by J. Eric S. Thompson (1948:25–26) of Cotzumalhuapa-style sculptures portraying extruded eyes hanging from their hollow sockets. According to Thompson, this strange convention relates to Late Postclassic Central Mexican symbolism pertaining to penitence and Ehecatl-Quetzalcoatl. A large tenoned sculpture in the Museo Nacional de Antropología de Guatemala portrays the same old character appearing on the "padlock" stones, and this figure clearly has his eyes dangling from their hollow sockets (Figure 7.16b). The tenoned sculpture also portrays masses of rope or braided hair at the sides of the head, recalling the Cotzumalhuapa-style boxers with rope or twisted hair hanging from the temple region of their helmet masks (Figure 7.6a–b).[5] In boxing events featuring stone weapons, eyes could have readily popped from their sockets from heavy blows to the head. The use of skulls and faces with extruded eyes on stone weapons probably was intended to intimidate the opponent. However, these stones would also carry a disturbing message to their bearers: they faced the potential of mutilation or death in battle.

The large sculpture of the old man with extruded eyeballs probably portrays the aged Maya deity known as God N, who typically has a similar beard, chapfallen mouth, and knotted headband. In fact, the head is notably similar to the pair

of massive God N heads originally placed at the northeast and northwest corners of Structure 10L–11 at Copán (Figure 7.16c). Although not a boxer, this aged being is closely linked to drinking and entertainment in Classic Maya iconography (Taube 1989), themes that are consistent with Mesoamerican boxing.

The manopla also appears in Classic and Postclassic Oaxaca. A Zapotec manopla in the collection of the Museo Nacional de Antropología in Mexico City

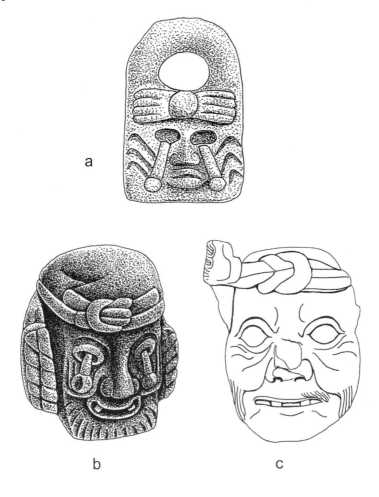

a

b c

FIGURE 7.16. The "padlock" stone and extruded eyeballs: *a*, padlock stone of old man with eyeballs hanging from sockets, highland Guatemala (*after de Borhegyi 1961: fig. 7.8*); *b*, Cotzumalhuapa-style monument of old man with pendant eyeballs (*drawing by Karl Taube of item on display in the Museo Nacional de Arqueología y Etnología, Guatemala City*); *c*, Late Classic sculpture of God N with bound waterlily headband, Temple 11, Copán; compare with Figure 7.16b.

is in the form of a jaguar head (Figure 7.17a; for other examples of jaguar head manoplas, see de Borhegyi 1961: fig. 8; Miller 1989: fig. 16). As in the case of the skull manoplas from Caracol and Teotihuacan, the open lower jaw serves as the handle. The four beaded elements on the cheeks of the jaguar probably denote blood, recalling the Dresden Codex portrayals of Chaak's weapon (Figure 7.14d). Taladoire (2003:329) notes that the aforementioned helmeted boxers from the Late Classic Huijazoo tomb murals hold manoplas in one of their raised hands (Figure 7.17b). In their other hand, the boxers grasp a leafy, vegetal material. The pose of the Huijazoo boxers is notably similar to a pair of figures appearing twice in the Colombino-Becker Codex of the Late Postclassic Mixtec (Figure 7.17c–d). In both scenes, the Mixtec figures have upraised arms, one hand holding a feathered item, possibly a headdress ornament, and the other holding a white manopla surrounded by blood. The prominent fans of blood indicate that these manoplas are weapons rather than items used to strike the rubber ball. John Pohl (personal communication 2004) notes that on page 12 of the Colombino-Becker, the pair of manopla-wielding figures appear with two seated nobles, one being the famed king of Tilantongo, Lord 8 Deer Jaguar Claw, who holds out a cup of foaming pulque. In this scene, the bloody manopla fighters appear in the context of festive drinking.

The Late Postclassic Borgia Codex, a manuscript probably deriving from Tlaxcala or Puebla, portrays Tlaloc holding an object in his upraised hand (Figure 7.18a). This item (appearing on Borgia pages 27 and 28 and in an eroded scene on page 75) is the head of Tlaloc with a loop handle at the back. On all three pages, water falls from the device, and on page 75 the water is portrayed as jade beads, recalling the weapons held by Chaak in the Dresden Codex (Figure 7.14d). Although these items resemble Tlaloc water jars, they lack spouts. As with the Colombino-Becker examples, they are probably Late Postclassic forms of the manopla, an item closely identified with powers of rain and lightning. Along with the handled device, Tlaloc wields lightning weapons in his other hand on Borgia pages 27 and 28, recalling the pairing of the lightning ax and the manopla or conch with the Classic and Postclassic Maya Chaak.

In the scenes appearing on pages 27 and 28, Tlaloc has his face turned sharply upward, with the manopla held up before him (Figure 7.18a). This pose is strikingly similar to that adopted by ballplayers appearing on Cotzumalhuapa stelae from Terminal Classic El Baúl (see Chinchilla this volume, Chapter 6; Figure 6.7b). In the case of two of the stelae, Monuments 6 and 8, the players have sculpted heads bound to their upraised hands. For Monument 6, the object apparently portrays the head of a masked boxer, such as has been discussed for the Cotzumalhuapa region (Figure 7.6a–b; for El Baúl Stela 6, see Parsons 1969: pl. 32c). Although these handpieces may be manoplas, their function remains uncertain. A Cotzumalhuapa-style vessel portrays Tlaloc holding up a human skull (Figure 7.18b). However,

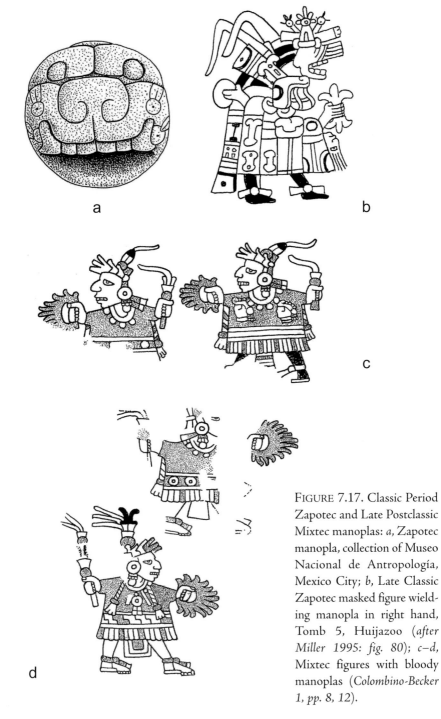

a

b

c

d

FIGURE 7.17. Classic Period Zapotec and Late Postclassic Mixtec manoplas: *a*, Zapotec manopla, collection of Museo Nacional de Antropología, Mexico City; *b*, Late Classic Zapotec masked figure wielding manopla in right hand, Tomb 5, Huijazoo (*after Miller 1995: fig. 80*); *c–d*, Mixtec figures with bloody manoplas (*Colombino-Becker 1, pp. 8, 12*).

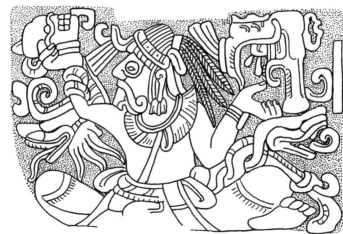

FIGURE 7.18. Tlaloc figures holding possible manoplas: *a*, Tlaloc holding lightning weapon and possible Tlaloc head manopla (*Borgia Codex, p. 28*); *b*, seated Tlaloc with snakes and a possible skull manopla, detail of Late Classic Maya vessel (*after Kerr 1992: 444* [*K3862*]).

rather than an actual skull, the object may well be a stone manopla carved in the form of a skull, recalling examples known for both Caracol and Teotihuacan.

Ball-on-Rope

For some Lubaantun figurines, the boxers hold a round object suspended from a cord (Figure 7.19a). These items are known archaeologically; two were excavated at Chiapa de Corzo (7.19b). The weapon is a stone sphere with a short protuberance pierced for suspension. This hole is to accommodate the flexible rope appearing with the Lubaantun examples. Lee (1969:147) notes that one such item still in the process of manufacture was discovered at Piedras Negras (see Coe 1959: fig. 40h). In addition, a finely carved Early Classic example is in the collection of the Museo de la Isla de Cozumel (Figure 7.19c–d). The weapon portrays two individuals seated cross-legged within quatrefoil caves. Whereas the left hand is on the knee, the right arm is upraised in a probable gesture of strength and aggression (see Mayer 2001: figs. 5, 8). Their pose is notably similar to the aforementioned Tlaloc appearing on the Cotzumalhuapa-style vessel (Figure 7.18b). The accompanying text contains a name tag describing the name of the weapon, *uyuuchtuun*, meaning "his *yuuch* stone" (Figure 7.19d). In a number of Mayan languages, the term *yuch* signifies "knot," and *yuuch* probably refers to the knotted rope handle of the stone weapon. The use of a flexible cord as the handle of this heavy weapon resembles the so-called whips used by contemporary jaguar fighters in Zitlala, Guerrero (see Williams García 1997:314). These are of leather, with a thick, bulbous portion serving as the working end of the weapon. Williams García (1997:324) mentions that according to local belief, fighters insert lead into the thick, bulbous end to make a more effective weapon, although he also notes that this might just be hearsay.

In the collections of the American Museum of Natural History, there is a remarkable Early Classic stone sculpture of a cat-like, crouching Chaak, complete with his furrowed brow, zoomorphic snout, and *Spondylus* ears (Figure 7.20a–b). Attributed to the area of Punta Gorda in southern Belize, the object is fashioned from limestone and is roughly 6 inches in height. The scroll atop his back may well represent the *muyal* cloud scroll, known for both the Middle Formative and later pre-Hispanic Maya. Of special interest is the large, immediately adjacent hole, indicating that this item was suspended from a cord. Indeed, the crouching form of this sculpture resembles many examples of Chaak hanging behind the legs of nobles (Figure 7.20c–d). Mention has been made of the vessel scene portraying Maya males wielding manoplas while wearing this device, and a squatting example from Uolantun Stela 1 is notably similar to the American Museum of Natural History piece. Nonetheless, this item is of limestone, by no means a

FIGURE 7.19. The "ball and rope" weapon: *a*, Lubaantun figures holding sphere hanging from rope (*from Joyce 1933: pl. 3: 1, 8, 11*); *b*, stone sphere excavated at Chiapa de Corzo, Chiapas (*after Lee 1969: fig. 103b*); *c*, inscribed Early Classic stone sphere in the collections of the Museo de la Isla de Cozumel (*Mayer 2001: fig. 4*); *d*, detail of Figure 7.19c: probable uyuuchtuun name-tag on inscribed Early Classic sphere (*after Mayer 2001: fig. 7*).

material commonly worn by elites as esteemed costume adornment. The figure is also quite spherical and has a hugely bulging back as well as feet tucked below and under the broadly spread knees. The sculpture could well be a personified and highly effective form of the "ball-and-rope" weapon, in this case with Chaak as the sprayer of blood and thereby rain.

FIGURE 7.20. Early Classic limestone Chaak as possible "ball and rope" weapon: *a–b*, profile and frontal views of Early Classic Chaak sculpture in the collections of the American Museum of Natural History (*catalog no. 30.3/ 2507, accession no. 1988-10*); *c*, Early Classic Chaak as hanging belt piece, Uolantun Stela 1 (*after Jones and Satterthwaite 1982: fig. 76a*); *d*, figure wearing Chaak beltpiece while wielding pair of manoplas, detail of Naranjo-style vessel (*after a photograph by Justin Kerr [K9073]*).

While the limestone Chaak could be perhaps both a weapon and an item of adornment, the regal stone items worn behind the legs of Classic Maya lords are probably finer versions of such weapons, in this case fashioned from jade, the pre-eminent stone of rulership. Nonetheless, in term of Classic Maya portrayals of regalia, the differences between royal accoutrements and weapons were surely ambiguous, with the potentially violent physical force of such items providing them powerful symbolic weight, much like the jeweled "maces" of European roy-alty. Whereas the painted vase of a figure wielding two manoplas wears a hanging Chaak behind his legs, the other aforementioned incised vessel portrays skulls in the same position, quite possibly an allusion to carved stone skull manopla weapons (fig. 7.20d; see Kerr 1992: 443 [K3844]).

Stone Spheres

One of the more common weapons used in ancient Mesoamerican boxing is the simple stone sphere, and hand-sized stones may have frequently also served as impromptu weapons. One Late Classic Maya vessel scene portrays a pair of men defending themselves with stones against warriors wielding shields and spears (see Kerr 1997:802 [K5451]). A zoomorphic *witz* mountain in the scene indi-cates that they are in a wild landscape distant from the safety of their communi-ty. Similarly, page 54c of the Madrid Codex portrays God Q, a being of death and sacrifice, menacing the merchant deity known as God M with a spear and stone (Figure 7.21a). On Madrid page 50a, God Q spears the merchant god and strikes him with his handheld stone (Figure 7.21b). In both Madrid scenes, these episodes occur on roads, indicating that the merchant god is being attacked while traveling.[6]

According to Orr (1997; 2003:83), the items wielded by the Dainzú boxers in their mitted hands may have been stone spheres found at Dainzú and Monte Albán. The balls held by the Dainzú boxers are notably smaller than the rubber balls known for the ancient Mesoamerican ballgame, and this is true for all the examples under discussion, as they were made to be readily clasped in the hand, not bounced across a court. A figurine group attributed to the Isthmus of Tehuantepec, Oaxaca, portrays two figures holding small balls in their upraised right hands, while another holds what appears to be either a manopla or the ball-and-rope weapon (see Day 2001:70–71). Although Day (2001:70–71) identi-fies these figures as participants in the ballgame, it is more likely that they per-tain to gladiatorial combat.

The Dainzú masked boxers frequently have been compared to a pair of hel-meted individuals appearing on the Cotzumalhuapa-style Monument 27 from El Baúl (Figure 7.6d). As in the case of other figures wearing helmet masks in

the Cotzumalhuapa region, they are boxers, although in this case their headgear portrays a carnivorous animal, quite possibly a bear.[7] Although like jaguars, bears are well known for their propensity to strike with their forepaws, they can also do this while standing on their hind legs, a trait of human boxers. Wearing the helmet masks, the fighters hold spheres in their gloved hands. But although the Dainzú boxers have only one glove, the El Baúl figures wear them on both hands, allowing two balls to be wielded simultaneously to strike and parry. One figure has his left hand raised as if to block a blow as he falls. His standing opponent has a stream of liquid falling from his mouth, probably blood from a punch to the face.

FIGURE 7.21. Late Postclassic combat scenes involving the Maya merchant god: *a*, God Q menacing God M (*Madrid Codex page 54c*); *b*, God Q impales God M (*Madrid Codex page 50a*).

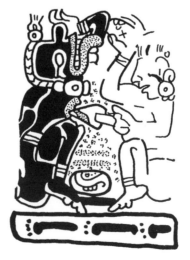

Boxers wielding stone balls as weapons also appear in ceramic sculpture of Protoclassic West Mexico. One Comala-style Colima figurine portrays a figure holding balls in both hands, with one raised as if to strike (Figure 7.22a). Although lacking a ballgame belt, the figure has heavy body padding around the ankles, his torso, and his head, which is covered by a helmet and a thick chin strap. Another Comala figurine portrays an explicit, helmeted boxer preparing to deliver a mortal blow to his defeated opponent, who also has a manopla or other boxing implement around his right hand (Figure 7.22b). Again, although a sphere is being wielded, this clearly is not a ballgame event.

Excavations at El Zapotal, Veracruz, revealed a series of large, richly costumed ceramic figures. One sculpture portrays a heavily padded male holding a small sphere in his open palm (Gutiérrez Solana and Hamilton 1977: ill. 28). Although this item has been interpreted as a rubber ball (Gutiérrez Solana and Hamilton 1977:67), it is far smaller than the balls appearing in Late Classic scenes of the Veracruz ballgame at El Tajín and Las Higueras. In addition, the heavy garb worn by this figure is quite unlike that of Classic Veracruz ballplayers, who typically wear thick belts and kneepads but are otherwise lightly dressed. In contrast, the El Zapotal figure has a broad belt covering his torso to his chest, a heavy skirt, and thick cuffs covering his right forearm. He also has a diagonal

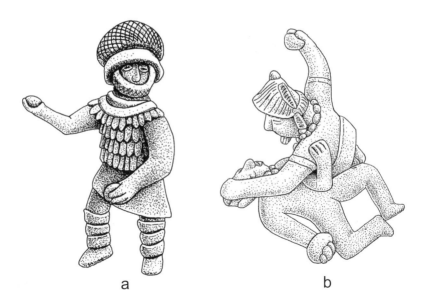

a b

FIGURE 7.22. Protoclassic Colima portrayals of boxers and combat: *a*, figurine of heavily padded figure wielding spheres in both hands (*after Day 1998: fig. 17*); *b*, ceramic figurine group of men in combat (*after Day 1998: fig. 23*).

shoulder element, recalling shoulder garments worn by masked Teotihuacan boxer figurines (Figure 7.5b–c). Although the El Zapotal figure lacks a mask, he wears a massive zoomorphic headdress held by a thick strap strung across the chin. Large flaps hanging from the sides of the headdress probably served as protective padding for the temporal region and shoulders. Rather than a ballplayer, this El Zapotal sculpture probably portrays a boxer with his stone ball.

For the Classic Maya, there is extensive evidence of spherical stone boxing weapons. It has been mentioned that in Classic texts, under the name Yopaat or Yopaat Bahlam, the Yopaat Chaak or a jaguar frequently wields a stone behind the head, the same position seen for the stone-wielding death god on Madrid page 54c (Figures 7.13g–h, 7.21a). Two Late Classic figurines portray an especially grotesque and fearsome boxing character who wears his flayed face hanging from his grinning, fleshless skull (Figure 7.23). For one powerfully built indi-

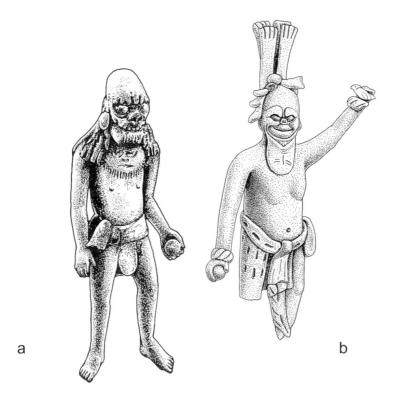

a b

FIGURE 7.23. Late Classic Maya boxers with flayed faces and skeletal features wielding stone spheres as weapons: *a*, Jaina-style figurine (*drawing by Alice Wesche, from Taube 1993: 57*); *b*, unprovenanced Jaina-style figurine holding sphere in right hand (*after photograph courtesy of Stephen Houston*).

vidual, the facial skin hangs upside down, indicating that it is the interior, bloody side ripped down from the face (Figure 7.23b). Both have thick locks of hair at the side of the head, recalling the thick hair or rope often seen on ancient Mesoamerican boxers. They also grasp the small stone ball in one hand, indicating that they are boxers, not ballplayers. The significance of this hideous character remains obscure, although it is conceivable that he is a specific death god or demonic *way*-spirit. However, it is also possible that boxers dressed as this being for gladiatorial combat. Clearly, in the intense arena of ritualized battle, such a costume could intimidate and even terrify an opponent.

The collections of the Museo de Arqueología e Etnología in Retalhuleu, Guatemala, contain a remarkable stone carving of a hand holding a stone in its palm (Figure 7.24a). It is readily apparent that this small stone object was carved to be actually held in the palm of the right hand. Whereas the deep indentation in the side of the stone is to accommodate a fighter's thumb, the other four digits readily fit between the five carved fingers. Not only does this carving portray a stone-wielding hand, it is an actual weapon, such as would be used in ritual boxing. Carlos Vélez-Ibañez (personal communication 2005) notes that such an

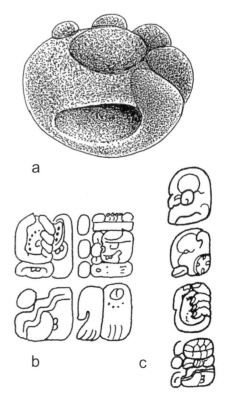

FIGURE 7.24. Stone-in-hand as weapon and glyph: *a*, manopla carved in form of hand holding a stone, collections of the Museo de Arqueología e Etnología, Retalhuleu, Guatemala (*after photograph by Karl Taube*); *b*, stone-in-hand glyph **JATZ'** in dedication text, Yaxchilan H.S. 2, Step VII: Q1–Q2 (*from Zender 2004: fig. 13a*); *c*, stone-in-hand glyph **JATZ'** in name-tag on unprovenanced Late Classic slate scepter (*after a photograph by Justin Kerr [K3409]*).

a

b c

object would be most effectively used in a lateral swiping motion from the side
to the central axis of the body, a very rare movement in martial arts disciplines.
It does, however, strongly resemble the striking motions of cats, including
jaguars. Whether held directly in the hand or in a mitt, stone balls used in box-
ing probably were often directed in sweeping, lateral motions.

The small stone sculpture of a hand wielding a boxing stone is a graphic por-
trayal of the Classic Maya "stone-in-hand" glyph, which Zender (2004) has re-
cently deciphered as **JATZ'**, meaning "to strike." This logographic sign is a hand
grasping a stone (labeled as such by stony *cauac* markings) placed in the center of
the palm, a glyph virtually identical to the carved stone weapon in Retalhuleu
(Figure 7.24b–c). Zender (2004:6–7) notes that a number of way-spirits bear
the **JATZ'** glyph in their names, including Jatz'al Tok Ek' Hix, or "Striking
Spark-Star Jaguar" (Figure 7.25). In one Late Classic vessel scene, this being
holds a skull object behind his head, recalling the aforementioned Yopaat Bahlam

FIGURE 7.25. The boxing spirit Jatz'al Tok Ek' Hix "Striking Spark-Star Jaguar": *a*,
glyphic name of Jatz'al Tok Ek' Hix, a captive king of Sak Tz'i', Tonina M.83 (*after Gra-
ham and Mathews 1996:113*); *b*, typical glyphic name of the boxing spirit, Late Classic
codex-style vessel (*from Zender 2004: fig. 10 [K1652]*); *c*, boxing spirit wielding skull
manopla and wrapped in the coils of a lightning serpent (*from Zender 2004: fig. 8c
[K2284]*).

glyphs portraying jaguars wielding spherical stones (Figure 7.25c; cf. Figure 7.13 g–h). According to Grube and Nahm (1994:688), this item is a stone skull; more specifically, it is probably a skull manopla, such as have been noted for Caracol and Teotihuacan. In terms of the aforementioned Tonina panel portraying two captives fighting, it is probably no coincidence that one individual, the erstwhile ruler of Sak Tz'i', also carries the name Jatz'al Tok Ek' Hix (Figures 7.8b, 7.25a).

Another way-spirit is named Jatz'on Ahkan, "Striking Ahkan." Grube (2004) has recently deciphered this deity's name, commonly known in the literature as God A[1], as Ahkan (or Akan), identifying him as a baleful god of alcohol and drunkenness. Zender (2004) notes that in one scene he wields a stone manopla as he battles a way-spirit who is armed with knives, even on his knees and elbows (Figure 7.26b; for entire scene, see Kerr 1989:49 [K791]). Ahkan also wields a large stone on the well-known Altar de Sacrificios Vase (Figure 7.26a), where it is possible that he is shown in combat with an adjacent way-spirit who holds a

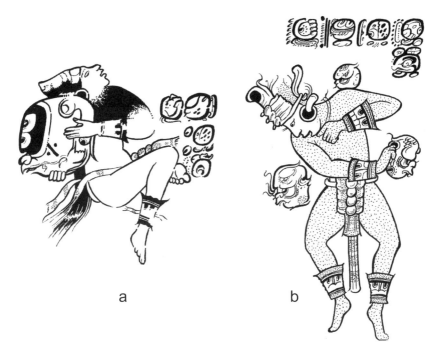

a b

FIGURE 7.26. The boxing spirit Jatz'on Ahkan "Striking Ahkan," an aspect of God A1: *a*, boxing spirit wielding large stone sphere, detail of Altar de Sacrificios vessel (*from Zender 2004: fig. 8b; after Stuart 1975:774–776*); *b*, boxing spirit juggling spherical stone weapons, detail of unprovenanced Late Classic vessel (*from Zender 2004: fig. 8a; after Kerr 1989:51 [K791]*).

large snake arching above his head (for the complete scene, see Stuart 1975: 774–776). The open mouth of the serpent touches the toe of Jatz'on Ahkan, and it is conceivable that venomous snakes were used in ritual combat. One Tikal graffito portrays a figure in the act of hurling a serpent held behind his back (see Figure 7.29b). In the aforementioned example of the Jatz'al Tok Ek' Hix demonic way-figure, the jaguar not only grasps a skull manopla, but also has an open-mouthed serpent around its neck (Figure 7.25c). In another Codex-style vessel scene, both the stone-wielding jaguar and his defeated human adversary wear snakes around their necks (Figure 7.13i). Although the use of venomous snakes in ritual combat remains conjectural, the stone-wielding jaguar and Jatz'on Ahkan way-spirits are consistent with two major themes of Mesoamerican boxing: jaguar symbolism and the drinking of alcoholic beverages.

Saps

Along with being held in the palm, stone spheres were also wrapped in leather or cloth to create a weapon resembling a modern sap, blackjack, or bludgeon. Two such objects are held by the aforementioned boxers from Piedras Negras (Figure 7.7). A Jaina-style figurine portrays a figure holding a small sphere in one hand and a cloth in the other (Figure 7.27). Although Schele and Miller (1986:256) note that this figure lacks ballplayer gear, they identify him as a ballplayer based on the ball in his hand:

> This Jaina figurine grasps a small ball in his right hand, but he is not wearing the standard ballgame costume. He is not girded for rigorous play; instead, he wears the simple clothing of the penitent or captive.

Schele and Miller (1986:256) also call attention to the "bruised and swollen nose and forehead" of this athlete. The left cheek is also heavily swollen, as if wounded from a heavy blow. Rather than the face of a ballplayer, this is the face of a boxer, and the items held in his hands are the separate components of the sap: a small stone ball and the enveloping cloth handle.

Zachary Hruby (personal communication 2001) has called our attention to a Late Classic Maya alabaster vase portraying two figures holding saps, with the wrapping cloth hanging loosely from the balls grasped in the palms of their hands (Figure 7.28a; for the entire scene, see Kerr 1992:403 [K3296]). Elaborately dressed in dance costume, both figures wear heavy masks, one portraying a jaguar, the other a crocodile. The accompanying text indicates that at least one (perhaps both) of these figures is the sixteenth king of Copán, Yax Pasaj Chan Yopaat, in the guise of various deities and dancing a "ballgame dance" (Zender 2004:4–5). However, given the handheld weapons, and the noted pugilistic associations of the

FIGURE 7.27. Bruised and swollen boxer wielding sap stone and cloth wrapping, Jaina-style figurine in New Orleans Museum of Art (*after Schele and Miller 1986: pl. 100*).

Yopaat deity, it is quite likely that the Copán king is here dressed as a masked boxer. In addition, he holds rattles in the form of giant, extruded eyeballs. As mentioned earlier, eyeballs may have been commonly dislodged from their sockets during boxing events. In the case of both the alabaster vase and the relief at Piedras Negras, the sap-wielding figures thematically overlap with the ballgame. For the Piedras Negras scene, the figures are clearly garbed as ballplayers, whereas the alabaster vessel text describes the Copán king as a ballplayer dancer.

A Late Classic Maya vessel fragment portrays a series of masked figures holding saps (Figure 7.28b). Although excavated at Uaxactun, the style of the vessel suggests that it derives from Belize. The figures have thick belts and cuffs, probably for protection. In addition, they wear masks and the netted headdress of God N. In one example, the mask is marked with wrinkles, indicating that these athletes are probably dressed as this old deity. As noted earlier, one sculpture seems to portray God N with extruded eyeballs, injuries that could readily occur during boxing bouts (Figure 7.16b). The masked men also have the nooses and paper earpieces commonly found with captives, such as the aforementioned pair dueling with bone daggers (Figure 7.8a). Along with grasping a cloth-wrapped sap in his right hand, one figure on the fragmentary vessel scene also holds a long, slender instrument, and it is possible that it is a type of dagger (Figure 7.28b). In the vessel scene, the

FIGURE 7.28. Boxers and dancers wielding saps: *a*, Yax Pasaj Chan Yopaat dancing in the guise of 7 Ajaw, wielding sap stone and probable rattle in form of disembodied eye (*after Kerr 1992:403 [K3296]*); *b*, well-padded boxers with saps, Late Classic sherd from Uaxactun (*after Ricketson and Ricketson 1937: pl. 86*).

cloth saps are held before the figures, a pose that is virtually identical to a Late Classic portrayal of the aforementioned Jatz'on Ahkan way-spirit who wields stones as his boxing weapons (see K5070). Although the cloth does not a have a rounded end indicating a wrapped ball, this item probably is also a sap.

Short Stone Clubs

The stone-in-hand glyph also appears on an elaborately carved, Late Classic slate club (Figure 7.24c; for a complete view of the object, see Coe and Kerr 1997: pls. 35–36). Not only does the stone-in-hand sign suggest that this is a weapon, but it is also provided with a blade extending from the cylindrical handle to the top of the club. The upper portion also has a projecting element on the thick, back side. As with the claw on modern hammers, this extra mass would serve to increase the torque of a blow. The form of the club is quite similar to the traditional *wahaika* hand clubs of the New Zealand Maori (see Mead 1984: nos. 44–45, 107). However, although wahaika are fashioned of wood, the surviving Classic Maya bladed clubs are typically of slate or schist (Figure 7.29). Such clubs are documented archaeologically at Caracol, Barton Ramie, and Copán (Figures 7.29a, c–d; see also Willey et al. 1994:258–259, fig. 204). Some examples bear glyphic texts mentioning kings, including rulers of Caracol and Naranjo (Figures 7.29d–e). For both the Naranjo club and the aforementioned example bearing the stone-in-hand glyph, the objects are labeled with the glyphic compound **u-mu-K'UH-ti/ta**, perhaps read *umk'uhuut*, the meaning of which unfortunately remains obscure. These finely carved objects are intriguing, as they suggest that kings may have wielded such weapons in courtly duels. The Naranjo text also mentions that the ruler "danced" (*ak'ut*) the "club dance" (see [K7966]), and it has been noted that kings may have employed these decorated weapons in festive celebrations relating to gladiatorial battles. Yet it is also conceivable that, although owned and displayed by kings, these objects may have been placed in the hands of captives or professional gladiators or captives during bloodsport events.[8] Thus, in one aforementioned scene, the owners or sponsors of two fighters are supplying them with bone daggers (see Kerr 1992:399 [K3264]). The tomb of Lady K'abal Xook of Yaxchilan contained similarly shaped bone awls or daggers, with six bearing her name (Martin and Grube 2000:126). Although it is unlikely that this famous queen engaged in gladiatorial battle (although see Reese-Taylor et al. this volume, Chapter 2), these items could well have been wielded by her sponsored combatants. Recall that in one Late Classic vessel, two women stand by and support a pair of fighting men (Figure 7.9a).

In terms of combat, the bladed stone clubs are distinct from the other stone weapons that have been discussed, as they were used for slashing blows rather than boxing. Nonetheless, these clubs do thematically overlap with Classic Maya boxing, as both are likely to have been used in gladiatorial combat. On the aforementioned Naranjo bladed club, the ruler usually named K'ahk' Ukalaw Chan Chaak carries a fuller royal name, including an epithet of the lightning deity Baj Chan Yopaat, or "Sky-Hammering Yopaat," with Yopaat rendered as Chaak wielding a stone weapon behind his head (Figure 7.29e). Given that the text opens with the verb *ajaw(oon)*,

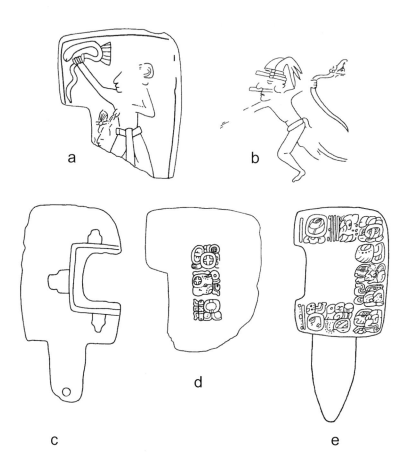

FIGURE 7.29. Classic Maya short stone clubs: *a*, fragmentary schist club with incised portrayal of figure holding serpent, Structure 197-1st, Copán (*after Sheehy 1991: fig. 12*); *b*, Tikal graffito of figure wielding serpent (*after Trik and Kampen 1983: fig. 62b*); *c*, incised bladed club, Barton Ramie, Belize (*after Willey 1965: fig. 300c*); *d*, fragmentary club with name of Caracol ruler (*after Martin and Grube 2000: 91*); *e*, club with name of Naranjo ruler K'ahk' Ukalaw Chan Chaak (*after a photograph by Justin Kerr [K7966]*).

or "he rules," it may be that K'ahk' Ukalaw Chan Chaak's godly epithet, otherwise unknown in the Naranjo inscriptions, pertains specifically to the ritual role of the Naranjo ruler as a lightning-bringer when wielding this boxing weapon. It was noted that one bladed club bore the "stone-in-hand" glyph denoting **JATZ'**, "to strike," such as appears in the names of the Ahkan and jaguar way-spirits, beings that commonly wield stone boxing weapons. It has been mentioned that serpents commonly appear with these way-beings and may have served as venomous

weapons in Classic Maya gladiatorial events. It is thus noteworthy that one fragmentary schist club excavated in Structure 197-1st from Patio Group 9M-22A at Copán features a standing figure wielding a snake high above his head, much as if it were an ax or other weapon (Figure 7.29a). According to Sheehy (1991:9), the figure grasps a trophy head in his left hand. Although the fragmentary nature of the piece makes it difficult to ascertain if this is a severed head, the shut eye denotes that this figure is indeed dead, quite possibly the vanquished foe of the snake-wielding individual. For a number of clubs, there are two (rather than one) projections on the back side, creating a U-shaped silhouette. Such a form would be very well suited for controlling or redirecting serpents, as their sinuous bodies could be held within the broad groove created by the two projections. However, as of yet, neither portrayals of these objects nor scenes of ritual battles with serpents have appeared in the known corpus of Classic Maya art.

CONCLUSION

In Mesoamerican studies, the rubber-ball game has dominated research pertaining to games and competitive sports. However, just as Culin (1907) ably documented for North America, ancient Mesoamerica surely had a wide array of competitive sports, including tournaments of boxing. Although many such events were one-on-one bouts, there were also larger *mêlées* featuring teams of players, as illustrated on several aforementioned Late Classic Maya vases (Figure 7.3). Boxing events thematically overlap with two other forms of performance, the ballgame and dance. However, although pugilistic bouts were probably performed often in ball courts, boxing is a distinct competitive event with its own rules and accoutrements, including helmet masks not worn by ballplayers. In addition, figures holding small balls or spheres are usually boxers rather than ballplayers, and perhaps this study will help promote a more critical and cautious identification of "ballplayers" in Mesoamerican art.

As both a festive and entertaining event, boxing was celebrated in dance, and in one Late Classic scene, sap-wielding figures are epigraphically described as performing the "ballgame dance" (for detail, see Figure 7.28a). Another vessel scene portrays helmeted boxers dancing and even singing. However, although it had an aspect of pageantry and performance, boxing was a decidedly bloody sport, and to put it simply, brave men died in terrible ways. This also brings up the question of the identification of these largely anonymous boxers. Finely made and at times glyphically inscribed Classic Maya stone weapons suggest that elite men may have engaged in dueling events, although it has been noted that such items may have been only employed in commemorative dance or temporarily lent to owned or sponsored combatants. A number of Classic Maya scenes suggest that individuals

engaged in gladiatorial combat were captives, as they wear the characteristic paper earpieces and nooses of captives around their necks. In ancient Rome, many gladiators were captured enemies and slaves condemned for criminal activities (Wiedemann 1992:102). Although frequently popular figures, Roman gladiators were also regarded with a great deal of ambivalence: "the gladiator was a marginal figure, regarded with fear and loathing as well as idolized" (Wiedemann 1992:130).

The widespread presence of boxing in Mesoamerica suggests that it is a sport of considerable antiquity. It has been noted that as in contemporary Guerrero, ancient Mesoamerican boxing was closely related to the symbolism of jaguars and rainmaking. Much as Covarrubias (1957) originally suggested, many Mesoamerican rain gods, including the Maya Chaak, the Zapotec Cocijo, and the Central Mexican Tlaloc can be traced to the Formative Olmec rain deity, who also has jaguar features (see also Taube 1995, 2004). Two Olmec serpentine statuettes in the collections of Dumbarton Oaks portray standing human figures partly transformed into jaguars (see Taube 2004:62–67). George Kubler (1962:70) described the more human-appearing figure as a "middle-aged gladiator." In fact, the figure is in a decidedly pugilistic stance, with the hands tightly curled into fists, and the same can also be said for the other statuette, which portrays a standing jaguar with clutched fists and its forelimbs bent as if in preparation to strike. The Olmec "knuckle duster" may well have been an instrument used for boxing (Taube 2004:63, 84). According to Michael Coe (1965:765), it served as "a fairly effective hand-weapon during close infighting." A number of authors have suggested that these instruments were fashioned from shell, quite possibly a conch (see Taube 2004:83). Claudia García-Des Lauriers (personal communication 2006) has called our attention to a pair of cut conch knuckle-dusters in the collections of the Museo Regional de Tapachula (Figure 7.30a). At times, the feline Olmec rain god clutches knuckle-duster weapons in both hands. For San Lorenzo Monument 10, the rain god wears a broad belt covering most of his torso, a form of protective padding also known for Classic Maya boxers (Figure 7.30c; compare with Figures 7.2d, 7.3b–c). Thus, two of the basic symbolic components of Mesoamerican boxing—jaguars and rain—not only continue in contemporary highland Guerrero, but can also be traced back to the lowland origins of Mesoamerican civilization.

ACKNOWLEDGMENTS

We wish to thank Heather Orr for kindly sharing her research concerning the Mesoamerican ballgame and boxing with us. We are indebted to Norman Hammond for generously providing photographs of figurines from Lubaantun, Belize. Oswaldo Chinchilla Mazariegos, Claudia García-Des Lauriers, Stephen Houston, Zachary Hruby, and Simon Martin also provided us with valuable

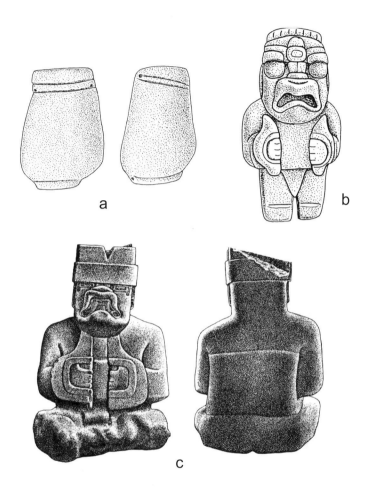

Figure 7.30. Knuckle-dusters and the Olmec rain god: *a*, cut conch knuckle-dusters, Museo Regional de Tapachula (*drawn after photograph courtesy of Claudia García-Des Lauriers*); *b*, jadeite statuette of Olmec rain god with a pair of knuckle-dusters (*after Sotheby's 1981: no. 55*); *c*, Olmec rain god with knuckle-dusters (note thick padding on abdomen), San Lorenzo Monument 10 (*from Coe and Diehl 1980: fig. 434*).

imagery and comments. The junior author wishes to thank Richard Leventhal and Loa Traxler for their invitations to present his decipherment of the "stone-in-hand" glyph at, respectively, UCLA (2001) and the University of Pennsylvania Museum (2004), and Joel Skidmore for encouraging its publication in *The PARI Journal*. And finally, we are grateful to Carol Leyba as well as Joel Skidmore for their detailed editorial suggestions.

NOTES

[1] In a discussion of the helmeted Lubaantun figurines, Frederick Stern (1949:39, n. 25) noted that "[s]imilar figurines, from San Pedro and San Antonio, Toledo, British Honduras, were on display in 1947 at the Chicago Natural History Museum."

[2] In this study, we refer to the important corpus of Justin Kerr photographs by their Kerr catalog numbers (for example, [K700]). This corpus can be examined online at *http:// www.mayavase.com.*

[3] Unfortunately, the meaning of this term remains somewhat obscure. It is possible that the term *yopaat* may ultimately bear some remote kinship to the K'ichee'an and Greater Q'anjobalan term *koyopa*, "lightning" (Kaufman 2003:473) or perhaps to the Yukatek term *yo'-pat*, "una manera de coroza o mitra que usaban los indios antiguos" (Barrera Vásquez 1980:980), but such relationships require further investigation.

[4] In a pair of Late Classic ceramic figures in the style of Remojadas, Veracruz, each holds a skull manopla in the upraised right hand (see Arte Primitivo 2005: no. 143). Along with wielding shields in their other hands, they also wear shell platelet helmets. Rather than ballplayers, these two figures clearly portray combatants armed for battle.

[5] A stone statuette attributed to the Olmec also portrays the theme of an injured, old athlete, in this case a ballplayer (Guthrie 1995: no. 134). His aged and wrinkled face is twisted grotesquely, and he appears to have a badly dislocated jaw. It is likely that this sculpture portrays injuries suffered in the frequently violent ballgame.

[6] In ancient Mesoamerica, adultery constituted one of the most condemned antisocial activities and was commonly punished through death by stoning, recalling the stone weapons commonly wielded by boxers. In Late Postclassic Central Mexico, Iztlacoliuhqui-Ixquimilli was the god of stone and castigation and typically has a cranium in the form of a curving obsidian knife. It has been noted that God Q of the Late Postclassic Maya codices is probably a version of this same being (Taube 1992:110–112). In the scenes in the Madrid Codex, God Q attacks the merchant god with a spear and a stone (Figure 7.20a–b). In one scene, God Q exhibits a curving headpiece, quite possibly a version of the curving blade appearing with the cranium of Iztlacoliuhqui-Ixquimilli.

[7] Bears holding sacrificial hearts appear on the facades of the Temple of the Warriors at Chichén Itzá (Tozzer 1957: fig. 431). In modern Mexico, the black bear (*Ursus americanus*) extends as far south as southern Zacatecas, close to the border of Jalisco, and it is quite possible that its habitat was even more extensive prior to the advent of firearms (Leopold 1959:412, fig. 152).

[8] For the funeral games in honor of his deceased father, Julius Caesar supplied gladiatorial arms and armor fashioned from precious silver: "even criminals condemned to fight wild beasts bore equipment made of silver" (Wiedemann 1992:13).

REFERENCES CITED

Anderson, A. H.
 1958 Recent Discoveries at Caracol Site. *Proceedings of the 32nd International Congress of the Americanists*, pp. 494–499. Copenhagen.
Arte Primitivo
 2005 *Fine Pre-Columbian and Tribal Art, Auction 31*. Howard S. Rose Gallery, Inc., New York.

Barrera Rubio, A., and K. Taube
 1987 Los relieves de San Diego: Nuevas perspectivas. *Boletín de la Escuela de Ciencias Antropológicas de la Universidad de Yucatán* 83:3–18.

Barrera Vásquez, A.
 1980 *Diccionario Maya Cordemex.* Ediciones Cordemex, Mérida.

Berjonneau, G., E, Deletaille, and J-L. Sonnery
 1985 *Rediscovered Masterpieces of Mesoamerica: Mexico-Guatemala-Honduras.* Editions Arts, Bologne.

Bernal, I.
 1968 The Ball Players of Dainzú. *Archaeology* 21:246–251.
 1973 Stone Reliefs in the Dainzú Area. In *The Iconography of Middle American Sculpture*, pp. 13–23. The Metropolitan Museum of Art, New York.

Bernal, I., and A.Seuffert
 1979 *The Ballplayers of Dainzú.* Akademische Druck, u. Verlagsanstalt, Graz.

Borhegyi, S. F. de
 1961 Ball-Game Handstones and Ball-Game Gloves. In *Essays in Pre-Columbian Art and Archaeology*, edited by S. K. Lothrop, pp. 126–151. Harvard University Press, Cambridge.
 1967 Piedras semiesféricas con asas para el juego de pelota y "manoplas" en Mesoamérica: Una posible alternativa para su función. *Estudios de Cultura Maya* 6:215–219.

Buikstra, J. E., T. D. Price, L. E. Wright, and J. A. Burton
 2004 Tombs from the Copan Acropolis: A Life-History Approach. In *Understanding Early Classic Copan*, edited by E. E. Bell, M. A. Canuto, and R. J. Sharer, pp. 191–212. University of Pennsylvania Museum of Archaeology and Anthropology, Philadelphia.

Calles Travieso, R.
 1994 *Atlzatzilistli:* Las ceremonias de petición de agua en Acatlán de Alvarez, Guerrero. In *Rituales agrícolas y otras costumbres guerrerenses (siglos XVI–XX)*, edited by M. Matías Alonso, pp. 99–107. Centro de Investigaciones y Estudios Superiores en Antropología Social, Mexico City.

Caso, A.
 1938 *Exploraciones en Oaxaca: Quinta y sexta temporadas 1936–1937.* Instituto Panamericano de Geografía e Historia, Mexico City.
 1967 Dioses y signos Teotihuacanos. In *Teotihuacan: Oceava Mesa Redonda*, pp. 249–279. Sociedad Mexicana de Antropología, Mexico City.

Clune, F. J., Jr.
 1963 Borhegyi's Interpretation of Certain Mesoamerican Objects as Ball-Game Handstones. *American Antiquity* 29(2):241–242.

Coe, M. D.
 1959 *Piedras Negras Archeology: Artifacts, Burials and Caches.* The University Museum, The University of Pennsylvania, Philadelphia.
 1965 The Olmec Style and Its Distributions. *In Handbook of Middle American Indians*, general editor R. Wauchope, Vol. 3, pp. 739–775. University of Texas Press, Austin.

2003 Another Look at the Maya Ballgame. *Il sacro e il paesaggio nell'America indigena*, edited by D. Domenici, C. Orsini, and S. Venturoli, pp. 197–204. CLUEB, Bologna.

Coe, M., and R. Diehl

1980 *In the Land of the Olmec*. University of Texas Press, Austin.

Coe, M., and J. Kerr

1997 *The Art of the Maya Scribe*. Thames and Hudson, London.

Collins Dictionary

2000 *Collins Dictionary: Spanish-English English-Spanish*. Sixth edition. Harper-Collins Publishers, New York.

Covarrubias, M.

1957 *Indian Art of Mexico and Central America*. Alfred A. Knopf, New York.

Culin, S.

1907 *Games of the North American Indians*. Twenty-Fourth Annual Report of the Bureau of American Ethnology. Smithsonian Institution, Washington, D.C.

Day, J. Stevenson

1998 The West Mexican Ballgame. In *Ancient West Mexico: Art and Archaeology of an Unknown Past*, general editor R. F. Townsend, pp. 150–167. The Art Institute of Chicago, Chicago.

2001 Performing on the Court. In *The Sport of Life and Death: The Mesoamerican Ballgame*, edited by E. M. Whittington, pp. 64–77. Thames and Hudson, London and New York.

Díaz Vásquez, R.

2003 *El ritual de la lluvia en la tierra de los hombres tigre: Cambio sociocultural en una comunidad náhuatl (Acatlán, Guerrero, 1998–1999)*. Conaculta, Mexico City.

Fernando, J. (editor)

1992 *El juego de pelota en el México precolombino y su pervivencia en la actualidad*. Ajuntament de Barcelona, Barcelona.

Fewkes, J. W.

1907 Certain Antiquities of Eastern Mexico. In *Twenty-fifth Annual Report of the Bureau of American Ethnology 1903–04*, pp. 221–284. Smithsonian Institution, Washington, D.C.

Follett, P.

1932 War and Weapons of the Maya. In *Middle American Research Institute, Tulane University*, No. 4, pp. 373–410. Tulane University, New Orleans.

Gallenkamp, C., and R. E. Johnson

1985 *Maya: Treasures of an Ancient Civilization*. Harry N. Abrams, New York.

Gillmeister, H.

1988 *La dissémination géographique des jeux traditionnels: L'unité et la diversité des jeux traditionnels en Europe*. Séminaire sur les Jeux Traditionnels. Comité pour le developpement du sport, Vila Real.

Graham, I. and P. Mathews

1996 *Corpus of Maya Hieroglyphic Inscriptions*, Volume 6, Part 2: *Tonina*. Peabody Museum of Archaeology & Ethnology, Harvard University, Cambridge.

Grube, N.
 2004 Akan—The God of Drinking, Disease and Death. In *Continuity and Change: Maya Religious Practices in Temporal Perspective*, edited by D. Graña Behrens, N. Grube, C. M. Prager, F. Sachse, S. Teufel, and E. Wagner, pp. 59–76. Acta MesoAmericana 14. Anton Saurwein, Markt Schwaben.

Grube, N., and W. Nahm
 1994 A Census of Xibalba: A Complete Inventory of *Way* Characters on Maya Ceramics. *The Maya Vase Book*, Vol. 4, edited by B. and J. Kerr, pp. 686–715. Kerr Associates, New York.

Guthrie, J. (editor)
 1995 *The Olmec World: Ritual and Rulership*. Harry N. Abrams, New York.

Gutiérrez Solana, N., and S. K. Hamilton
 1977 *Las esculturas en terracotta de El Zapotal, Veracruz*. Universidad Nacional Autónoma de México, Mexico City.

Hammond, N.
 1976 A Classic Maya Ball Game Vase. In *Problems in Economic and Social Archaeology*, edited by G. de G. Sieveking, I. W. Longworth, and K. E. Wilson, pp. 101–108. Gerald Duckworth and Company, London.

Hellmuth, N. M.
 1991 A Hunting God and the Maya Ballgame of Guatemala: An Iconography of Maya Ceremonial Headdresses. In *The Mesoamerican Ballgame*, edited by G. W. van Bussel, P. L. F. van Dongen, and T. J. J. Leyenaar, pp. 135–159. Rijksmuseum voor Volkenkunde, Leiden.

Jones, C., and L. Satterthwaite
 1982 *The Monuments and Inscriptions of Tikal: The Carved Monuments*. University Museum Monograph 44. The University Museum, University of Pennsylvania, Philadelphia.

Jones, T.
 1994 Of Blood and Scars: A Phonetic Rendering of the "Penis Title." In *Seventh Palenque Round Table, 1989*, edited by V. M. Fields, pp. 79–86. Pre-Columbian Art Research Institute, San Francisco.

Joyce, T. A.
 1933 The Pottery Whistle-Figurines of Lubaantun. *Journal of the Royal Anthropological Institute of Great Britain and Ireland* 63:15–25.

Kaufman, T.
 2003 A Preliminary Mayan Etymological Dictionary. Famsi: www.famsi.org/reports/01051.

Kerr, J.
 1989 *The Maya Vase Book*, Vol. 1. Kerr Associates, New York.
 1992 *The Maya Vase Book*, Vol. 3. Kerr Associates, New York.
 1997 *The Maya Vase Book*, Vol. 5. Kerr Associates, New York.
 2000 *The Maya Vase Book*, Vol. 6. Kerr Associates, New York.

Kubler, G.

1962 *The Art and Architecture of Ancient America*. Penguin Books, Middlesex.

Lee, T.

1969 *The Artifacts of Chiapa de Corzo, Chiapas, Mexico*. Papers of the New World Archaeological Foundation, No. 26. Brigham Young University, Provo.

Leyenaar, T. J. J.

2002 The Modern Ballgames of Sinaloa: A Survival of the Aztec Ullamamaliztli. In *The Sport of Life and Death: The Mesoamerican Ballgame*, edited by E. M. Whittington, pp. 122–129. Thames and Hudson, London and New York.

Leopold, A. S.

1959 *Wildlife of Mexico: The Game Birds and Mammals*. University of California Press, Berkeley.

Lounsbury, F. G.

1989 The Names of a King: Hieroglyphic Variants as a Key to Decipherment. In *Word and Image in Maya Culture: Explorations in Language, Writing and Representation*, edited by W. F. Hanks and D. S. Rice, pp. 73–91. University of Utah Press, Salt Lake City.

Martin, S., and N. Grube

2000 *Chronicle of the Maya Kings and Queens*. Thames and Hudson, London and New York.

Matías Alonso, M.

1997 *La agricultura indígena en la montaña de Guerrero*. Plaza y Valdés, Mexico City.

Maudslay, A. P.

1889–1902 Archaeology. In *Biología Centrali-Americana*. 5 vols. R. H. Porter and Dulau, London.

Mayer, K. H.

2001 An Unprovenanced Stone Sphere with Maya Glyphs. *Mexicon* 23(5):112–114.

Mead, S. M.

1984 *Te Maori: Maori Art from New Zealand Collections*. Harry N. Abrams, New York.

Miller, A.

1995 *The Painted Tombs of Oaxaca, Mexico: Living with the Dead*. Cambridge University Press, Cambridge.

Miller, M.

1989 The Ballgame. *Record of the Art Museum, Princeton University* 48:22–31.

Miller, M., and S. Martin

2004 *Courtly Art of the Ancient Maya*. Thames and Hudson, London and New York.

Obregón Téllez, J., and M. Martínez Resclavo

1991 *La montaña de Guerrero: Economía, historia y sociedad*. Instituto Nacional Indigenista, Mexico City.

Olivera, M.

1994 *Huemitl* de Mayo en Zitlala: Ofrenda para Chicomecóatl o para la Santa Cruz? In *Rituales agrícolas y otras costumbres guerrerenses (siglos XVI–XX)*, edited by

M. Matías Alonso, pp. 83–97. Centro de Investigaciones y Estudios Superiores en Antropología Social, Mexico City.

Orr, H.

1997 Power Games in the Late Formative Valley of Oaxaca: The Ballplayer Carvings at Dainzú. Ph.D. dissertation, University of Texas at Austin.

2003 Stone Balls and Masked Men: Ballgame as Combat Ritual, Dainzú, Oaxaca. *Ancient America* 5:73–104. Center for Ancient American Studies, Barnardsville.

Ortiz Díaz, E.

1993 Ideología y vida doméstica. In *Anatomía de un conjunto residencial Teotihuacano en Oztoyahualco*, edited by L. Manzanilla, pp. 519–547. Instituto de Investigaciones Antropológicas, Universidad Nacional Autónoma de México, Mexico City.

Parsons, L. A.

1969 *Bilbao, Guatemala: An Archaeological Study of the Pacific Coast Cotzumalhuapa Region*, Vol. 2. Publications in Anthropology 12, Milwaukee Public Museum, Milwaukee.

1988 The Ballgame in the Peripheral Coastal Lowlands. In *Ulama: Het balspel bij de Maya's en Azteken/ The Ballgame of the Mayas and Aztecs*, edited by T. J. J. Leyenaar and L. A. Parsons, pp. 22–61. Spruyt, Van Mantgem and De Does, Leiden.

Ricketson, O. G., Jr., and E. Bayles Ricketson

1937 *Uaxactun, Guatemala: Group E—1926–1931.* Carnegie Institution of Washington, Washington, D.C.

Robicsek, F., and D. Hales

1981 *The Maya Book of the Dead: The Ceramic Codex.* University of Virginia Art Museum, Charlottesville.

Sahagún, Fray Bernardino de

1950–1982 *Florentine Codex: General History of the Things of New Spain*, translated by A. J. O. Anderson and C. E. Dibble. School of American Research, Santa Fe.

Sánchez Andraka, H.

1983 *Zitlala: Por el mágico mundo indígena guerrerense.* Costa-Amic Editores, Mexico City.

Schele, L.

1995 An Alternative Reading for the Sky-Penis Title. *Texas Notes on Precolumbian Art, Writing and Culture* 69. Center of the History and Art of Ancient American Culture, Austin.

Schele, L, and M. E. Miller

1986 *The Blood of Kings: Dynasty and Ritual in Maya Art.* George Braziller, New York.

Scott, S.

2001 *The Corpus of Terracotta Figurines from Sigvald Linné's Excavations at Teotihuacan, Mexico (1932 and 1934–35) and Comparative Material.* National Museum of Anthropology, Stockholm.

In press The Teo-Cotz Guy: The Teotihuacan Terracotta Masked Figurine and the Cotzumalguapa Connection. In *Faces of Continuity and Change: Figurine Studies*

at the Turn of the Millennium, edited by C. Kolb and C. Otis-Charlton. University of Pennsylvania Museum Press, Philadelphia.

Seler, E.

1912 Similarity of Design of Some Teotihuacan Frescoes and Certain Mexican Pottery Objects. In *XVIII International Congress of Americanists*, Part 1, p. 194. London.

Sepúlveda Herrera, M. T.

1982 *Católogo de máscaras del estado de Guerrero en las colecciones del Museo Nacional de Antropología*. Instituto Nacional de Antropología e Historia, Mexico City.

Sheehy, J. J.

1991 Structure and Change in a Late Classic Maya Domestic Group at Copan, Honduras. *Ancient Mesoamerica* 2(1):1–19.

Sotheby's

1981 *The Bogousslavsky Collection of Pre-Colombian Art*. Sotheby Parke Bernet, New York.

Stern, T.

1949 *The Rubber-Ball Games of the Americas*. Monographs of the American Ethnological Society 17.

Stuart, D.

1998 "The Fire Enters His House": Architecture and Ritual in Classic Maya Texts. In *Function and Meaning in Classic Maya Architecture*, edited by S. D. Houston, pp. 373–425. Dumbarton Oaks, Washington, D.C.

Stuart, G.

1975 Riddle of the Glyphs. *National Geographic* 148(6):768–791. December.

Taladoire, E.

2003 Could We Speak of the Super Bowl at Flushing Meadows? *La pelota mixteca*, a Third Pre-Hispanic Ballgame and Its Possible Architectural Context. *Ancient Mesoamerica* 14:319–342.

Taube, K. A.

1986 The Teotihuacan Cave of Origin: The Iconography and Architecture of Emergence Mythology in Mesoamerica and the American Southwest. *Res, Anthropology and Aesthetics* 12:51–82.

1988 *The Albers Collection of Pre-Columbian Art*. Hudson Hills Press, New York.

1989 Ritual Humor in Classic Maya Religion. In *Word and Image in Classic Maya Culture*, edited by W. F. Hanks and D. S. Rice, pp. 351–382. University of Utah Press, Salt Lake City.

1992 *The Major Gods of Ancient Yucatan*. Studies in Pre-Columbian Art and Archaeology 32. Dumbarton Oaks, Washington, D.C.

1993 *Aztec and Maya Myths*. University of Texas Press, Austin.

1995 The Rainmakers: The Olmec and Their Contribution to Mesoamerican Belief and Ritual. In *The Olmec World, Ritual and Rulership*, edited by J. Guthrie, pp. 82–103. The Art Museum, Princeton University.

2000 *The Writing System of Ancient Teotihuacan*. Ancient America 1. Center for Ancient American Studies, Barnardsville and Washington, D.C.

2003 Ancient and Contemporary Maya Conceptions about the Field and Forest. In *Lowland Maya Area: Three Millennia at the Human-Wildland Interface*, edited by A. Gomez-Pompa, M. F. Allen, S. Fedick, and J. Jimenez-Moreno, pp. 461–492. Haworth Press, New York.

2004 *Olmec Art at Dumbarton Oaks*. Dumbarton Oaks, Washington, D.C.

Thompson, J. E. S.

1948 *An Archaeological Reconnaissance in the Cotzumalhuapa Region, Escuintla Guatemala*. Contributions to American Anthropology and History 44. Carnegie Institution of Washington, Washington, D.C.

Tozzer, A. M.

1957 *Chichen Itza and Its Cenote of Sacrifice: A Comparative Study of Contemporaneous Maya and Toltec*. Memoirs of the Peabody Museum of Archaeology and Ethnology, Harvard University, Vols. 11, 12. Peabody Museum, Cambridge, MA.

Trik, H., and M. E. Kampen

1983 *The Graffiti of Tikal*. Tikal Report No. 31, The University Museum, University of Pennsylvania, Philadelphia.

Von Hesberg, H.

1999 The King on Stage. In *The Art of Ancient Spectacle*, edited by B. Bergmann and C. Kondoleon, pp. 64–75. The National Gallery of Art, Washington, D.C.

Von Winning, H.

1987 *La iconografía de Teotihuacan: Los dioses y los signos*. 2 vols. Universidad Nacional Autónoma de México, Mexico City.

Webster, D. (editor)

1989 *The House of the Bacabs, Copan, Honduras*. Studies in Pre-Columbian Art & Archaeology No. 29. Dumbarton Oaks Research Library and Collections, Washington, D.C.

Wiedemann, T.

1992 *Emperors and Gladiators*. Routledge, London.

Willey, G. R.

1965 Artifacts. In *Prehistoric Maya Settlements in the Belize Valley*, by G. R. Willey, W. R. Bullard, Jr., J. B. Glass, and J. C. Gifford, pp. 391–522. Papers of the Peabody Museum of Archaeology and Ethnology, Harvard University 54. Peabody Museum, Cambridge, MA.

Willey, G. R., R. M. Leventhal, A. A. Demarest, and W. L. Fash, Jr.

1994 *Ceramics and Artifacts from Excavations in the Copan Residential Zone*. Papers of the Peabody Museum of Archaeology and Ethnology, Harvard University, Vol. 80. Harvard University, Cambridge, MA.

Williams-García, R.

1997 Fiestas de la Santa Cruz en Zitlala. In *Danzas y Andanzas [Etnología]*, by R. Williams-García, pp. 313–325. Instituto Veracruzano de Cultura, Veracruz.

Zender, M.

2001a The Ball's in Your Court: Rulership, Religion and Recreation in Classic Maya Ballgame Texts. Paper presented at the 8th Annual UCLA Maya Weekend,

Oct. 13–14. Cotsen Institute of Archaeology, University of California, Los Angeles.

2001b Comments on an Incised Vase [K7749]. Electronic document, http://www.mayavase.com/com7749.html, accessed January 18, 2007. Foundation for the Advancement of Mesoamerican Studies, Inc.

2004 Glyphs for 'Handspan' and 'Strike' in Classic Maya Ballgame Texts. *The PARI Journal* 4(4):1–9.

2006 Teasing the Turtle from Its Shell: **AHK** and **MAHK** in Maya Writing. *The PARI Journal* 6(3):1–14.

SECTION III

TROPHY-HEAD TAKING

CHAPTER 8

Heads of Flesh and Stone

JANE STEVENSON DAY

CHAPTER 9

Rolling Heads: The Diquís Stone Balls and Trophy-Head Taking
in Ancient Costa Rica

HEATHER ORR

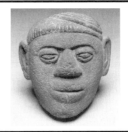

CHAPTER 8

HEADS OF FLESH AND STONE

Jane Stevenson Day

Throughout history, war, violence, and human sacrifice have been part of cultures around the world, and basic to these ancient practices was the taking of trophy heads (Ehrenreich 1998; Leach 1989). The immense symbolic and physical importance of the human head as the seat of the soul and the source of power appears to transcend time and space. As Nigel Davies (1984:213) has pointed out, it was both the earliest documented form of human sacrifice and the one that has tended to survive the longest. From Neanderthal skulls ritually placed in a cave during the last great ice age to the decapitation of hostages in Iraq today, the tradition continues. This paper focuses on the taking of trophy heads in one region of ancient Costa Rica, where a scenario of violence and organized aggression was played out under the mask of ritual.

THE GIFT OF BLOOD

In the pre-Hispanic Americas, violence and human sacrifice played a significant role in religious ceremonies. At the state level, cultures such as the Aztec in Mesoamerica and the Inca in the Andean region employed cyclic, often bloody, rituals to appease their deities and assure order in the universe. Humans—most often captives, women, children, and slaves—were sacrificed in public places where an audience could observe the death of the victims and the presentation of the sacred gift of life to the gods. Both among the local populace and the enemies of the state, this cycle of violent acts inspired terror and awe as well as the hope that the world as they knew it would continue.

In cultures peripheral to the great centralized Mesoamerican and Andean states, societies were apt to be organized as chiefdoms rather than states. A vast body of literature (for example, Carneiro 1970; LeBlanc 2003:181–191; Lange 1992:434) discusses the characteristics of chiefdoms and their development from egalitarian tribes. In ranked societies headed by chiefs, competition for control of resources resulted in almost constant warfare, which served to concentrate leadership, wealth, and power in the hands of one strong man or one lineage. This immersion in martial conflict underlies many of the cultural traits associated with chiefdoms, such as male dominance, dramatic initiation rites, constant battles with neighboring chiefs, and a warrior cult focused on acquisition of property, authority, and personal power. The taking of prisoners for human sacrifice and the display of their heads as trophies of war often characterize such chiefdoms (Davies 1984). In addition, the flow of blood, initiated by decapitation, was deemed essential in agricultural societies to assure fertility and regeneration of crops and people. Evidence for this association of blood with agricultural needs is dramatically seen in Mesoamerica, where human hearts were offered to the sun on Aztec pyramids; Mayan figurines dressed as ballplayers hold a knife in one hand and a human head in the other; and stone sculptures, such as a stela from Aparicio (Figure 8.1), depict blood spouting in streams from the severed necks of decapitated ballplayers—a ritual watering of the earth. A significant image in Peru is the Andean decapitator god who holds a *tumi* (half-moon-shaped) sacrificial knife in one hand and a human head in the other (Cordy-Collins 2001a:26, pl. 24). As in Mesoamerica, Andean scholars also see a close connection between the ritual taking and displaying of human heads and agricultural fertility (Benson 2001:6). The need for sun and rain to nurture crops and the belief that the gods controlled the natural elements were uni-

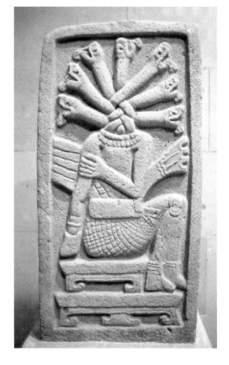

FIGURE 8.1. Stone ballgame stela from Aparicio, Veracruz, Mexico, A.D. 400–700 (*Photo by H. E. Day.*)

versal, and both simple and sophisticated societies responded with sacrificial offerings. In the pre-Hispanic Americas, this violent spilling of blood was condoned and considered crucial for the continuity of life.

The Trophy-Head Cult in Costa Rica

This paper focuses on a trophy-head cult that flourished in the Atlantic Watershed region of ancient Costa Rica during the last 500 years of the pre-Columbian era. At this time (A.D. 1000–1520) aggressive chiefs, dependent on warfare and its resulting booty for status and personal power, dominated political and religious life. Responding to agricultural needs, chiefs and shamans propitiated the gods by offering the blood of prisoners captured in battle and wore their enemies' severed heads as trophies of war. These activities are vividly depicted by local artists in magnificent stone sculptures reflecting the themes of a warrior society focused on battle and headhunting. Examination of the figures and their accoutrements allows us to suggest some new interpretations of the cult, its significance in ancient Costa Rican society, and its relationships with other pre-Columbian cultures in the ancient Andean area and Mesoamerica.

The Geographical Setting

Costa Rica is divided by natural barriers of mountains and water into three regions: the Southwestern Diquís region, the Greater Nicoya Area, and, the focus of this paper, the Atlantic Watershed, composed of the temperate Central Highlands and the Atlantic drainage system (Figure 8.2). As clearly evidenced by trade goods and shared iconography, these three areas were in continual contact with one another in spite of challenging geographic barriers. Early trade routes along rivers and across mountain passes carried genes and ideas as well as culturally distinct, valuable objects of pottery, jade, stone, and gold intended for burial in elite graves. In addition, over the years between 500 B.C. and A.D. 1520, influences also flowed into the region via external trade routes and perhaps actual migrations of people from more sophisticated cultures to the north and south of Costa Rica. In the Atlantic Watershed, as in all of Costa Rica, these influences varied in direction and intensity through time and space, leaving a veneer of changing iconography on indigenous cultures (Day 1998, 1994; Snarskis 1984; Stone 1977). Yet, in spite of the intrusion of new people and concepts, ancient traditions survived, including the use of related Chibchan languages and a reliance on local shamans, and a blend of old and new are continually reflected in the art and world view of populations in pre-Hispanic Costa Rica.

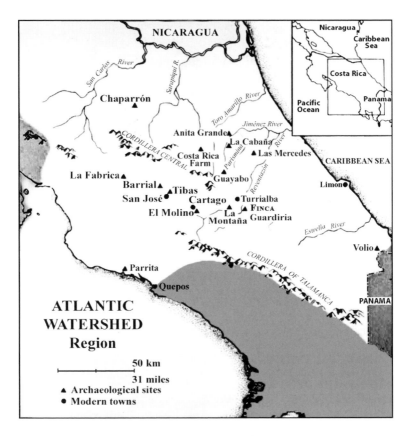

FIGURE 8.2. Map of Atlantic Watershed region, Costa Rica. (*Map by H. E. Day.*)

The Stone-Carving Tradition

Fine stone sculpture in the round is rare in the pre-Columbian Americas, but it became a hallmark of the late pre-Hispanic period in the Atlantic Watershed of Costa Rica. The tradition began about the time of Christ, when decorated stone metates for grinding corn began to be made in all three areas mentioned above. Their appearance and development were a result of changing agricultural patterns that initiated an escalating dependence on maize rather than root crops (Snarskis 1984:210). Over time, the metates became increasingly elaborate, taking on significance as sculptures as well as tools. While grinding stones were used wherever corn was grown, their presence as actual works of art occurred, with a few exceptions, primarily in Costa Rica. This happened particularly in the Atlantic Watershed region where their elaboration reached its height in the production of highly decorated stone platforms known as "flying panel metates" (Figure 8.3). Found in

association with burials and funerary offerings, these have been interpreted as ritual grinding stones used to crush/transform the inedible hard kernels of corn into meal for human consumption. By extension, this act of destruction that changes one form into another (hard grains into human sustenance) suggests a parallel transformation and eventual regeneration of the human body at the time of death (Graham 1981, 1992). The complex, almost baroque, iconography carved on the metates focuses on depictions of long-beaked birds carrying human heads in their beaks, masked shaman figures, and a limited number of powerful animals such as crocodiles and jaguars (Figure 8.3). The beaked bird, carrier of trophy heads, is still remembered by indigenous people today as the main player in an ancient creation myth in which a long-beaked bird pecks a vaginal opening between the legs of a sexless being to create a woman. The bird then transports in its beak the semen of a male to the groin of the first female, thus establishing the fertility of humans (Balser 1955; Bozzoli de Wille 1979; Day 1993:298; Stone 1977). This bird and the trophy heads are carved repetitively on the large, elaborate metates and appear on the contemporaneous jades and ceramics of the period, evidencing an early relationship of trophy heads with death, fertility, rebirth, and regeneration.

The tradition of stone carving in the round is first associated with these immense decorated metates, but after about A.D. 500 the tradition develops further into the masterful creation of some of the finest human sculptures ever made in the ancient New World. From hard volcanic stone, using only wood and stone tools and simple abrasion techniques, artists sculpted magnificent figures. This tradition of figural carving eventually replaces the elaborate ritual metates

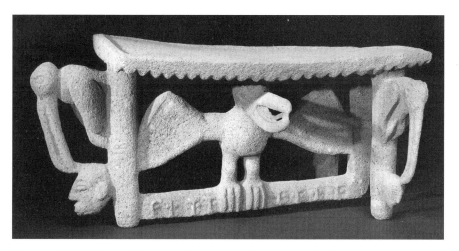

FIGURE 8.3. Elaborate flying panel metate, Atlantic Watershed, Costa Rica, A.D. 1–500. (*Courtesy of the Denver Art Museum.*)

adorned with long-beaked birds and trophy heads and, after A.D. 700, there is a growing preoccupation with the portrayal of a trophy-head cult. By A.D. 1000, the earlier iconography has been absorbed by this dominant theme and expanded into the complex symbol system of a headhunting society.

STONE SCULPTURE: THE TROPHY-HEAD CULT

The following section of this paper presents compelling evidence of the presence and significance of a Costa Rican headhunting cult based on a large collection of stone sculptures from a number of sources, including the Denver Art Museum. Many of the pieces have not been published before, and together they form a tight corpus of objects with a specific cultural and geographical context in the Atlantic Watershed of Costa Rica during the final 500 years of the pre-Columbian period. In this collection of figures, the components of the violent trophy-head cult appear full blown, with its activities and themes depicted in amazing carved statues of nude humans, a few almost life-size. The extraordinary sculptures depict a specific cast of characters that participate in the trophy-head rituals. In this repertoire, powerfully built warriors carry weapons and often have a trophy head in their hands or slung across their backs; other nude males hold ritual cups or shrunken human heads; prisoners stand or kneel bound with ropes; hunkering shamans smoke cigars or stare straight ahead in a trance; tall mortuary slabs, decorated with friezes of abstract trophy heads, mark elite tombs; and stone trophy heads are often so realistically carved they appear to be portraits. Young, nude women are also represented, displaying their breasts, stroking their long hair, and occasionally nursing infants. The largest of these realistically conceived sculptures must be considered as public art, meant to be seen and to convey the elements of the violent trophy-head cult and the division of masculine and feminine roles dictated in a warrior society.

THE ICONOGRAPHY OF POWER

The limited, but dramatic, group of players represented in the stone sculptures of Atlantic Costa Rica range from less than 12 inches to almost life-size. They are made of local, gray volcanic stone and are smoothed to a fine finish by the sculptor. Due to geographical distribution and the hands of different artists, styles may vary from one sculpture to another, but all the figures clearly display repetitive elements and characteristics connecting them to one another and to the themes of war and of the trophy-head cult. The ancient sites of their origin and the people who inhabited them obviously shared mutually understood iconography and cultural values.

Female Figures

Considering first the sculptures of women, we find that many are nude, adolescent girls (Figure 8.4). Most of these slim, juvenile figures stand with one hand supporting each small, pointed breast. This stylized display of the breasts is the major motif associated with females generally and varies little from one figure to another. Indeed, unless pregnant, most females are depicted as slender and young, though offering their breasts in an inviting, erotic gesture. In other New World cultures, women are more apt to be depicted with rounded, full bodies, bulbous thighs and exaggeratedly large breasts, seemingly suggesting fertility rather than an invitation to sexual activity.

Another young woman stands in profile, holding her hair in one hand, smoothing or perhaps washing it with the other, in ritual display (Figure 8.5). In many cultures, hair is connected with sexuality, power, and the life force (Leach 1989). For example, in Peru it had mystical connotations with

FIGURE 8.4. Adolescent girl displaying her breasts, Atlantic Watershed, Costa Rica, A.D. 1000–1500. (*Courtesy of the Denver Art Museum.*)

coming-of-age ceremonies for girls and boys, and Moche pottery depicts individuals ritually washing their hair over a large, shallow basin (Donnan 1976:132). Additionally, in both Andean and Mesoamerican cultures, combat scenes show warriors holding their defeated foes, probably destined for sacrifice, by a symbolic lock of hair (Berdan and Anawalt 1992:135, 137, 139; Donnan 1976:111; Proulx 2001:128, pl. 6.10). Certainly hairdressing itself has been a matter of ritual elaboration throughout time, and ornate arrangements of hair can be seen on female figures in western European sites as early as the Upper Paleolithic 40,000 years ago. Beginning in the Preclassic New World (about 1500 B.C.), ceramic figures exhibit a remarkable variety and elaboration of hairstyles, perhaps indicating rank, sex, or ritual activity. As late as 1521, in the final Aztec period, a

woman's hairstyle communicated her status as married, single, or publicly available. There is also a widespread association between head hair, power, and sexual energy (Leach 1989:82–83), with perhaps the most familiar example of this theme vividly recorded in the ancient biblical story of Samson and Delilah, in which Samson's amazing physical power is sapped when Delilah cuts off his hair. Based on these examples, the obvious focus on this figure's luxuriant hair suggests a sexual context or ritual.

In contrast to the slim, adolescent bodies of the first two stone figures, Figure 8.6 depicts the sensuous, fully rounded figure of a more mature woman. She stands with her left hand raised to her mouth and her right hand on her pregnant belly. Her close-fitting helmet, with a projecting spool at the top, is one that John Hoopes (this volume, Chapter 11) suggests is a standardized form indicating ritual or shamanistic headgear. It is interesting to note that her hand-to-mouth gesture is echoed in other pregnant female figures; Graham (1992:178, fig. 5) depicts such a figure carved on the leg of a large metate. The gesture is also depicted on a number of male sculptures associated with the trophy-head cult, seeming to indicate a special relationship between fertility and sustenance.

FIGURE 8.5. Young woman stroking her hair, Atlantic Watershed, Costa Rica, A.D. 1000–1500. (*Courtesy of the Denver Art Museum.*)

FIGURE 8.6. Pregnant female with hand at mouth, Atlantic Watershed, Costa Rica, A.D. 1000–1500. (*Courtesy of the Denver Art Museum.*)

Another theme, though much rarer in stone than in ceramics, is the depiction of a mother nursing a baby (Figure 8.7). The motif seems to relate to the trophy-head cult as the final image in the regeneration cycle. The mature figure of this seated woman has geometric body decorations running down each arm. The use of decorative body designs and the fact she is seated on a shaman's stool as she nurses her child may mark this apparently strong adult woman as an individual of power—perhaps a shaman herself, or the wife of a chief.

Male Figures

There is more variety in the stone sculptures of men than of women. Figure 8.8 is typical of the many carved warrior figures of the period. He stands proudly holding his weapon in one hand and a trophy head in the other. While styles of carving may vary somewhat from site to site and from artist to artist, this basic warrior and his associated accoutrements remain remarkably similar from one sculpture to another. Around his waist and torso is a broad belt of many strands of rope or woven fiber. This woven belt is the only characteristic attire of the male warrior figures who otherwise are completely

FIGURE 8.7. Woman nursing a baby, Atlantic Watershed, Costa Rica, A.D. 1000–1500. (*Courtesy of the Denver Art Museum.*)

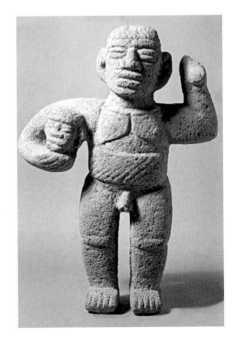

FIGURE 8.8. Warrior with ax, trophy head, and woven belt, Atlantic Watershed, Costa Rica, A.D. 1000–1500. (*Courtesy of the Denver Art Museum.*)

nude. It has been suggested (Day 2001; Parsons 1988: 226) that the wide fiber gir-
dle at the waist of these figures may represent a protective ballgame yoke or belt.
As mentioned earlier, the Mesoamerican ballgame was associated with agricultur-
al fertility and regeneration and often ended in sacrificial decapitation. According
to Borhegyi (1968), in its most ancient form the game and its iconography may
have been based in an early trophy-head warrior cult, where a human head was
substituted for a rubber ball. Further evidence of a ballgame played with a human
head and its close association with death and rebirth can be found in the ancient
Maya book *The Popol Vuh* and its account of the activities of the ballplaying Hero
Twins (Tedlock 1985). I don't think we can rule out that there may be a reflection
of this theme and game in Costa Rica, just as there was in late pre-Hispanic Taino
cultures in the Caribbean, where stone slabs or rocks outlining simple ball courts
are found at many archaeological sites (Rouse 1992: 15). It is also of note that the
migrations of the Tainos north out of the Orinoco River drainage of northern
South America and into the Caribbean islands overlap chronologically with the
rise of the trophy-head cult in Atlantic Costa Rica and with changing agricultural
and architectural practices in the area (Rouse 1992:169; Snarskis 1992). This may

be a significant association, as in both
pre-Columbian and ethnographic
sources there is evidence of the pres-
ence of a ballgame played by tribes
along the Orinoco River drainage
(Stern 1948).

Some male figures are depicted
in a kneeling position (Figure 8.9).
They are seen on one knee, with the
left hand at the forehead. Numbers
of these figures have been found, and
the gesture of the open hand held in
a salute may be associated with a
lower rank or perhaps with submis-
sion. It seems uncertain whether
these are warriors, slaves, or perhaps
captives.

Captive figures are, of course,
essential to the drama of the trophy-
head cult. Figure 8.10 is typical of
many others in the "prisoner category"
of the cult. The nude male stands

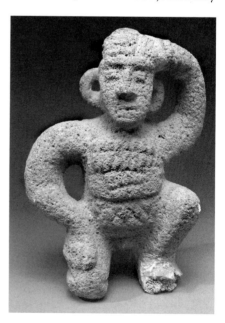

FIGURE 8.9. Kneeling male figure, Las
Mercedes, Atlantic Watershed, Costa
Rica, A.D. 1000–1500. (*Courtesy of the
Denver Art Museum.*)

with his hands bound together with a rope above his head. Though all the figures are similar, they vary somewhat in position; some may have their hands tied behind or in front of them, and others may crouch or kneel instead of standing. All are depicted completely nude, a condition typical of prisoner figures throughout both Mesoamerica and the Andean area (among the Aztec, Maya, Mochica, and Inca). The drilled holes in the earlobes of the captive once held ear adornments, perhaps made of gold or other valuable material and taken as booty by his captor.

The warrior in Figure 8.11 is marked with a massive stitched scar on his chest. He stands with an ax or sacrificial blade in his upraised left hand and a shrunken human head in his right. The interwoven stitched scar design extends vertically down his chest from neck to genital area. The eyes appear to be closed, signifying death or possibly a shamanistic trance. Like several other figures, the

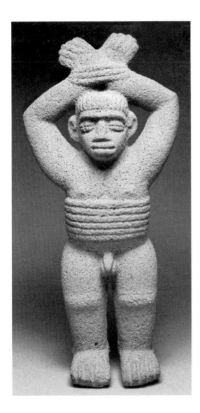

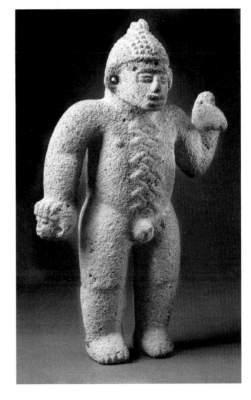

FIGURE 8.10. Male prisoner with bound hands, Atlantic Watershed, Costa Rica, A.D. 1000–1500 (*Courtesy of the Denver Art Museum.*)

FIGURE 8.11. Male figure with stitched scar on torso, Atlantic Watershed, Costa Rica, A.D. 1000–1500 (*Courtesy of the Denver Art Museum.*)

warrior wears a cone-shaped hat, probably part of a shaman's ritual attire. Special headgear marks many shaman figures in pre-Columbian Costa Rica. In Greater Nicoya, a three-layered hat (Day and Tillett 1996) can be seen on figures in clay, stone, and jade. In the Atlantic region, a distinctive cone-shaped cap marks at least some of the powerful shamans (Hoopes and Mora-Marín, this volume, Chapter 11). The unusual stitched element on the torso is reminiscent of Aztec chest incisions, used to remove the heart for human sacrifice. While the taking of trophy heads dominates Costa Rica's large stone sculptures, other types of sacrifice may have also existed. Certainly heart extraction was a common form of sacrifice in the Aztec culture and in other areas of Mesoamerica. What influence the Aztecs may have had in Costa Rica is not certain, but late Aztec trading colonies have been historically documented in lower Central America at the time of the Spanish Conquest (Lothrop 1926: 114), and there appear to be lingering traces of Aztec influence reflected in the language of contemporary Talamanca and Guaymi Indians in Costa Rica today (Bozzoli de Wille 1979).

Another male figure is unique in the corpus of sculptures. He stands holding a cup in his right hand and a sacrificial blade in his left (Figure 8.12a–b). The left hand is hidden behind his back as if to shield the sight of the weapon from others. Viewed from the rear, it can be seen that the weapon this warrior holds is a large sacrificial knife. Its lunar or tumi shape is rare among the Costa Rican stone warrior figures, but it is the same form as the sacrificial knife held by the decapitator god in Mochica iconography. The imagery strongly suggests that this figure may be the designated executioner in the trophy-head story (Cook 2001:158). The cup, which is also associated with several other sculptures, may be a vessel for taking hallucinogenic drugs or, as in numbers of other cultures around the world, it may have been used for the consumption of a ritual drink of blood taken from a powerful foe, to increase the victor's strength (for example, Cordy-Collins 2001b: 21–52).

From the artistic viewpoint, the most magnificent of the stone sculptures is a large, handsome male (Figure 8.13). He stands regally erect, holding a multi-strand whip over his left shoulder and a cup in his right hand. His spectacular, long hair hangs in a ponytail down his back. Around his waist and torso he wears the ball-player-style textile belt. The figure represents a young man, quite probably a chief at the height of his power. The strong muscular body, proud stance, and arrogant face all characterize him as a person of authority to be reckoned with and feared. His accoutrements also add to a sense of power. The large whip with its long multi-strands, the small, ritual cup, and his long, thick hair bound up in regal style contribute to his haughty presence. The high-quality rendering of the figure impressively demonstrates the ability and talent of the pre-Hispanic artists and the use of sculpture as public art in ancient Costa Rica.

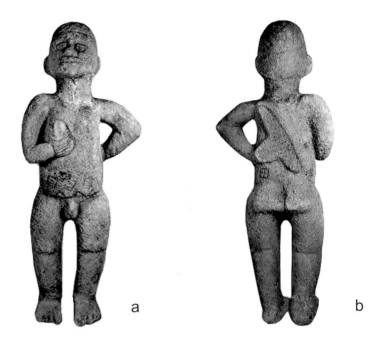

FIGURE 8.12. Executioner figure, Atlantic Watershed, Costa Rica, A.D. 1000–1500, front and rear views. (*Courtesy of the Denver Art Museum.*)

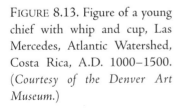

FIGURE 8.13. Figure of a young chief with whip and cup, Las Mercedes, Atlantic Watershed, Costa Rica, A.D. 1000–1500. (*Courtesy of the Denver Art Museum.*)

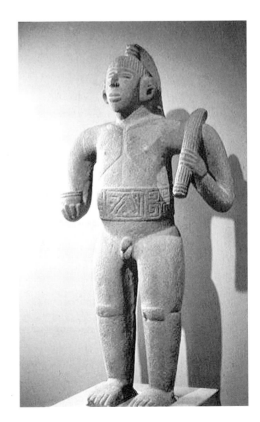

Among the repertoire of the trophy-head sculptures is an unusual depiction of a shaman (Figure 8.14). This tall, slender figure stands erect, holding a monkey on his back. The animal's legs curve around the adult male's waist, and its spindly arms cling around his neck. Shamans are well known to have alter egos, or familiars, in the form of a specific animal who is his or her special helper. The shaman can change at will into the animal form, as needed. This sculpture probably represents a shaman carrying his alter ego (in this case a monkey) on his back. There is little doubt that shamanism was an important element of ritual life in ancient Costa Rica. Throughout time, shamans, both men and women, were individuals of special power in their communities as religious leaders, healers, and conduits to the otherworld. In Costa Rica in general, women as well as men were shamans; in addition, some images clearly depict shamans as hermaphrodites (see Mason 1945: pl. 35b), combining the essential power of both sexes in one individual (Day and Tillett 1996:221–235). This powerful figure carrying his monkey counterpart probably played a significant role in the rituals related to the trophy-head cult.

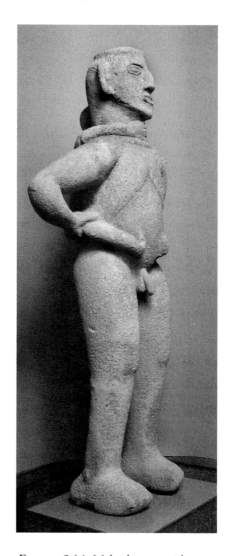

FIGURE 8.14. Male shaman with monkey on his back, Atlantic Watershed, Costa Rica, A.D. 1000–1500. (*Courtesy of the Denver Art Museum.*)

Other, more typical shaman figures of the period are sculptures of seated or hunkering nude males with their arms resting on their upraised knees (Figure 8.15). These are found abundantly in Costa Rica and are the most common stone sculptures from the Atlantic region. This figure is unaccompanied by accou-

Figure 8.15. Hunkering shaman fig-
ure, Atlantic Watershed, Costa Rica,
A.D. 1000–1500. (*Private Collection.*)

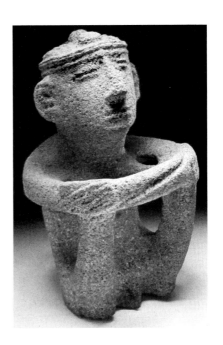

trements, but others often smoke
cigars or inhale drugs through a dou-
ble or single tube held to the nose.
Generally they are accepted as repre-
sentations of shamans who sit staring
straight ahead as if in a hallucino-
genic trance. Their sizes range from 4
to 18 inches.

Stone Trophy heads

Carved trophy heads are among the most significant symbolic objects in the head-
hunting cult. Their concrete presence in burials firmly supports evidence of
organized violence practiced in Costa Rican warrior societies (Hartman 1901;
Stone 1977). Figure 8.16 has naturalistic features with oval eyes, triangular nose,
full lips, and flange-shaped ears. The patterned striation marks on top of the head
indicate hair. The sculpture is realistic, but its small size suggests it may represent
a head shrunken to be worn as a trophy.

Other heads are closer to life-size. While some of the heads are quite stylized
and may be the product of one artist or workshop, others appear to be well-made
depictions of individuals (Figure 8.17), perhaps chiefs or, alternatively, portrayals
of important enemies taken in battle, decapitated and eventually buried with the
conquering chief. In this vein, it is interesting to note that at the site of Guayabo,
eight stone trophy heads were found in a burial, each with the same distinctive
hair arrangement, perhaps identifying defeated members of one lineage or clan
(Stone 1977:203). Hartman (1901) also encountered stone trophy heads in the
stone cist burials at Orosi. These realistic human faces stare at us from the past
and, whether large or small, they remain as an iconographic statement that con-
cretely documents the presence of decapitation and sacrifice in ancient Costa
Rica.

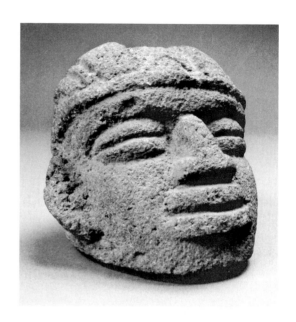

FIGURE 8.16. Shrunken trophy head, Atlantic Watershed, Costa Rica, A.D 1000–1500. (*Courtesy of the Denver Art Museum.*)

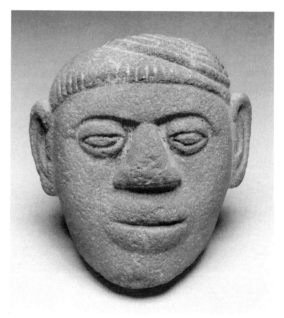

FIGURE 8.17. Portrait trophy head, Atlantic Watershed, Costa Rica, A.D. 1000–1500. (*Courtesy of the Denver Art Museum.*)

Also associated with elite graves in the Atlantic Watershed are small, stone stelae (Figure 8.18). None of these thin, slab monuments are identical, but all have similar characteristics. They are rectangular slabs of stone usually decorated with two small human figures, male and female, standing side by side on the

top; bands of textile design and a row of tiny abstract trophy heads run vertically down each side. At times the human figures may be substituted with images of jaguars, an animal associated with death and the underworld throughout the pre-Columbian world. As in Figure 8.18, the human male figures often wear the heavy woven belt already discussed above, and the women, as usual, are nude. These slabs have been found in archaeological context (Mason 1945), and their counterparts in decorated slabs of wood were described by Columbus when he saw them on the Caribbean coast of Costa Rica in 1502 (Fernando Colon 1959).

Discussion

Beginning around A.D. 1000, large stone sculptures such as the ones described and illustrated here were made and used at large sites in the Atlantic region of Costa Rica. They document a change from the iconography of the earlier long-beaked-bird/trophy-head theme to a full ritual repertoire actually depicting the players in a trophy-head cult. Such change suggests a transformation in the society itself—from tribal organization to chiefdoms. Archaeological research supports such a change at this time through evidence of increasing popula-

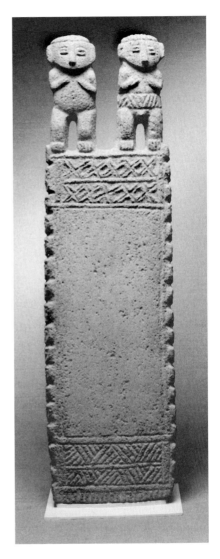

Figure 8.18. Stone mortuary slab, Atlantic Watershed, Costa Rica, A.D. 1000–1500. (*Courtesy of the Denver Art Museum.*)

tion and the presence of numbers of large central sites with roads, plazas, stone ceremonial structures, and new styles of dwellings (Snarskis 1992). Two of these sites provide particularly rich information: Las Mercedes (Hartman 1901; Mason 1945) in the lowland eastern plains, and the jungle site of Guayabo on the verdant

slopes of the mountains (Fonseca 1981). An interesting special placement of some of the stone figures has been recognized at both sites, as well as at the lesser-known site of Costa Rica Farm (Skinner 1926:462–463). The research shows that some of the larger sculptures were once positioned on the stone walls, stairways, or platforms at Guayabo and Las Mercedes and on either side of doorways at the site of Costa Rica Farm. This positioning of the sculptures on high structures would allow them to be seen from plazas below by members of the community.

The site of Las Mercedes has been destroyed over the years by looters and agricultural activities, but when it was found in the late 1800s during the building of a railroad, it yielded hundreds of stone figures and fragments which were collected and preserved as the Minor Keith Collection in the American Museum of Natural History in New York (Hartman 1901; Mason 1945). While not scientifically excavated, the objects clearly demonstrate both the diversity of style and the standardization of iconography that once existed in the sculptural repertoire of large sites of the Late Period. Examples of all of the stone sculptures discussed above were present at Las Mercedes, including the magnificent figure of the young male chief with his multi-strand whip (Figure 8.13). In addition, evidence indicates that some of the large stone figures originally stood at either side of stairways on ceremonial mounds, held in place by a socket of stone slabs (Hartman 1901).

At the site of Guayabo (Fonseca 1981), looters had already removed most of the stone sculptures, but the architectural components remain, and archaeological evidence indicates the presence of a large town with a ranked society, ruled over by a chief who probably controlled numerous other sites in the region. Guayabo's architecture (Figure 8.19) is impressive. It includes a paved roadway passing through an entrance gate to the central quadrangular plaza, mounds with buildings on top, stone walls, an underground water system, and cobblestone causeways connecting plazas. One large mound with nine stone sculptures around it parallels the earlier discovery of the public display at Las Mercedes of the socket-mounted figures.

The evidence from these two sites indicates that the chiefs of these centralized towns controlled labor forces capable of constructing private and public buildings, causeways, water systems, and roadways. In addition, the centers attracted a corps of talented sculptors who carved the fine stone figures and the accoutrements that validated chiefly status. Such chiefs enforced rule at home and controlled lesser sites in the area through a squad of aggressive warriors eager for warfare, booty, and the taking of trophy heads. It appears that at least some of the stone sculptures were once situated on mounds where they could be seen from below. This leads us to infer that they were placed there intentionally for public viewing. Many of the statues are large enough to be seen from the plazas of the town and may have been grouped in tableaux to portray the ritual stories and per-

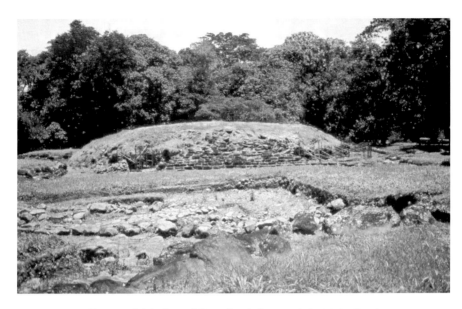

FIGURE 8.19. Site of Guayabo. (*Photograph by H. E. Day.*)

sonages of the headhunting cult. Ann Cyphers (1997) thinks that such groupings were one of the main uses of the large stone figures found at the Olmec site of San Lorenzo on the Gulf Coast of Mexico. I have also suggested in another context (Day 1998, 2001) that smaller figurines were also grouped together in graves to tell a story or commemorate a special event. The very early (ca. 1500 B.C.) ceramic group of ballplayers from the shaft tombs at El Opeño in West Mexico and the cached miniature scene of the Olmec jade figures standing in front of a stela from the site of La Venta on the Gulf Coast of Mexico (ca. 900 B.C.) are two examples of this. In nonliterate, ranked societies, chiefs would have understood the propaganda value of a dramatic display of mythological or real events through mutually understood imagery.

Veiled by time, conquest, and cultural change, interpretation of the characters and actions in this violent trophy-head taking is uncertain. However, the players in the trophy-head story and the elements and accoutrements associated with them are so clearly repetitive and standardized that we must assume that the narrative would have been known and understood by most people living 1,000 years ago in the Atlantic Watershed region. Even though the towns or villages in the area may have been in constant conflict with one another, culturally, linguistically, and probably ethnically they were one people. I think we can speculate that there was once an ancient legend of great cultural significance that justified the organization of violent acts by a powerful chief and his warriors. Told and retold over time and reinforced by sculptural tableaux in stone, the heroic tale was passed

down through generations by a strong oral tradition, just as myths are still pre-
served today among the surviving indigenous peoples of Costa Rica (Bozzoli de
Wille 1982). The male figures—chiefs, warriors, prisoners, executioners, and
shamans—and the female figures associated with them—nubile adolescent girls,
pregnant women, and nursing mothers—suggest the elements of the story might
have been combined as follows.

During a time of crisis, caused perhaps by drought, disharmony, or disease, a
strong warrior chief was encouraged by circumstances and influential shamans to
go to war in order to obtain prisoners as offerings for a blood sacrifice. The chief,
who had surrounded himself with an eager group of young warriors, rose to the
occasion. He led his men into battle against neighboring towns, captured prisoners,
and acquired treasure, land, and booty. He and his troops defeated their foes and
returned home in triumph with their captives. The captives were proudly displayed
at the town center in bonds and then publicly decapitated at the hands of a desig-
nated executioner. Under the guidance of shamans, these human sacrifices and gifts
of blood were presented as offerings to propitiate the gods and assure the continu-
ity of agricultural and human fertility in the community. The young women, always
a part of the spoils of war, were then shared out among the warriors, along with
other booty, as reward for their loyal support. The chief, who had organized the vio-
lent rituals, was seen as a great hero and provided a feast for all, including ample
portions of maize beer served from the massive *chicha* jars whose remnants are
found at most sites throughout Costa Rica. Among indigenous peoples today, tra-
ditional communal labor forces continue to exist, and at day's end, copious amounts
of chicha are still served to the group (Ferrero 1981). Whether some sort of ball-
game was played in the plazas of the towns as part of the celebrations is uncertain.
Snarskis (1984, 1992,) describes various-sized plazas associated with major
mounds at sites in the region and suggests they may have been the focus of ceremo-
nial encounters of various kinds. It does not seem unreasonable to speculate that
one of their uses might have been for playing a ceremonial or celebratory ballgame.
In addition, the few cultural and temporal clues mentioned earlier, and the ball-
game-style belt associated with the male figures, support this possibility.

This story may or may not be accurate, but the cast of characters in such a
drama is certainly reflected in the stylized but realistic stone sculptures examined
in this paper. Their public display would have served as a tool of propaganda, visu-
ally reinforcing the necessity for the bloody activities of the cult and the assigned
roles for members of society: women as second-class citizens and bearers of chil-
dren, men as warriors and perpetrators of aggression, and chiefs as defenders of the
community, distributors of wealth, and providers of trophy heads. Through this
integrating system of organized violence masked by ritual requirements, chiefs and
warriors flourished and both the secular and the sacred worlds were sustained.

Conclusion

Seldom is graphic imagery such as the sculptural record from Costa Rica available to document ancient societies. This corpus of stone figures concretely depicts a headhunting warrior cult that existed and flourished for at least 500 years in Atlantic Costa Rica. Its roots lay in earlier regional traditions where images of shamans, long-beaked birds, and trophy heads reflected cultural beliefs and values associated with birth, death, and regeneration. Out of this grew ranked societies led by chiefs who validated their power and status through wealth sharing, warfare, and public display. In addition, they guaranteed the fertility of crops and the regeneration of life through the traditional method of exchanging human blood for this assurance from the gods. Successful sacrificial offerings of blood benefited the entire populace, and the violence associated with its acquisition not only provided wealth and status, but also confirmed the cultural viability of the values of the community. Rather than destroying the community, violence actually bound its members together as co-actors in a bloody ritual performance—bloodshed, pain, and death were one side of the coin, and sustenance, regeneration, and life the other.

Generally speaking, in most societies violence is an embedded aspect of human interaction. It often goes masked and unrecognized and is not necessarily separated out from other cultural components. It can take many forms—from small- and large-scale wars and episodes of genocide, to individual abuse of one person by another or actual sacrifice of one member of a society for the good of all. However, to sustain itself and to be viable, violence must be condoned by the society it serves and must be linked to prevalent cultural values (Whitehead 2004). It cannot truly be separated from the other activities that organize and maintain specific cultures. At Atlantic Watershed sites in Costa Rica, the general population, as well as the powerful chiefs, shamans, and warriors, apparently condoned as necessary the violent activities organized by their leaders. Repetitive dramatic performances of decapitation may have reduced sensitivity to its horror and engendered a fatalistic acceptance that following another battle there could be a reversal of roles and the victor might become the victim.

The presence of organized violence and the use of blood sacrifices for the benefit of an entire community are basic to the world view of most cultures in the pre-Columbian Americas. This widely recognized focus provides context for the brutal aggression associated with the trophy-head cult in ancient Costa Rica. The underlying violence of the cult may have been organized by the chiefs and shamans, but it was supported and accepted by the community. It is interesting to consider that while warfare and the taking of prisoners were roles performed by the warriors, the actual killing and decapitation of heads was shared by the trio of

victim, observer, and perpetrator (Whitehead 2004:67). This sharing of responsibility for human sacrifice and violence has historically bound groups together in cultures around the world. Through mutual acceptance, guilt for the brutal act is distributed among all participants, both active and passive; one may kill, another be killed, and one may only watch, but the ritual is understood and fulfilled by all. In pre-Hispanic Costa Rica, the sacrifice was not only individually meaningful, but was considered crucial to the continuation of life itself, thus allowing a cycle of violent events to wear the mask of sacred necessity.

REFERENCES CITED

Balser, C.
 1955 A Fertility Vase from the Old Line, Costa Rica. *American Antiquity* 20(4): 384–387.
Benson, E., and A. Cook (editors)
 2001 *Ritual Sacrifice in Ancient Peru.* University of Texas Press, Austin.
Berdan, F., and P. Anawalt
 1992 *The Codex Mendoza,* Vol. III Facsimile. University of California Press, Berkeley and Los Angeles.
Borhegyi, S. de
 1968 The Pre-Columbian Ballgame: A Pan-Mesoamerican Tradition. *Proceedings of the 38th International Congress of Americanists.* Munich.
Bozzoli de Wille, M. E.
 1979 *El nacimiento y la muerte entre los Bribris.* Editorial Costa Rica, San José.
Carneiro, R.
 1970 A Theory of the Origin of the State. *Science* 169:733–738.
Colon, F.
 1959 *The Life of the Admiral Christopher Columbus by His Son Ferdinand.* Translated and annotated by B. Keen. Rutgers University, New Brunswick, NJ.
Cook, A.
 2001 Huari D-Shaped Structures, Sacrificial Offerings, and Divine Rulership. In *Ritual Sacrifice in Ancient Peru,* edited by E. Benson and A. Cook, pp. 139–165. University of Texas Press, Austin.
Cordy-Collins, A.
 2001a Decapitation in Cupisnique and Early Moche Societies. In *Ritual Sacrifice in Ancient Peru,* edited by E. Benson and A. Cook, pp. 21–35. University of Texas Press, Austin.
 2001b Blood and the Moon Princess. In *Ritual Sacrifice in Ancient Peru,* edited by E. Benson and A. Cook, pp. 37–52. University of Texas Press, Austin.
Cyphers, A.
 1997 El contexto social de monumentos en San Lorenzo. In *Población, subsistencia y medio ambiente en San Lorenzo Tenochtitlan,* edited by A. Cyphers, pp. 184–191. Universidad Nacional Autónoma de México.

Davies, N.

 1984 Human Sacrifice in the Old World and the New. In *Ritual Human Sacrifice in Mesoamerica*, edited by E. Boone, pp. 211–225. Dumbarton Oaks, Washington, D.C.

Day, J. S.

 1993 The Media of Ritual. In *Precolumbian Jade*, edited by F. Lange, pp. 289– 298. University of Utah. Salt Lake City.

 1994 Central Mexican Imagery in Greater Nicoya. In *Mixteca-Puebla, Discoveries and Research in Mesoamerican Art and Iconography*, edited by H. B. Nicholson and E.Quinones, pp. 235–247. Labyrinthos.

 1998 The West Mexican Ballgame. In *Ancient West Mexico, Art and Archaeology of the Unknown Past*, edited by R. Townsend, pp. 151–168. The Art Institute of Chicago.

 2001 Performing on the Court. In *The Sport of Life and Death: The Mesoamerican Ballgame*, edited by M. Whittington, pp. 69–71. The Mint Museum of Art, Charlotte, NC.

Day, J., and A. Tillett

 1996 The Nicoya Shaman. In *Paths to Central American Prehistory*, edited by F. Lange, pp. 221–235. University Press of Colorado, Boulder.

Donnan, C.

 1976 *Moche Art and Iconography*. UCLA Latin American Studies Center Publications, Los Angeles.

Ehrenreich, B.

 1998 *Blood Rites*. Henry Holt, New York.

Ferrero, L.

 1981 Ethnohistory and Ethnography in the Central Highlands – Atlantic Watershed and Diquís. In *Between Continents, Between Seas: Precolumbian Art of Costa Rica*, edited by E. Benson, pp. 93–111. Harry Abrams, New York.

Fonseca, O.

 1981 Guayabo de Turrialba and Its Significance. In *Between Continents, Between Seas: Precolumbian Art of Costa Rica*, edited by E. Benson, pp. 104–109. Harry Abrams, New York.

Graham, M.

 1981 Traditions of Costa Rican Stone Culture. In *Between Continents, Between Seas: Precolumbian Art of Costa Rica*, edited by E. Benson, pp. 113–151. Harry Abrams. New York.

 1992 The Early Art of the Atlantic Watershed of Costa Rica. In *Wealth and Hierarchy in the Intermediate Area*, edited by F. Lange, pp.165–206. Dumbarton Oaks, Washington, D.C.

Hartman, C.

 1901 *Archaeological Researches in Costa Rica*. Royal Ethnographical Museum, Stockholm.

Lange, F. (editor)

 1992 *Wealth and Hierarchy in the Intermediate Area*. Dumbarton Oaks, Washington, D.C.

Leach, E.
 1989 Magical Hair. In *Myth and Cosmos*, edited by J. Middleton, pp. 77–108. University of Texas Press, Austin.
LeBlanc, S.
 2003 *Constant Battles*. St. Martin's Press, New York.
Lothrop, S.
 1926 *Pottery of Costa Rica and Nicaragua*. Museum of the American Indian, Heye Foundation, New York.
Mason, J. A.
 1945 Costa Rica Stonework: The Minor C. Keith Collection. *Anthropological Papers of the American Museum of Natural History* 39(3):193–329.
Parsons, L.
 1988 The Ballgame in the Peripheral Coastal Lowlands. In *Ulama: The Ballgame of the Mayas and Aztecs, 2000 B.C.–A.D. 2000, From Human Sacrifice to Sport*, edited by T. Leyenaar and L. Parsons, pp. 22–25. Spruyt, Van Mantgem and De Does, Leiden.
Proulx, D.
 2001 Ritual Use of Trophy Heads in Ancient Nazca Society. In *Ritual Sacrifice in Ancient Peru*, edited by E. Benson and A. Cook, pp. 119–136. University of Texas Press, Austin.
Rouse, I.
 1992 *The Tainos*. Yale University Press, New Haven.
Skinner, A.
 1926 Notes on Las Mercedes, Costa Rica Farm, and Anita Grande. In *The Pottery of Costa Rica and Nicaragua*, Appendix IV, Vol. II, edited by S. Lothrop, pp. 461–468. Museum of the American Indian, Heye Foundation, New York.
Snarskis, M.
 1984 Central America: The Lower Caribbean. In *The Archaeology of Lower Central America*, edited by F. Lange and D. Stone, pp. 195–232. The School of American Research and University of New Mexico Press, Albuquerque and Santa Fe.
 1992 Wealth and Hierarchy in the Archaeology of Eastern and Central Costa Rica. In *Wealth and Hierarchy in the Intermediate Area*, edited by F. W. Lange, pp. 141–165. Dumbarton Oaks, Washington, D.C.
Stern, T.
 1948 *The Rubber Ballgames of the Americas*. J. J. Augustin, New York.
Stone, D.
 1977 *Pre-Columbian Man in Costa Rica*. Peabody Museum, Cambridge, MA.
Tedlock, D.
 1985 *Popol Vuh*. Simon and Schuster, New York.
Whitehead, N. (editor)
 2004 *Violence*. School of American Research, Santa Fe, NM.

CHAPTER 9

ROLLING HEADS: THE DIQUÍS STONE BALLS AND TROPHY-HEAD TAKING IN ANCIENT COSTA RICA

Heather Orr

INTRODUCTION

The impressive monumental stone balls associated with the Diquís region of Costa Rica have long raised questions regarding their makers and their meaning. Researchers have suggested that the spherical sculptures were displays of socioeconomic control and functioned as ideological manipulation to reinforce rank. Yet, the nature of the ideology expressed through these, and related, monuments remains a subject of ongoing discourse in the field (for example, Drolet 1988; Fernández 1999; Fernández and Quintanilla 2003; Hoopes 2005; Quintanilla 2007).

This chapter explores that subject further by suggesting that the Diquís balls be considered within the context of the Costa Rican practice of trophy head-taking (see also Graham 1981:126). The stone spheres have been studied comprehensively elsewhere, particularly in the important ongoing work by Ifigenia Quintanilla (see 2007; Fernández and Quintanilla 2003; Hoopes n.d.; Lothrop 1963; Stone 1943). This paper is not an attempt to further those studies, but is rather an effort to examine meaning within the wider scope of relevant artistic production and an ideological framework linking the spherical form with creation mythology. The artworks supporting this argument include several previously

unpublished pieces from the Schmidt collection in the Maltwood Museum and Art Gallery of the University of Victoria.[1]

THE STONE SPHERES OF COSTA RICA

Archaeological and in situ stone spheres are concentrated largely in the lowlands of the Diquís, or Sierpe-Térraba Delta, in the southwest of the Diquís sub-region of the Greater Chiriquí archaeological zone (southern Costa Rica and northern Panama). Seven additional archaeological examples are presently known in the Central and Nicoya regions (and one dubious example was reported in the Chiriquí region of Panama; Quintanilla 2007). These simple geometric forms are thus, regionally speaking, an anomaly in Costa Rican and Chibcha-Chocó (Chibchan, or Isthmo-Colombian) material culture.

The carved stone spheroids of southwest Costa Rica (Figure 9.1) were initially produced early in the Aguas Buenas Period (A.D. 300–800), with their production and distribution increasing by the early Chiriquí phase (A.D. 800– 1500; Quintanilla 2007; see also Baudez et al. 1993; Fernández and Quintanilla 2003; Lothrop 1963; Snarskis 1981; Stone 1977). A great number of the 300-plus surviving examples of these sculptures are near-perfectly spherical, with smoothly worked surfaces that tend to be polished in the larger examples. The measurements for the spheres range from a few inches to 8 feet; they can weigh over 8— to as much as 16—tons (Fernández and Quintanilla 2003; Lothrop 1963; Quin-

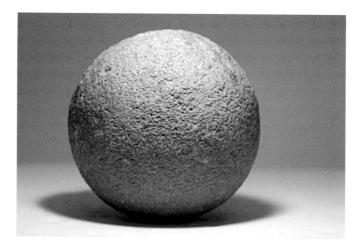

FIGURE 9.1. Diquís stone sphere, Chiriquí period, 23.15 cm diameter, granodiorite. (*Schmidt collection, Courtesy of Maltwood Museum and Art Gallery, University of Victoria. All photos and drawings by the author unless otherwise indicated.*)

tanilla 2007). The stone balls were carved from hard igneous stones such as gab-bro and granodiorite, and softer sedimentary stones such as limestone, often quarried and transported from some distance (Quintanilla 2007). They were erected on specially prepared, hard-packed earthen locations or stone pavements, in fields, plazas, and on, or in association with, mound complexes and cemetery areas; they have been found in both smaller villages and more important centers (Fernández and Quintanilla 2003; Lothrop 1963; Quintanilla 2007; Snarskis 1981; Stone 1943). The archaeology of the stones is often problematic: many stones have been moved or reused, and a number of associated sites have been disturbed by looting or plantation activity.

It is clear that the spherical form and typically smoothed surfaces are central-ly important to these sculptures, the execution of which required a high degree of artistic skill and labor. Most researchers presume that these often beautifully crafted surfaces were left exposed and that the smoothed surfaces themselves were of greatest significance (Hoopes, personal communication, 2008). However, Quintanilla has identified ten examples that are decorated with relief carving, noting that the carving was executed in such a way as to not interfere with the spherical appearance of the monuments (2007:112 ff.). The relief carving on these examples is limited to zoomorphic (for example, feline) and abstracted motifs found regionally in other mediums, including jewelry of gold and jade, ceramics, and petroglyph carvings (Quintanilla 2007:112 ff.). The appearance of relief carving on these surviving stones suggests that at least some stone spheres might have been covered with some form of gesso and painted with similar iconography; the practice of painting stone sculpture was certainly widespread in the Isthmo-Colombian and other regions of the ancient Americas (although it does not appear that any traces of gesso or pigment have survived on the spheres). The limited spheres with relief carving, together with the possibility of painted spheres, suggest that some of the original visual information associated with these sculptures may have been lost. However, the presence of the carved motifs, at least, underlines the imperative to view these sculptures as one component of a broader artistic tradition, rather than in isolation, as previous approaches have tended to do (see discussion in Quintanilla 2007). Indeed, the stones themselves may be explicitly and implicitly represented in other art forms. For example, a number of contemporary Diquís hammered gold pectorals are decorated with prominent bosses, or half-spheres (Quintanilla 2007:56).

THE STONE BALLS AND SOCIAL COMPLEXITY

The spherical sculptural format of the Diquís balls appears during the key period of A.D. 300–600 (Aguas Buenas B in Costa Rica). This much-studied era is

known for the rapid emergence of social complexity throughout the Chibchan (Isthmo-Colombian) region. The material record reflects a rise in hierarchy in the appearance of prestige goods, such as jade, gold, and elaborate ceramics and sculpture in specialized mortuary complexes, plus the appearance of monumental architecture, elaborate and monumental stone sculpture, and increasingly complex iconography (see Hoopes 1996, 2005). It is in this same period that the Costa Rican practice of trophy-head taking also emerges in the artistic record (see Day this volume, Chapter 8; Graham 1981:123; Hoopes 2005, 2007a; Leibsohn 1988). Hoopes identifies the emergence of both trophy-head taking and the elite mortuary complex of Costa Rica with paramount sorcerers (discussed below; Hoopes 2007a; Hoopes and Mora-Marín this volume, Chapter 11).

The majority of documented stone spheres come from contexts identifiable with rank and office. In situ monuments have been found in alignment groupings associated with large-scale mound architecture, open plazas, and specially prepared open fields set apart from mound groupings. Some of these examples appear to have cosmological alignments, principally with the east–west cardinals, or, more rarely, to magnetic north. However, a careful study has revealed no consistent pattern or explicit astronomical associations (Quintanilla 2007:72 ff.).

Alignment patterns are site-specific and not repeated. Therefore, it may eventually prove more fruitful to view the geometric patterns created by these groupings as the kinds of motifs found elsewhere on the relief-carved spheres and related materials. Ultimately those iconic images represent the particular actions, events, supernaturals, or constellations associated, culturally or by site, with ranked positions, offices, or kinship groups (Quintanilla 2007; see also Hoopes 2005; Quilter and Hoopes 2003).

The literature has tended to maintain that smaller stone spheres were a component of the elite mortuary complex from A.D. 300 to 600 (for example, Drolet 1988; Graham 1981; Lothrop 1963). However, Quintanilla's recent thorough reexamination of the evidence indicates that the more likely pattern is surface examples being located nearby, or (rarely) in association with, graves or cemeteries (2007). Nevertheless, the link between the stone balls and monumental mound-plaza architecture itself is indicative of an intrinsic relationship with hierarchy.

Sculpture in other forms—predominantly the carved barrel (*barriles*) forms (Aguas Buenas Period), stone zoomorphs, and the peg-base statues (Chiriquí Period)—has been found in the vicinity of the stone spheres. The plank-shaped peg-base statuettes appear to continue, in a more stylized form, the Aguas Buenas tradition of freestanding figural sculpture.[2] The earlier, more naturalistically rendered "double-statues" and individual figural representations represent male figures, characteristically carrying trophy heads and axes. The conical caps often

worn by these figural representations have been identified by John Hoopes with the *usékars* (Bribri-Cabécar), paramount sorcerers who held the highest office in Costa Rican society at the time of contact (Hoopes 2007a; see also Day this volume, Chapter 8; Quintanilla 2007:39 ff.).

The peg-base statues (Figure 9.2) are named after their rounded lower ends, which served as "pegs" to stand the sculptures upright in earthen mounts. Like their predecessors, they were intended to stand as didactic displays in association with residential groupings or communal structures. The peg-base statues were carved from the same materials as the stone balls, and, like the spheres, range in scale from a few centimeters to a couple of meters high (although the majority tend to be under 90 cm).

These sculptures represent male, female, and transgendered anthropomorphic figures carved with a strong frontal orientation. The peg-base statues are highly stylized; however, it is clear that they are also individualized (Drolet 1992). They are shown with particularized costume elements: feline, serpentine, and other zoomorphic features (also found more explicitly in the barrel and

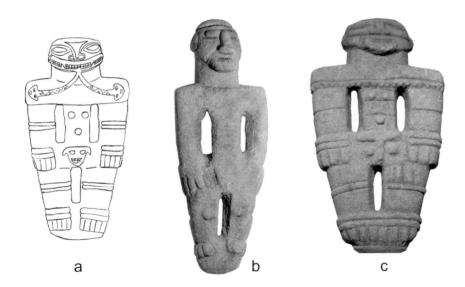

a b c

FIGURE 9.2. Peg-base statuettes: *a*, Diquís, Chiriquí Period, 48 cm, ferrous andesite; figure with feline and serpentine characteristics and trophy head at groin (*drawn after Quintanilla 2007: Fig. 24a*); *b*, Diquís, Chiriquí Period, 37.8 cm, sandstone (*Schmidt collection, courtesy of Maltwood Museum*); *c*, Diquís, Chiriquí Period, 43 cm, sandstone (*Schmidt collection, courtesy of Maltwood Museum*).

zoomorphic sculptures). Many are shown with trophy heads, and a few examples appear to represent bound prisoners.

Archaeological and documented examples of the peg-base statuettes appear to have close associations with the stone spheres. In certain of these cases, the statues have been found with zoomorphic sculptures, carved stone metates, and ceramics, purposefully broken and in piles or isolated deposits, nearby mound structures and stone balls (Lothrop 1963; Quintanilla 2007:51). The purposefulness of these features should be emphasized: this is suggestive of termination rituals found elsewhere in the Americas, particularly given the somewhat aggressive character of the breakage and the allocation of the features (see, for example, Mock 1997; compare Quintanilla 2007:51). This kind of purposeful termination of sculpture in association with raised structures is also reminiscent of the ritual termination of shamans' seats and paraphernalia found extensively in the ethnography of tropical forest cultures (see, for example, Reichel-Dolmatoff 1974, 1975). If, indeed, these features with broken statuary represent similar activities, a further tie may be drawn between those same artworks and rank—as defined by paramount shamanism.

Intact groupings of peg-base statuettes and spheres (and other associated sculpture) were probably originally arranged so as to relate narratives (Graham 1981: cat. nos. 244, 245; Lothrop 1963; Stone 1943; see also Day this volume, Chapter 8; compare Drolet 1992). However, any reconstruction of narrative relationships between these monuments is problematic at best. Partly this is due to the often incomplete data (see discussion in Quintanilla 2007); but the sculptures are also didactic rather than illustrative in nature: their associated stories would have been spun by ritual protagonists or evoked in the minds of the beholders (see Bozzoli de Wille 2006; Gowans 1981, for a discussion of didacticism).

Certain general inferences can be drawn. The stones and associated sculptures were interrelated programmatically; these sculptural programs were erected in prepared fields and plazas in a manner comparable with the better-known stelae-altar programs of the Maya region farther north. Likewise, oral traditions were probably unpacked in ceremonial interactions with these sculptural programs, and any interpretation must take into account the missing elements, such as perishable materials, paint, and the bodily decoration of ceremonial practitioners (see, for example, Hoopes and Fonseca 2003; Joyce 1997; Looper 2003; O'Day n.d.).

STONE BALLS AND POWER

Although the original context of most stone balls has been disturbed, Fernández and Quintanilla suggested that "[i]t is highly probable that (they relate) to the worldview, cosmology, or astronomical knowledge of the balls' makers" (2003:229;

see also Lothrop 1963; Quintanilla 2007). The authors thus posited that the stone balls were erected in site centers with complex architecture as expressions of the legitimization of power (see also Graham 1981; Quintanilla 2007). The spheres have been more broadly considered in terms of the labor intensity, skill and expertise, labor management, and sociopolitical organization that were required for their production (Fernández 1999; Fernández and Quintanilla 2003; Graham 1981; Hoopes 2005, personal communication 2007; Lothrop 1963; Quintanilla 2007). In these terms, the monuments have been viewed as displays of political and social power, perhaps in relation to interaction spheres. Indeed, as understood by specialists, the Diquís Delta of Costa Rica was a strategic location for trade and interregional interaction. Fernández and Quintanilla (2003) identify the area as a center of production of artworks as power symbols or status markers, having further possible associations with local ethnicity.

While researchers agree the Diquís stone balls were expressions of "power," the actual nature of that power, beyond "political," remains to be defined more closely. As considered in the introduction to this volume, any discussion of power is problematized by current theoretical discourse. For the purposes of this paper, I defer to the introduction's discussion of the agency of artworks as embodied or encoded objects exerting power cognitively and physiologically over their audience through the activation of the imaginary. I believe that the larger context of the stone spheres was didactic in nature. That is, the stone spheres should be viewed primarily as having been organized in sculptural programs, either independently or with additional sculptural forms, such as those considered above. The narratives, and associated psychological or visceral responses specific to the works, were triggered in the imagination of the beholder by the "freeze-frame"-like imagery (that is, didactic imagery) of the sculptures (see Reilly 1994). Ultimately those narratives bolstered sociopolitical authority (see also Fernández and Quintanilla 2003; Graham 1992). It is therefore to those narratives that I now turn. I first identify the stone spheres with effigy trophy heads and then consider the stone sphere sculptural programs within the context of the ideological underpinnings for trophy-head taking, including creation mythology.

Trophy Heads

Organized violence is most apparent in the ancient artistic record of Costa Rica in the form of representations of trophy heads in ceramics, stone sculptures, and stone mace heads or finials (Figure 9.3). While headhunting was clearly tied to an emerging power structure in Costa Rica, the ideological foundation of that link is still a topic of discourse. John Hoopes (2007a; see also discussion in 2005) has recently suggested a model involving shamanic warfare, or assault sorcery and

revenge, that was related to notions of social justice and community well-being. Following this model, this form of warfare and trophy-head taking underpinned the authority of the *usékar* paramount sorcerers, who are reported in the ethnographies as being the highest ranking members of Costa Rican society (see also Hoopes and Mora-Marín this volume, Chapter 11). Other researchers (for example, Day this volume, Chapter 8; Day and Tillett 1996) have instead considered trophy-head taking along more specifically political lines, associating the emergence of the practice with a newly formed class of paramount chiefs. The evidence supporting both models indicates that trophy heads were associated with magical power, and trophy-head taking was clearly tied to complex notions of power—social, political, and metaphysical—in ancient Costa Rica (for example, Chacon and Dye 2007; Proulx 2001).

Trophy heads and their takers are elaborately represented in jade and gold adornments, ceramics, and stone sculpture throughout much of the pre-Columbian history of the region (see, for example, Day this volume, Chapter 8; Hoopes 2007a; Hoopes and Mora-Marín this volume, Chapter 11; Leibsohn 1988; Quilter and Hoopes 2003). Most interesting for the purposes of this paper is the appearance of freestanding carved stone representations of trophy heads in the Diquís/ Chiriquí region during the period in question (A.D. 300–600) (Figure 9.3). Most, if not all, sculptural effigy heads appear to have represented trophy heads (compare Leibsohn 1988; refer also to De la Cruz 1988).[3] The majority of these works have such particular facial features and hairstyles that they are most likely portraits of specific individuals (see also Day this volume, Chapter 8). While effigy trophy heads are typically identifiable by the closed eyes and skeletalized or downturned mouths, it is clear that some are enlivened with open eyes and mouths that may be forming words (for example, Figure 9.3f). This enlivening of the decapitated head highlights the indigenous view of trophy heads as repositories of life force, and brings to mind similar imagery related to rolling-head myths elsewhere in the Americas (Rex Koontz, personal communication 2008; refer to Gillespie 1991; Hoopes 2007a; Koontz 2009:73 ff.).

Ethnographic and artistic evidence indicates that actual trophy heads were objects of display; they were brandished by the takers, worn emblematically (Figure 9.2a), and displayed in public venues "on poles in front of oratories and temples" (Oviedo in Lothrop 1926:35, cited in Hoopes 2007a). It is likely that many stone effigy trophy heads were displayed in the same manner. Documented examples of these small-scale sculptures have been found in elaborate graves and nearby monumental architecture (Hartman 1901; Stone 1977; see also Benson 1981). Additionally, they are portable enough to have been manipulated in ceremonial displays. For example, the finials representing trophy heads probably decorated

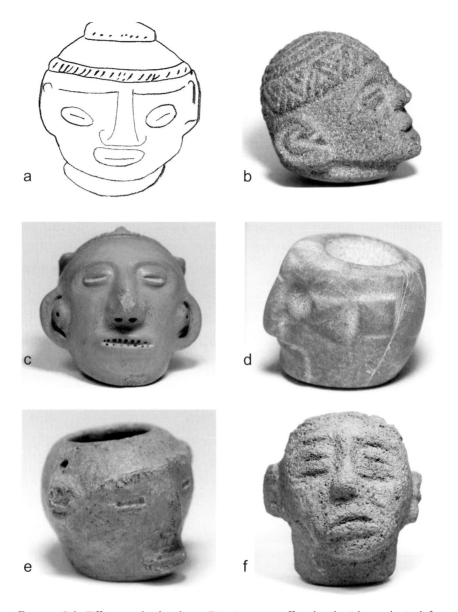

FIGURE 9.3. Effigy trophy heads: *a*, Diquís, stone effigy head with a spherical form (*drawn after object on display in the National Museum of Costa Rica, San José*); *b*, Central Highlands/Atlantic Watershed, 11 cm, carved volcanic stone head (*Schmidt collection, courtesy of Maltwood Museum*); *c*, Central Highlands/Atlantic Watershed, ca. A.D. 500–1000, ceramic effigy head with closed eyes and skeletalized mouth (*Schmidt collection, courtesy of Maltwood Museum*); *d*, Central Highlands/Atlantic Watershed, 3.9 cm, jadeite, effigy head finial (*Schmidt collection, courtesy of Maltwood Museum*); *e*, Diquís, Aguas Buenas Period, 3.5 cm, miniature effigy head vessel (*Schmidt collection, courtesy of Maltwood Museum*); *f*, Central Highlands/Atlantic Watershed, 14.5 cm, carved volcanic stone effigy head (*Schmidt collection, courtesy of Maltwood Museum*).

wooden staffs or poles that could have been erected in the manner described by
Oviedo (Figure 9.3d; see also De la Cruz 1988).

Numerous examples of ceramic and carved stone effigy heads are roughly
spherical in form (Figure 9.3a–c, e). Indeed, the ceramic examples retain the
rounded shape of the vessel bowl.[4] While there is no apparent direct evidence
linking the two, I believe that the stone balls and effigy trophy heads can be
viewed as related in part through this purposeful use of the spherical form.

The peg-base statuettes associated with some Diquís balls provide insights
into this possible association. As mentioned, these statuettes appear to have been
portraits of ranked individuals. The figures are frequently shown with trophy
heads and with the anthropomorphic features believed to indicate the transfor-
mation into animal forms identified with shamanic practice in Mesoamerica and
Central and South America (for example, Aguilar 2003; Bozzoli 2006; Hoopes
1996, 2005, 2007a, 2007b; Hoopes and Mora-Marín this volume, Chapter 11;
Reichel-Dolmatoff 1975; Reilly 1989; Stone-Miller 2004; Whitehead 2002).
The regular presence of trophy heads with these transformative figures has led
Hoopes to investigate the literature on assault sorcery (Hoopes 2007a). The
kanaimà jaguar-sorcerers of Guyana are "dark shamans" who maintain social
order through the threat of assault sorcery (Whitehead 2002). These paramount
shamans and their apprentices transform into jaguars to punish and kill their
enemies. The kanaimà maintain and enhance their rank and authority through
terrorization and fear of violence. By contrast, the Costa Rican usékar jaguar-sor-
cerers used assault sorcery, specifically trophy-head taking, for the purposes of
healing community breaches or injustices (Gabb 1875; Hoopes 2007a; see also
Hoopes 2005; Hoopes and Mora-Marín this volume, Chapter 11; compare Day
this volume, Chapter 8). These ritual specialists also assumed jaguar forms and
traced their ancestry to jaguars. Hoopes identifies these ritual specialists with the
representations in Costa Rican art of transformative beings (such as examples of
peg-base statuettes), apparently undergoing therianthropic or physical transfor-
mation, and carrying trophy heads. This hypothesis addresses at least those fig-
ural representations with feline features (see also Hoopes 2007b; O'Day n.d.)
and some aspect of trophy-head taking. The programmatic relationship between
peg-base statues, identifiable with shamanic practices and trophy-head taking,
and the stone spheres suggests ties to the creation mythology of the region that
are comparable with Mesoamerica.

STONE BALLS AND COSMOGENESIS

The ethnography indicates that the Talamanca trace their origins to seeds or
maize seeds (Gabb 1875; Hoopes 2007a; Bozzoli 2006). As Luis Ferrero relates,

"In historic times, at least, the Talamancan tribes conceived of a single principal deity, which they called Sibö. Sibö (associated with a long-beaked bird, apparently a kite or buzzardlike–carrion-eater) brought 'seeds' from which all people sprouted, and later selected the clans upon which the rights to produce shamans, etc. were bestowed" (1981:103; see Bozzoli 1972, 1979, 2006, for Sibö and the designation of clans).

Several researchers have compared this bird of creation with the Mesoamerican Principal Bird Deity (P.B.D.; see discussion in Graham 2003). The P.B.D. is a key actor in lowlands cosmogonic myth and is identified by some researchers as Itzam-yeh, the alter ego of Itzam-na, the prototypical sorcerer or shaman. The P.B.D. is also represented in variations of the creation myth carrying rounded objects. Izapa Altar 20 (Late Formative Period, ca. 200 B.C.–A.D. 200) shows this mythical bird of creation bringing a large spherical object to a seated noble (see Guernsey 2006). This sphere has been interpreted as one of the three hearth stones set in place at the beginning of creation, and as the ballgame ball central to lowlands creation mythology (Guernsey 1997, 2006; Taube 1985, 1995).[5] Another early version of the primordial bird carrying rounded objects is represented in the murals of the west wall at San Bartolo, Guatemala (refer to the publication of this wall in *National Geographic Magazine*, January 2006). Here this being bears two gourds (*Jicara?*) of the same type found in the tree upon which it alights (Taube 2009).

Mesoamerican creation mythology conflates seeds, decapitated heads, and ballgame balls. The severed heads of the Maize God, and his son, the Hero Twin Hunahaw, are identified with maize seeds and the ballgame ball, in the great paradigmatic epic and metaphor for the life cycle of maize from the *Popol Vuh* (see, for example, Freidel et al. 1993; Taube 1995). While there is no such obvious relationship drawn in Costa Rican creation myth between severed heads and seeds, the ethnographic identification of shamans' heads as the locus their power, wisdom, and fecund nature may have similar overtones (for example, Bozzoli 2006; Chacon and Dye 2007; Gabb 1875; Reichel-Dolmatoff 1974, 1975).

The Costa Rican creator bird Sibö is closely associated with shamanism or sorcery. Indeed, Hoopes indicates that "(in) stories of Creation, the usékars are said to have been brought by the deity Sibö to protect indigenous people from dangerous animals who could consume them or make them ill" (2007a). Sibö can thus be seen as a legitimizing ancestral prototypical shaman/sorcerer (similar to the Mesoamerican P.B.D.) for its principal role in the creation of humans, the bringing of the usékars, and its efforts to ensure the well-being of the human community (see also Bozzoli 1972, 1979, 2006; Graham 2003). By extension, images of avian anthropomorphs with trophy heads might represent transformed religious specialists bearing something like the seeds brought by Sibö to originate the

human race (for example, see Day this volume, Chapter 8; Graham 2003; Hoopes and Mora-Marín this volume, Chapter 11).

The Costa Rican sculptural programs considered above quite possibly embodied these ideas. For instance, the Diquís stone balls could be viewed as analogues of trophy heads conflated with the seeds of creation delivered by Sibö, or a similar ancestral avian entity. Additional comparisons with Mesoamerican materials might inform those associations.

STONE SPHERES AND ROLLING HEADS

Although the stone spheres of Costa Rica are unique in the Chibchan region, they share strong ties with analogous materials in Mesoamerica.[6] There is a long tradition in Mesoamerica of rounded, monumental sculptures that represent disembodied heads, similar in nature and scale to both the sculpted trophy heads and the stone balls of Costa Rica (Figure 9.4; see also Graham 1981; Chinchilla this volume, Chapter 6; Taube and Zender this volume, Chapter 7). The earliest of the Mesoamerican examples, on a grand scale, are, of course, the Olmec-style colossal heads dating to the Early and Middle Formative Periods, circa 1200–400 B.C. In Mesoamerican studies, these works have long been understood to represent important elite individuals wearing ballplayer caps. Susan Gillespie (1991) and others (for example, Orr 2003; Reilly 1994) have posited a relationship between these heads and the "rolling head" myths associated with primordial decapitation sacrifice and ballgames throughout the Americas. Gillespie points out that "(g)iven the symbolic equivalence of the ball in motion and the human head, then the head in this context would also be considered animated, capable of its own movement. Decapitation would, therefore, bring about not a lifeless head, but a head that, once freed from the body, could jump, roll, and fly" (1991:326).

Later examples of carved stone spheres (from the Late Formative through the Terminal Classic, ca. 200 B.C.–A.D. 700/900) include disembodied human heads rendered as spheres as well as plain spheroids like the Diquís balls. These are found throughout Mesoamerica, from the Guerrero (Figure 9.4a) and Oaxaca (Figure 9.4b) highlands, the lowlands of the Gulf Coast and Soconusco regions of Mexico (see note 5), and the Pacific Coast of Guatemala (for example, Chinchilla this volume, Chapter 6; see also Parsons 1986). Researchers have likewise related many of these works to creation mythology and/or the Mesoamerican ballgame, and related rituals ensuring adequate rainfall and agricultural fertility (for example, Chinchilla this volume, Chapter 6; Gillespie 1991; Guernsey 2006; Orr 1997; Parsons 1986; Taube and Zender this volume, Chapter 7).

Smaller, plain stone spheroids (ranging from marble- to grapefruit-size or slightly larger) are ubiquitous in the archaeological record throughout Mesoamerica, in all periods. These have been identified with ritualized, combative versions of the handball game, or boxing matches, represented at the Late Formative site of Dainzú, Oaxaca (Orr 1997, 2003; Chinchilla this volume, Chapter 6; Taube and Zender this volume, Chapter 7). These mock combats were tied to the events of creation in the form of rain-petitioning ceremonies and territorial issues. Blood sacrifice was made through the injuries sustained by the aggressive use of stone balls and through the decapitation sacrifice that appears to have followed at least some of these symbolic games (Orr 1997, 2001, 2003; Taube and Zender this volume, Chapter 7).

This brief consideration of the Mesoamerican spheres suggests that it may be no coincidence that the spherical form appears contemporaneously

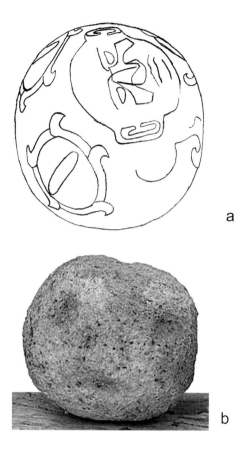

a

b

FIGURE 9.4. Stone spheres in Mesoamerica: *a*, Guerrero, Late Middle–Late Formative Period, 36 cm diameter, spherical effigy head (*drawn after Couch 1988: pl. 45*); *b*, Coixtlahuaca, Oaxaca, highly eroded spherical effigy head (*photo by author of object on display in the Coixtlahuaca community museum*); see also Chinchilla this volume: Figure 6.13.

with the practice of decapitation sacrifice and trophy-head taking in Costa Rica. The restricted dispersal of the Diquís stone balls suggests a local, perhaps ethnically identifying, development. While these ideas and practices did not diffuse into the Chibchan region from Mesoamerica, researchers do not doubt that ancestral Costa Ricans were very much aware of Mesoamerican traditions, specifically those associated with rank—including the ballgame (for example, Hoopes 2005).

I suggest that, similar to the Mesoamerican materials, the Diquís stone balls can be read as a conflation, or iconographic overlay, of trophy heads taken by paramount assault sorcerers, and the seeds of human genesis brought by a creator bird being identified prototypically with those same paramounts. The relationship between that prototypical being and paramounts with specific offices, like those of the usékars, would be made apparent through the association of the spheres and related sculpture with the actions and the architecture of those persons (see also Drolet 1992), and through representations of those same individuals and their actions in figural statuary. These embodied art forms and their associated stories thus underscored a dialectic of authority and the logic for assault sorcery in the form of headhunting.

CONCLUSION

Further investigation along the lines presented above may prove fruitful. For example, current available ethnographic research is mute with regard to the Diquís balls; the narratives revealing their local significance might be revealed in the ongoing studies by Costa Rican anthropologists (for example, Bozzoli 2006). In addition, future analysis should approach the spheres as components of larger sculptural programs, each element an encoded chapter of a narrative sequence.

ACKNOWLEDGMENTS

I wish to thank John Hoopes and David Mora-Marín for unpublished research freely shared during the preparation of this manuscript. I am additionally grateful to the two anonymous reviewers and to Stephen Houston, Julia Guernsey, Rex Koontz, and John Hoopes for their very helpful comments on drafts of this paper. I am also indebted to the kindness and gracious assistance of the staff at the Maltwood Museum and Art Gallery, University of Victoria, and to Mr. Karl Schmidt.

NOTES

[1] A manuscript publishing the entire collection of over 200 pieces is currently in preparation by the author for submission by arrangement to the University Press of Colorado.

[2] The somewhat dramatic shift from a high degree of naturalism to stylization suggests that artists may have been copying the peg-base stone figures from forms specific to other sculptural mediums, such as metalwork or jade. The sculptures suggestively share stylistic tendencies with the San Agustín culture of Colombia.

[3] Leibsohn suggests that not all such disembodied effigy heads represent trophy heads, but that some examples appear to have been portraits or represent supernaturals (Leibsohn 1988). However, effigy trophy heads were effectively portraits, whether generalized or

specific; supernatural features may be tied to the anthropomorphic features found in figural representations such as the peg-based statues (see also Day this volume, Chapter 8). Such works more likely represent therianthropic transformation of human ritual practitioners than supernatural entities per se (see discussion below).

4 Hoopes notes that artistic and ethnographic evidence indicates that, in some cases, trophy heads were carried upside down and used as water vessels (2007a). This association with water raises interesting questions regarding the often-hypothesized relationship between notions of fertility and trophy-head taking (for example, Day this volume, Chapter 8). This hypothesis is elaborated in Hoopes 2007a, where overall community well-being and healing are seen to occur through the agency of trophy-head-taking assault sorcerers.

5 Julia Guernsey (1997, 2006) has demonstrated convincingly that the P.B.D. was the prototype for Izapan rulership. Through a comprehensive discussion of the shamanic nature of Izapan and Soconusco culture in the Late Formative Period, she shows that Izapan nobles represented themselves costumed as, transforming into, and taking on the attributes of the P.B.D., and thereby enacting the role of the Izapan variant of this creator being in large-scale statements of legitimacy.

Izapa Altar 20 is located on Mound 30 of Complex B above three pillars supporting monumental stone spheres (around 60 cm in diameter) like the Diquís balls (Lowe et al. 1982: fig. 9.1; Guernsey 2006). The scale of the ball shown with the bird on Altar 20 and the Complex B stone balls may reflect the actual size of Izapa and Maya rubber hipball game balls, which, several researchers have suggested, could have been one or more feet in diameter (see Nadal 2001). The Complex B pillars (Miscellaneous Monuments 6, 9, and 10) supporting the stone spheres were erected in a triangular arrangement at the north end of the main plaza (Lowe et al. 1982; Norman 1973). Julia Guernsey (2006) has shown that the Izapa creation story was related in the sculptural-architectural programming of Complex B as the dialectic for the legitimacy of Late Formative Izapan rulership. Karl Taube and others have noted that the triadic arrangement of the pillars may reference the three-stone hearth that was set in place at the center of the universe during the time of creation in later known, and related, Maya mythology (cited and discussed in Guernsey 2006). Guernsey interpreted the iconography of Altar 20 in context to suggest that "Altar 20 . . . placed the delivery of the ball against (the) backdrop of creation, implying a metaphorical overlap between the ballgame ball and the (hearth) stones of creation" (1997; compare 2006).

Numerous variations of creation myths in Costa Rican and related ethnographies identify mythological birds like Sibö with the creation of humans. Costa Rican representations of avian anthropomorphs, best known from jade and gold ornaments and stone sculpture dating from the Aguas Buenas to later periods, have been interpreted as religious specialists transforming into particular primordial birds, possibly in pageants that in some way invoked these narratives (for example, Aguilar 2003; Graham 2003; Mora-Marín, in press; Snarskis 2003; see also Day this volume, Chapter 8; Hoopes and Mora-Marín this volume, Chapter 11).

6 This paper cautiously presumes historic interaction spheres between Costa Rica and Mesoamerica but does not support previous arguments for a shared ideology spanning a broad geographic and temporal space (see discussion of this issue in Hoopes 2005:18 ff.; compare Snarskis 2003).

REFERENCES CITED

Aguilar, C.
 2003 *El jade y el chaman*. Editorial Tecnológica de Costa Rica, Cartago.

Baudez, C., N. Borgnini, S. Lagligant, and V. Lauthelin
 1993 *Investigaciones arqueológicas en el delta del Diquís*. Centro de Estudios Mexicanos y Centroamericanos (México) and the Delgación Regional de Cooperación Científica y Técnica en America Central, San José, Costa Rica.

Benson, E. (editor)
 1981 *Between Continents, Between Seas: Precolumbian Art of Costa Rica*. Harry N. Abrams, New York.

Benson, E., and A. Cook (editors)
 2001 *Ritual Sacrifice in Ancient Peru*. University of Texas Press, Austin.

Bozzoli de Wille, M. E.
 1972 *La vida y la muerte entre los Bribrí*. Editorial Universidad de Costa Rica, San José.
 1979 *El nacimiento y la muerte entre los Bribris*. Editorial Universidad de Costa Rica, San José.
 1982 Narraciones talamanqueñas. *Vinculos* 8(1–2):1–12.
 2006 *Oí decir del usékar*. Editorial de la Universidad Estatal a Distancia (EUNED), San José, Costa Rica.

Chacon, R., and D. Dye (editors)
 2007 *The Taking and Display of Human Body Parts as Trophies by Amerindians*. Springer, New York.

Couch, C.
 1988 *Precolumbian Art from the Ernest Erickson Collection*. American Museum of Natural History, New York.

Cruz, De La, E.
 1988 Mace Heads as Stylistic Signaling Devices. In *Costa Rican Art and Archaeology: Essays in Honor of Frederick R. Mayer*, edited by F. W. Lange, pp. 111–130. University of Colorado, Boulder.

Day, J., and A. Tillett
 1996 The Nicoya Shaman. In *Paths to Central American Prehistory*, edited by F. Lange, pp. 221–236. University Press of Colorado, Boulder.

Drolet, R.
 1988 The Emergence and Intensification of Complex Societies in Pacific Southern Costa Rica. In *Costa Rican Art and Archaeology: Essays in Honor of Frederick R. Mayer*, edited by F. W. Lange, pp. 163–188. University of Colorado, Boulder.
 1992 The House and the Territory: The organizational Structure for Chiefdom Art in the Diquís Subregion of Greater Chiriqui. In *Wealth and Hierarchy in the Intermediate Area: A Symposium at Dumbarton Oaks*, edited by F. W. Lange, pp. 207–242. Dumbarton Oaks, Washington, D.C.

Fernández, P.
 1999 Símbolos de prestigio y expresiones de rango en la Costa Rica prehispanica. In *Oro y jade: Emblemas de poder en Costa Rica*. Museo de Oro, Banco de la Republica, Bogotá.

Fernández, P., and I. Quintanilla

2003 Metallurgy, Balls, and Stone Statuary in the Diquís Delta, Costa Rica: Local Production of Power Symbols. In *Gold and Power in Ancient Costa Rica, Panama, and Colombia*, edited by J. Quilter and J. Hoopes, pp. 205–243. Dumbarton Oaks, Washington, D.C.

Ferrero, L.

1981 Ethnohistory and Ethnography in the Central Highlands-Atlantic Watershed and Diquís (translated by M. Snarskis). In *Between Continents, Between Seas: Precolumbian Art of Costa Rica*, pp. 93–103. Harry N. Abrams, New York.

Freidel, D., L. Schele, and J. Parker

1993 *Maya Cosmos: Three Thousand Years on the Shaman's Path*. William Morrow, New York.

Gabb, W. M.

1875 On the Indian Tribes and Languages of Costa Rica. *Proceedings of the American Philosophical Society* 14:483–602.

Gillespie, S.

1991 Ballgames and Boundaries. In *The Mesoamerican Ballgame*, edited by V. Scarborough and D. Wilcox, pp. 317–346. University of Arizona Press, Tucson.

Gowans, Alan

1981 *Learning to See: Historical Perspectives on Modern Popular/Commercial Arts*. Bowling Green University Popular Press, Bowling Green, OH.

Graham, M. M.

1981 Traditions of Costa Rican Stone Sculpture. In *Between Continents, Between Seas: Precolumbian Art of Costa Rica*, pp. 113–134. Harry N. Abrams, New York.

1992 Art-Tools and the Language of Power in the Early Art of the Atlantic Watershed of Costa Rica. In *Wealth and Hierarchy in the Intermediate Area*, edited by F. W. Lange, pp. 165–206. Dumbarton Oaks, Washington, D.C.

2003 Creation Imagery in the Goldwork of Costa Rica, Panama, and Colombia. In *Gold and Power in Ancient Costa Rica, Panama, and Colombia*, edited by J. Quilter and J. Hoopes, pp. 279–300. Dumbarton Oaks, Washington, D.C.

Guernsey, J.

1997 Of Macaws and Men: Late Preclassic Cosmology and Political Ideology in Izapan-Style Monuments. Ph.D. dissertation, University of Texas at Austin.

2006 *Ritual and Power in Stone: The Performance of Rulership in Mesoamerican Izapan Style Art*. University of Texas Press, Austin.

Hartman, C.

1901 *Archaeological Researches in Costa Rica*. Royal Ethnographical Museum, Stockholm.

Hoopes, J.

1996 Settlement, Subsistence, and the Origins of Social Complexity in Greater Chiriqui: A Reappraisal of the Aguas Buenas Tradition. *In Paths to Central American Prehistory*, edited by F. W. Lange, pp. 15–48. University Press of Colorado, Niwot.

2005 Emergence of Social Complexity in the Chibchan World of Southern Central America and Northern Colombia, AD 300–600. *Journal of Archaeological Research* 13(1):1–47.

2007a Sorcery and Trophy Head Taking in Ancient Costa Rica. In *The Taking and Display of Human Body Parts as Trophies by Amerindians*, edited by R. Chacon and D. Dye. Springer, New York.

2007b Ancient Costa Rica and the Chibchan World. Paper presented at the Denver Art Museum Symposium: Costa Rica and the Pre-Columbian World, Honoring the Contributions of Frederick Mayer, November 10, 2007.

n.d. Stone Balls of Costa Rica. Available online at http://web.ku.edu/~hoopes/balls.

Hoopes, J., and O. Fonseca
2003 Goldwork and Chibchan Identity: Endogenous Change and Diffuse Unity in the Isthmo-Colombian Area. In *Gold and Power in Ancient Costa Rica, Panama, and Colombia*, edited by J. Quilter and J. Hoopes, pp. 49–89. Dumbarton Oaks, Washington, D.C.

Joyce, R.
1997 Performing the Body in Pre-Hispanic Central America. *Res, Anthropology and Aesthetics* 33:147–165.

Koontz, R.
2009 *Lightning Gods and Feathered Serpents: The Public Sculpture of El Tajín*. University of Texas Press, Austin. In press.

Leibsohn, D.
1988 The Costa Rican Effigy Head Tradition. In *Costa Rican Art and Archaeology: Essays in Honor of Frederick R. Mayer*, edited by F. W. Lange, pp. 131–160. University of Colorado, Boulder.

Looper, M.
2003 From Inscribed Bodies to Distributed Persons: Contextualizing Tairona Figural Images in Performance. *Cambridge Archaeological Journal* 13(1):25–40.

Lothrop, S.
1963 *Archaeology of the Diquís Delta, Costa Rica*. Papers of the Peabody Museum of Archaeology and Ethnology, Harvard University, 51. Peabody Museum Press, Cambridge, MA.

Lowe, G., T. Lee, and E. Martinez
1982 *Izapa: An Introduction to the Ruins and Monuments*. Papers of the New World Archaeological Foundation 31. New World Archaeological Foundation, Provo, UT.

Mock, S. B.
1997 *The Sowing and the Dawning: Termination and Dedication Processes in the Archaeological and Ethnological Record of Mesoamerica*. University of New Mexico Press, Albuquerque.

Mora-Marín, D.
in press The "Charlie Chaplin" Silhouette Figural Theme: A Middle American Theme. *Ancient America*.

Nadal, L.
2001 Rubber and Rubber Balls in Mesoamerica. In *The Sport of Life and Death: The Mesoamerican Ballgame*, edited by M. Whittington, pp. 20 31 ..s and Hudson, New York.

Norman, G.
1973 *Izapa Sculpture, Part 1.* Papers of the New World Archaeological Foundation 30. New World Archaeological Foundation, Provo, UT.

O'Day, K.
n.d. Gold Crocodilian Pendants and Their Wearers in the Diquís Region of the Americas. MS. in possession of the author.

Orr, H.
1997 Power Games in the Late Formative Valley of Oaxaca: The Ballplayer Carvings at Dainzu. Ph.D. dissertation, University of Texas at Austin.
2001 Processional Rituals and Shrine Sites: The Politics of Sacred Space in the Late Formative Valley of Oaxaca. In *Landscape and Power in Ancient Mesoamerica,* edited by R. Koontz, K. Reese-Taylor, and A. Headrick, pp. 55–79. Westview Press, Colorado.
2003 Stone Balls and Masked Men: Ballgame as Combat Ritual, Dainzu, Oaxaca. *Ancient America,* 5.

Parsons, L.
1986 *The Origins of Maya Art: Monumental Stone Sculpture of Kaminaljuyu, Guatemala, and the Southern Pacific Coast.* Dumbarton Oaks Studies in Pre-Columbian Art and Archaeology 28. Dumbarton Oaks, Washington, D.C.

Proulx, Donald
2001 Ritual Use of Trophy Heads in Ancient Nazca Society. In *Ritual Sacrifice in Ancient Peru,* edited by E. Benson and A. Cook, pp. 119–136. University of Texas Press, Austin.

Quilter, J., and J. Hoopes (editors)
2003 *Gold and Power in Ancient Costa Rica, Panama, and Colombia.* Dumbarton Oaks, Washington, D.C.

Quintanilla, I.
2007 *Pre-Columbian Spheres of Costa Rica.* Fundación Museos Banco Central de Costa Rica, San José.

Reichel-Dolmatoff, G.
1974 Funeral Customs and Religious Symbolism among the Kogi. In *Native South Americans,* edited by P. Lyon, pp. 289–301. Little, Brown and Company, Boston.
1975 *The Shaman and the Jaguar.* Temple University Press, Philadelphia.

Reilly, K.
1989 The Shaman in Transformation Pose: A Study of the Theme of Rulership in Olmec Art. In *Record of the Art Museum, Princeton University* 48(2):5–21.
1994 Visions to Another World: Art, Shamanism, and Political Power in Middle-Formative Mesoamerica. Ph.D. dissertation, University of Texas at Austin.

Snarskis, M.
1981 The Archaeology of Costa Rica. In *Between Continents/Between Seas: Precolumbian Art of Costa Rica,* pp. 18–84. Harry N. Abrams, New York.
2003 From Jade to Gold in Costa Rica: How, Why, and When. In *Gold and Power in Ancient Costa Rica, Panama, and Colombia,* edited by J. Quilter and J. Hoopes, pp. 159–204. Dumbarton Oaks, Washington, D.C.

Stone, D.

1943 Preliminary Investigation of the Flood Plain of the Rio Grande de Terraba, Costa Rica. *American Antiquity* 9(1):74–88.

1977 *Pre-Columbian Man in Costa Rica.* Peabody Museum Press, Cambridge, MA.

Stone-Miller, R.

2004 Human-Animal Imagery, Shamanic Visions, and Ancient American Aesthetics. *Res, Anthropology and Aesthetics* 45:47–68.

Taube, K.

1985 Classic Maya Maize God: A Reappraisal. In *Fifth Palenque Round Table, 1983*, edited by V. M. Fields, pp. 171–182. Pre-Columbian Art Research Institute, San Francisco.

1995 The Rainmakers: The Olmec and Their Contribution to Mesoamerican Belief and Ritual. In *The Olmec World: Ritual and Rulership*, edited by J. Guthrie, pp. 83–104. The Art Museum, Princeton University, Princeton, NJ.

2009 The Murals of San Bartolo, Guatemala: Early Maya Creation Mythology and the Origins of Gods and Kings. Presentation given for the Alianza organization at the Denver Art Museum, February 15.

Whitehead, N.

2002 *Dark Shamanism: Kanaimà and the Poetics of Violent Death.* Duke University Press, Durham, NC.

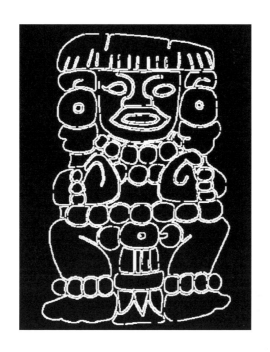

Section IV

Pain and Healing

Chapter 10
Pretium Dolores, Or the Value of Pain in Mesoamerica
Claude-François Baudez

Chapter 11
Violent Acts of Curing: Pre-Columbian Metaphors of Birth and
Sacrifice in the Diagnosis and Treatment of Illness "Writ Large"
John Hoopes and David Mora-Marín

Chapter 12
To Boast in Our Sufferings: The Problem of Pain in
Ancient Mesoamerica
Stephen Houston

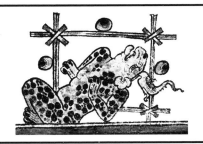

CHAPTER 10

PRETIUM DOLORIS, OR THE VALUE OF PAIN IN MESOAMERICA

Claude-François Baudez

INTRODUCTION

While expressing repulsion toward the human sacrifices perpetuated by Mesoamerican peoples, the Spaniards were much interested in their practices of "penance," such as vigils, abstinence, and fasting, which were also commonly performed in sixteenth-century Europe.[1] However, they were reluctant to accept bloodletting for purposes other than medical, and thought this practice was inspired by the devil. Sahagún described painless, simple "bloodying": "with an obsidian blade one cut [the lobes of] one's ears"; and "the drawing of straws [through parts of the body]" (Sahagún 1950–1984, bk. II:197–198). In southern Mesoamerica, Landa, reporting on the Maya, told how "they offered sacrifice of their own blood, sometimes cutting themselves around in pieces and they left them in this way as a sign" (Tozzer 1941:113). This sentence describes the practice of cutting the edges of the ear, both to let blood and to exhibit evidences of self-mutilation. A few lines later, Landa added: "sometimes they scarify certain parts of their bodies, at others they pierced their tongues in a slanting direction from side to side and passed bits of straw through the holes with horrible suffering" (Tozzer 1941:113).

In most self-sacrifices, blood had to be profusely shed, and the Mexica priests proudly displayed their hair gluey with coagulated blood spilled from their ears. The body parts favored by the Mesoamericans for bloodletting, such as the ears,

the tongue, or the penis, were well-irrigated parts that produced, when cut or pierced, flows of the precious liquid. Furthermore, the self-sacrificial implements favored by the Mesoamericans had barbed edges (such as the stingray spine or the maguey leaf) that tore the flesh and produced abundant bleeding. On the other hand, some "penance" rites performed by the Mexica did not include bloodletting—such as flogging, wearing vestments made of nettles, chewing obsidian blades, or burning oneself with the resin from lighted torches.[2]

Throughout Mesoamerica, blood self-sacrifice with varying amounts of pain had been performed for many centuries and since early times, as evidenced by the Preclassic murals at San Bartolo (Saturno 2006) showing individuals piercing their penises with long sticks, or the Late Classic Lintel 24 from Yaxchilan showing a queen passing a spiny cord through her tongue (Figure 10.1).

The amount of pain involved made the difference between the several forms of self-sacrifice. Pain then had a value that merits being evaluated. This is the first step to take before asking questions relative to the sociological and psychological functions of pain in Mesoamerican religions, in self-torture as well as in the torture of others, such as captives or condemned persons.

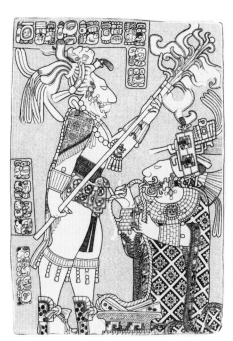 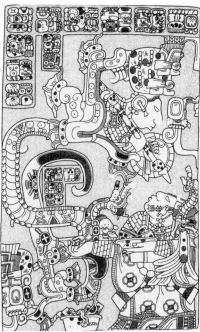

FIGURE 10.1. Self-sacrifice at Yaxchilan. *Left:* Execution (Lintel 24). *Right:* Offering (Lintel 25). (*After Graham and von Euw 1977.*)

In fact, if pain enhanced the value of self-sacrifice for the Maya and the Aztecs—as at El Tajín, Monte Albán, Tula, and Chichén Itzá—why should this not be the case in the sacrificing of others, by means of torture applied before or during execution? One would be entitled to think so, insofar as, for Maya and Aztecs, the sacrifice of self and the sacrifice of others were equivalent—that is to say, alternative means of paying one's debt to the powers of nature or the gods. In fact, in all cases where the sacrificer endeavors to identify with his victim (Baudez 2004; Graulich 2004:148–159), it is understood that the end objective is always the sacrifice of self. This assumption is symbolically substantiated by those images of self-decapitation shown on some Maya vases (Figure 10.2) and codices. If pain had an enhancing value in self-sacrifice, it would also be the case in the sacrificing of others, as shown by the (admittedly infrequent) images of torture that the Maya have left us. One can infer that pain had a price, precisely when one speaks in terms of payment (of a debt) or of investment before the powers from which one expects favors, and within this perspective, that the values of such sacrifices and self-sacrifices should be higher when accompanied by pain (for example, see Orr and Koontz this volume, Introduction).

In this paper I limit myself to examine, in images taken from different pre-Columbian cultures, the explicit as well as the implicit manifestations of pain in

FIGURE 10.2. Detail of Vase MS 0739, self-decapitation.
(*After a watercolor by I. Bonzom, after Reents-Budet 1994: fig. 6.44.*)

sacrificial contexts. This preliminary approach may pave the way to future researchers concerned with the role and significance of pain in Mesoamerican civilizations.

While Aztec and Mixtec manuscripts favor us with blood-drenched temples, gaping chest wounds, severed heads, and humans clothed in the hides of skinned victims, the Classic Maya showed great reticence in depicting blood sacrifices. Execution scenes are extremely rare in their monumental art: cardiotomy figures discreetly depicted on two stelae (6 and 11) at Piedras Negras and decapitation on a single relief at Palenque (Figure 10.3). Vases rarely portray executions. The

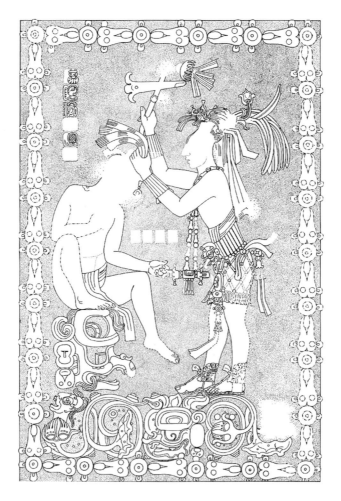

FIGURE 10.3. Palenque, House D, Pier F. Decapitation.
(*After Greene Robertson 1985: fig. 222.*)

same reticence seems to apply to self-sacrifice, with the notable exception of the Preclassic murals at San Bartolo (Saturno 2006), followed in Classic times by the Yaxchilan lintels, a court scene at Bonampak, a few odd vases, and a complex of mutilated phalli from the northern lowlands. Given these facts, it is easier to understand why, as recently as sixty years ago, the Maya were described as a gentle, peaceful people, not prone to blood sacrifices, in happy contrast to their terrible Aztec cousins. No blood scenes can be found in the monumental art of Copán, but every monument on the site has at least one motif pointing to sacrifice or self-sacrifice; the latter is the most frequently suggested, to the point where bloodletting instruments are held by ancestors or supernatural creatures that surround the ruler (Baudez 1994). It is now apparent that civilizations such as those of Teotihuacan[3] and the Classic Maya, who did not or very rarely portray bloody executions, did, however, allude to them by depicting instruments of torture or symbols such as knotted cords, pierced ribbons, and other marks of degradation.

Explicit Manifestations of Pain

Mesoamericans did not express human suffering through facial expression. At Bonampak, the captives painted with bleeding fingers in Room 2 do not show pain; if anything, they appear to be, with their wide-open eyes and dropped jaws, in a state of stupor. The same features are shared with the wounded warriors painted on the walls of Building B at Cacaxtla. This lack of facial expression, known to be the general rule in this part of the world, has but few exceptions. These, however, do raise many questions: why are the figurines of Classic Veracruz the only ones shown smiling?

In Central Mexico, pain is not depicted through grimaces or contorted features, but by cries and tears, conventionally depicted. One or two tears appear on cheeks, either as pear-shaped marks or as a rectangle followed by a ring or a disk.

Early Classic Teotihuacan

On Mural 2 of Portico 2 at Tepantitla (Teotihuacan), two participants in a ballgame with sticks lie prone outside the playing field (Baudez 2007a). That they are players is evidenced by the clothes worn by one and the stick lying close to the other. It is obvious that one has been excluded from the game because he has been wounded. He expresses his pain by shedding a tear and spouting a scroll that emerges from his mouth and translates his cries (Figure 10.4). The other player's wounds are far worse: a bleeding knee and both broken ankles as shown by the turned-in position of his feet (Figure 10.5). He has been undressed except for his loincloth; he is not dead, however, for he also is seen crying and moaning.

FIGURE 10.4. Tepantitla, Portico 2, detail of Mural 2: A wounded ballplayer is lying outside the playing field. (*Watercolor by I. Bonzom, photo by the author.*)

FIGURE 10.5. Tepantitla, Portico 2, detail of Mural 2: A severely wounded ballplayer is crying (tear) and moaning (scroll). (*Watercolor by I. Bonzom, photo by the author.*)

Far from this scene, on the southern end of Mural 3 in the same Portico 2, stands another figure, also in obvious pain (Figure 10.6). This man shows his left profile, as he stands totally naked, his extremities painted blue; his right hand brandishes a leafy branch while his left rests on his buttocks. He has two tears, one on his cheek, one on his chest, and a succession of five scrolls emerge from his mouth. A stream, half red and half blue (blood and water?), flows from his open chest and mingles with the waters of a river flowing from the mountain nearby. One could easily interpret this character as an allegory referring to human sacrifice as the source of fertility: he echoes, both visually and vocally, the way in which the wounded ballplayers express their own suffering.

Tears, and scrolls emerging from their mouths, express the pain of the three individuals described above. The tears and moans are greater when the wounds

FIGURE 10.6. Tepantitla, Portico 2, detail of Mural 3: A naked sacrificial victim is crying and moaning. (*Photo by the author.*)

are more serious and the pain is deeper; while the wounded ballplayers show their pain by shedding one tear and exhaling one scroll, the sacrificial victim sheds two large tears and a series of five scrolls.

The door jambs at the entrance to Corridor 1 of Patio Blanco at Atetelco show two more wounded ballplayers (Figure 10.7). The one on the left has two broken ankles; while he does not seem to be in tears, his mouth does exhale two scrolls. On the right, the player has but one broken ankle and two tears on his cheek, and sparks a series of three scrolls. Here the signs of pain are not in proportion with the seriousness of the wounds.

Late Postclassic Central Mexico

In the *Codex Nuttall*, there are two instances where two tears flow down the cheeks of a victim. In the gladiatorial sacrifice (Figure 10.8), the latter is dressed in the emblematic garment of Xipe Totec (*yopitzontli* bonnet and white and red forked ribbons) and tied by a cord to a round, perforated stone or *temalacatl*. Armed with

FIGURE 10.7. Atetelco, Patio Blanco, Corridor 1: Two wounded ballplayers lying in pain. (*After Cabrera 1995: figs. 18-10, 18-11.*)

sticks, he faces two jaguar-warriors provided with clawed gloves, who strive to brand him for sacrifice through scratching. The sacrifice called *tlacacaliztli* uses darts propelled by the *atlatl* (Figure 10.9); the victim, in tears, has his hands and feet tied to a trapezoidal frame. Darts were used so the blood could flow on the earth and thus fertilize it. In the same codex, slightly before the scene showing the gladiatorial sacrifice of 10 Dog (page 83), we are shown the capture by the ruler 8 Deer of 4 Wind, shedding tears. Another captive in tears is 2 Flower, captured by 8 Deer in a 9 Death year (page 76). There follows a troop of 13 men doomed to be sacrificed, as indicated by the small sacrificial white flag carried by each; among these, the third man, 13 Movement, is in tears. Of all the characters captured or sentenced to torture that figure in this manuscript, only two are shedding tears. Are they the only ones sentenced to torture? Or do these tears mean that their capture and sacrifice are especially important? Tears may also express sorrow.

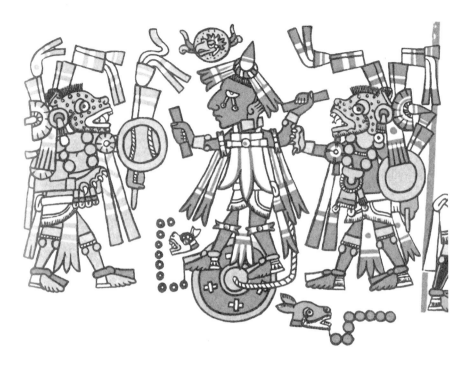

FIGURE 10.8. *Codex Nuttall*, p. 83: *Tlahuahuanaliztli* or gladiatorial sacrifice.

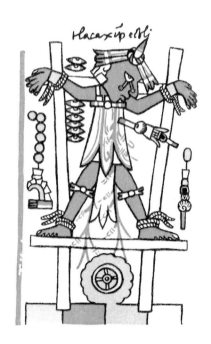

FIGURE 10.9. *Codex Nuttall*, p. 84.
Tlacacaliztli or arrow sacrifice.

Pages 59 and 60 of the Codex Mendoza describe the punishments inflicted on children of both sexes from eight to twelve years of age. At eight years, if one is to believe the Spanish comment, a father and a mother explain their duties to their children and the punishment by spines they must expect in case of misbehavior (Figure 10.10:1). The children cry even though in this case they are not being punished, just warned. At nine years, the maguey thorns may be applied (Figure 10.10:2); at ten years, both children are beaten with sticks (Figure 10.10:3), at eleven they suffocate with the fumes of burning hot chilies (Figure 10.10:4). At twelve, the boy is made to lie naked and bound on damp earth, while the girl has to do housework before dawn (Figure 10.10:5). It is the only time that she does not cry; the boy, by contrast, sheds tears every time he is punished. In the punishment of children as well as in self-inflicted torture, spines are favorite instruments.

Besides in the Nuttall and Mendoza codices, tears are often shown running on the cheeks of men and women in many pictorial manuscripts, such as the Florentine, Magliabechiano, and Tudela codices. In addition to pain, tears can express sorrow experienced during a funeral or when receiving or announcing bad news (a sentence following a trial, or when the Mexicans hear of the power of the Spaniards), or when being in jail (López Luján 2006; Escalante 1996:496–500). Another use of tears is to illustrate the metaphorical ties between tears and rain, which made the Aztec rejoice when the infants taken to sacrifice were crying (Sahagún 1950–1984).

Cries or moans are also expressed by one or a series of scrolls. Generally called "speech scrolls," they are in fact scrolls of expression or emanations that may convey words, speeches, chants, prayers, but also calls (by players, for instance) or cries and moans.

While, as a rule among the Maya, pain was banished from the faces of humans, it was, curiously enough, admitted in felines. I have suggested that "the assimilation of the sacrificer with his victim leads, on the symbolic level, to presenting the jaguar, that emblem of predation, aggressiveness and violence, as the arch image of the victim, both in death and under torture" (Baudez 2004). In fact, images of decapitation of half-human, half-feline victims are not infrequent, and jaguars are sometimes shown on a scaffold (Figure 10.11), either dead or with their maws wide open, howling to the heavens with pain.

IMPLICIT MANIFESTATIONS OF PAIN

Instruments of self-torture were placed in caches and in tombs, and their images decorate monuments and vases. In southern Mesoamerica, the preferred instrument of self-sacrifice was the stingray spine, while in the north, maguey or cactus thorns, or maguey half-leaves with barbs on one side, were more currently used,

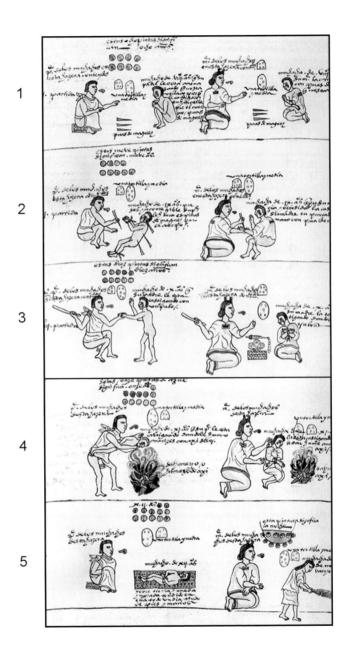

Figure 10.10. *Codex Mendoza*, pp. 59–60:
Punishments inflicted upon children of both sexes.

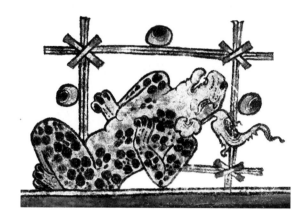

Figure 10.11. Detail of Vase K791, dead jaguar and scaffold.
(*After a Justin Kerr roll-out photo.*)

together with eagle, jaguar, and deer bone awls. Thorns are pointed and sharp enough to prove quite efficient as piercing instruments. Stingray spines, with their barbed flesh-tearing edges, were certainly painful. The choice of stingray spines by the Maya was not due only to their physical suitability but also to their marine origin: reference has been made (Baudez 2002) to the narrow association, as yet little understood, of self-sacrifice with the marine world. *Spondylus* spiked valves collected the blood flowing from marine weapons, which sometimes included fossil shark teeth, urchin spines, and porcupine fish quills. At Teotihuacan the iconography of mural painting shows that, besides simple cactus plants and thorns, barbed points were probably also made in stone (Figure 10.12). For self-sacrifice, the Maya also used obsidian blades, some with reworked tips.

Little is really understood of the most important symbolic value that materials such as flint and obsidian had in the sacrificial realm. Some caches and burials filled with hundreds of rough fragments of both stones are a good case in point. At Teotihuacan, as among the Maya, the meaning and the part played by eccentric blades are not clearly understood either. In Maya caches, eccentrics show great variety, while their painted representations steadily repeat the same two shapes: a perforated three-pointed stone (Figure 10.13) and a spiked circle mounted on a shaft (Figure 10.14). While these objects presumably were used to inflict torture, what about the other eccentrics found in caches? Could their meaning be simply symbolic?

Instruments of torture included scaffolds, in the shape of frames or ladders, to which men (and transformed jaguars) earmarked for torture, were tied. Vase MS 0739 offers a simplified version of this rite: here the feline is simply tied to a pole (Figure 10.15).

FIGURE 10.12. Atetelco, Patio Blanco, Portico 1, Murals 5–7, barbed points and other sacrificial implements. (*After Cabrera 1995: fig. 18.*)

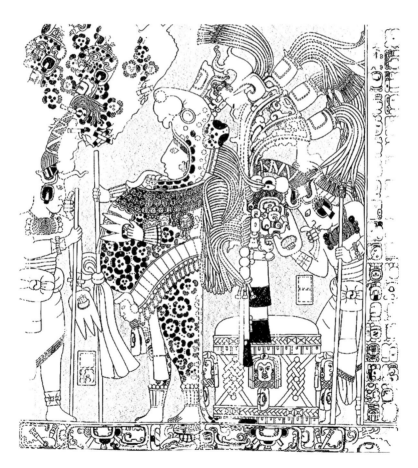

FIGURE 10.13. Tikal, Temple 3, Lintel 2. The king and two attendants display three-pointed stones and sticks, supposedly instruments of torture. (*After Jones and Satterthwaite 1982: fig. 72.*)

The chapter on torture is far from closed. Tooth mutilation, such as filing and carving cavities for jade or hematite inlays, was surely a source of pain at the moment of the operation; the pain could be felt later and perhaps for a lifetime, as these mutilations often exposed nerves and were the source of abscesses.

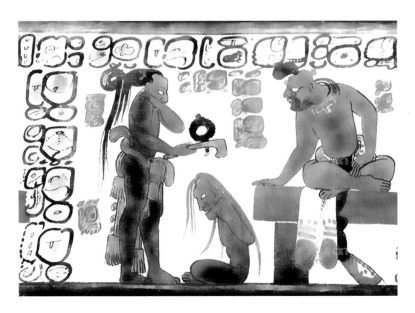

FIGURE 10.14. Vase K5850. Under supervision of their master, a captive is to be tortured with a rounded spiked stone. (*After a roll-out photo by Justin Kerr.*)

FIGURE 10.15. Detail of Vase MS 0739. A human figure presents a jaguar tied to a torture pole. (*After a watercolor by I. Bonzom, after Reents-Budet 1994: fig. 6.44.*)

The Sacrifice of the Gods at Santa Rita (Late Postclassic Maya)

The murals at Santa Rita Corozal, destroyed shortly after Gann discovered them more than one hundred years ago, give us an idea of a Maya pantheon in the fifteenth century. The entire (11 m or so) length of the north facade had been preserved; the central door was framed by two reptilian heads in profile, probably of the earth monster; above this door there was a front-facing head probably of the same creature, making Structure 1 into a *teratomorphous* (having a monster form) building comparable to a Chenes or Río Bec temple. The paintings on the eastern half of the northern wall have a blue background, those on the western half a pink one. The paintings that decorated the eastern wall of the building had been vandalized by townspeople before Gann could sketch them. The western wall was well preserved on 3 m of its length, and its paintings were found to be in good state. The southern wall had entirely disappeared.

So far, these murals have been studied more for their style (known as International Late Postclassic) than for their content (Quirarte 1982; Robertson 1970). They have generally been interpreted as pictures describing a war (eastern wall), followed by the capture of prisoners (north wall) and their execution (west wall).

It has been shown (Baudez 2002:347–357) that all the characters represented were gods and not historical or allegorical beings. Some Maya gods have been identified from the codices—namely, Gods L, K, D, M, plus another god of trade, and perhaps God E; the grotesque features on the other faces betray their supernatural essence. Two of them (Numbers 1 and 8 on the western part of the north wall) do not touch ground, but are in a kind of levitation in which their feet rest upon a self-secreted support. Some gods seem to be from Central Mexico, such as Number 6 on the eastern half of the north wall, who recalls *Xochipilli* by the painting around his mouth, his earplug, his large necklace, and some elements of his headdress (Figure 10.16). As for Number 7, because of his dog helmet and the ball-court design hanging from his neck, he could well be *Xólotl* (Jourdan 1999).[4]

All these characters are shown as sacrificial victims, with tied wrists or carrying symbolic bonds such as armbands or bracelets made of rope. When these characters are shown tied to each other, they are not victors leading the chained defeated, nor are they torturers taking their victims to the scaffold. They are gods on the way to self-sacrifice, as described in the Aztec myth of the creation of the sun and the moon at Teotihuacan.

One of the episodes pertaining to the Aztec feast of *Tlacaxipehualiztli* (or the "flaying of men") described by Diego Durán (1967:97) demonstrates the will of all the gods to be united by binding themselves into one body. A host of deities of both sexes, individually portrayed by a man attired in the specific costume and attributes of each, is first gathered. When these impersonators are sacrificed and

flayed, others wear their skins and respective god attributes. Thus adorned, they participate in a ceremony called *neteotoquilizli*, "reputarse por dios," in which they declare their divine identity. It is then that "para significar que todo era un poder y una unión, juntábanse todos estos dioses en uno y atábanles el pie derecho del uno con el pie izquierdo del otro, liándoles las piernas hasta la rodilla y asi atados, unos con otros, andaban todo aquel día susténtandose los unos con los otros." Once this ceremony is over, they are relieved of their skins by the priests, who then hang them on perches ("con mucha reverencia"). At Santa Rita, the gods are also tied to each other, but here as captives to show that the pantheon has self-sacrificed as a whole to set the Fifth Sun in motion.

Not much can be made of the sketch Gann has left us of the east wall. It may represent a god sacrificing his companions, or the offering of a sacrifice to the sun, as on the west wall. On the latter, one can distinguish at least three individuals, but only two are well preserved in Gann's recording (Figure 10.17). The first one, sporting a long Pinocchio-like nose, is dancing; he brandishes a rattle in his right hand and strikes a vertical drum with the other. The sounds coming from the drum rise to the sun in the shape of double scrolls. The sun is shown as a human face caught within large jaws, surrounded by a radiating disk. On the drum, two streams of scrolls pour out of the jaws of a human skull; one rises to the skies, the other drops to earth, suggesting the double destination of the sacrifices exhibited by the character seen walking toward it. This god upholds the severed heads of two deities by their hair. The head of God M, one of the gods of trade, identified by his long nose and thick lip, is presented to the sun; the other, the head of an old god, droops toward earth. A severed jaguar head lies at the feet of the most erased character on the far right.

The body of paintings that decorated the outer walls of Structure 1 at Santa Rita is reminiscent of the Teotihuacan myth. *Nanahuatzin* and *Tecciztecatl*, having jumped into the fire and turned into the sun and the moon, are now set motionless in the skies: "... y los dioses otra vez se hablaron, y dijeron: ¿Cómo podemos vivir? ¿no se menea el sol? ¿Hemos de vivir entre los villanos? Muramos todos y hagámosle que resucite por nuestra muerte" (Sahagún 1956, bk. VII, ch.2:28). Then Wind takes it upon himself to put to death all the gods (including the unwilling Xólotl) and, seeing no immediate effect, starts to blow, and this forces the sun into motion.

The story portrayed at Santa Rita differs slightly from Sahagún's version.[5] On the north wall, the gods are all gathered, ready to sacrifice themselves (including Xólotl). On the east wall, it is Wind or other gods who officiate and sacrifice their fellows. On the west wall, the gods have sacrificed each other, as evidenced by the presence of the figure on the right (Figure 10.17:3) holding the severed heads of

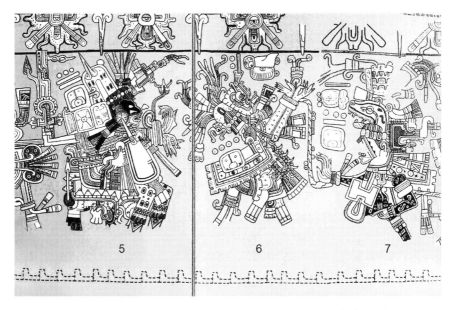

FIGURE 10.16. Santa Rita Corozal, Structure 1, eastern half of north wall, characters 5–7. (*After Jourdan 1999, after Gann 1900.*)

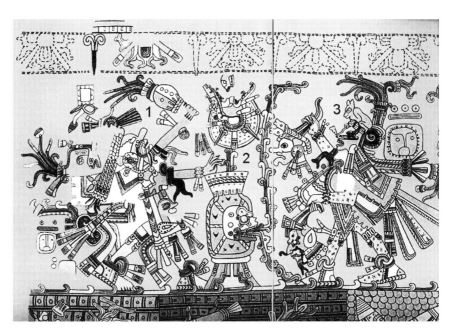

FIGURE 10.17. Santa Rita Corozal, Structure 1, western wall, characters 1–3. (*After Jourdan 1999, after Gann 1900.*)

two of his fellow gods, while another facing him (Figure 10.17:1) offers, by his dancing and music, a collective sacrifice to the sun star up in the sky. A jaguar stands among the victims, in confirmation of the Classic Maya custom of ritually killing (and perhaps torturing) felines. The skull placed on the drum (Figure 10.17:2), an allegory of sacrifice, releases the energy that will nourish both sun and earth.[6]

In some cases at least, torture may have been added to beheading (here there is no indication of cardiotomy whatsoever). Character 7, seen on the western part of the north wall, is seated on a scaffold; he has two twists of rope on his left wrist and two more around his right arm (Figure 10.18). His yellow skin is covered with stains, and a boar's head serves as his helmet. Character 6 has his back to him and is marching to the left; a cord seemingly held by Character 5, mostly erased, ties his wrists; his belt masks and his helmet are bird heads. Character 8, probably the God D of the codex, is standing upon two intertwined serpents. Ribbons, not cords, circle his wrists. His right hand upholds a knotted snake, and a small bird serves as his helmet.

Following in the steps of his fellows, Character 7 accepts to sacrifice himself to save a world he leaves to mankind, and by so doing he escapes to a better world.

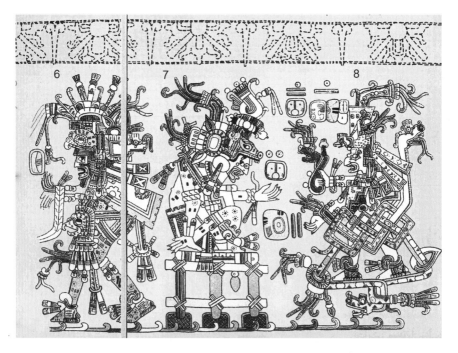

FIGURE 10.18 Santa Rita Corozal, Structure 1, western half of north wall, characters 6–8. (*After Jourdan 1999, after Gann 1900.*)

He, furthermore, accepts torture by the hands of his fellow gods, knowing that the pain undergone will increase the value and the merit of his sacrifice.

CONCLUSION

If pain was an added value to Mesoamerican sacrifices, it was never systematically applied. Among the Mexica, self-sacrifice was mandatory for everybody only on very limited occasions such as at the feast celebrating the birthday of the sun at 4 *ollin*. "And they cut the ear [lobes] of small children lying in the cradles. And everyone drew blood" (Sahagún 1950–1984, bk. II:216). Many people drew their blood during the great festivals; however, the rite's frequency and the part given to pain varied greatly according to one's individual piety: "The drawing of straws [was done], perchance on one's ear or, *whoever willed it*, his tongue or his thigh" (Sahagún 1950–1984, bk. II:197; author's italics). Self-sacrifice took different forms depending on the rank of everyone within the social and religious hierarchy. The addition of pain to bloodlettings was a way to build up and strengthen the clergy's hierarchy. The novice priests in the *calmecac* were invited to do penance and practice painful self-sacrifice at every occasion (Sahagún 1950–1984, bk. VI: ch. 40). It was a standard practice for the priests, who were supposed to "earn merit" for the whole society. When the dignitaries were required to do penance during four or five days preceding a festival, the preparation could last eighty days for the priests. In the manuscripts, the latter are usually depicted with a censer in one hand and a couple of maguey spines in the other. At Tlaxcala every four years, before the festival of Tlacaxipehualiztli, the high priests tried to outdo one another in passing a higher number of sticks through their tongues. Some succeeded in passing 405, others only 200: "como quien no dice nada"! (Motolinía 1985:107).[7] At his coronation ceremony, the Aztec king is shown as a priest with censer and maguey spines in hand. On several monuments (for instance, the Dedication Stone), the king is represented letting blood, but always from his ears. Therefore, it does not seem that the king's self-sacrifice, although probably frequent, had to be painful. This contrasts with the Classic Maya kings and queens who, as amply demonstrated on the Yaxchilan lintels, selected the most painful ways to let blood.

The Aztec often inflicted pain on their victims but—apparently—not for the sake of it. During the *Xocotl Huetzi* festival, the captives were first thrown into the fire and, after some time, taken out of the furnace by the priests who tore out their hearts. The major purpose was not torture but homage to the god of fire. The *Matlatzincas*, the "people of the net," squeezed their victims in large nets until they expired. Here also the excruciating pain they inflicted was not what mattered. This manner of sacrifice was instead a reference to their practice of hunting with nets.

On the other hand, the Maya certainly tortured their prisoners, at least some of them. In the Yucatan, the development at the end of the Classic Period of the penis sacrifice is a case in point (Baudez 2007b). At Uxmal in the tenth century, statues of men naked from the waist down in order to have sticks passed through their members decorated the higher temple of the Adivino and the north and west buildings of the Monjas Quadrangle. Some of these figures represent captives. It is likely that they were invited to painfully mutilate themselves before being sacrificed on the altar. This practice was not unknown to the Classic Maya of the central lowlands, as one image from Palenque demonstrates.

NOTES

[1] I thank Yvette Castro-Kornfeld for translating this paper from the French. I am also grateful to Leonardo López Luján and Michel Graulich for reading the manuscript and greatly improving the original text with their useful comments and suggestions.

[2] See references in Graulich 2000:54 and n. 5.

[3] A mural without provenience (Berrin and Pasztory 1993:200, cat. no. 46), showing two coyotes tearing off the heart of a deer, may be interpreted as an allegory of sacrifice through cardiotomy. On the Tepantitla murals, four men are seen seizing the limbs of another, lying on the ground, an action that would immediately precede the victim's setting on the sacrificial altar. On the same mural, a crying, naked man (Figure 10.11) appears as a victim of sacrifice; however, one may observe that the spurt of blood and water that flows from his chest comes from the *right* side where his heart is not supposed to be, confirming the nonrealistic, allegorical aspect of this scene.

[4] As demonstrated by Seler (1963:143–146), Xólotl and the ballgame were closely associated. In fact, according to the Codex Magliabechiano (XIII, 3), "Quetzalcoatl era hermano de un dios que se llamaba Xubolt, el qual ponen en los juegos de pelota." In the song during the *Atamalcualiztli* festival, ". . . juega a la pelota Xólotl/en el mágico campo juega Xólotl a la pelota."

[5] In the *Leyenda de los Soles* version (*Códice Chimalpopoca* 1945:340–348), only five gods and goddesses commit self-sacrifice. "Sun remained four days motionless in the sky. Speechless, the gods sent "the obsidian falcon" to ask him why. Sun answered that he claimed the "bountiful blood" and power. *Tlahuizcalpantecuhtli*, "the lord of the House of Dawn" (that is, Venus) shot an arrow to him. Sun retaliated, reached his aggressor and sent him head down into the "nine folds" (of hell). *Titlacahuan* (another name for Tezcatlipoca), *Huitzilopochtli*, *Xochiquetzal*, *Yapalliicue* and *Nochpalliicue* gave in and were sacrificed" (Graulich 2000:121–122).

[6] In the *Leyenda de los Soles*, *Tonatiuh*, "Sun," turned over richly decorated shields and darts to the 400 *Mimixcoa*, enjoining them to feed him and their mother Tlaltecuhtli (Graulich 2000:161–165).

[7] According to Graulich, the number of 405 alludes to the myth of the four hundred *Mimixcoas* vanquished by their four brothers and their sister, and given to the Sun and Earth to nourish them (Graulich 2000:161–165).

References Cited

Baudez, C-F.
1994 *Maya Sculpture of Copán: The Iconography.* University of Oklahoma Press, Norman.
2002 *Une histoire de la religion des Mayas. Du panthéisme au panthéon.* Bibliothèque Histoire. Paris, Albin Michel.
2004 Los cautivos Mayas y su destino In *Los cautivos de Dzibanché*, edited by E. Nalda. INAH, Mexico.
2007a El juego de balón con bastones en Teotihuacan. *Arqueología Mexicana* XV, (86):18–25. Mexico.
2007b Sacrificio y culto fálico in Yucatan. *Mayab* 19:71–85. Madrid.

Berrin, K., and E. Pasztory (editors)
1993 *Teotihuacan, Art of the City of the Gods.* Thames and Hudson, New York.

Cabrera, R.
1995 Atetelco. In *La pintura mural prehispánica en México: I. Teotihuacán,*, edited by B. de la Fuente, pp. 202–256. Instituto de Investigaciones Estéticas, Mexico.

Codex Mendoza
1992 *The Codex Mendoza.* 4 volumes. Facsimile, edited by F. Berdan and P. Rieff Anawalt. University of California Press, Berkeley, Los Angeles, Oxford.

Codex Nuttall
1975 *The Codex Nuttall. A Picture Manuscript from Ancient Mexico*, edited by Zelia Nuttall, with new introductory text by A. G. Miller. Dover Publications, New York.

Códice Chimalpopoca
1945 *Anales de Cuauhtitlan y Leyenda de los Soles.* Translated by P. F. Velásquez, UNAM, Mexico.

Durán, D.
1967 *Historia de los Indios de la Nueva España e Islas de la Tierra Firme*, edited by A. M. Garibay. 2 vols. Porrúa, Mexico.

Escalante Gonzalbo, P.
1996 El trazo, el cuerpo y el gesto. Los códices mesoamericanos y su transformación en el Valle de México en el siglo XVI. 2 vols. Tesis de doctorado en historia, Facultad de Filosofía y Letras, UNAM, México.

Fuente de la, B. (editor)
1995 *La pintura nural prehispánica en México: I. Teotihuacan.* Tomo I: Catálogo. Instituto de Investigaciones Estéticas, UNAM, Mexico.

Gann, T. W. F.
1990 *Mounds in Northern Honduras.* United States Bureau of American Ethnology Annual Report, 19. Washington, D.C.

Graham, I., and E. von Euw
1977 *Corpus of Maya Hieroglyphic Inscriptions.* Vol. 3, Part 1. Peabody Museum of Archaeology and Ethnology, Harvard University, Cambridge, MA.

Graulich, M.
2000 *Mythes et rituels du Mexique ancien préhispanique.* Académie Royale de Belgique, Mémoires de la Classe des Lettres, 67(3). Palais des Académies, Brussels.
2005 *Le sacrifice humain chez les Aztèques.* Fayard, Paris.

Greene Robertson, M.
 1985 *The Sculpture of Palenque.* Vol. III: *The Late Buildings of the Palace.* Princeton University Press, Princeton.

Jones, C., and L. Satterthwaite
 1982 *The Monuments and Inscriptions of Tikal: The Carved Monuments.* University Museum Monograph 44. The University Museum, University of Pennsylvania, Philadelphia.

Jourdan, C.
 1999 *Santa Rita. Les peintures murales de la structure 1: Réajustement de leur appartenance culturelle et nouvelle approche iconographique.* Mémoire de DEA, manuscrit, Université de Paris I.

López Luján, L.
 2006 *La Casa de las Águilas. Un ejemplo de la arquitectura religiosa de Tenochtitlan.* 2 vols. MARP, Harvard University /CONACULTA/INAH/Fondo de Cultura Económica, Mexico, D.F.

Motolinía o Fray Toribio de Benavente
 1985 *Historia de los indios de la Nueva España.* Edited by C. Esteva. Historia 16. Información y Revistas, Madrid.

Quirarte, J.
 1982 The Santa Rita Murals: A Review. In *Aspects of the Mixteca-Puebla Style and Mixtec and Central American Culture in Southern Mesoamerica.* Papers from a symposium organized by Doris Stone, MARI. Occasional Paper 4, Tulane University, New Orleans.

Reents-Budet, D.
 1994 *Painting the Maya Universe: Royal Ceramics of the Classic Period.* Duke University Press, Durham and London.

Robertson, D.
 1970 The Tulum Murals: The International Style of the Late Postclassic. In *Proceedings of the 38th International Congress of Americanists, Stuttgart 1968,* Vol. 2, pp. 77–88.

Sahagún, B. de
 1950–1984 *Florentine Codex, General History of the Things of New Spain.* Translated and edited by A. J. O. Anderson and C. E. Dibble. 12 vols. School of American Research and the University of Utah, Santa Fe and Salt Lake City.

 1956 *Historia general de las cosas de Nueva España,* edited by A. M. Garibay. 4 vols. Porrúa, Mexico.

Saturno, W.
 2006 The Dawn of Maya Gods and Kings. *National Geographic* 209(1):68–77.

Seler, Eduard
 1963 *Codex Borgia, eine altmexicanische Bilderschrift der Bibliothek der Congregatio de Propaganda Fide.* 3 vols. Berlin 1904–1909. Translated from Spanish by Mariana Frenk. Fondo de Cultura Económica, Mexico and Buenos Aires.

CHAPTER 11

VIOLENT ACTS OF CURING: PRE-COLUMBIAN METAPHORS OF BIRTH AND SACRIFICE IN THE DIAGNOSIS AND TREATMENT OF ILLNESS "WRIT LARGE"

John W. Hoopes and David Mora-Marín

Modern surgery, to the uninitiated, might be interpreted as fraught with violence. From the initial incision of a scalpel to the whirring blades of a bone saw to the excision of a tumor, techniques of modern medicine would be identified as acts of organized violence were it not for the science of anesthesia. However, surgery heals by doing violence to tissue. Like tropical foliage that becomes more lush after pruning, cutting away disease rejuvenates the body. This process has analogies in ancient medicine. In a similar sense, methods for curing disease within the context of a pre-Columbian non-biomedical model of disease included violent acts. Among these were methods replete with pain, blood, and the arrival to or departure from life in the present world: the acts of birth and homicide. Each was associated with its expert practitioner, the midwife and the warrior, who were linked within cognitive metaphors for the ongoing process of creation and perpetuation of the cosmos. Those roles were metaphorically conflated in many indigenous contexts in the Americas, where birth and bloody sacrifice were conceptually equated and orchestrated as acts of organized violence. We know this because metaphors and images were constructed and commissioned by principal actors to justify acts of violence as rituals of healing, creation, and renewal.

In the context of non-biomedical models for disease, acts of ritual violence are not acts of savage aggression but calculated strategies for the elimination of sources of illness. Warriors are not individuals who have succumbed to their raw emotions, but thinking, planning, and carefully calculating actors engaged in the elimination of maleficent forces. They do not act in a fashion that is out of control, but rather in a form of hyper-control. A "theory of the unity of knowledge" (Douglas 1991) explains how individuals who have the power to cure can also use this power to harm and to kill, a factor that contributes to ambiguous attitudes toward shamans (Buchillet 2004). This paper strives to reconstruct an emic perspective on warfare—the way it was considered by its agents—by examining models for the conception of illness and procedures by which a powerful individual, using supernatural techniques, sought to diagnose and cure illnesses through the use of ritual violence that was presented as a patterned, ritual sequence of diagnosis and treatment within metaphors of birth and creation.

A paradox of the pre-Columbian world view is that violent acts of war were likened to the maternal act of giving birth. What these have in common is the conception of pregnancy as an illness requiring magical diagnosis and treatment and the experience of trauma and bloodshed in the act of creation. Acts of bloody sacrifice, like the bloody act of human birthing, were linked in complex metaphors by which male actors appropriated the procreative power of women to affirm their participation in ongoing acts of creation. These included rituals of male genital bloodletting that mimicked menstruation and birthing (Stone 1988) as well as the assertion of metaphorical and metaphysical linkages between midwifery (dealing with another's pain and blood) and warfare. The trauma of war and the trauma of birth were ideologically interconnected, explaining how a warrior was like a midwife. These metaphors offer examples of males expressing female identities in the context of various stages of warfare. They illuminate how violent acts such as decapitation and heart removal may have been metaphorically linked to childbirth. They also provide hints at metaphorical equivalences of destruction and acts of creation, cycles of death and rebirth, and what may have been dual (male-female) identities of prominent deities in Mesoamerica and elsewhere. They show how the act of homicide was metaphorically linked to childbirth and how simultaneous acts of both destruction and creation might eliminate the source of illness and disease while enhancing fertility and childbirth within an idiom of cosmogenesis.

A consideration of the practice of violence as a form of medicine places rituals of decapitation and human sacrifice into a different context. Rather than interpreting them as the unbridled fury of individuals seeking vengeance, they can be construed as a reluctant but necessary act of "defense against the dark arts," a

method of correcting immoral behavior and a contribution to the ongoing process of creation. A warrior eliminates the causes of illness that are counter to the preservation of peace and good health while at the same time perpetuating the generative process in a cycle of death and rebirth. Organized violence may have the semblance of mayhem, but it was a carefully orchestrated act intended to restore order and perpetuate life cycles. Like surgery, it was considered emically as a method of healing. Acts of violence often included references to cosmogenesis, a metaphorical replay of the events of creation in an endless cycle of destruction and renewal. Although inherently conflictive and destructive of the world of its victims, warfare and sacrifice were also acts of resolution and creation.

Sources of Illness

The causes of illness in pre-Columbian societies were almost always attributed to non-biomedical causes. The Tukanoan-speaking Desana, for example, attributed most illnesses to sorcery (Buchillet 2004). Illness could be the result of inappropriate handling of magical objects, inappropriate visits to sacred places, and even inappropriate glances at powerful individuals. Illnesses could result from personal transgressions and moral shortcomings, such as failure to perform expected ritual acts and mistakes that carried supernatural repercussions. They could result from neglect, but also from active maleficence. Illnesses could be caused by inadequate attention to the spirits that animated the world, conceived as dwelling within objects that we classify as both animate and inanimate. These could be caused by spirits and other supernatural beings who had no human manifestations. Illnesses could be caused by deities, including the forces of nature (such as thunder, lightning, or wind) and celestial bodies (the moon, stars, and planets). They could also result from the deliberate acts of maleficent individuals, including witches and sorcerers. These were "dark shamans," active practitioners of assault sorcery (Whitehead and Wright 2004), whose power could be focused on specific individuals or groups and could affect the weather to cause floods, droughts, earthquakes, and other natural disasters.

Buchillet (2004) outlines a number of sources of illness identified by the Desana, such as breaking dietary or hunting rules, failure to properly invoke and thank animal spirits, and neglecting to utilize protective spells in dangerous situations. Illnesses could be caused by malicious sorcery, including the use of poisons, spells, and magical darts or other pathogenic objects that could be "cast into" a person or became lodged in the body.[1] According to the Desana, sorcery happens because of jealousy and transgressions of implied reciprocity, "refusal to give or to lend something, meanness, insults, anger, or vengeance from some harm or

injustice done to the victim" (Buchillet 2004:116–117). Competition over wo-men and refusal of matrimony by a woman or her parents could be the cause of sorcery. The failure to engage in reciprocity or to adequately "pay" for something through an appropriate exchange or sacrifice was especially hazardous, perhaps because of its potential to become manifest in human consciousness as the emo-tion of shame. "A headman or political leader with great visibility, a *yee* or a *kumu* known for his frequent successes in therapy or even a master of dances and chants (*barí*) can also become the object of envy, resentment, and other antisocial senti-ments" (Buchillet 2004:117) and hence the object of assault sorcery. Lack of respect could also draw malicious magical attacks. Buchillet notes, "Various epi-demics of malaria or diarrhea that, in the past, devastated specific communities of the region were attributed to the ill will of a yee or of a kumu, who was angered because he felt that he had not been shown respect or because a member of his own family refused to give him something he asked for" (Buchillet 2004:119).

Illnesses could also be linked to the concept of animal co-essences. Vogt (1965) has amply documented the relationships between the notion of "soul" and social control among the Tzotzils of Zinacantan. He describes the Tzotzils as believing in two important entities: a *ch'ulel* or "inner soul" (plural *ch'uleletik*) and a *chanul* or "animal spirit companion" (plural *chanuletik*), the latter referred to by the term *vayijel* among the Tzotzil of Larraínzar (Holland 1964: 303). The ch'ulel is an indestructible and eternal soul that resides in the blood and is thus connect-ed to the heart; it is placed inside an individual at the moment of birth by the ancestral deities, or *totilme'iletik* (singular *totilme'il*). The ch'ulel is shared by the individual person and the individual's chanul, and thus they share the same fate: whatever happens to one will happen to the other. Also, the ch'ulel is transmitted from individual to individual within a patriline: at the moment of death, a per-son's ch'ulel will rest for a period of time equal to that of the number of years that person lived, after which his or her ch'ulel—and the corresponding chanul—will be transmitted, possibly with the deceased ancestor's name as well, to a descen-dant or to someone else within the patriline. The recipient of the ancestral ch'ulel/chanul package becomes a *k'exolil* or "substitute" for the ancestor. For this reason the ancestral deities are in charge of guarding the individual's chanul in a series of corrals located in the most sacred mountain of all, a volcano called *banki-lal muk'ta vits* or "senior large mountain." Each of the 7,600 inhabitants of Zinacantan at the time of Vogt's writing contained a chanul inside one of these corrals. A *muk'ta 'alkalte* ("great alcalde") deity, as a "celestial counterpart of the highest ranking member of the religious hierarchy in Zinacantan" (Vogt 1965:34), supervises the totilme'iletik in their task. Now, the ch'uleletik and the chanuletik are crucial to the health of the individuals in the town, and in fact, of

the town itself. Each ch'ulel is divided into 13 parts, in parallel with the 13 layers of the world in Tzotzil cosmology, suggesting indeed a close association between the body, in this case the ch'ulel contained within the body, and the structure of the world; harm could possibly be inflicted on one or more of these parts, as a result of *xi'el* ("fright") which leads to "soul loss," or as a result of a person's chanul leaving the sacred corral where it is guarded. The latter type of causal factor is usually the result of an individual breaking a moral code that causes affliction to the community, leading the ancestral deities to punish that individual by letting his or her chanul wander outside of the corral, and could therefore be considered a macro-illness, or the result of a sorcerer who carries "a witchcraft ritual in a cave to 'sell' one or more parts of a victim's ch'ulel to *yahval balamil* ('earth-owner')," who then uses the victim of the sorcery as his servant. Whatever the cause, such loss of soul leads to sickness or *chamel*, which can only be treated and cured by a *h'ilol* ("curer," literally "seer"; plural *h'iloletik*), who communicates with the ch'ulel by pulsing the victim's hand to communicate with his or her soul-carrying blood (*pik ch'ich'*). And again, some of the cures, particularly those for soul loss resulting from social transgressions punished by the ancestral deities, involve the community as a whole. Gossen (1994) also notes that the most common source of illness in Chamula is harm to the chanul or animal soul companion, who "shares every stroke of fortune that its human counterpart experiences."

Houston and Stuart (1989) have documented co-essences in ancient Maya thought, and these may have been associated with illnesses. There are several *wayob'* mentioned on pottery vessels who carry the glyph for "death" or "dead" as part of their name. Interestingly, the term *chäm* ("to die") can also be used to derive a term for "illness," as with Tzotzil *chamel* "sickness." Various such wayob' are cataloged by Grube and Nahm (1994:704–707), who translate them roughly as follows, although one of the authors (Mora-Marín) has adapted their transliterations to make them consistent with Proto-Ch'olan etymologies as much as possible for consistency:

ta(h)n(-al) b'ih-il chäm-i 'on-the-road death'

. . . *xin-il chäm-i* 'stinking death'

uk-w-i chäm-i '?' 'death'

k'ahk'(-al) ohl chäm-i 'fire-center death'

chächäk ch'äj chäm-i 'red bile death'

These imply that some Maya *ajawo'b*, a category that combines aspects of both shaman and warrior, may have used sorcery to cause disease and employed illnesses as weapons (Figure 11.1). The most threatening were instances of illnesses that affected whole communities.

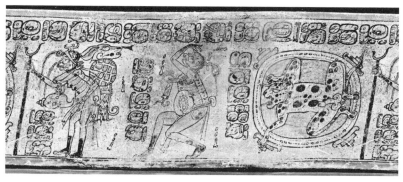

FIGURE 11.1. Disease-throwing *wayob'*: Late Classic Maya vase painting. (Drawing by Mora-Marín after Kerr 771; Photograph K771, detail © Justin Kerr.)

HIERARCHIES OF ILLNESS

Community-wide and universal illnesses can be conceived as "macro-illnesses," analogies of personal disease on a larger scale. "Macro-illness" is here defined as the application of non-biomedical models of individual illnesses and the metaphor of the human body to conditions that affect a community as a whole or even the world and the universe at large. What was construed as community-wide illness could be the simultaneous affliction of several individuals by the same physical ailment. However, the concept of "illness" could also be extended to the

well-being of the community as a whole. Natural disasters such as floods, climatic extremes such as droughts, and even generalized psychic malaise would be manifestations of "disease writ large."

Many diseases would have been familiar at both the micro- and the macroscale. For example, diarrhea was a watery illness that was undoubtedly a common occurrence in pre-Columbian societies, especially in urban settlements such as Teotihuacan and Tikal. The "macro-illness" equivalent of diarrhea would be excessive, torrential rain resulting in flooding. In fact, the contamination of water sources as the result of floods would have increased the incidence of diarrhea, contributing to the perception of an illness that affected an entire community. There was a close relationship between human behavior or illness and climatological phenomena. This is what made the release of blood effective in magic related to rain. Johannes Wilbert (1996) has documented the practices of weather shamans, who understood associations between climatological phenomena and diseases and worked to heal communities by altering the weather, among the Warao of the lower Orinoco River region in northern Guyana. Dry skin and high fever as a personal illness would have a macro-illness equivalent of drought and excessive heat. Winds, in particular, were thought to bring illness and could be controlled by individuals blowing into storms. Individuals who could control the weather could also control disease.

Sources of macro-illness would have included enemy sorcerers, who were assigned responsibility for widespread malaise and misfortune. Individuals at the top of the hierarchy of healers also had the ability to create "disease writ large," and the employment of violence in curing macro-illness resulting from maleficent magic would have been a powerful motivation behind both magical and physical warfare. Within the idiom of disease and healing, identifying the malefactor was a diagnostic procedure.

THE BODY AS METAPHOR FOR THE WORLD

Diagnosis requires an intimate knowledge of the geography of illness at the levels of the cosmos, the world of everyday life, and the body. In the cosmology of many indigenous cultures of the Americas, the human body, with its organs, fluids, and natural processes, was used as a metaphor (or even a simile) for the universe (Houston et al. 2006). Bubbles in flowing water are depicted as eyes in Teotihuacan iconography, and in ancient Maya art it is common for trees to have human faces. The *Popol Vuh* is replete with cosmological references to the human body, naming locations such as the "Heart of Sky" as well as a "Blood River" and "Pus River" in Xibalba. Depictions of *witz* monsters as skulls created metaphorical associations between features of karst topography, such as hills and caves, and anatomical parts

such as bones and teeth. Umbilical cords represent connections between humans and the cosmos (Looper and Guernsey Kappelman 2001).

Metaphors of the human body permitted the ills of the world to be confronted as if they were illnesses of a human body. All healing took place within a larger metaphor of the ongoing process of creation, a process that was related to both birth and death. Healing, including through acts of violence, was a part of the ongoing perpetuation of creation. Ultimately, through death came life. The conception of pregnancy as an illness had a counterpart in a macro-illness related to the birthing of the world in the cyclical process of cosmogenesis. For the ancient Maya, this was linked specifically to the cyclical sacrifice and rebirth of the Maize God.

HIERARCHIES OF HEALERS

Magic workers were ranked according to their skills at handling different kinds of illness. These were ordered according to a hierarchy, with individuals who dealt with their own personal ailments at the lowest level and leaders who sought remedies for worldwide or universal illnesses at the highest level. In Costa Rica, the Bribri/Cabécar had several different varieties of healers and magic workers. Among these were the *awás*, who dealt with personal illnesses, and the *usékars*, who dealt only with community-wide illnesses (Hoopes 2007). A similar hierarchy of magical healers undoubtedly existed in Mesoamerican thought, with rulers of individual polities—also the top-ranking magicians or sorcerers—addressing macro-illness.

Holland (1964:304) notes that the sacred mountain of the Tzotzil in Larraínzar is thought to contain thirteen levels. He writes:

> The companion animals of the elders and curers are lineage gods which occupy the highest levels of the sacred mountain. Like all Maya deities, their role is dualistic. On the one hand, they protect and defend their inferiors by providing for their physical needs and curing their illnesses, and in this capacity they act as intermediaries between man and the gods. On the other hand, they are responsible for maintaining the sacred traditions of their ancestors by punishing transgressors with witchcraft. In this capacity, they transform themselves into malevolent animals such as owls, hummingbirds, eagles, king vultures, butterflies, rainbows, whirlwinds, and balls of fire, and appear to their enemies as omens of death.
>
> The companion animals, or naguals, of the most powerful *principales* in Larraínzar occupy the most important seats in the 13th level of the sacred mountain. The companion animal of the paramount principal, a giant jaguar, has the most imposing position from which he consults directly with the ancestor gods in matters concerning the rule of his inferiors.

The diagnosis and treatment of disease could function at either a personal or a community-wide level, with different levels of practitioners addressing different levels of illness. The paramount ruler was charged with addressing the highest level of macro-illness. The rhetoric of healing social ills is still used in modern parlance with macro-illnesses such as Communism, terrorism, or even moral decay. Human sacrifice by individuals at the top of the social hierarchy was a method for eliminating macro-illnesses caused by maleficent sorcerers.

Diagnosis and Treatment

The concept of macro-illness and its diagnosis, together with metaphors of birth, sacrifice, creation, and order, help us to recognize a sequence of actions represented in pre-Columbian iconography. Diagnosis and treatment of macro-illnesses appear to be represented in the following sequence of awareness, empowerment, and healing:

1. Trance- and divination-related insight is depicted as meditation in a seated posture with closed or semi-closed eyes for the purpose of discerning the nature and cause of the illness. This was the first step in the assumption of a liminal, protected state toward supernatural empowerment. This step could be assisted by the ingestion of medicinal plants, including potent psychotropic agents.[2] It was often accompanied by fasting.

2. Diagnosis-related divination included discerning the genealogy of the course of disease, identifying how it was "born." When the disease was due to maleficent sorcery, discerning the ancestry of the malefactor was especially relevant for arriving at a course of action that would effect a cure.

3. Treatment began with a dance performance, often with snakes, which resulted in the actor becoming identified with the Axis Mundi at the center of the universe. This stage was an affirmation of lineage and power, drawing upon sources that could be traced to the events of the creation of the universe.

4. Physical transformation into an animal predator was asserted in order to exert personal power in direct defense of the community against the source of illness and to actively pursue and eliminate it.

5. The individual identified as the source of the illness was captured; this was followed by his confinement (a metaphor for pregnancy) and ultimate decapitation (a metaphor for birth). This was done

along with ritual bloodletting and purification by water in the form of rain and storms. In so doing, there was a ritual birth representing an ongoing act of creation and cosmogenesis.

6. The power of the actor was celebrated through rituals and ceremonies, often associated with calendrical events and/or royal accession, as well as cosmologically auspicious astrological correlations.

7. The deed was commemorated with the creation of talismans, inscriptions, monuments, and stories to reinforce the power of healers and perpetuate their ability to manipulate psychology through the power of suggestion, especially terror and threats. It was in this process that both the myths and the imagery "came alive" and played a role in self-perpetuation.

The steps in this sequence were elements of a drama performed through a series of ritual postures and dances. They also became powerful themes in artwork, providing elites with the means to document and communicate their actions, as well as to reinforce adherence to supernatural beliefs which in turn enhanced their power to dominate and control.

The Role of the Healer

The practice of shamanism—here defined as a means of gaining knowledge through "techniques of ecstasy" that involved the soul's travel out of the body (Eliade 1964)—and physical warfare were intimately connected. The roles of shamans and warriors in pre-Columbian societies were not readily separated, especially when the illnesses being diagnosed and treated were ones that transcended the individual to include an entire lineage or community. This is due to the perception of warfare, including magical attacks, as an extension of the practice of healing. The power of shamans as healers varied from individuals concerned with individual diseases to those who addressed larger illnesses that affected the community as a whole.

One of the shaman's roles was to detect, identify, and cure illness. The process of diagnosis required divining the name, origin, and nature of the illness, while effecting a cure was often characterized as trickery or active defeat of the cause or source of the illness. This metaphor of diagnosis and defeat is one embedded in the Quiché *Popol Vuh*, in which the Lords of Xibalba—the embodiments of disease—are first named and later defeated through decapitation. The Hero Twins are both warriors and healers, creating a world that is healthier for humans through magical attacks on the sources of disease. From ritual combat, defeat, and decapitation came the origin of humans and the creation of our present world.

This metaphor establishes a cognitive framework for the actions of ajawo'b as healers, diagnosing the sources of illness or misfortune and confronting them directly through the use of metaphorical and physical acts, ultimately resulting in both metaphysical and physical sacrifice of the enemy, whose destruction in turn provided energy for birth and renewed life.

The methods of preparation for ritual warfare help illuminate the role of the shaman as both warrior and healer. Warfare took place on both supernatural and physical planes, with success in the latter ultimately dependent on success in the former. Therianthropy, the ability of a human to transform wholly or partially into an animal, was central to magical warfare. Its effectiveness was due in large part to a psychological manipulation of human emotions. Shamans were masters at using the power of suggestion, using elements of memory and metaphor to provoke calculated responses. Maya *ajaws*, Costa Rican *usékars*, and South American jaguar-shamans (Desana *yee*, Patamuna *weytupok*, and so on) were feared and respected as beings with supernatural powers. Neal Whitehead (2002) has explained in detail how dread of supernatural attacks can provide an effective method of social control in the absence of a police force. Belief in the ability of shamans to detect illness by using supernatural means and to punish maleficence and moral transgressions through magical attacks was a powerful psychological tool. The ability to conjure and control supernatural power also played a role in pre-engagement psychological warfare, perhaps most importantly in its prevention through intimidation. The threat of physical attack and metaphysical annihilation was an effective method of peacekeeping and control through sustained deterrence.

Identifying the Source of Macro-Illness

The healing of diseases began with divining their sources and discerning which of many possible causes were responsible. Shamanic techniques, such as trance and transformation, were central to this process. In cases where witchcraft or sorcery was involved, one of the methods of response was organized violence in the form of warfare, including the capture and sacrifice of the maleficent individual. Metaphysical combat focused on the containment and even destruction of the evil-doer's animal co-essence, in order to protect the souls of the victims from further attack. However, what is classified etically as "organized violence" may have been interpreted emically as an act of creation analogous to birth—a concept not typically identified as "violence" in the Western mind.

"In Amazonia illness, ill-fortune and ill-weather are never natural events but always moral ones deriving from the transgressions of oneself or enmity of others and so only to be averted through shamanic action, especially by experienced and

politically senior men" (Whitehead, personal communication 2006). Discerning the cause of disease often means identifying individuals who are responsible for it. Wilbert notes,

> The idea is widespread in South America as it is elsewhere; sickness is held to be caused by human neglect of the supernaturals who vent their wrath by punitive pathogenic action. Warao weather shamanism also operates . . . on the basis of mystical retribution, especially where the code of altruistic conduct has been violated. The theory of spirit aggression is involved in this area because the rain lords' ire is deliberately caused by a shaman's conjuring." (Wilbert 1996:43)

The failure to act cooperatively, or to behave in ways considered immoral, could result in retribution from the ancestral gods, equated with the forces of nature. Individuals acting thus could thereby bring about illness at both an individual and a macro-illness level. Identifying these individuals and putting an end to their negative behavior was thus a method of diagnosis and treatment of illness.

Divining, Fasting, and Trance

Divining the source of illness required experience and skilled insight. This included the ability to discern the genealogy of the illness. Preparations to accomplish this end included fasting and trance states. The latter, also referred to as "altered states of consciousness" (ASC), are a basic methodology of shamanism. Trance served as an important method of diagnosis. By entering into a trance state, it was possible to have a clearer vision, to identify connections, and to draw upon intuition to gain insights. The Desana jaguar-shaman (yee) uses hallucinogenic snuff (yopó or *Anandenanthera peregrina*) to have direct contact with spirits and "is said to have the ability to transform himself into a jaguar in order to accomplish his goals.". Furthermore, "The yee is described as being able to see the illness inside the patient's body and to divine the cause of the evil, a capacity strictly associated in Desana thought with the inhalation of the hallucinogenic snuff" (Buchillet 2004:111). These hallucinogens serve as a concrete aid to enhance intuition. They may have a physiological basis in facilitating apophenia, the perception of connections between seeming unrelated elements. Neurophysiological research suggests a relationship between elevated dopamine levels and apophenia, a heightened perception of connections and significant relationships among apparently unrelated phenomena (Brugger 2001). An apophenic state enhanced an individual's ability to intuit or "divine" relationships (or perceived ones) that would not otherwise be readily apparent.

Fasting is a prerequisite for many rituals, including the crafting of wooden gods by a priest, as recounted by Landa (Tozzer 1941:160). In the curing chants of the

Bacabs, these terms for "fasting" and "night" are clearly related to the concept of birthing (Schele 1993:2), as when the *h-men* or healer asks of the disease he is confronting: "When you were born, who was the lord of your creation? Who was the lord of your darkness?" The healer then identifies the creator of the disease, as in the case of the incantation for "jaguar-macaw-seizure": "The Great-Sun-Lord, Blindfolded Face of the Sun, created you." And following this, the healer explores the genealogy of the disease, identifying its birth mother and birth father. Thus, the process of healing requires that the healer recognize who created the disease, as well as their genealogy. This shows that birth and genealogy are not just metaphors, but in fact instrumental models for healing. Also, the reference to "fasting" suggests that birthing and creation were conceived of as a result of ritual action.

Healing as Creation and Birth

The association of childbirth, sacrifice, and cosmogenesis is vividly portrayed in the Late Preclassic mural of the explosive, bloody birth of the Maize God in the center of a quincunx of babies portrayed next to images of male genital bloodletting at San Bartolo (Saturno et al. 2005). In Classic Mayan writing, the glyph T712, representing a piercing instrument used for bloodletting, is a logogram for **CH'AB'**, "fasting, to fast" (Figure 11.2).[3] As such, it is used in the narration of events that are often accompanied by scenes of ritual bloodletting. While *ch'ahb'* ("fast") does not mean "to let blood," it probably was used to refer to the entire ritual process that included the bloodletting act, given that fasting or abstinence were prerequisites for such ritual acts. Interestingly, T712 **CH'AB'** is also used in parentage statements, as a "child of parents" glyph. Consequently, the glyph reflects the same association with ritual and birthing or creation that is apparent in the *Ritual of the Bacabs*. In fact, David Stuart and Stephen Houston (personal communication, 1995) have observed that in certain ritual implements, such as the corpus of jade belt plaques, the glyphs T712 **CH'AB'** "fast, abstinence" and T841 **AK'AB'(AL)** "night(/darkness)" make up a couplet, just as in the *Ritual of the Bacabs*. Given the review above, it is apparent that this couplet refers to birth or creation, by alluding to ritual action (*ch'ahb'*) and to the night or darkness (*ahk'äb'(-al)*) during the moment before creation.

Interestingly, the Mixtec creation story contains similar conceptual motifs. The Vienna Obverse Codex, for example, opens with a listing of these motifs (Boone 2000:90–91): foremost among these are prayer and offering, likely a couplet referring to ritual in general. This is consistent with the view that sustenance of the Creators and of Creation is provided through ritual: through prayers and offerings. Therefore, prayers and offerings are intrinsically related to the act of creation. The *Ritual of the Bacabs* (Roys 1965), in fact, bears this out quite transparently. Linda Schele (1993:1) analyzes this compilation of curing chants as thematically parallel

FIGURE 11.2. For T1.712 [841] collocation, read 7u-CH'AB [7AK'AB'](-li), for *u ch'ab', u yak'ab'* "its fasting, its darkness": *a*, Jade Museum, Costa Rica, jade plaque No. 2007 (INS 2007); *b*, Jade Museum, Costa Rica, jade plaque No. 4443 (INS 4443); *c*, Dumbarton Oaks quartzite pectoral glyphs C5-D6. (*Drawings by David Mora-Marín.*)

to the Classic Period accounts of creation discussed by Freidel et al. (1993). She argues that the curing chants in the *Bacabs* are made up of passages that "begin with a description of the moment of Creation that establishes time and place," followed by a recounting of "the genealogy, place, and context of the birth of the disease," knowledge that was crucial for the healer, the h-men, to be able to control the disease.[4] In Schele's analysis, it is clear that the curing chants open with a formulaic couplet describing the day 4 Ahaw, the day of the Creation event according to Freidel et al. (1993), as a day of <ch'ab> "creation" and <ak'ab> "darkness." Schele argues that <ak'ab> is a reference to the state of darkness evident at the moment of creation, not only as alluded to in the *Popol Vuh* ("how things were put into shadow"), but also as depicted in several ceramic vessels from the Classic Period. The term <ch'ab> denotes not essentially "creation" or "create" but simply "abstinence" or "fast(ting)," referring to a state of ritual purity. The meaning "to create," or more specifically, "to beget, to make out of nothing," is arrived at through derivational forms such as in <u ch'abtahoon Dios> "criónos Dios de nada (God created us out of nothing)" (Berrera 1980:120). Indeed, Kaufman and Norman (1984: 119) reconstruct *ch'ahb'* to Proto-Ch'olan with the basic, nominal meaning of "*ayuno*

(fast)", referring to the ritual act of fasting. They also reconstruct *ahk'äb' to Proto-Ch'olan with the basic, nominal meaning of "night." The meaning "darkness," both in Ch'olan and Yukatekan, is arrived at through derivation, in the forms ahk'b'-al and áak'b'-il, respectively. Consequently, the <ch'ab, ak'ab> couplet of the *Ritual of the Bacabs* seems to refer to "fasting, abstinence" and "night."

THE POETICS OF VIOLENCE AND THE CREATION OF FEAR

Neil Whitehead (2002) has described in detail the mythology and reality associated with the concept of *kanaimà* used to create an atmosphere of terror and control in rural communities in Guyana. The kanaimà is a maleficent "dark shaman" who, together with apprentices, transforms himself into a jaguar or other animal for the purpose of implementing assault sorcery in order to punish and destroy an enemy. The kanaimà created fatal illness by prolonged psychological torment, debilitation with poisons, and ultimately, a degrading attack that produced a slow, torturous death accompanied by humiliation. As Whitehead describes it, the practice is still very much alive in Guyana today. The kanaimà is jaguar-like in that, once his prey is identified, he will stalk and even "play with" his intended victim through actions that are designed to provoke extreme anxiety, terror, and both physical and psychological illness. The kanaimà will slowly poison his victim, initiating a process of a painful, wasting death. The graceless *coup de grace*, however, involves attacking the victim from behind, inserting a sharp, forked stick into the anus, forcefully withdrawing a section of the rectum and severing it so as to produce a prolonged, bloody, agonizing death. The ritual killing is not complete until the kanaimà visits the recent grave of the deceased and tastes a sample of the decaying corpse, in so doing destroying the soul of his victim. The details of a kanaimà attack are well known in the communities where these dark shamans reside. In fact, their effectiveness depends in large part on their use of terror to intimidate and debilitate potential victims. As Whitehead astutely observes, the kanaimà uses fear and the threat of violence to maintain social order. It is the horror of a kanaimà attack that inhibits gossip, fighting, sexual abuse, theft, and other antisocial behavior within rural communities. The reason for this is that the kanaimà plays the role of the authority of last resort in resolving interpersonal disputes. A person who wishes to see his neighbor dead can appeal, through intermediaries, to the kanaimà. However, in so doing, they can also become a potential victim.

The kanaimà constituted an effective system of social control in which individuals were coerced into moral behavior through the ever-present threat of violent death from supernatural causes. The kanaimà functioned as a kind of "godfather" in a system similar to that of the Sicilian *Cosa Nostra* or mafia. An individual who was

having problems—a daughter who had been raped or a farmer whose produce was being stolen from his fields—could communicate the details of the situation to the kanaimà by means of intermediaries. Through a reciprocal arrangement, the kanaimà would agree to extract revenge in return for a payment, services, or a continuing debt of unbalanced reciprocity. The ability of the kanaimà to effect a method of last resort to ultimate "justice" was one of the reasons this supernatural violence was tolerated and even supported. Occult violence, in the sense of being both hidden and supernatural, was a means of controlling populations through fear as well as a method of providing recourse for grievances when the individuals affected were not powerful enough to defeat the source of their troubles.

This system could be implemented at various scales. Just as a healer could identify and eliminate the source of a personal illness, a powerful magic worker could identify and eliminate the source of trouble or illness by targeting a maleficent individual or even an entire settlement or polity. Diagnosis of personal disease often required identification of the person (a witch or sorcerer) who was causing the illness. Diagnosis of a macro-illness, such as a flood, drought, crop failure, or epidemic of physical or psychic maladies, was undertaken by a healer at the top of the hierarchy, such as an *ajaw* with magical powers (a "shaman king"). In ancient Maya society, the ajaw may have assumed a role analogous to (but within a different social hierarchy than) that of the Patamuna kanaimà, fostering an atmosphere of apprehension while simultaneously offering both diagnosis and remedy, together with the threat of retribution against enemies.

While the specific example of kanaimà occurs in the small, tribal societies of Guyana, such processes may also have been used to give power to the leaders of more complex chiefdoms and states. A Mesoamerican ruler who promulgated the mythology of an animal co-essence—implying, as does the kanaimà, that he can transform into a jaguar, bird, crocodile, snake, or other animal in order to gather information and mete out justice—had a powerful tool at his disposal for maintaining order. Animals encountered in the forest were not animals, but humans in animal form. Powerful individuals, especially the ajawo'b, were not humans, but primordial animal beings in human form. The issue was not one of a human turning into an animal or vice versa, but a being whose true nature was comprised of both. It was this supernatural nature that qualified an individual to be a powerful healer, not only of personal illnesses but of macro-illnesses brought about by other beings with similar natures and abilities. Among the causes of floods, droughts, crop failures, economic reversals, and so forth were the actions of dark shamans or maleficent sorcerers, whose capture and sacrifice was a specific methodology for effecting a macro-cure. At a personal level, individuals were affected by the "illness" of pregnancy, whose "cure" by a midwife was the release of

the infant and its spirit companion in an act of traumatic, bloody violence. At the level of macro-illness, this could become an act of cosmogenesis, a replay of the birthing of the universe, with all of its metaphorical associations.

Representation as the Axis Mundi

In order to effect a cure to an illness, it was incumbent upon the shaman to demonstrate his qualifications and to assert his abilities. At a personal level, this could be accomplished with sleight-of-hand and other demonstrations of magic. At a community-wide level, it was effected through public performance. A critical element of this was the actor's presentation of himself as the Axis Mundi. For the Maya, this consisted of self-representation as the World Tree or the stalk of the Young Maize God.

The standing posture of the "Charlie Chaplin" figures evokes this notion of standing erect at the center of the universe (Figure 11.3) (Mora-Marín n.d.). This stance probably represents a critical moment in a dance performance. One of its elements is the representation of the performer as a creator or parent with ambiguous or dual sexual identity (Looper 2002:177). As Looper notes, "As any farmer knows, the distinct male organs (the tassel) and female organs (ears and silks) of maize occur on the same plant. Maya rulers may have seen themselves as analogous to the corn plant, alternatively able to fertilize and give birth" (Looper 2002:181).

The notion of parenting and creating, including an ambiguity or substitution of gender roles, is central to the representation of a ruler's role in cosmogenesis. These include identification of the ruler as midwife or even as birthing mother. Stone (1992) also observes that kings were sometimes portrayed holding children, a theme that can be traced back to Olmec art and is associated with depictions in which kings hold the ceremonial bar, an instrument often linked to double-headed zoomorphic creatures in Classic Maya art. Ruler portraits, including the ceremonial bar motif, are often characterized by a bent-arm, "crab-claw" hand position. The crab-claw/bent-arm gesture characteristic of the Ruler-as-Axis-Mundi posture is suggestive of gender duality or ambiguity. Stone argues that these images are meant to show the ruler as "guardian" or "parent" of the sky (that is, cosmic order), the latter symbolized by the ceremonial bar, which often is a blend of a double-headed zoomorph with a sky-band motif.

Erich Fox Tree (personal communication, 2005) has explained to one of the authors (Mora-Marín) that the crab-claw/bent-arm gesture is actually the sign for "woman" in several sign languages from the Maya region. That this gesture, one clearly associated with gender duality in Maya art, should become linked,

FIGURE 11.3. "Charlie Chaplin"-style figures in jade from both the Maya area and Costa Rica: *a*, Kerr Portfolio 3705; *b*, jade figurine from cache under Hieroglyphic Stairway of Structure 10L26 *(after Freidel et al. 1993:243, fig. 5:5c)*; *c*, jade carving, Hakiuv, Costa Rica *(after Benson 1981)*; *d*, "Young Lord," Olmec; *e*, Leiden Plaque *(after Schele and Miller 1986:36, fig. 12; 121,pl. 33)*; *f*, Stela P, Copán *(after Fash 1991: fig. 51)*; *g*, *(after Museo Nacional de Antropología 2004:198)*.

from early on, to the ritual creation of the Axis Mundi, is strongly suggestive of the importance of birthing as a key conceptual framework for ritual practices in the Maya region. This gesture is also clearly associated with women outside the Maya region—for example, in a recently published Aztec-style sculpture (Figure 11.3g) and in several Costa Rican–style jade figures closely related thematically to

the so-called Charlie Chaplin theme (Mora-Marín n.d.), some of which are clearly female.

THERIANTHROPIC TRANSFORMATION

The concept of the *nagual, tonal, way,* or animal co-essence was widespread not only in Mesoamerica, but across broad regions of the New World, extending into southern Central America, northern South America, Amazonia, and the Central Andes (Figure 11.4). It was also present throughout most of North America, with specific examples including the bird-man of the Mississippian Southern Cult and the cannibalistic *windigo* of historic Athapaskan cultures. Some of its clearest and earliest manifestations are in the iconography of the Cupisnique and Chavín cultures of northern Peru, where sculptures at sites on the coast such as Pampa de las Llamas-Moxeke and in the highlands at Chavín de Huántar depict anthropomorphic beings with fanged faces and sharp claws. The former may date as early as 1800 B.C., while the temple at Chavín de Huántar has recently been redated to as early as 1100 B.C. (Kembel 2001). The "Goddess" figure at Teotihuacan, depicted as a faceless beast with huge claws, may be a representation of the therianthropic co-essence of a Teotihuacan ruler as well as a deity. The open mouth and scrolls containing bell-shaped flowers suggest the use of *ololiuqui* (*Rivea corymbosa*), a hallucinogenic morning glory (Hofmann 1971; Schultes 1941), or perhaps the hallucinogenic moonflower (*Datura* spp.) (Schultes and Hofmann 1980). The reptilian headdress depicted on the Feathered Serpent Pyramid (Taube 1992) and also appearing on monuments such as Stela 31 at Tikal alludes to an alter ego or co-essence. The iconography persists until the time of Spanish contact and beyond, with the concept of animal co-essences as well as witches and sorcerers who cause disease remaining common in Latin America even today.

Among the earliest examples from Mesoamerica are the Olmec "transformation figures" carved in jade and greenstone, as represented in the collections of Dumbarton Oaks (Reilly 1989; Taube 2004) and elsewhere. However, there are many others. In Maya art, representations are more subtle, with animal co-essences indicated by appended ears, paws, or other animal parts within a rich assortment of beings (Grube and Nahm 1994). Skins and palanquins are frequently used to suggest jaguar, crocodile, and eagle animal co-essences. Maya rulers were sometimes referred to as *wayal* or *wayas* or *wayab'* (for example, *b'aklel wayal* as part of Chan B'ahläm's name at Palenque), terms that refer to shape-shifters or sorcerers (Houston and Stuart 1989). It is therefore clear that rulers could transform into their co-essences and that, in some cases, such ability was central to their charismatic legitimation.

FIGURE 11.4. Therianthropic beings from Mesoamerica, Costa Rica, and Colombia: *a*, Olmec transformation figure, Mexico (*after Benson and de la Fuente, 1996: fig. 70*); *b*, anthropomorphic jaguar, Guatemala (*after Benson and de la Fuente 1996:94*); *c*, Olmec transformation figure, Mexico (*after Benson and de la Fuente 1996: fig. 68*); *d*, jade carvings, Costa Rica (*after Soto 1996, Cat. 1928*); *e*, stone sculpture, Costa Rica (*after Jones 1998: fig. 50*); *f*, stone sculpture, Costa Rica (Denver Art Museum); *g–i*, stone sculpture, San Agustín, Colombia (*after Duque 2000*).

In Costa Rica, therianthropic beings are commonly depicted in freestanding sculptures from sites such as Las Mercedes in the Caribbean lowlands (Mason 1945), on "flying panel" metates from the central highlands, and in peg-based statues from the Diquís region (Lothrop 1963). They are often represented holding trophy heads, a clear association between therianthropic transformation and decapitation. The iconography of central Panama is replete with images of anthropomorphic beings depicted with fangs and claws. These are especially prominent in the gold and polychrome ceramics from Sitio Conte, where the most elaborate objects bear central decorations portraying a ferocious-looking being with fangs and claws (Labbé 1995). The artwork of the Upper Magdalena region of southwestern Colombia is replete with representations of individuals with fangs and claws (Duque 2000). Several of these figures are shown holding what appear to be infants or children (Figure 11.4i).

Stone-Miller (2004) argues "that the unified human-animal continuum presented throughout the art of the indigenous Americas flows from the high value placed on visionary experiences of animal transformation." These transformations had great value for explaining the role of magical actors and their enemies. While a person was believed to actually and fully transform into an animal, this was accomplished within a magical context. However, the two were simultaneous identities. Wilbert (1996:100), for example, notes that the Warao identify alligators as "something like the soul of the sorcerer," and he notes that "between the two there exists a nagual type of relationship: whatever happens to one—whether in dream or reality—inevitably happens to the other." Divining the identity and actions of an animal co-essence was the same as identifying the actions of an actual person. A magician or sorcerer could also act in the guise of an animal co-essence. Therianthropic transformation was therefore used to both diagnose and eliminate the causes of illness.

The concept of the nagual, from the Aztec *nahualli*, can refer to witches, shape-shifters, and animal co-essences. The glyphs for **ua-y(a)** or *way* have been deciphered in Maya texts (Houston and Stuart 1989). Nikolai Grube reported that Yucatec Mayas in Quintana Roo "called the animals in which the sorcerer transformed himself *u way*, 'his nagual'" (Coe 1992:256). It has been reported that "[a]mong the Yukatek-speaking Maya of Quintana Roo, the ancient concept of way—the spirit companion of gods, ancestors, kings, and queens—connotes an evil, transforming witch, a person to be feared rather than admired" (Freidel et al. 1993:192). While this may be part of the legacy of Spanish interpretation, "Modern shamans are always at least potentially sorcerers and witches because the same forces that can generate prosperity, health, and wealth can also generate poverty, famine, and disease. Shamans have to work at their craft to avoid arousing, even unintentionally, evil in the cosmos" (Freidel et al. 1993:193). It was the

perception that they were responsible for evil in the form of macro-illness that made specific individuals the targets of shamans seeking to cure them.

The specific etymology of *way* has been the topic of debate. Houston and Stuart suggest that it derives from the verbs "to sleep" and "to dream" (1989), which may be related to the concept of trance states. These dream or trance states were sometimes induced through the use of entheogenic plants that were eaten or administered via enemas. The association of the animal co-essence with trance and dreaming emphasizes how this entity operated in a liminal state, neither fully awake (in the physical world) nor asleep (in an imagined world), but in a magical space with elements of both, where perception and intuition were heightened—as in the consciousness of a wild animal. Traveling into this dream state as an animal provided a context for discerning and combating illness that originated in the behavior of other supernatural animal co-essences.

As Michael Heckenberger has noted for north-central Brazil, "Counter-witchcraft is . . . both a juro-political instrument administered through chiefs and prominent men, and . . . an ethnomedical technique applied by shamans and counterwitches to rid society of spiritual parasites and pathogens" (Heckenberger 2004:180). One of the most common techniques of witchcraft in Amazonia is transformation into a jaguar, often regarded as a form of assault sorcery (Whitehead and Wright 2004). For the Desana, the power of the jaguar-shaman resided in the head (Buchillet 2004). Decapitation was therefore the designated method of control and destruction. Bloodshed brought the process full circle.

However, a decapitated head could still retain vitality and power, as in the story from the *Popol Vuh* of the head of Hun Hunahpu impregnating Blood Woman with the Hero Twins. Although the Hero Twins "defeat" the Lords of Xibalba through trickery and decapitation, this was not the end of illness but a mythical procedure for healers to follow. Wright (2004:16 ff.) recounts a story told by the Baniwa of the northwest Amazon that tells how their neighbors the Guahibo acquired *ipithátem* (revenge killing magic). In ancient times, a shaman obtained *malikhai* (shamanic powers) and lost control of himself. He was transformed into an enormous, homicidal black jaguar who murdered even his own family. The shaman told others to destroy him by cremating his body. Instead, they cut off his head and threw it into the river. "The head floated downriver still with its brains and *the knowledge of how to cause all sicknesses and also how to cure them*. . . . [T]he Guahibo shamans called Dzauinaikada got the head, took out the brains, and got all the shamanic powers in them, thus learning all sorts of evil things. . . . *After they had learned al these things, they began to transform into jaguars, forest-spirits, and other animals; they threw sickness-giving spirit darts onto people and ate people*" [emphasis added]. Ancient Guahibo jaguar-shamans are considered to prowl Baniwa territory even today (Wright 2004:16 ff.). Transformation

into a jaguar gave an individual the power to diagnose and cure diseases, but also to cause them. In the context of non-biomedical models of disease transmission, jaguar-shamans and other animal/human beings were major sources of illness. The Baniwa story emphasizes how the power of the jaguar-shaman resides in the head, and that the head of the sorcerer is itself a source of magic.[5]

By transforming himself into an animal (typically a jaguar, a crocodile, a harpy eagle, a vulture, a bat, or a snake), a shaman (or shaman/king) was able to act in a supernatural context in order to identify the source of illness—a form of supernatural espionage. This method produced a non-biomedical diagnosis of a macro-illness. Illnesses caused by maleficent magic workers (enemies construed as witches, sorcerers, and harmful therianthropic beings) could be resolved by capturing and decapitating the person who was actively causing the illness, in the process providing a pretext for warfare. The decapitation itself was both an end and a beginning, as indicated by its association with birth.

Capture, Decapitation, and Trophy Display

Decapitation plays a prominent role in the defeat of maleficence. The capture and decapitation of the enemy and the display of the decapitated head therefore form a principal element in the ritual sequence of the defeat of disease (Figure 11.5). While decapitation was a very specific method of terminating the maleficent power of an embodied source of illness, it was also tied to acts of rebirth and generational succession. In the *Popol Vuh*, Blood Woman (Xquic) is impregnated by the decapitated head of Hun Hunahpu—the Maize God—and gives birth to the Hero Twins, who in turn decapitate the Lords of Xibalba and oversee the rebirth of the Maize God.

Bloody decapitation was associated with fertility and cosmogenesis. Schele and Mathews (1998:146) note that the six streams of blood that spurt from the neck of a decapitated ballplayer at Chichén Itzá stand for the "Wak-Kan," the World Tree that was raised upon the rebirth of the Maize God to establish cosmic order. From the same severed neck emerges a vine bearing squash, an allusion to fertility and the "cosmic umbilicus" (Looper and Guernsey Kappelman 2001). This recalls the squash that was substituted for the decapitated head of Hunahpu in an episode from the *Popol Vuh*. When the squash is smashed during a ballgame, its seeds scatter and sprout.

Decapitation is associated with specific celestial events. These include the disappearance of Venus, which is reborn as the morning and evening stars, and with eclipses of the moon. Decapitation and birth were also metaphors, respectively, for the setting and rising of the sun. Decapitation imagery and mythology is also associated with eclipse cycles (Milbrath 1999:130). For example, Milbrath

FIGURE 11.5. Maya warrior in tribute-presentation theme. Note that the leader of the gifting party has two trophy heads dangling from his belt (see detail at top). Late Classic Maya vase painting. (*Drawing by Mora-Marín after Kerr 558; Photograph K558, detail © Justin Kerr*).

(1999:116, 121) associates the decapitated jaguar depicted on Yaxchilan Lintel 26 with a lunar eclipse.

Therianthropic beings have a specific association with decapitation. Anthropomorphic jaguars and crocodiles are frequently depicted holding decapitated heads in the pre-Columbian art of Costa Rica (Figure 11.6) (Hoopes 2007). In Maya iconography, the Water Lily Jaguar is frequently associated with decapitation (Milbrath 1999:124). His characteristic vines allude to the hallucinogenic effects of the white lotus (*Nymphaea alba*) as well as rainy-season fertility and the cosmic umbilicus.

FIGURE 11.6. Individuals with trophy heads from Costa Rica: *a*, man with crocodile skin markings, Azúl de Turrialba, Costa Rica (*after Deletaille and Deletaille 1992*); *b*, therianthropic being, Las Mercedes, Costa Rica (*after Mason 1945: pl. 35B*); *c*, therianthropic being, Diquís Delta, Costa Rica (*after Lothrop 1963: pl. XIIb*); *d*, therianthropic being, Diquís Delta, Costa Rica (*after Mason 1945: pl. 54C*).

Documenting the Procedure

The final stage in the cycle of assault sorcery was its documentation through the creation of stories, myths, and (in the case of the Maya and other literate groups) written texts. It was also represented in artwork. One of the principal functions of documentation was to reinforce belief in magic and assault sorcery through the perpetuation of memories and stories of traumatic death.

The effectiveness of magic depends on belief, just as the effectiveness of terrorism depends on the degree to which a population is terrorized. As Whitehead points out, "The physicality of violent assault cannot be limited to its destruction of human bodies but, necessarily, must also be related to the way violence persists as memory, trauma, and in the intimate understanding of one's self-identity" (Whitehead 2005). Artwork, especially on carved stone, provided a method for perpetuating memory. Izapa Stela 21, with a dramatic depiction of bloody decapitation, is an early example of how this was accomplished in the absence of texts. Another early example of this is La Mojarra Stela 1, which tells how a local ruler "chopped the head" of an enemy. Later examples, such as the murals at Bonampak, the stucco reliefs at Tonina, and the Great Ball Court reliefs at Chichén Itzá reinforced the mythology of violent death by decapitation.

BIRTH AND WAR

What is the relationship between birth and warfare? Both are experiences accompanied by bloodshed as well as physical and emotional trauma. Childbirth and warfare each presented respectively a significant probability of death for otherwise healthy adult women and men. A woman who has given birth passes through a transformation. Having risked her life to give birth to a child, she will never again be the same. Similarly, a warrior who has gone to battle and especially completed a sacrifice has also participated, through bloody trauma, in a ritual of transformation. These experiences leave permanent psychological signatures, undoubtedly correlated with the physiology of memory within the brain. There are also psychological relationships. Modern Western medicine now acknowledges a relationship between post-traumatic stress disorder (PTSD), first identified in U.S. soldiers fighting in Vietnam (although known as "shell shock" as early as World War I), and trauma and birth stress (TABS), a form of PTSD that results from a traumatic birth experience.[6] While each is the exception rather than the rule among warriors and mothers, the relationship may be analogous to pre-Columbian concepts of bloody experiences in war and birth. Among the common elements is the "reality" of experiences in a dreamlike or liminal state. Characteristic symptoms of PTSD include visionary experiences such as nightmares,

which occur while sleeping, and flashbacks, which occur during full consciousness. These psychological events seem to transport one back to the episode of trauma or induce realistic episodes in which elements of the initial experience are combined with new experiences. Both are accompanied by genuine sensations of terror and their accompanying physiological responses (rapid heartbeat, hyperventilation, vasodilation, cold sweat, and so on). They can be induced by trance-like states, especially in the presence of psychological "triggers" (images, sounds, smells, and the like). The ability to induce or manipulate these triggers is a key part of the repertoire of shamans, sorcerers, and other magic workers. Similar skills, especially for coping with anxiety and extreme pain, are also part of the training of a midwife (Figure 11.7) (McClenon 2002:53–57). It is therefore important to consider that both organized warfare and the birthing process include spiritual, psychological, and physical struggle and its resolution.

The ancient Maya frequently linked the violent acts of birth and warfare. Chac Chel, "Lightning Rainbow" or the Old Moon Goddess, was a midwife and a warrior with mythological links to both destruction and creation. She was a sorceress who controlled the weather, causing thunderstorms and devastating floods. It is she who released a flood at the end of the Third Creation. This was followed by her presiding over the birth of the Fourth Creation. Chac Chel is often depicted with the ears of a jaguar or wearing a headdress with jaguar ears and is also sometimes shown with jaguar paws. This suggests that she had therianthropic powers and links shape-shifting with midwifery. Schele (1997:164), in her comments on a Jaina figurine depicting Chac Chel, notes, "The rectangular war shield carried by this old goddess may seem out of place for a midwife, but the Lower Temple of the Jaguars at Chich'en Itza shows other old goddesses dressed as warriors and carrying weapons. She, like God L, her associate, was a warrior deity." Chac Chel also appears on a vase depicting birthing (Taube 1994). The trauma of birth and the trauma of war and sacrifice may also have been linked in Maya cosmology. The release of amniotic fluid that precedes a birth may have had a metaphorical link with Chac Chel's release of a great flood, while the bloody process of birth itself, including lifting a newborn baby, was analogous to decapitation, the release of copious amounts of blood, and the elevation of a severed head. Each was a painful and dreaded but necessary act that was required for the perpetuation of the order of the world.

For the Aztecs, parturition and warfare were clearly related. Clendinnen notes, "For those who emerged victorious from the struggle, the warrior metaphor was still insisted upon, the midwife greeting the newly delivered child, the little 'captive', with war-cries, while praising the panting mother for her warrior's courage" (1991:175). The Aztecs considered women who had died in childbirth to be analogous to warriors who had died on the battlefield. The latter

FIGURE 11.7. Shape-shifting midwives and birthing/creation goddesses: *a*, Goddess O, the Birth Vase, Side 1 (*after Taube 1994, fig. 2a*); *b–c*, Goddess O, Late Classic Maya vase detail (*after Taube 1994: fig. 2c*); *c*, Chac Chel, Jaina figurine (*after Schele 1997: pl. 3*); *d*, Chac Chel, Column A3, Lower Temple of the Jaguars, Chichén Itzá (*after Schele and Mathews 1998: fig. 6.11*); *e*, Aztec Earth Monster, greenstone relief, Templo Mayor, Mexico (*after Pasztory 1983: pl. 98*); *f*, (*after Pasztory 1983: pl. 282*); *g*, Aztec stone beaker, relief carving (*after Pasztory 1983: pl. 282*); *h*, Aztec female deity, greenstone relief, Mexico (*after Pasztory 1983: pl. 106*); *h*, Aztec Earth Monster (Tlaltecuhtli) (*after Covarrubias 1954: fig. 8*); *i*, Tlaltecuhtli, Aztec Calendar Stone, central relief, Templo Mayor, Mexico (*after Pasztory 1983: pl. 133*).

accompanied the Sun as it rose in the east, while the former accompanied its setting in the west (Smith 2003). A relationship between birth and war is suggested by the nature of Cihuacoatl, at the same time a goddess of birth, midwifery, and healing and the official title of the chief (male) war captain, a position reportedly created by Izcoatl and used by Tlacaelel (Smith 2003). This goddess "exhorted women to be like warriors when they expelled the baby from their wombs" (Schele and Mathews 1998:373 n. 65).

Another example of the conflation of birth with warfare is the Aztec story of the birth of Huitzilopochtli, who, according to certain myths, was able to divine the evil intentions of his sister Coyolxauqui and his brothers the Four Hundred Sons from within the womb of his mother Coatlicue. Huitzilopochtli prepares himself accordingly and emerges from the bloody process of birth as a fully armed warrior, engaging in battle with the cosmos (the Moon and stars) and emerging victorious as the paramount Sun deity. When a sunrise bathes the eastern sky in red, the Sun is "born," and the East is associated with the color of blood. Aztec human sacrifice and bloodshed for the perpetuation of the Sun's daily rising in the East is a regular commemoration of this event, as the Sun is reborn each day from the Earth, with Huitzilopochltli's bloody birth and battle occurring simultaneously beyond the horizon.

The association of birthing with warfare was not specifically Mesoamerican. For the Yanomami, the concept of *unokai* was used to refer to a menstruating woman (Whitehead, personal communication 2006) as well as a warrior who was successful in killing his opponent (Chagnon 1988). Fausto (2004:168) notes that, in the Amazon, "warfare rites and male initiations thrive on the analogy with the reproductive and transforming power of menstrual blood, and sometimes establishes an explicit connection between the shedding of the visitor's blood and menstruation." He interprets initiation and warfare rites as being "a kind of ritualized male menarche and a mode of male procreation." The ability of young males to shed blood is analogous to that of young females to menstruate, and although each process is fraught with ritual pollution, it is also a source of creative power. He notes that Warí treatment of killers is directly related to fertility:

> After the homicide the victim's blood-soul penetrates the killer's body and makes him fat, a fact that is compared to female pregnancy. During the seclusion the blood is digested and transformed into semen, which will inseminate the women. Homicide leads to the constitution of two rapports of filiation: an actual one (the killer fertilizes the women with the exblood, now sperm), and a spiritual one (the killer is conceived as the 'father' of the victim's spirit. (Fausto 2004:169 n. 29)

Birthing

The imagery of parental guardianship and female fertility is linked to sacrifice. For example, Stone (1992) points to the abundance of evidence regarding the significance of infant sacrifice. In addition, female symbols, in general, are clearly linked to bloodletting sacrifice, conducive to vision- and god-conjuring, which may take place as a prelude to war, as in the case of Lady K'ab'al Xook from Yaxchilan (Lintel 24).

Another important association of birth has been discovered by Freidel et al. (1993), who note umbilical cords are represented iconographically in Classic art, and that in such representations they serve as links between the sky, earth, and underworld.[7] Those authors also proposed that the Principal Bird Deity served as a conduit for the transmission of supernatural power between the sky and the earth. Taube (1994) has been able to demonstrate a strong link between the birth ropes and umbilical cords, both of which are clearly associated with women and birth, as well as with the ritual practices of the midwife, in addition to presenting new evidence supporting the hypothesis that the umbilical cords were thought of as the links between the worlds. Taube also explains that the cords may be represented as twisted and snake-headed, concluding, "Whether as umbilical cords or as the birth rope, the snakes are a clear metaphoric reference to birth, that is, the ritual summoning of supernatural beings into the human realm was considered as a process of birth" (1994:660). As Taube notes, Stuart (1988:192) has described how Dos Pilas Stela 25 bears a reference to the "birth" of the Paddler Gods as a result of the action by a Dos Pilas lord; the action, specifically, could not have been one of actual birthing, of course, but instead, one that could be thought of as birthing in a metaphorical sense. Stuart proposes that the act was one of bloodletting, adding that this relationship between birthing and bloodletting could explain why some male rulers wear female costumes in scenes of bloodletting; Taube (1994:660) adds that perhaps bloodletting from the penis was an imitation of "the pain and copious blood occurring at birth," and notes that "the rope often passed through the wounded genitalia probably represented the bloodied umbilicus emerging from the loins." Looper and Guernsey Kappelman (2001), for their part, have observed that the calendrical and astronomical evidence associated with the Principal Bird Deity and the umbilical cords are suggestive of rain-making rituals.

Birth and Female Identity

The imagery of birth is significant, because it suggests a motivation for the common adoption of female identity by Maya rulers, in a process akin to that of shamanistic transvestism, third gender, or "two-spirit" (Bacigalupo 2004; Brown

1997; Flaherty 1988; Looper 2002). Stone (1992:195) refers to this as "social impersonation" in Maya art and iconography, whether it is based on social position (for example, Palenque nobles impersonating captives) or gender (for example, the mention of Chan B'ahläm of Palenque as the "mother" of the Cross Group gods, the birth of the Paddler Gods "overseen" or "caused" by "Shield-God K" of Dos Pilas).[8] As noted by Houston (1996), the allusion to the birthing of the Palenque Triad is contextualized more concretely by references in the Cross Group texts to *pib'-nah* ("sweatbaths") and the architectural presence of such structures, which are commonly utilized in birthing rituals supervised by midwives. As observed by Freidel et al. (1993:102–107), by Taube (1994:674) in his study of the Birth Vase, and by Looper and Guernsey Kappelman (2001), the Birth-Rope-conflated-with-the-Umbilicus motif makes up the basic metaphor for understanding the link between the sky and the underworld through the center of the cosmos.[9]

Guernsey Kappelman and Reilly (2001) provide evidence for both avian and jaguarian interworld communication portals during the Middle and Late Preclassic Periods in the art of southeastern Mesoamerica, showing that these "cosmic cords" are present in Olmec art, both with communicative and transformative connotations. They suggest that avian imagery is perhaps more closely associated with rituals for communication with the sky, and jaguarian imagery with rituals for communication with the underworld. They also note that the point of such shamanic communication rituals would have been to attain esoteric knowledge, concluding, "In political terms, the cords also visualized the source of supernatural power that validated the unique position held by Formative Period rulers" (Guernsey Kappelman and Reilly 2001:47).

This supernatural power was the same power necessary for shape-shifting, and thus birthing was also associated with the concept of *way*, the co-essence of an individual that may be contained or manifested. Images of Chac Chel on the Birthing Vase depict her with jaguar ears and claws, indicating that midwives were also shape-shifters. An individual's animal co-essence is present from the time of birth. (The infant were-jaguar prominent in Olmec art may represent the initial birthing of the *way*.) Both birthing and therianthropic transformation, in turn, provided metaphorical links to the act of cosmogenesis.

Birthing as a Metaphor for Healing

For the ancient Maya, within a model related to birthing and genealogy, healing was understood at many levels as an ongoing process of creation. The *Popol Vuh* uses several metaphors to describe the Creator God, including metaphors of light, as in the allusion to "how things were put in shadow and brought to light,"

metaphors of birth and birthing, as in the epithets "the midwife, matchmaker" and "Bearer, Begetter," as well as metaphors of craftsmanship, as in the epithets "Maker, Modeler" (Tedlock 1985:71). The original mother was "she who gives birth to girls" and the father was "he who gives birth to boys." This Creator God exhibits a series of dualities, as illustrated by the "mother-father of life, of humankind" duality (Tedlock 1985:72). In addition, this creator felt the need to create "a giver of praise, giver of respect, provider, nurturer" (Tedlock 1985:79). Eventually, after several trials, humans came to fulfill this role. And it is through the giving of praise, of respect, through ritual practices such as incense burning and chanting, and the delivery of "payments" or gifts ("sacrifice" and "offerings") that humans provide for the gods, that humans nurture the gods. In so doing, they give birth to the world and usher it through endless cycles of death and rebirth.

SACRIFICE AND SUBSTITUTION

The concept of k'ex, or substitution, provides a central theme for the organization of violence related to healing, birth, and cosmogenesis. Taube, in his analysis of the Birth Vase (1994), noted an intimate relationship of birth and death imagery. He explains this through a discussion of the k'ex sacrifice, a substitution of one thing as payment for another. He notes, "In early Maya languages, k'ex signifies 'substitute' or 'exchange' and is also used in modern curing ceremonies to refer to the act of substituting a sacrificial offering for the patient" (Taube 1994:669). These offerings serve as "virtual decoys," attracting the attention of maleficent forces as a protective strategy. The symbolism of these offerings includes references to birthing. For example, Taube notes that contemporary Zinacanteco k'ex offerings include the use of a rope, alluding to the cosmic umbilicus.

K'ex sacrifices are used as offerings to the underworld, the source of death and illness. They are a way of maintaining equilibrium: "Just as the new child is brought into the world, something must be given in return to the gods of death and the underworld" (Taube 1994:669). K'ex sacrifices are associated with the dedication of a new house and with birth, both of which are metaphors for cosmogenesis. Taube notes that sacrifice scenes on Stelae 11 and 14 from Piedras Negras indicate that "the accession of the king was a form of birth, and as such, it required the k'ex offerings" (Taube 1994:672). Human sacrifice was also used in healing rituals. "The use of human victims in curing is recorded for the 16th-century Yucatec. Thus, there are reports that pairs of boys were sacrificed for the ailing Juan Cocom, a principal informant for Diego de Lanza. It is likely that these sacrifices constitute forms of k'ex curing rites" (Taube 1994:671 n. 9).

Generational substitution, the notion of the child replacing the parent, was a significant aspect of the concept of k'ex (Taube 1994:673). "Bringing the newborn into this world requires a replacement in the world of the dead: in this case, the deceased ancestor destined for the underworld is the k'ex for the newborn child" (Taube 1994:673). Taube cites a Huastec belief that some aggressive and dangerous fetuses yet in the womb can themselves be the sources of illness, and that their birth requires the death of another person.[10] Human sacrifice is payment for the rebirth of the cosmos. The metaphorical conflation of sacrifice and birth, with the principal actor as both warrior and midwife, is central to rituals of cosmogenesis. One implication of this is that places suitable for birth were also used for sacrificial rites. The sweatbaths-as-birthing chambers in the Cross Group at Palenque (Houston 1996) may have also been the loci for sacrifices-as-births.

Sacrifice, Childbirth, and Cosmogenesis

The act of bloody sacrifice-as-birth was intimately linked to the notion of cosmogenesis. As pointed out by Houston et al. (2006:89), in Mesoamerican thought, "time and space could not exist without acts of bodily sacrifice." Some hints as to the origins of the interlinked concepts may be found in the mythology of Tlaltecuhtli, an Aztec deity associated with bloody sacrifice, cosmogenesis, and childbirth. A myth of Tlaltecuhtli in the *Histoyre du méchique* (de Jonghe 1905) describes how this deity, in crocodilian form, was seized by Tezcatlipoca and Quetzalcoatl (who have transformed themselves into serpents) and ripped into pieces. One portion of this reptilian being became the sky and the other the earth, while the body became the source of streams, rivers, flowers, and trees (de Jonghe 1905). However, the earth monster "wailed for food, refusing to bring forth until she was saturated and satiated with blood and human hearts" (Clendinnen 1991:177). Tlaltecuhtli is most frequently depicted with an open, upturned maw, recalling the dragon's mouth on the sarcophagus lid at Palenque. Crocodilian earth and sky monsters and glyphic references to crocodile sacrifice, flowing blood, and concepts of creation suggest that the Classic Maya had a version of this Central Mexican mythology (Houston et al. 2006), although the details of this mythology remain unclear. Houston et al. (2006:93) note that an increasing body of evidence supports "the idea that, in their earliest manifestations, Maya day signs represent bloody objects ripped primordially from a sacred body," and that "[t]ime itself issues from a dismembered body, in most cases from a crocodile." The origins of day signs may be derived from mythology of the bloody "birth" of cosmogenesis, likened to a baby emerging from the womb and conceptually linked to the birth imagery of the Late Preclassic mural on the North Wall

at San Bartolo (Saturno et al. 2005). Houston et al. (2006:94–95) cite evidence for the conception of founding ancestors as sacrifices, associated with the origins of royal Maya dynasties, linked by representations of an iguana/crocodile to primeval sacrifice. Although the name of this deity is the masculine form of "Earth lord," Tlaltecuhtli was often represented as female, depicted in the squatting pose of childbirth, and has been interpreted as androgynous, hermaphroditic, or sexually ambivalent. Tlaltecuhtli was associated specifically with the pain of childbirth, and midwives "exhorted Tlaltecuhtli to come to their aid when an infant warrior threatened to kill the mother during a difficult labor" (Miller and Taube 1993:168). The metaphors of bloody sacrifice, childbirth, and cosmogenesis are all manifest in the mythology of a primeval crocodile, suggesting that a reptilian nagual or way would have been perceived as especially powerful in curing the ills of the world.

CONCLUSION

The diagnosis of macro-illnesses that were attributed to assault sorcery through rituals of trance and divination and the treatment and resolution of illnesses through therianthropic transformation and bloody sacrifice by decapitation represent a significant form of organized violence across a wide region of the Americas. This violence, an attack on agents of maleficence within the context of warfare, was couched within metaphors of birth and creation, with the shaman/ warrior exposing himself to violence, blood, and ritual pollution in a fashion analogous to that of a midwife. Violent curing was part of the replay of the events of cosmogenesis, with bloodshed and death paying the debt or being offered as a k'ex or substitute for rebirth, renewal, and good health. This was conceived as part of an endless and ongoing cycle, rather than a linear process with a beginning and an end.

The mental association of warfare with birth has structural elements in which male activities that require bloody, traumatic experiences parallel those of women in the act of birthing. Men experience the intensity of birth through warfare, which itself is an act of healing, renewal, and perpetuation of the world through an unfolding, cyclical process of creation. Both midwives and shaman/warriors were physicians who manipulated consciousness to resolve conflict, cure illnesses (including pregnancy), and in so doing, transform human experience.

NOTES

[1] The Desana identify illnesses by a form of the verb "to send to," "to give an order to," or "to command," implying that they are willfully sent by spirits or human malefactors (Buchillet 2004).

2 These would include tobacco (*Nicotiana rustica*) and a variety of mushrooms (*Psylocibe mexicana*), *yopó* or *cohoba* (*Anandenanthera peregrina* or *A. colubrina*), water lily (*Nymphaea alba*), morning glory (*Rivea corymbosa* and *Ipomoea violacea*), diviner's sage (*Salvia divinorum*), and marine bullfrog (*Bufo marinus*) in the Maya area and coca (*Erythroxylon coca*) and *ayahuasca* (a combination of *Banisteriopsis caapi* and *Psychotria viridis*) in northern South America.

3 Various epigraphers and art historians were instrumental in determining the value and variety of uses of T712, among them Barbara MacLeod, Stephen Houston, David Stuart, and Nikolai Grube. Mora-Marín (2001) suggests that the iconic motivation of T712 could implicate the term *ch'aach'ab'* ("perforator") as a linguistic source word, via the process of rebus logography, for the logographic value of T712 as **CH'AB'**. Mora-Marín in fact notes that in at least one instance from a perforator from Yaxchilan, the glyph is used as a label meaning "perforator."

4 Barbara MacLeod assisted Schele in the task of providing new translations of the *Bacabs* that would contextualize its curing chants in light of the Maya creation story proposed by Freidel et al. (1993).

5 The representation on Tikal Stela 31 of the ruler Siyaj Chan K'awiil II holding the head of a jaguar-shaman (often identified as the Jaguar War God) may allude to a similar story of the capture and decapitation of a powerful sorcerer. It may be the actual head of Great Jaguar Paw, the Tikal ruler deposed by his father Siyaj-K'ah in association with Yax Ayiin, whose co-essence appears to have been a crocodile or caiman, recalling an ancient rivalry between crocodile and jaguar *wayob'*.

6 Information from Trauma and Birth Stress, a charitable trust in New Zealand (*http://www.tabs.org.nz/*).

7 Previously, Miller (1974) had identified the presence of umbilical cords in the imagery at Tulum.

8 Stuart (1988:192) describes this allusion to a male ruler from Dos Pilas as responsible for the birth of the Paddler Gods.

9 At one end of this link is the sky portal or sky hole, which Freidel et al. (1993) propose is represented by the **IK'-WAY** glyph, referring to the zenith of the sky. At the other end of this link is the underworld portal, represented by the MAW of the underworld.

10 This concept has parallels in Amazonian beliefs concerning child sorcerers (Santos-Granero 2002).

References Cited

Bacigalupo, A. M.
 2004 The Mapuche Man Who Became a Woman Shaman: Selfhood, Gender Transgression, and Competing Cultural Norms. *American Ethnologist* 21(2): 440–457.

Benson, E. (editor)
 1981 *Between Continents/Between Seas: Precolumbian Art of Costa Rica.* Harry N. Abrams, New York.

Benson, E., and B. de la Fuente
 1996 *Olmec Art of Mexico.* Harry N. Abrams, New York.

Berrera Vásquez, A.
 1980 *Diccionario Maya Cordemex: Maya–Español, Español–Maya.* Ediciones Corde-
 mex, Mérida.
Boone, E.
 2000 *Stories in Red and Black: Pictorial Histories of the Aztecs and Mixtecs.* University
 of Texas at Austin.
Brown, L. B.
 1997 *Two Spirit People: American Indian, Lesbian Women and Gay Men.* Haworth
 Press, New York.
Brugger, Peter
 2001 From Haunted Brain to Haunted Science: A Cognitive Neuroscience View of
 Paranormal and Pseudoscientific Thought. In *Hauntings and Poltergeists: Multi-
 disciplinary Perspectives,* edited by J. Houran and R. Lange. McFarland and
 Company, Inc., North Carolina.
Buchillet, D.
 2004 Sorcery Beliefs, Transmission of Shamanic Knowledge, and Therapeutic Prac-
 tice among the Desana of the Upper Río Negro Region, Brazil. In In *Darkness
 and Secrecy: The Anthropology of Assault Sorcery and Witchcraft in Amazonia,*
 edited by N. L. Whitehead and R. Wright, pp. 109–131. Duke University
 Press, Durham, NC.
Covarrubias, M.
 1954 *The Eagle, the Jaguar, and the Serpent: Indian Art of the Americas. North Amer-
 ica: Alaska, Canada, and the United States.* Alfred A. Knopf, New York.
Chagnon, N. A.
 1988 Life Histories, Blood Revenge, and Warfare in a Tribal Population. *Science* 239:
 985–992.
Clendinnen, I.
 1991 *Aztecs: An Interpretation.* Cambridge University Press, New York.
Coe, M. D.
 1992 *Breaking the Maya Code.* Thames and Hudson, New York.
De Jonghe, E. (editor)
 1905 Histoyre du Méchique. *Journal de la Société des Americanistes:* 1–42.
Deletaille, E., and L. Deletaille (editors)
 1992 *Tresors du Nouveau Monde.* Musées Royaux d'Art et d'Histoire, Brussels.
Douglas, M.
 1991 Witchcraft and Leprosy: Two Strategies of Exclusion. *Man* 26(4):723–736.
Duque Gomez, L.
 1996 *San Agustín, Colombia: Patrimonio de la Humanidad.* 2nd. ed. Edición Arco,
 Santa Fe de Bogotá.
 2000 *San Agustín, Colombia: Patrimonio de la humanidad.* Editorial Arco, Bogotá.
Eliade, M.
 1964 *Shamanism: Archaic Techniques of Ecstasy.* Princeton, Princeton University Press.
Fash, W. L.
 1991 *Scribes, Warriors, and Kings: The City of Copán and the Ancient Maya.* Thames
 and Hudson, New York.

Fausto, C.

2004 A Blend of Blood and Tobacco: Shamans and Jaguars among the Parakanã of Eastern Amazonia. In *In Darkness and Secrecy: The Anthropology of Assault Sorcery and Witchcraft in Amazonia*, edited by N. L. Whitehead and R. Wright, pp. 157–178. Duke University Press, Durham, NC.

Flaherty, G.

1988 Sex and Shamanism in the Eighteenth Century. In *Sexual Underworlds of the Enlightenment*, edited by R. Porter and G. S. Rousseau. University of North Carolina Press, Chapel Hill.

Freidel, D. A., L. Schele, and J. Parker

1993 *Maya Cosmos: Three Thousand Years on the Shaman's Path*. William Morrow, New York.

Gossen, G. H.

1994 From Olmecs to Zapatistas: A Once and Future History of Souls. *American Anthropologist* 96(3):553–570.

Grube, N., and W. Nahm

1994 A Census of Xibalba: A Complete Inventory of Way Characters on Maya Ceramics. In *The Maya Vase Book*, Vol. 4, edited by B. Kerr and J. Kerr, pp. 686–715. Kerr Associates, New York.

Guernsey Kappelman, J., and F. K. Reilly, III

2001 Paths to Heaven, Ropes to Earth: Birds, Jaguars and Cosmic Cords in Formative Period Mesoamerica. *Ancient America* 3:33–52.

Heckenberger, M. J.

2004 The Wars Within: Xinguano Witchcraft and Balance of Power. In *In Darkness and Secrecy: The Anthropology of Assault Sorcery and Witchcraft in Amazonia*, edited by N. L. Whitehead and R. Wright, pp. 179–201. Duke University Press, Durham, NC.

Hofmann, A.

1971 Tonanácatl and Ololiuqui, Two Ancient Magic Drugs of Mexico. *Bulletin on Narcotics* 1:3–14.

Holland, W. R.

1964 Contemporary Tzotzil Cosmological Concepts as a Basis for Interpreting Prehistoric Maya Civilization. *American Antiquity* 29:301–306.

Hoopes, J. W.

2007 Sorcery and Trophy Head Taking in Ancient Costa Rica. In *The Taking and Display of Human Body Parts as Trophies by Amerindians*, edited by R. Chacon and D. Day, pp. 444–480. Springer, New York.

Houston, S. D.

1996 Symbolic Sweatbaths of the Maya: Architectural Meaning in the Cross Group at Palenque, Mexico. *Latin American Antiquity* 7(2):132–151.

Houston, S.D., and D. Stuart

1989 The Way Glyph: Evidence for "Co-Essences" among the Classic Maya. *Research Reports on Ancient Maya Writing* 30. Center for Maya Research, Washington, D.C.

Houston, S. D., D. Stuart, and K. A. Taube

2006 *The Memory of Bones: Body, Being, and Experience among the Classic Maya*. University of Texas Press, Austin.

Jones, J. (editor)

1998 *Jade in Ancient Costa Rica*. Metropolitan Museum, New York.

Kembel, S. R.

2001 *Architectural Sequence and Chronology at Chavín de Huántar, Peru*. Ph.D. dissertation, Department of Anthropology, Stanford University. University Microfilms International, Ann Arbor.

Labbé, A.

1995 *Guardians of the Life Stream: Shamans, Art and Power in Prehispanic Central Panamá*. University of Washington, Seattle.

Looper, M. G.

2002 Woman-Man (and Man-Woman): Classic Maya Rulers and the Third Gender. In *Ancient Maya Women*, edited by T. Ardren, pp. 171–202. Gender and Archaeology Series 3. AltaMira Press, Walnut Creek, CA.

Looper, M. G., and J. Guernsey Kappelman

2001 The Cosmic Umbilicus in Mesoamerica: A Floral Metaphor in the Source of Life. *Journal of Latin American Lore* 21(1):3–54.

Lothrop, S. K.

1963 *Archaeology of the Diquís Delta, Costa Rica*. Papers of the Peabody Museum of Archaeology and Ethnology 51. Harvard University, Cambridge.

Mason, J. A.

1945 *Costa Rican Stonework: The Minor C. Keith Collection*. Anthropological Papers of the American Museum of Natural History 39, Pt. 3. American Museum, New York.

McClenon, J.

2002 *Wondrous Healing: Shamanism, Human Evolution, and the Origin of Religion*. Northern Illinois University Press, DeKalb, IL.

Milbrath, S.

1999 *Star Gods of the Maya: Astronomy in Art, Folklore, and Calendars*. University of Texas Press, Austin.

Miller, A. G.

1974 The Iconography of the Painting in the Temple of the Diving God, Tulum, Quintana Roo, Mexico: The Twisted Cords. In *Mesoamerican Archaeology: New Approaches*, edited by Norman Hammond, pp. 167–186. University of Texas, Austin, TX.

Miller, M. E., and K. A. Taube

1993 *The Gods and Symbols of Ancient Mexico and the Maya: An Illustrated Dictionary of Mesoamerican Religion*. Thames and Hudson, New York.

Mora-Marín, D.

n.d. The "Charlie Chaplin" Silhouette Figural Theme: A Middle American Theme. Manuscript in the author's possession.

2001 The Grammar, Orthography, Content, and Social Context of Late Preclassic Mayan Portable Texts. Ph.D. dissertation, Department of Anthropology, State

University of New York at Albany. In *Dissertations & Theses: Full Text* [database on-line]; *http://www.proquest.com* (publication number AAT 3034877).

Museo Nacional de Antropología (Mexico)

2004 *National Museum of Anthropology, Mexico City.* Harry N. Abrams in association with CONACULTA-INAH, Mexico City.

Pasztory, E.

1983 *Aztec Art.* Harry N. Abrams, New York.

Reilly, F. K., III

1989 The Shaman in Transformation Pose: A Study of the Theme of Rulership in Olmec Art. *Record of the Art Museum of Princeton University* 48(2):4–21.

Roys, R. L.

1965 *Ritual of the Bacabs.* University of Oklahoma Press, Norman.

Santos-Granero, F.

2002 Saint Christopher in the Amazon: Child Sorcery, Colonialism, and Violence among the Southern Araway. *Ethnohistory* 49(3):507–543.

Saturno, W. A., K. A. Taube. and D. Stuart

2005 *The Murals of San Bartolo, El Petén, Guatemala,* Part 1: *North Wall.* Ancient America 7. Center for Ancient American Studies, Barnardsville, NC.

Schele, L.

1993 Creation and the Ritual of the Bakabs. *Texas Notes on Precolumbian Art, Writing, and Culture* 57:1–10.

1997 *Hidden Faces of the Maya.* Alti Publishing, New York.

Schele, L., and P. Mathews

1998 *The Code of Kings: The Language of Seven Sacred Maya Temples and Tombs.* Scribner, New York.

Schele, L., and M. E. Miller

1986 *The Blood of Kings: Dynasty and Ritual in Maya Art.* G. Braziller and Kimbell Art Museum, New York and Fort Worth.

Schultes, R. E.

1941 A Contribution to Our Knowledge of *Rivea corymbosa*: The Narcotic *Ololiuqui* of the Aztecs. *Botanical Museum Leaflets.* Harvard University, Cambridge.

Schultes, R. E., and A. Hofmann

1980 *Plants of the Gods: Origins of Hallucinogenic Use.* McGraw Hill Co., New York.

Smith, M. E.

2003 *The Aztecs.* Blackwell Publishing, Malden, MA.

Soto, Zulay

2000 *Catalogo de arte precolombino costarricense.* Museo del Jade. Instituto Nacional de Seguros, San José, Costa Rica.

Stone, A.

1988 Sacrifice and Sexuality: Some Structural Relationships in Classic Maya Art. In *The Role of Gender in Precolumbian Art and Architecture,* edited by V. E. Miller, pp. 75–103. University Press of America, Lanham, MD.

1992 Aspects of Impersonation in Classic Maya Art. In *Sixth Palenque Round Table, 1986,* edited by V. Fields, pp. 194–202. University of Oklahoma Press, Norman.

Stone-Miller, R.
 2004 Human-Animal Imagery, Shamanic Visions, and Ancient American Aesthetics.
 Res 45:47–68.
Stuart, D.
 1988 Blood Symbolism in Maya Iconography. In *Maya Iconography*, edited by E. P.
 Benson and G. G. Griffin, pp. 175–221. Princeton University Press, Princeton.
Taube, K.A.
 1992 The Temple of Quetzalcoatl and the Cult of Sacred War at Teotihuacan. *Res*
 21:53–87.
 1994 The Birth Vase: Natal Imagery in Ancient Maya Myth and Ritual. In *The Maya
 Vase Book*, edited by J. Kerr, pp. 652–685. Kerr Associates, New York.
 2004 *Olmec Art at Dumbarton Oaks*. Dumbarton Oaks Research Library and Collec-
 tions, Washington, D.C.
Tedlock, D. (translator and editor)
 1985 *Popol Vuh: The Mayan Book of the Dawn of Life*. New York: Simon and Schus-
 ter.
Vogt, E.
 1965 Zinacanteco 'Souls.' *Man* 65:33–35.
Whitehead, N. L.
 2002 *Dark Shamans: Kanaimà and the Poetics of Violent Death*. Duke University
 Press, Durham, NC.
 2005 Afterword: The Taste of Death. In *Terror and Violence: Imagination and the
 Unimaginable*, edited by A. Strathern and N. L. Whitehead. Pluto Press, Lon-
 don.
Whitehead, N. L., and R. Wright
 2004 *In Darkness and Secrecy: The Anthropology of Assault Sorcery and Witchcraft in
 Amazonia*. Duke University Press, Durham, NC.
Wilbert, J.
 1996 *Mindful of Famine: Religious Climatology of the Warao Indians*. Harvard Univer-
 sity Press, Cambridge, MA.
Wright, R.
 2004 The Wicked and the Wise Men: Witches and Prophets in the History of the
 Northwest Amazon. In *In Darkness and Secrecy: The Anthropology of Assault
 Sorcery and Witchcraft in Amazonia*, edited by N. L. Whitehead and R. Wright,
 pp. 82–108. Duke University Press, Durham, NC.

CHAPTER 12

TO BOAST IN OUR SUFFERINGS: THE PROBLEM OF PAIN IN ANCIENT MESOAMERICA

Stephen Houston

[D]o not wound him to the depth of his flesh, [allow] that he may
suffer little by little.
> —From *Canción de la danza del arquero flechador, Cantares de
> Dzitbalché, Colonial Yucatan* [Barrera Vásquez 1965:72].

A basic question in human pain and suffering is whether a neurological inci-
dent—the experience of severe discomfort, or "pain"—has any meaning.
Does it represent something other than the ebb and flow of unpleasant prods to
the nervous system?[1] In the Mediterranean area during antiquity, pain could be
viewed as a sentinel of deeper conditions, a disorder that needed treatment, and,
to physicians like Galen, a varied experience that required classification. To doc-
tors of the time, pain ranged from "pungitive" (sharp) to the weighty and oppres-
sive feeling of generalized aching, often centered on a particular organ (Rey
1993:27). Some of these classifications remain valid as descriptions of experience:
pain as distension of fibers, feeling of weight, pulsation linked to arterial rhythms,
stabbing sensation (Rey 1993:95; Silverman 2001:162). Above all, pain in antiq-
uity offered little moral value "within the arena of . . . good or evil" (Rey 1993:40).
There was no "good" pain.

In contrast, Christian theology elevated pain and its emotional counterpart,
suffering, to a new role as an instrument of good and God. Whether brief or

331

long-lasting, pain inflicted on sinners was the justice of a righteous deity. The human body felt the direct wrath of God through a tool that forced the sufferer to contemplate the relation of flesh to spirit. In cases of intractable, hopeless illness, pain became a Christian "mystery," either inexplicable—as God's will so often was—or as a cleansing agent of the soul. By connecting human experience to the sufferings of the Cross, pain opened a path to fuller Christian existence. The weakness of flesh, a mere "carnal envelope," gave way to strengthened spirit, in penance to God and to the advantage of individual souls (Rey 1993:57, 184–185). In the words of Pope John Paul II, whose final days showed a very public concern for the meaning of pain, "'suffering' seems . . . *essential to the nature of man*" (John Paul II, 1984, *Salvafici Doloris*, I, 2, italics in original; Glucklich 2001:4). Writing as a relatively recent convert to Christianity, C. S. Lewis (1950: 80–81, 85) suggested that pain expressed the fallen state of humanity (as in, "all is not well") and exploded the view that humans stood alone in self-sufficiency (as in "humans require the comfort and help of God"). For Lewis, pain was a wake-up call to the spiritually indolent or inattentive. In the twentieth century, similar, if secular, versions of such ideas also arose within the so-called dolorist movement: "I am suffering, therefore I am." To the dolorists, pain assumed moral value as an effective means of personal catharsis and as an encouragement to lucid thought (Rey 1993:318; Teppe 1973).

In present-day clinical medicine and experimental physiology, pain has its own set of explanations. Most are mechanistic in nature. Pain has become (again) a medical issue, not a moral one. The first kind of explanation asserts a functional role. The sensation of a hand held in flame instructs someone never to do it again. A more comprehensive view is that pain stems from the body in disarray. Pain is "nociceptive," resulting from actual damage to tissue, with relatively short-term suffering; or it is "neuropathic," a chronic condition triggered by malfunction or injury to the nervous system, not always in ways that can be understood by physicians, at least for the moment (Craig 1999:336–337; Hall 1994:11–17). "Mixed pain" combines both, with the added effect that neurological processing may amplify localized pain into a general feeling of distress. An alternative view in more recent study is to distinguish between "phasic" or instant pain, just at the beginnings of tissue damage, "acute" pain of a more sustained sort, and the "chronic" pain that is often the most difficult to treat (Craig 1999:333–334). The pathway of pain is now understood to move from an actual physical insult to its translation into signals, then as a transmission up the spinal chord for modulation by the brain, and, finally, as the creation of a perception of pain.[2] The size of the pain fibers determines the quality of pain, some yielding a sharp sensation, others a more continuous, almost diffuse feeling (Hall 1994:11). The control and manage-

ment of pain entails interventions along that pathway, with intensity of pain being determined by age, sex, and mental state. Yet, for all the therapeutic strategies available at present, pain and suffering remain intensely subjective experiences. It is here that language and imagery come to enable a deeper empathy, a joint understanding and recollection of what it means to suffer (J. Cambier, in Rey 1993: 333–335).[3]

Quite simply, pain and suffering are about more than illness or accidental trauma. People inflict pain on themselves and on others. Some of this can be understood as a psychiatric or even psychological condition. Freud would explain "unpleasure" as a "preparatory act" for future pleasure, and as a way to deal with the psychic obstacles that an ordered society might impose on individual gratification (Freud, in Gay 1989:611, 625; Glucklich 2001:221). The widespread appearance of self-mutilation, often by young women, appears to alleviate stress and may not even be experienced as pain per se (Favazza 1996:194–195, 205). Illnesses of this sort are not of immediate concern here, in a book on violence in Mesoamerica. Moreover, the proposition that group behavior can be understood through the tools of psychoanalytic theory represents an inherent absurdity— Aztec self-sacrifice as a form of "cutting"—for the reason that the tensions and forces described by Freud and his followers operate at the level of individuals. Instead, the social dimension of pain—of pain inflicted and pain witnessed, of suffering felt, displayed, choreographed, and scripted—lies at the heart of this book.

The literary scholar Elaine Scarry (1985:162) portrays pain as an escalating destruction of the person, beyond words to describe. Pain unmakes all, particularly for those who have been subjected to torture. It is a personal experience that simply cannot be communicated. Using counter-examples, Ariel Glucklich (2001: 43, 50–51) shows this to be wrong, proposing the existence of "communities of pain" made up of people who share the same "language" or understanding of what pain means. In a landmark study, Mark Zboroski (1952) demonstrated marked differences between ethnic groups in how they experienced or dealt with pain (see also Bates 1995; Greenwald 1991). Moreover, a few members of any particular "community" might feel pain and project suffering; others not in direct pain would see those acts and draw meaning from them. They may even empathize with the pain through "surrogate senses," a sense of furtive identification with the pain-taker. In a sense, this becomes an imaginative exercise that permits the virtual experience of pain (Miller 1993:67).

In scripted settings, violence to self and others forms part of this system, although, as a term, "violence" raises certain problems from a comparative perspective. Labels like "victim," "victimizer," and "observer" have an almost juridical

quality, implying judgments about whether the infliction of pain is good or bad, whether violence is "moral" from a particular standpoint. For example, the moral premise of capital punishment is that the state takes life because a person needs to pay for horrid acts. In some feminist writing, the "victim," even if male, is understood to undergo a cultural process of reverse-gendering, from robust, well-armored, "active" male to vulnerable, stripped, "passive" female. The "bad" role of victimizer merges subtly with a larger, dispositive statement about masculine nature (Trexler 1995:1).[4]

But the fact is, to characterize one person as a "victim," another as "victimizer" depends greatly on the audience and on the status of the "victim" (Miller 1993: 55). In Classical Greece, the rape of low-status women did not induce the same outrage as the violation of high-born ladies who carried and might transmit important bloodlines (Omitowoju 2002:13, 17). From an ethological perspective, exposure to violence can even be suggested to fulfill two, diametrically opposed functions: (1) scripted violence releases urges that might veer out of control, to collective disadvantage if not properly vented; or (2) scripted violence promotes further acts of aggression by those who wish to harness human belligerence (Fox 1977:136, 139; Heelas 1983:376; Hartrup and de Wit 1978:298). In other words, "controlled violence" is not, for some, a "bad" practice at all, especially for those who believe in the innate tendency of humans to commit acts of aggression (for example, Bandura 1979: fig. 5). The challenge in accepting such theories is that they will always seem plausible. But they are seldom proved through statements of direct intent by the practitioners of pain.

Historians of human experience can thus offer the belief that pain has meaning and that those meanings have the possibility of changing over time. The claim that pain has no meaning at all—the most common perception today—is itself an assertion (a disapproving one) about wider beliefs concerning the relation between humans and divine will. It stands in necessary dialogue with prior, semiotic views of pain. Historians can equally propose that the infliction of pain, an act of violence to a body or bodies, conveys quite varied concepts of what is good and bad, and what the instrumentality of pain-making might be thought to accomplish. In his contribution to this volume (Chapter 10), Claude Baudez, who illustrates various examples of expressed pain across Mesoamerica, assembles a collection of violent displays and indicates that some of these were overt, others implicit. Following Graulich (2004), he suggests that pain enhanced the worth of self-sacrifice or, rather, of self-sacrifice through proxies, and that sacrifice addressed and resolved levels of supernatural indebtedness. Part of this perspective may be valid, and others have noted it before Graulich, in persuasive manner (for example, Monaghan 1995, 2000; Taube 1993). Yet pain is unlikely to be re-

ducible to a single set of expressive or ritual objectives. There could also have been (1) odium against enemies and the need to dishonor or dehumanize such people (Houston et al. 2006); (2) an aesthetic of pain-expression and stylized violence; (3) pain-as-ritual instrumentality, with precise objectives in mind (see below); (4) mortal injury that-is-not-pain (as in static scenes of decapitated ballplayers in coastal Veracruz); (5) exhibits of the deceased as proof that they are truly dead, that they no longer pose a threat; (6) *Schadenfreude*, the act of taking particular delight in the misery of enemies (Portmann 2000); and (7) visionary pain as erotic sensation (Morris 1991). These are but seven of many other shadings. It is probably no coincidence that the group most concerned with detailed depiction of the human body—the Classic Maya—were also the most overt in linking expressive emotion, true suffering, with traumas of the flesh (Houston 2001).

The very problem of pain for those who observe displays of suffering in pre-Hispanic Mesoamerica is the difficulty of stepping outside of ourselves. The imagery and actions are so shocking to present-day sensibilities, as they were to the Spaniards (not otherwise known for squeamishness), that repulsion and disgust lurch right to the foreground. Consider, for example, death by arrow sacrifice, found throughout Mesoamerica. The goal was clearly, sadistically, to inflict and sustain torment by multiple laceration. And we also see the widespread practice of torturing children so as to facilitate rain-making (Barrera Vásquez 1965: 72; Durán 1964:215; Ortiz and Rodríguez 2000:88–89; Román 1990; Sahagún 1950–1982: bk. II, ch. 20; Tozzer 1941: fnn. 535, 536). The trauma of Aztec heart sacrifice can scarcely be imagined, although we are told that some "victims" entered into this offering with earnest acceptance, and that the cutting itself passed quickly (Durán 1964:196). Perhaps yet more horrific was the disembowelment of people lashed to wooden frames. Descriptions from Japan of *seppuku* evoke something of what that sensation must have been: an embroilment of pain, intense, long-lasting, and, in Japan, a tableau of "assistants" who operated in a distinct aesthetic of bloody red-on-white (Blomberg 1994:72; Taube 1988).[5] That combination of colors was present among the Maya, too.

Taube and Zender (this volume, Chapter 7) do an excellent job describing bone-crushing boxing, as do other contributors who examine the ballgame in Mesoamerica and Central America. Truly, these were sporting events with consequences. From our distant vantage, it is possible to sense the exhilaration but also the suffering. Blatant exhibitions of pain show that such displays mattered, that a misstep resulted in severe injury, and that suspense (even mock suspense) played a role in audience reaction. In contrast, other displays, such as the dance in Room 3 at Bonampak, Chiapas, were mostly stagecraft: the painful insertion of sticks into the male member was less reality than sleight-of-hand, a mock

"penis" in place of the real thing (Karl Taube, personal communication 1998). Ross Hassig's (1988:128–130) view that stylized warfare among the Aztec served as training in anticipation of genuine combat resembles the ethological arguments discussed before. Perhaps, maybe: but the bald functionality of such explanations and their leveling to "practical reason" (common sense as adjudged by an outsider) would appeal more to Émile Durkheim than to most anthropologists today. The point is, for each of these acts, the analyst has to move quickly, if with difficulty, from sensationalism or personal distaste to a genuine grappling with meaning and setting.

Fortunately, the lexical evidence for "pain" is fairly consistent throughout Mesoamerica, hinting that the semantic domains have not changed greatly over time. In the Lowland Maya languages, "pain" is often described as a "biting," as though the metaphor (or literal reality) was that of being consumed: thus, Ch'or-ti' k'ux, but also yah, perhaps an onomatopoeic word expressing a cry of pain (Stross n.d., transcribed from Charles Wisdom; see also ya cux in Ch'olti' [Ringle n.d.]; Kaufman and Norman 1984:137; Laughlin 1988, II:431). "Throbbing" and "pinching" were described as well (Ch'olti', hitz [Ringle n.d.]), apparently as part of an indigenous understanding of physiology by which "nerves" overlapped with "blood" (chichel in Ch'olti' [original orthography]). Yucatec Maya has much the same range of meanings, including k'ux, but also ch'ii', "bite, eat meat," "twist" or ch'ot, rather like the extruded bowels in Mesoamerican imagery (Barrera Vásquez 1980:92, 141). A feeling of depression, k'om, can also be found in the Yucatec sources (Barrera Vásquez 1980:412), along with a linkage between "hardening," kanmal (as in clay or bread), and states of physical distress (Barrera Vásquez 1980:297); see also the probable cognate in Ch'olti', chanil, "sorrows, pains" (Ringle n.d.). Insofar as disease in Mesoamerica did not "just happen," but had complex etiologies, it seems possible that pain as flesh-consumed or as flesh-eaten hints at more than a metaphor: someone, something, caused misery by consuming the body. This recalls John Monaghan's (2000:37) belief that Meso-american theology rested in part on the notion of "phagiohierarchy," of things that eat other things, of meals taken or deferred by supernatural beings. Pain may not be "good." In Mesoamerica, however, it was "moral" in the sense of serving larger purposes and helping to meet inescapable obligations. Pain had meaning. Of the many defects in Mel Gibson's movie Apocalypto—a work bound to influence public perception—the greatest may have been its detachment of ancient Mesoamerican suffering from what pain was supposed to mean. For Gibson, blood and agony mostly involved a cynical show by unbelieving priests and kings. As compiled by Orr and Koontz, this volume does much to rectify Gibson's misrepresentation of Maya and Mesoamerican violence.

There is still much to do. A volume on organized violence in the ancient Americas sets an expansive agenda. The infliction of pain, its emotional experience as suffering, and the diversity of meaning attached to such human conditions promise yet more books to come: ones that tabulate and examine Mesoamerican ideas for such concepts; ones that detail the nature of pain and violence over time; others that explore the collision of indigenous concepts with ideas of suffering introduced by Christian friars and priests. Bound to stimulate, this book offers a model for all future work on the problem of pain in ancient Mesoamerica.

Acknowledgments

I thank Rex Koontz and Heather Orr for the opportunity to think about the meaning of pain and suffering in comparative perspective. Part of the title is taken from Romans 5.

Notes

1 "Pain" is about tissue damage, and "suffering" is "an emotional and evaluative reaction to any number of causes, some entirely painless" (Glucklich 2001:11). Nonetheless, an affective or emotive quality can also pervade a sense of pain (Melzack and Dennis 1978).

2 Some specialists believe that this theory of signals moving through "gateways" is generally viable but insufficiently precise in describing the specific mechanisms at work in the perception of pain (Skevington 1995:23).

3 Note that the technology of institutionalized killing in prisons of the United States has gone from the gibbet and public merry-making to clinical procedures that destroy life but do not, it is claimed, cause pain (Foucault 1977:11). Judicial torture, too, has made a slow exit. Its disappearance in eighteenth-century France probably came about because of "the surgical delineation of pain as dangerous in both physical and psychological terms" (Silverman 2001:62).

4 A plausible alternative, however, is that female attributes are used to express a condition of vulnerability: the goal is not feminization but bringing to bear all possible attributes of defenselessness (Houston et al. 2006).

5 Catharina Blomberg (1994:72) mentions that "no vital organs were damaged by this method, and the victim might have to wait for hours before death occurred." In much pain-making of Mesoamerica, the focus was on "acute" rather than "phasic" or "chronic" pain.

References Cited

Bandura, A.

1979 Psychological Mechanisms of Aggression. In *Human Ethology*, edited by M. von Cranach, K. Foppa, W. Lepenies, and D. Ploog, pp. 316–356. Cambridge University Press, Cambridge.

Barrera Vásquez, A.

1965 *El libro de los Cantares de Dzitbalché.* Instituto Nacional de Antropología e Historia, Mexico City.

1980 *Diccionario Cordemex: Maya Español, Español-Maya.* Ediciones Cordemex, Mérida.

Bates, M. S.

1995 A Cross-Cultural Comparison of Adaptation to Chronic Pain among Anglo-Americans and Native Puerto Ricans. *Medical Anthropology* 16:141–173.

Blomberg, C.

1994 *The Heart of the Warrior: Origins and Religious Background of the Samurai System in Feudal Japan.* Japan Books, Folkstone.

Craig, K. D.

1999 Emotions and Psychobiology. In *Textbook of Pain,* edited by P. D. Wall and R. Melzack, pp. 331–344. 4th edition. Churchill Livingstone, Edinburgh.

Durán, D.

1964 *The Aztecs: The History of the Indies of New Spain.* Translated by D. Heyden and F. Horcasitas. Orion, New York.

Favazza, A.

1996 *Bodies under Siege: Self-Mutilation and Body Modification in Culture and Psychology.* Johns Hopkins University Press, Baltimore.

Foucault, M.

1977 *Discipline and Punish: The Birth of the Prison.* Vintage Books, New York.

Fox, R.

1977 The Inherent Rules of Violence. In *Social Rules and Social Behaviour,* edited by P. Collett, pp. 132–149. Blackwell, Oxford.

Gay, P.

1989 *The Freud Reader.* Norton, New York.

Glucklich, A.

2001 *Sacred Pain: Hurting the Body for the Sake of the Soul.* Oxford University Press, New York.

Graulich, M.

2004 *Le sacrifice humain chez les Aztèques.* Fayard, Paris.

Greenwald, H. P.

1991 Interethnic Differences in Pain Perception. *Pain* 44:157–163.

Hall, J. L.

1994 Anatomy of Pain. In *Handbook of Pain Management,* edited by C. D. Tollison, pp. 11–17. 2nd edition. Williams and Wilkins, Baltimore.

Hartrup, W., and J. de Wit

1978 The Development of Aggression: Problems and Perspectives. In *Origins of Aggression,* edited by W. Hartrup and J. de Wit, pp. 279–304. Mouton, the Hague.

Hassig, R.

1988 *Aztec Warfare: Imperial Expansion and Political Control.* University of Oklahoma Press, Norman.

Heelas, P.

1983 Anthropological Perspectives on Violence: Universals and Particulars. *Zygon* 18(4):375–404.

Houston, S.
 2001 Decorous Bodies and Disordered Passions: Representations of Emotion among the Classic Maya. *World Archaeology* 33(2):206–219.
Houston, S., D. Stuart, and K. Taube
 2006 *The Memory of Bones: Body, Being, and Experience among the Classic Maya.* University of Texas Press, Austin.
Kaufman, T. S., and W. M. Norman
 1984 An Outline of Proto-Cholan Phonology, Morphology, and Vocabulary. In *Phoneticism in Mayan Hieroglyphic Writing*, edited by J. S. Justeson and L. Campbell, pp. 77–166. Publication No. 9. Institute for Mesoamerican Studies, State University of New York at Albany.
Laughlin, R.M.
 1988 *The Great Tzotzil Dictionary of Santo Domingo Zinacantán.* 3 vols. Smithsonian Contributions to Anthropology 31. Smithsonian Institution Press, Washington, D.C.
Lewis, C. S.
 1950 *The Problem of Pain.* Macmillan, New York.
Melzack, R., and S. G. Dennis
 1978 Neurophysiological Foundations of Pain. In *The Psychology of Pain*, edited by R. A. Sternbach, pp. 1–26. Raven Press, New York.
Miller, W. I.
 1993 *Humiliation.* Cornell University Press, Ithaca.
Monaghan, J.
 1995 *The Covenants with Earth and Rain: Exchange, Sacrifice, and Revelation in Mixtec Society.* University of Oklahoma Press, Norman.
 2000 Theology and History in the Study of Mesoamerican Religions. In *Handbook of Middle American Indians*, Supplement 6: *Ethnology*, edited by J. D. Monaghan, pp. 24–49. University of Texas Press, Austin.
Morris, D. B.
 1991 *The Culture of Pain.* University of California Press, Berkeley.
Omitowoju, R.
 2002 Regulating Rape: Soap Operas and Self Interest in the Athenian Courts. In *Rape in Antiquity: Sexual Violence in the Greek and Roman Worlds*, edited by S. Deacy and K. F. Pierce, pp. 1–24. Duckworth, London.
Ortiz, P., and M. del Carmen Rodríguez
 2000 The Sacred Hill of El Manatí: A Preliminary Discussion of the Site's Ritual Paraphernalia. In *Olmec Art and Archaeology in Mesoamerica*, edited by J. E. Clark and M. E. Pye, pp. 74–93. National Gallery of Art, Washington, D.C.
Portmann, J.
 2000 *When Bad Things Happen to Other People.* Routledge, London.
Rey, R.
 1993 *The History of Pain.* Translated by L. E. Wallace, J. A. Cadden, and S. W. Cadden. Harvard University Press, Cambridge, MA.
Ringle, W. M.
 n.d. *Concordance of the Morán Dictionary of Ch'olti'.* Digital manuscript on file, Department of Anthropology, Davidson College.

Román Berrelleza, J. A.
 1990 *Sacrificios de niños en el Templo Mayor, México*. Consejo Nacional para la Cultura y las Artes, Mexico City.
Sahagún, B. de
 1950–1982 *The Florentine Codex: General History of the Things of New Spain*. Translated by A. J. O. Anderson and C. E. Dibble. University of Utah Press, Salt Lake City.
Scarry, E.
 1985 *The Body in Pain: The Making and Unmaking of the World*. Oxford University Press, Oxford.
Silverman, L.
 2001 *Tortured Subjects: Pain, Truth and the Body in Early Modern France*. University of Chicago Press, Chicago.
Skevington, S. M.
 1995 *Psychology of Pain*. Wiley, New York.
Stross, B.
 n.d. Concordance of Ch'orti', from notes by Charles Wisdom. Digital manuscript on file, Department of Anthropology, University of Texas, Austin.
Taube, K. A.
 1988 A Study of Classic Maya Scaffold Sacrifice. In *Maya Iconography*, edited by E. P. Benson and G. G. Griffin, pp. 331–351. Princeton University Press, Princeton.
 1994 The Birth Vase: Natal Imagery in Ancient Maya Myth and Ritual. In *The Maya Vase Book, A Corpus of Rollout Photographs of Maya Vases*: Vol. 4, edited by J. Kerr, pp. 652–685. Kerr Associates, New York.
Teppe, J.
 1973 *Apologie pour l'anormal ou Manifeste du dolorisme; Suivi de Dictature de la douleur*. J. Vrin, Paris.
Tozzer, A. M.
 1941 *Landa's Relación de las cosas de Yucatan*. Papers of the Peabody Museum of American Archaeology and Ethnology, Vol. 18. Harvard University, Cambridge, MA.
Trexler, R. C.
 1995 *Sex and Conquest: Gendered Violence, Political Order, and the European Conquest of the Americas*. Cornell University Press, Ithaca.
Zboroski, M.
 1952 Cultural Components in Response to Pain. *Journal of Social Issues* 8:6–30.

CONTRIBUTORS

EDITORS

Heather Orr (Introduction, Chapter 9) has studied Mesoamerican ballgames, ritual combats, and pilgrimage and procession, and the site of Dainzú, Oaxaca, Mexico. Her publications on these subjects include *Procession Rituals and Shrine Sites: The Politics of Sacred Space in the Late Formative Valley of Oaxaca*, and *Stone Balls and Masked Men: Ballgame as Combat Ritual, Dainzú, Oaxaca*. Her current research interests in ancient Costa Rican art involve the preparation of a book on the previously unstudied Schmidt collection in the Maltwood Museum and Art Gallery, at the University of Victoria. Heather Orr is Professor of Art History at Western State College of Colorado. Contact information: Dr. Heather S. Orr, Department of Art, Quigley Building, Western State College of Colorado, 600 North Adams Street, Gunnison, CO, 81231; horr@western.edu.

Rex Koontz (Introduction, Chapter 3) has studied and published on the site of El Tajín for more than a decade, most recently in *Lightning Gods and Feathered Serpents: The Public Sculpture of El Tajín* (University of Texas Press, 2009). More general interests include the aesthetics of non-Western art and its relation to power, as well as the history and historiography of Mesoamerica. *Landscape and Power in Ancient Mesoamerica*, edited with Kathryn Reese-Taylor and Annabeth Headrick, addresses aesthetics and power, while *Mexico* (5th and 6th editions), with Michael Coe, is a general treatment of Mesoamerican history. Rex Koontz teaches art history at the University of Houston. Contact information: Dr. Rex Koontz, School of Art, 100 Fine Arts, University of Houston, Houston, TX 77204-4019; rkoontz@uh. edu.

AUTHORS

Adriana Agüero Reyes (Chapter 5) teaches Mesoamerican art and Gulf Coast Archaeology in the Universidad Autónoma del Estado de México (UAEM). She received her licenciatura in archaeology from the Escuela Nacional de Antropología e Historia (ENAH) in 2000. Presently her M.A. research in Mesoamerican Studies at the Universidad Nacional Autónoma de México (UNAM) is on the custom of placing offerings (including human sacrifice) when initiating new building stages in major structures. Her thesis treated Central Veracruz iconography, her chief area of study. Contact information: Adriana Agüero Reyes, Trípoli 110, Colonia Portales, Delegación Benito Juárez, z.p. 03300, Mexico City, D.F., Mexico; adrianaaguero77@hotmail.com.

Honorary director of research at the National Center of Scientific Research (CNRS, France), archaeologist **Claude-François Baudez** (Chapter 10) has led several archaeological investigations in Costa Rica and Honduras to study poorly known cultures of Mesoamerica and the Intermediate Area. He is also a Mayanist with a special interest with iconography. He has been co-director of the French Mission at Toniná, director of the first phase of the Copán Project, and has studied iconography at Balamku (Campeche). He is the author of several monographs on Central American archaeology, of numerous articles on Maya iconography, of a book on Copán sculpture, and has written a book on the history of the religion of the ancient Maya. Contact information: Dr. Claude Baudez, 8bis rue Charcot, 92200 Neuilly-sur-Seine, France; claude.baudez@orange.fr.

Archaeologist **Oswaldo Chinchilla Mazariegos** (Chapter 6) graduated from the University of San Carlos, Guatemala (1990) and received his Ph.D. from Vanderbilt University (1996). Currently Curator of the Popol Vuh Museum, Francisco Marroquín University, and professor at the University of San Carlos, his research focuses on the archaeology of the Pacific Coast of Guatemala, Classic Maya writing and iconography, and the history of archaeology in Guatemala. He has carried out extensive field research in the Cotzumalhuapa region of Guatemala's Pacific piedmont, including recording and analysis of the sculptural corpus, studies of settlement patterns and urbanism, and documentary research on the pre-Columbian peoples of the area. He is the author of *Guatemala, Corazón del Mundo Maya* (Barcelona, 1999), and *Kakaw: Chocolate in Guatemalan Culture* (Museo Popol Vuh, 2005), and co-editor of *The Decipherment of Ancient Maya Writing* (University of Oklahoma Press, 2001). Contact information: Dr. Oswaldo Chinchilla, Museo Popol Vuh, Universidad Francisco Marroquín, 6 Calle Final Zona 10, Guatemala 01010; ofchinch@ufm.edu.gt.

Annick Daneels (Chapter 5) received her Ph.D. in Art History and Archaeology, Ghent University, Belgium, in 1987, and her Ph.D. in Anthropology, National Autonomous University of Mexico (UNAM), in 2002. She is currently tenured associate researcher at the Instituto de Investigaciones Antropológicas of the UNAM. She has specialized in the archaeology of Central Veracruz, with a field project initiated since 1981. Her interests include the topics of sociopolitical organization, economic networks, and the nature and levels of religious integration, with contributions published mainly as book chapters in Mexico, the United States, and Europe. Contact information: Dr. Annick Daneels, Instituto de Investigaciones Antropológicas, Circuito Exterior s/n, Ciudad Universitaria, México, D.F. C.P. 04510; annickdaneels@hotmail.com.

Jane Stevenson Day (Chapter 8) is Chief Curator Emeritus of the Denver Museum of Nature and Science. During her years at the museum she organized numbers of major exhibits focused on the ancient New World, including *Aztec: The World of Moctezuma and Costa Rica: The Art and Archaeology of the Rich Coast*. She was also active in developing the museum's very popular travel program and active adult lectures and educational opportunities.

As a scholar she has specialized in, and published extensively on, the art and archaeology of Costa Rica. Most recently she has become particularly interested in the Mesoamerican ballgame and its presence in Mexico and cultures far distant from the Mesoamerican heartland. Her research on this topic is reflected in publications such as "The West Mexican Ballgame" in *Ancient West Mexico: Art and Archaeology of the Unknown Past*, edited by Richard Townsend (The Art Institute of Chicago, 1999), and "Performing on the Court" in *The Sport of Life and Death: The Mesoamerican Ballgame*, edited by Michael Whittington (Mint Museum, 2001). Contact information: Dr. Jane Stevenson Day, 1510 East 10th Avenue, #9W, Denver, CO 80218; janedayphd@gmail.com.

Marlene Fritzler (Chapter 2) received her M.A. in Art History and Archaeology from the University of Calgary in 2005. Her research—focusing on gender roles among the Late Classic Maya—redefined the roles of nine royal women as warrior queens in their own right. Marlene's interdisciplinary investigations were funded by the distinguished Social Sciences and Humanities Research Council of Canada. She has recently served as the Education Coordinator for the exhibition "Ancient Peru Unearthed" at the Nickle Arts Museum, University of Calgary. Contact information: Marlene Fritzler, 49 Stratford Place, S.W., Calgary, Alberta, Canada, T3H 1H7; marlenefritzler@hotmail. com.

Julia Guernsey (Chapter 2) is an Associate Professor in the Department of Art & Art History at the University of Texas at Austin. Her research and publications focus on the Middle and Late Preclassic periods (300 B.C.–A.D. 250) in ancient Mesoamerica, in particular on sculptural expressions of rulership during this time. She is also project iconographer for the La Blanca Archaeological Project, where she continues to participate in ongoing excavations and analysis of materials from this Middle Preclassic site on the Pacific Coast of Guatemala. Her most recent research appears in her book *Ritual and Power in Stone: The Performance of Rulership in Mesoamerican Izapan-Style Art* (University of Texas Press, 2006), and in articles in *Antiquity, Ancient America, Res: Anthropology and Aesthetics, Mexicon, Journal of Latin American Lore, Memorias de la Segunda Mesa Redonda Olmeca*, proceedings of the annual *Simposio de Investigaciones Arqueológicas en Guatemala*, and the exhibition catalogue *Lords of Creation: The Origins of Sacred Maya Kingship*. Contact information: Dr. Julia Guernsey, University of Texas at Austin, Department of Art and Art History, 1 University Station D1300, Austin, Texas 78712-0337.

John W. Hoopes (Chapter 11) is an Associate Professor in the Department of Anthropology and Director of the Global Indigenous Nations Studies Program at the University of Kansas. He received a B.A. in Archaeology from Yale University (1980), where he studied with Irving Rouse, George Kubler, and Michael Coe, and a Ph.D. in Anthropology from Harvard University (1987), which he completed under the direction of Gordon R. Willey, Rosemary Joyce, and Izumi Shimada. He has conducted archaeological fieldwork in New Mexico, Ecuador, and Costa Rica. He is the author of numerous articles and co-editor of two books: *The Emergence of Pottery: Technology and Innovation in Ancient Societies*, with William K. Barnett (Smithsonian Institution Press, 1995) and *Gold and Power in Ancient Costa Rica, Panama, and Colombia*, with Jeffrey Quilter (Dumbarton Oaks, 2003). He teaches courses on the art and archaeology of Mesoamerica and the central Andes, the history of anthropology, ceramic analysis, critical thinking, and shamanism. His most recent research has focused on pre-Columbian cultures of the Isthmo-Colombian and pan-Caribbean culture areas. Contact information: Dr. John W. Hoopes, Department of Anthropology, University of Kansas, Fraser Hall, Room 622, 1415 Jayhawk Blvd, Lawrence, KS 66049-7556; (785) 864-2638 office, (785) 864-5224 fax; email: hoopes@ku.edu; website: http://people.ku.edu/~hoopes.

Stephen Houston (Chapter 12) serves as Dupee Family Professor of Social Science at Brown University. Previously he taught at Brigham Young University, as Jesse Knight University Professor. Houston has conducted research in Belize,

Honduras, Mexico, and particularly Guatemala, where he helped direct excavations at Piedras Negras. The author of over 130 articles, chapters, and reviews, Houston has also written and edited a number of books, the most recent being *The Memory of Bones: Body, Being, and Experience among the Classic Maya*, with David Stuart and Karl Taube. Contact information: Dr. Stephen Houston, Dept. of Anthropology, Box 1921, Providence, RI 02912; Stephen_Houston @brown.edu.

Arthur A. Joyce (Chapter 1) is an Associate Professor of Anthropology at the University of Colorado at Boulder. He received his Ph.D. from Rutgers University in 1991. Joyce's research focuses on the pre-Columbian peoples of Mesoamerica, particularly issues of power, political dynamics, and landscape. Since 1986 he has conducted interdisciplinary archaeological and paleoenvironmental research in Oaxaca. He is the author of *Arqueología de la costa de Oaxaca: Asentamientos del período Formativo en el valle del Río Verde inferior* (with M. Winter and R. G. Mueller, Centro INAH Oaxaca, 1998), "Domination, Negotiation, and Collapse: A History of Centralized Authority on the Oaxaca Coast before the Late Postclassic" in *After Monte Albán: Transformations and Negotiation in Oaxaca, Mexico* (edited by J. Blomster University Press of Colorado, 2008), and "Polity Produced and Community Consumed: Negotiating Political Centralization through Ritual in the Lower Rio Verde Valley, Oaxaca" (with Sarah Barber) in *Mesoamerican Ritual Economy* (edited by E. C. Wells and K. L. Davis-Salazar, University of Colorado Press, 2007). Contact information: Dr. Arthur A. Joyce, Department of Anthropology, University of Colorado at Boulder, Hale Science Building 350, Boulder, CO 80309-0233; arthur.joyce@ colorado.edu.

Peter Mathews (Chapter 2) is a Professor in the Department of Archaeology, La Trobe University, Melbourne, Australia. He specializes in the study of Maya hieroglyphic writing. Dr. Mathews has been awarded several prestigious fellowships over the course of his career, including an Australian Research Council Senior Research Fellowship (1999), a Killam Resident Fellow (1996), and a John D. and Catherine T. MacArthur Fellowship (1984). He is the co-author with Linda Schele of *Code of Kings: The Language of Seven Sacred Maya Temples and Tombs* (1998) and the author of *Corpus of Maya Hieroglyphic Inscriptions*, Vol. 6; "Tonina (1980–1999), Maya Early Classic Monuments and Inscriptions" in *A Consideration of the Early Classic Period in the Maya Lowlands* (1986), edited by Gordon R. Willey and Peter Mathews, and "Lords of Palenque: The Glyphic Evidence" in *Primera Mesa Redonda de Palenque*, Part I (1974). Contact Information: Dr. Peter Mathews, Archaeology Program, La Trobe University Victoria 3086, Australia; P.Mathews@latrobe.edu.au.

David F. Mora Marín (Chapter 11) earned his B.A. in Anthropology and Linguistics at the University of Kansas in Lawrence in 1996, and his Ph.D. in Anthropology at the State University of New York at Albany in 2001. His research deals primarily with the application of historical linguistic methodologies to the reconstruction of the earlier stages of the Lowland Mayan (Ch'olan, Yucatecan) languages, and the application of such reconstructions to the study of the history and structure of Lowland Mayan writing, from the Late Preclassic Period on. His recent studies, most of them carried out since his arrival at the University of North Carolina at Chapel Hill, deal with the reading format of the Cascajal Block, the grammatical structure of Late Preclassic texts from the Maya highland and lowland regions, the orthographic principles and linguistic affiliation of Classic Lowland Mayan writing, the structure of the Primary Standard Sequence, and the history of the jade lapidary tradition of ancient Costa Rica, a topic on which he has learned much from, and collaborated with, John Hoopes at the University of Kansas. Contact information: Dr. David Mora-Marín, Linguistics Department, University of North Carolina, 325 Dey Hall CB #3155, Chapel Hill, NC 27599; (919) 843-5621.

Kathryn Reese-Taylor (Chapter 2) is an Associate Professor in the Department of Archaeology at the University of Calgary. She is currently the director of the Naachtun Archaeological Project in the north-central Peten, Guatemala. Her primary research interests lie in the political ideology and state formation of the Lowland Maya from the Late Preclassic to the Classic Periods (300 B.C.–A.D. 800). She is the co-editor of *Landscape and Power in Ancient Mesoamerica* with Rex Koontz and Annabeth Headrick. Other selected recent publications include "Fit to be Tied: Funerary Practice Among the Prehispanic Maya" in *Ancient America,* "The Passage of the Late Preclassic into the Early Classic" and "The Shell Game: Commodity, Treasure and Kingship in the Origins of Classic Maya Civilization," both in *Ancient Maya Political Economies,* and "Ritual Circuits as Key Elements in Maya Civic Center Design" in *Heart of Creation: The Mesoamerican World and the Legacy of Linda Schele,* as well as three articles concerning current work at Naachtun in the proceedings of the annual *Simposio de Investigaciones Arqueológicas en Guatemala.* Contact information: Dr. Kathryn Reese-Taylor, Department of Archaeology, Earth Sciences, Room 806, University of Calgary, 2500 University Drive NW, Calgary, Alberta, Canada T2N 1N4.

John F. Scott (Chapter 4) received his Ph.D. at Columbia University, Department of Art History and Archaeology, in 1971. He has specialized in pre-Columbian sculpture of Mexico, the Dominican Republic, Colombia, and Ecuador. He has surveyed the art history of Latin America in his textbook,

Latin American Art: Ancient to Modern (University Press of Florida, 1999), and most recently has contributed essays in *A New World: Pre-Columbian Art from the Carroll Collection* (Johnson Museum of Art, 2008). He taught for 25 years at the School of Art & Art History of the University of Florida, from which he retired in 2006 as Professor Emeritus. He had previously taught at Rice and Cornell Universities, and curated exhibitions at The Metropolitan Museum of Art; Sewell Gallery and the Museum of Fine Arts, Houston; and the University Gallery and the Harn Museum of Art, Gainesville. Contact information: Dr. John Scott, 3112 N.W. 57th Terrace, Gainesville, FL 32606; jfscott@ufl.edu.

In addition to extensive archaeological and linguistic fieldwork in Yucatan, **Karl Taube** (Chapter 7) has participated in archaeological projects in Chiapas, Mexico, coastal Ecuador, highland Peru, Copán, Honduras and in the Motagua Valley of Guatemala. Taube is currently serving as the project iconographer for the San Bartolo Project in the Peten of northern Guatemala. Taube has broad interests in the archaeology and ethnology of Mesoamerica and the American Southwest, including the development of agricultural symbolism in pre-Hispanic Mesoamerica and the American Southwest, and the relation of Teotihuacan to the Classic Maya. Much of his recent research and publications center on the writing and religious systems of ancient Mesoamerica. Contact information: Dr. Karl Taube, Dept. of Anthropology, UC Riverside, Riverside, CA 92521-0418; taube@ucr.edu.

Andrew Workinger (Chapter 1) is an instructor at the University of Tennessee at Chattanooga. He graduated from Vanderbilt University in 2002. His dissertation research focused on the coast of Oaxaca, Mexico, specifically looking at interregional interaction with the highlands. Other areas of interest include the period of European contact in Mexico and the archaeology of the Southeastern United States. He has recently begun working in the Mixteca Alta region of Oaxaca, investigating the contact period *Mapa de Teozacoalco* and its relation to the pre-Hispanic and early historic settlement surrounding the town of San Pedro Teozacoalco. Contact information: Dr. Andrew Workinger, Department of Sociology, Anthropology, and Geography, University of Tennessee at Chattanooga, 615 McCallie Avenue, Chattanooga, TN 37403-2598; AndrewWorkinger@utc.edu.

Marc Zender (Chapter 7) (Ph.D., Archaeology, University of Calgary 2004) is a Lecturer in the Department of Anthropology, Harvard University, and a Research Associate of the Peabody Museum of Archaeology & Ethnology. He also assists Joel Skidmore in maintaining Mesoweb, one of the premier websites

specializing in ancient Mesoamerican cultures. Zender's research interests include anthropological and historical linguistics, comparative writing systems (particularly Maya and Aztec writing) and Mesoamerican archaeology. He is project epigrapher for the Proyecto Arqueológico de Comalcalco, directed by Ricardo Armijo Torres, and has undertaken linguistic, epigraphic. and archaeological fieldwork in much of the Maya area, most recently in Copán, Honduras, where he assists Dr. William L. Fash in teaching the Harvard Field School. Contact information: Dr. Marc Zender, Lecturer, Anthropology, Peabody Museum of Archaeology and Ethnology, Harvard University, 11 Divinity Avenue, Cambridge MA 02138; (617) 496-7186; mzender@fas.harvard.edu.

INDEX

349